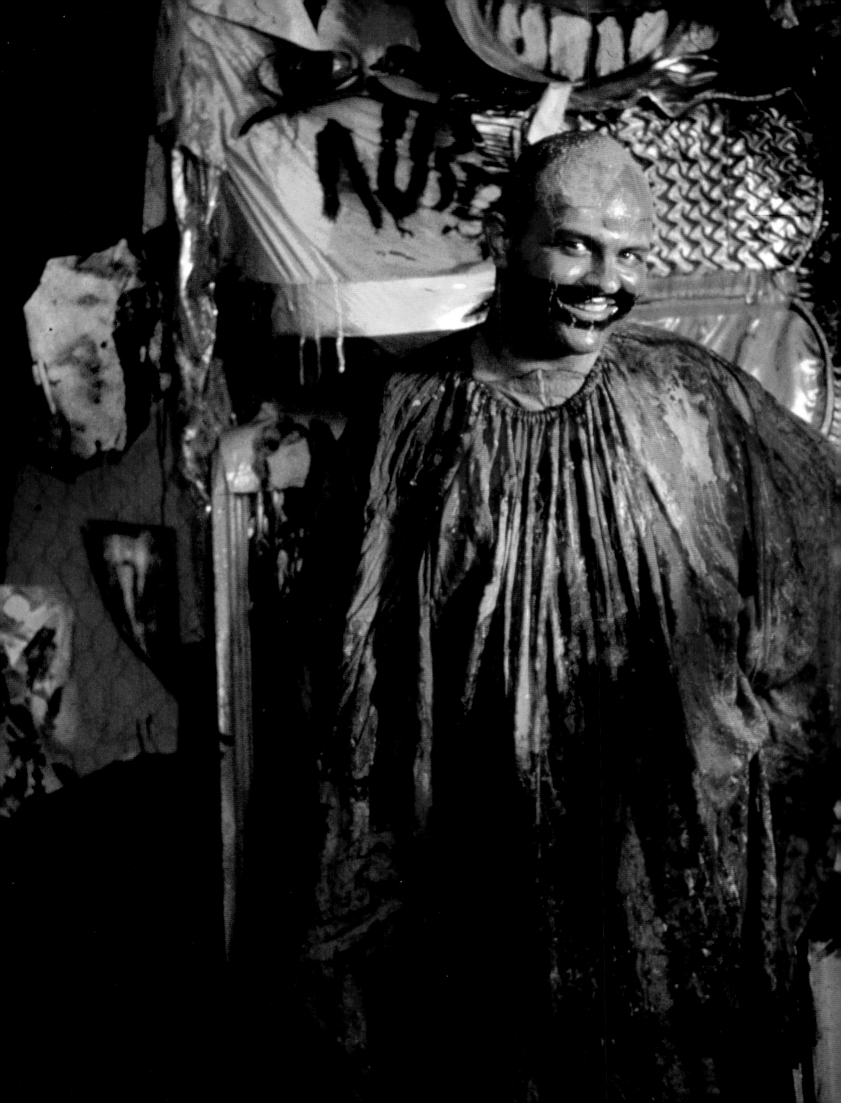

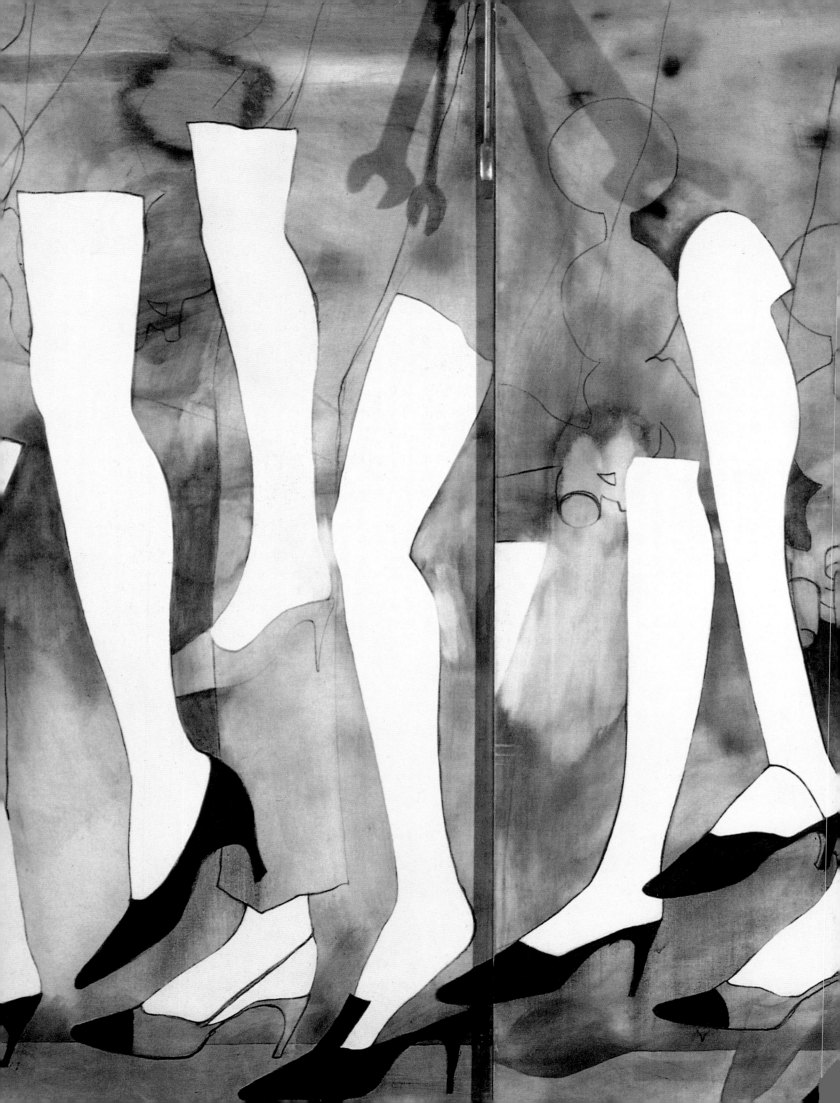

JIM
Walking Memory

DINE

1959 — 1969

GUGGENHEIM MUSEUM

Jim Dine: Walking Memory, 1959–1969
Organized by Germano Celant and Clare Bell

Support provided by The Florence Gould Foundation

Solomon R. Guggenheim Museum
February 12–May 16, 1999

Cincinnati Art Museum
October 22, 1999–January 9, 2000

Guggenheim Museum Publications
1071 Fifth Avenue
New York, New York 10128

Hardcover edition distributed by
Harry N. Abrams
100 Fifth Avenue
New York, New York 10011

Design: Massimo Vignelli
Design Assistant: Letizia Ciancio

Editor: Stephen Robert Frankel
Production: Esther Yun

ISBN 0-8109-6918-1
ISBN 0-89207-215-6

Printed in Italy

cover:
Red Robe with Hatchet (Self-Portrait). *1964 (fig. 128)*

frontispieces:
1. Dine wearing the costume from his The Smiling Workman *and standing in*
The House. *an environment included in the exhibition* Ray-Gun. *held at the*
Judson Gallery. New York. January 4–March 23. 1960. Photo by Robert R. McElroy

2. Detail of Walking Dream with a Four-Foot Clamp. *1965 (fig. 142)*

3. Nancy and I at Ithaca (Straw Heart). *1966–69/1998 (fig. 151)*

Contents

Lenders to the exhibition

Preface

Thomas Krens

I met Jim Dine for the first time in 1974, at his studio in Putney, Vermont. Only three years earlier, he had moved to the foothills of the Green Mountains straight from four years of an expatriate's life in Europe. He was already a master of paintings, drawings, and prints. I had long been an admirer of Dine's accomplishments in the 1960s and was eager to see firsthand the new directions his work had taken. His self-imposed years away from the center of the American scene had considerably changed the dynamic of his work and process. I found new motifs to contend with, and his paint and lines were much looser in feel. His abstract field paintings with various objects attached had given way to a more traditional style of portraiture and still life. It was obvious to all concerned that Dine had undergone a radical rethinking of his aesthetic goals.

In the summer of 1976, I had the privilege to sit down and talk to Dine about the course his art had taken during the decade following the explosion of Pop art. Our conversation formed the foundation for an exhibition and catalogue of Dine's printwork from 1970 to 1977 at the Williams College Museum of Art, which I organized. Dine approached our talk with the same kind of straightforward acumen that he brought to his art. It was an earnest and educational discussion about his ideas, his work, and his life history. Dine had begun to attack the figure with a vengeance, using an approach shaped by memory and the notion of the mirror image. The caustic quality of his previous subjects had been replaced by classical distortions of form and modeling. The graphic, facile quality that had sustained his earlier works had been replaced by a richer palette that shifted emphasis away from the mark on the canvas or page to the subject itself. I began the interview by asking why Dine had taken up figuration with such tenacity after his celebrated performances and mixed-media works of the 1960s. He told me that he had never left it.

The decade from 1959 to 1969, which Dine spent living and working among New York's coterie of avant-garde artists has often been treated as an anomaly with respect to his later work. He was one of the first to introduce raw emotional content into performance art and was one of its most controversial champions. Yet, he only created five performance pieces. Dine's earliest paintings were equally celebrated. The store-bought items he attached to his paint-filled canvases were brimming with an exhilaration of the new, only to be replaced in the next decade with classical figuration evoking the past. I remember Dine telling me that during this ten-year period he had felt an enormous amount of anxiety over achieving fame as an artist so rapidly and at such a young age. The fact that his early work was turned into a Pop art spectacle was even more discomfiting to him. Dine shifted the tenor of his work at the end of 1969 in order to save the artist in himself. While Dine's motifs remain some of the most cherished images in American art, his desire to be a painter has always superseded any aspirations he might have had for celebrity. He continues to be one of the most provocative painters of interiors. Without an understanding of his initial body of work, it would be impossible to grasp Dine's unique abilities as an artist engaged with such issues as perception and subjectivity. It is the Guggenheim Museum's privilege to present this survey of Dine's earliest work so that audiences are afforded the chance to learn about one of America's most intensely fascinating, challenging, and formidable artists of the 1960s.

Jim Dine: Walking Memory, 1959–1969 continues the institution's commitment to in-depth analysis of the crucial early oeuvre of artists. Dine joins fellow American artists Robert Rauschenberg and Helen Frankenthaler, whose early endeavors have been the subject of recent exhibitions at the Guggenheim. It would be impossible to have realized this project without the support, guidance, and close involvement of the artist himself. Although I know he would rather have been working in his studio, he made sure that he was available whenever his memories, resources, and candor proved indispensable to a better understanding of his work. It has been personally and professionally gratifying to have continued a dialogue with Dine. His insight and enthusiasm about art is evident throughout these pages and in the exhibition itself.

The curators of the exhibition are Germano Celant, Senior Curator of Contemporary Art, and Clare Bell, Associate Curator for Prints and Drawings. Each has brought an enormous amount of skill and insight to the project. Both contributed essays to this catalogue and moderated the discussion with Dine about his work that forms the basis of this publication. They each have been assisted by numerous staff members as well as those outside the institution whose expertise and archives have been invaluable. I would also like to thank the Cincinnati Art Museum, our partner venue in this endeavor, especially Barbara K. Gibbs, Director, and John Wilson, Curator of Painting and Sculpture, along with Jean E. Feinberg, former Curator of Contemporary Art, for their considerable support. Another note of thanks is due to PaceWildenstein Gallery, most especially to Arnold Glimcher, President, and Susan Dunne, Director, whose efforts at locating works and providing critical information about them have been essential to the show.

The Florence Gould Foundation provided much-needed support, for which I am extremely grateful. To the lenders who have agreed to part with their works temporarily in order to realize this momentous and rare exhibition, the Guggenheim, its curators, and our audience owe an enormous debt of thanks. To all those individuals who, each in their own way, have helped guide the project to fruition, I wish to express my deepest appreciation.

Acknowledgments

Germano Celant and Clare Bell

Long before the quotidian was canonized as Pop, Jim Dine implicitly understood the beauty of the prosaic. When he first emerged as a maverick on the New York art scene in the late 1950s, he was younger than most of his contemporaries and without much formal training. His willingness to take chances and experiment with new idioms of expression led him down a historic path, first as a chimerical performance artist and next as the creator of some of this century's most recognizable images. While Dine's association with the nation's Pop art movement during the 1960s was involuntary, his passion for the American landscape of objects remained steadfast. There have been numerous shows devoted to aspects of Dine's work. None, however, has focused exclusively on those crucial years between 1959 and 1969, after which he beat a hasty retreat from the New York art scene. It is a story that bears telling, but one that would be impossible to do without the involvement of numerous key people, most especially the artist himself, who has permitted us almost unlimited access to his memory and whose formidable vision and contribution to the art of our time are clearly evident in these pages.

Assembling the contents of this exhibition and catalogue might best be described as a treasure hunt. The artist's own archive does not nearly record the breadth of his work that exists from the period. To gather the plethora of materials from which to select required an enormous commitment and resolve on the part of the exhibition's coordinator. That job was expertly filled by Kara Vander Weg, Project Curatorial Assistant. Her professionalism, keen eye for detail, and expertise in the field of art were instrumental in the effective realization of the project. We also owe her a tremendous debt of gratitude for the willingness and enthusiasm that she brought to every facet of this undertaking. A special thanks is extended to Dine's studio assistant, Marre Moerel. Her tireless efforts in coordinating every detail of the artist's involvement and her encyclopedic knowledge of his work made such a publication and exhibition possible. We would also like to thank Anna Costantini, together with Marta Leget and Lucia Brignamo, for their assistance.

This exhibition and publication could not have succeeded without the efforts of museum staff members from every department. We are indebted to Thomas Krens, who as director of the Solomon R. Guggenheim Foundation and a scholar who has studied Dine's work, has given his full support to this project. Suzanne Quigley, Head Registrar for Collections and Exhibitions, and Lisa Lardner, Assistant Registrar, were responsible for coordinating the shipments of Dine's work from a multitude of locations, a formidable task that they completed with astonishing ease. Carol Stringari, Senior Conservator, expertly applied her knowledge to protecting the fragile works from this period of the artist's career. Ellen Labenski, Assistant Photographer, responded to photographic requests with speed and accuracy, assisted by Kimberly Bush, Photography and Permissions Associate. The exhibition could not have been mounted without the invaluable efforts of Karen Meyerhoff, Director of Exhibition and Collection Management and Design; Sean Mooney, Exhibition Design Coordinator; Maria Concetta Pereira, Design Assistant; Mary Ann Hoag, Lighting Designer; Peter Read, Jr., Manager of Exhibition Fabrication and Design; Jocelyn Brayshaw, Chief Preparator; and Barry Hylton, Art Handler. Others who helped to shape this project were Marion Kahan, Exhibition Program Manager; Peter Katz,

former Senior Budget Analyst; Scott Gutterman, Director of Public Affairs; Alexandra Bodner, Public Affairs Coordinator; Ben Hartley, Director of Corporate Communication and Sponsorship; Anne Chase-Mustur, Development Coordinator; Jessica Ludwig, Chief Graphic Designer/Exhibition Design Coordinator; Julie Lowitz, Assistant General Counsel; Erica Hausladen, legal department; and Nina Wong, Manager of Budgeting and Planning. We are thankful to Michael Lavin, Technical Support Manager, and Paul Kuranko, Electronic Art and Exhibition Specialist, for their skillful coordination of the technological aspects of the project. A special thanks is also extended to Bonnie Katherine Cheng, Project Curatorial Assistant, for her invaluable assistance in the coordination and research associated with this project.

This catalogue was realized through the boundless talents of the Guggenheim's Publications Department. For his discernment, guidance, and the central role he took in the implementation of this catalogue, we would like to thank Anthony Calnek, Director of Publications. Massimo Vignelli provided the creative force that shaped the design of the catalogue, and we are grateful for his contribution to this project; likewise, we thank Letizia Ciancio, of Vignelli Associates, for her work on the catalogue. We were extremely fortunate at the museum to be able to utilize the talents of Elizabeth Levy, Managing Editor/Manager of Foreign Editions, and Esther Yun, Assistant Production Manager. Their mastery of the immense number of details surrounding the production of this book was of paramount importance to its successful publication. Overseeing the research on Dine's performances from the period was Julia Blaut, Assistant Curator. Her essay in the catalogue is a result of her exceptional acumen and her outstanding work on this period of Dine's career, and represents one of the most comprehensive studies of his theatrical-based works ever completed. Sloane Tanen, curatorial intern, greatly assisted her in this endeavor by compiling the often obscure research information. We would also like to extend our gratitude to Alla Rachkov, who transcribed the interview between the artist and the exhibition's curators and who worked as a curatorial intern. Demonstrating great knowledge and sensitivity to the subject matter at hand, Stephen Robert Frankel, editor of the exhibition catalogue, gave incomparable help in shaping the material contained within these pages. Meghan Dailey, Assistant Editor, provided invaluable advice and assistance. We also thank Liza Donatelli, Administrative and Editorial Assistant.

Many individuals generously dedicated their time and energies to the exhibition as interns and volunteers. This list includes Kathleen Bell, Kerry Junge, Dong-yeon Koh, Jonathan Lackman, Stephanie Nannen, Florencia Oris De Roa, Kerri Smith, Taliesin Thomas, and Hilda Werstchteul.

The staff of the PaceWildenstein gallery provided generous assistance in locating and documenting Dine's works from the period. We would especially like to thank Arnold Glimcher, President, Susan Dunne, Director, photographers Ellen Page Wilson and Gordon Riley Christmas, and Alina A. Pellicer, Manager of Research and Archives.

The catalogue serves as the first comprehensive color documentation of many of the works from this period in the artist's career, and the skills of many individuals have contributed to the photography shown here. Although they are credited individually for their work, we would like to thank photographers Jörg P. Anders, Ruriel Anssens, Dirk Bakker, Oscar Balducci, Mimmo Capone, Geoffrey Clements, Sheldan C. Collins, Susan Einstein, Tom Haartsen, Robert Häusser, David Heald, Martha Holmes/Life Magazine,

Bill Jacobson, C. Kaufman, Gary Mamay, Robert R. McElroy, Scott Miles, Bob Mitchell, Elisabeth Novick, Douglas M. Parker, Phillips/Schwab, Eric Pollitzer, Ian Reeves, John G. Ross, Lothar Schnepf, John Sigfried, Dan Soper, Michael Tropea, Tony Walsh, John Webb, Katherine Wetzel, and Janet Woodard. We are indebted to the following individuals (in addition to the collectors, galleries, and museums whom we have credited elsewhere) for the assistance they provided in obtaining photographs: Sasha Cutter and the staff of Monacelli Press; Dorothy Gutterman, Melina Mulas and Valentina Balzarotti Barbieri from Archivio Ugo Mulas; and Peter Namuth from the Hans Namuth archive.

It was through archival research that we were able to resurrect much of the valuable information about the artist and the period. For their assistance in obtaining archival materials, we thank Robert Bertholf, Curator of the State University of New York at Buffalo Poetry/Rare Books Collection; Warren Bunn, Curatorial Assistant, Herbert F. Johnson Museum of Art; Nancy Dean, Cornell University; Susan Hapgood; Jon Hendricks; Carol Janis and the staff of the Sidney Janis Gallery; Barbara Prior, Art Librarian at the Oberlin College Department of Art; Marcus Ratliff; Steven W. Siegal, Library Director/Archivist and the staff of the 92nd Street YM-YWHA; Anita Reuben Simons; Ileana Sonnabend, Antonio Homem and Laura Bloom from the Sonnabend Gallery; Richard Stillwell; and Amy Wilson, Special Projects Coordinator of the Judson Memorial Church. We are also grateful to the staff members of the various libraries we frequented while compiling information for the project. For generously sharing their scholarly resources with us, we are indebted to Martha Boyden, who as Arts Liaison at the American Academy in Rome provided research concerning Dine's works in Italian collections; Jean E. Feinberg; Marco Livingstone; and Joseph Jacobs, Curator of American Art at the Newark Art Museum.

No exhibition could exist without the generosity of its lenders. We are grateful to the collectors and institutions, listed elsewhere in this publication, who have contributed their works to the exhibition.

"I Love What I'm Doing": Jim Dine, 1959–1969
Germano Celant

The object-paintings of those artists who began their careers in the 1950s—as harbingers of what would become known as Neo-Dada, Pop art, and the New Realism—appeared on the scene like an ironic reversal of history. If one acknowledges that in World War II people pillaged and killed in the name of history; that the very facts of history are full of sorrow and death; that the protagonists of history are hypocrites who mask their misdeeds with false ideals; that, finally, history is a tragedy—then one might easily admit that the banal, grotesque comedy of day-to-day existence, with its common, impersonal identity in which objects intrude on the lives of everyone, is a thousand times better. The tragic and the remarkable, the dramatic and the exceptional can be countered with the comic and the ironic, the obvious and the trivial, because ordinary acts are no less significant than extraordinary events in their effect on us. Actually, the object-painting is more the product of skepticism than of social concern. None of the creators of object-paintings—not Jasper Johns, not Arman, not Claes Oldenburg, not Jean Tinguely, not Jim Dine—reveres the things he paints or incorporates into his works. If there is anything they want to prove, it is that there is nothing intrinsically ideal or utopian about objects, nor do they possess any evil in and of themselves that might lead the world to ruin. Things can only show the uniformity and simplicity of a world based on habits and facts, where the construction and definition of an individual's creativity is free of all prejudicial positions other than that of the choice of the objects selected and represented. This "low" social awareness is not to be considered either superior or inferior to the "high" social awareness of an artistic procedure that sees itself as aristocratically standing above things. What we have, then, is a redemption of art through a critical, ironic attitude— one that does not aspire to celebrate the positive or negative hero typical of a wartime or postwar culture with a taste for drama and history, such as that of Action Painting or Abstract Expressionism. Rather, it seeks to present itself as a detached, impersonal document of a society characterized by the recognizability of its things and objects. It is able to discover things and see everyday events as components of a situation that is based not on an abstract perspective or a nihilistic ideology, but on an evaluation of the practical exigencies of life in terms of the universal conditions of existence.

Dine's painting itself arises as an antithesis to historical painting, as comedy instead of drama, as a taste for the particular instead of the universal. The theme of his art is the contrast between the everyday life of little things and little people and the solemn ruins of the universal view of an ambitious society caught up in the definition of history. It deals in the customary exchange of truth and illusion, and offers an alternative of values based on the evidence of a reality that allows no other option than the fact that it stands before us all. In the presentation of the thing or the object, the subject or protagonist of "history" begins to disappear, or at least to define a more localized, individual history. It is thus the beginning of a more authentic existence both for the artist and his or her art—both being no longer vehicles of symbolic values and secondary meanings, but definitions of an identity that is personal and linguistic, particular and formal.

The need that, around 1959, yielded the great production of object-paintings by the artists of Neo-Dada, Pop art, and the New Realism was not so much a need to clarify the relationship between the thing-in-itself and the space of art, or between the unit and the whole, the object and its context

(as was the case with Marcel Duchamp); rather, it was a need to explain a new relationship occurring between the human being and the things to which he or she is bound, no longer connected to them for abstract, intellectual reasons but for concrete, utilitarian ones. The attempt to give objects a symbolic and universal meaning was no longer of interest. A thing is no longer a metaphor for something else, but rather goes back to being a thing—a light bulb or a paintbrush, a can or a hammer, a pie or a chair. However, the meanings attributed to it by those who look at it remain many and various, to the point that one may reasonably conclude that each of these meanings is transitory—that the thing is no longer transformed into something other than itself, but rather becomes an occasion for ideas, serving only as a temporary repository for those ideas it arouses through mental associations. It does not convey them; it is only at the disposal of the different meanings that each person might attribute to it. The thing, in fact, must be left alone; it remains a thing, however open it may be to people's ideas.

The object and the thing are therefore only what they are. They must be accepted in all their crudeness, which is neither beautiful nor ugly. They cannot be explored or interpreted; what is of interest is to present them or reproduce them in all their plain, banal obviousness, concerning oneself with clarifying and exacerbating the conflict between their "thing-ness" and our notion of what is human, establishing a current of sympathy and equilibrium between their external condition and the reality beneath it— each being equally unknowable. This indeterminate, indiscriminate acceptance of the object or thing, as an entity that creates a problem that one cannot ignore, masked, at the time, a sort of heretical position with respect to the gestural, heroic manner of the Abstract Expressionists, who still asserted the power and authority of the individual as a protagonist interacting with the forces of history. In asserting the mere fact of an object or thing, the intention is rather to isolate reality, unprejudiced and intact, from its historical interpretations. This means reducing to zero, not increasing and deepening, the value of experience. Lacking historical experience—indeed, negating it—the artist deliberately renounces any attempt to imagine the past or future; he or she must stick to the present, to a reality that does not include the possible, a truth that does not extend to the probable, and thus is bound to the detail, to the minimum dimension of space and time, to what happens here and now and is registered without one's seeking its causes or drawing conclusions.

This position, which aims at going beyond the sublimating, ideological character of art in favor of an involvement with the things of the world, has its historical roots in the art of Caravaggio in sixteenth-century Italy.[1] It continued in the seventeenth century in the still lifes of Italian painter Evaristo Baschenis and in the eighteenth century in those of French painter and engraver Louis-Léopold Boilly, appeared in the United States in the trompe-l'oeil works of nineteenth-century painters William Michael Harnett and John Peto, and has made its way through the art of the twentieth century in a variety of mediums and forms, in the work of such artists as Duchamp, Giorgio Morandi, Alberto Giacometti, and Balthus in Europe, then given new life by Johns, Dine, and other American Neo-Dada and Pop artists, and continuing to this day in the work of Jeff Koons and Charles Ray. Based on an observation of the real, this art declares a detachment from historical imagination as well as from an approach that constitutes the painting as reality itself, autonomous and independent of the person. The work

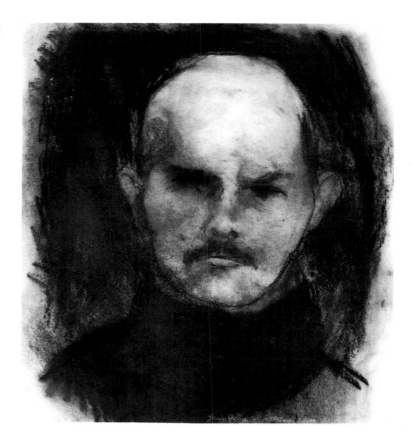

4. Self-Portrait, 1958
Charcoal on paper
20 3/4 x 18 1/2 inches (52.7 x 47 cm)
Private collection, New York

is bound not only to the person creating it, but is a thing whose existence is circumscribed in time and space. This direct take on the world renews the objectification and cold contemplation of reality: it is an attentive, objective observation of things, without the excitement and high emotional pitch that are characteristic of so much of the history of art from Mannerism to Action Painting.

How are we to trace the development of this artistic language that does not conform to drama or tragedy but rather to everyday life? It represents something that occurs not through any historical imperative but by chance, without any distant causes or important consequences. According to this perspective, art sees things and then identifies their reasons for being; it assumes an object and then acknowledges its character as individual vehicle. This procedure makes no explanation, except, perhaps, a posteriori, and one becomes aware of the latter only because it belongs to the absolute present and not to the past.

That Dine is interested in a painting of facts and not history, of recording and not imagination, of particularities and not universality, of the ordinary and not the exceptional, is confirmed by the fact that he immediately declares himself an artist through things. He asserts that the reality of art, and of his own self, can no longer come out of the convulsive, emphatic gestures, improvised and unconscious, of Abstract Expressionism, but exists and is motivated through the inert, inanimate presence of objects—and requires just as much involvement and skill on the part of the artist, since objects too are part of the turbulent stream of life, albeit quotidian, everyday life. All the same, Dine's involvement is different from that of Duchamp or Johns. He does not take ordinary things out of their everyday context and put them into a new, previously unrelated context, such as the walls of an exhibition space or the canvas of a painting, in order to negate them. Rather, he adopts them and reverses roles with them: It is they that are empowered to construct the art object and establish the identity of the artist. In *Green Suit* (fig. 27) and *Untitled (After Winged Victory)* (fig. 29), both 1959, the reversal of the relationship between reality and painting transforms everyday objects such as cotton and nylon garments into artistic realities. The garments in the latter work become a sculpture resembling the form of the famous Hellenistic marble statue *Victory of Samothrace*, ca. 200 B.C., and give shape to the pictorial surface of artistic being. Here, things become a strategy of painting; they occupy its vital territory, which is determined by the poles of the artifact and its artificer, the art and the artist. The object-thing acquires its reality in the sculpture or painting; it is used on the various planes of three-dimensionality and two-dimensionality, and is borrowed by them to constitute the classical figures of sculpture and painting. Dine recognizes the object-painting's or object-sculpture's link to tradition and respects it, but he also demands a new value. He takes cognizance of them as objects made of objects that remain in time only if isolated and removed from the flux of their banal existence. These objects, which have no place in the ideal space of history, nevertheless evoke the passage of time, for they reveal and underscore a situation of extremity and ending, as a kind of still life. From the latter's origin in Caravaggio and the still-life painters from Peto to Duchamp, Dine's work is descended symbolically and metaphysically, deriving from that same turning of the gaze to the memento mori, which he inevitably carries within himself. It is a vision that flows unchanged throughout his painterly adventure, right up to the present day, even when the things and objects he used seem to have lost their predominance

over the attention paid to the history of classical images. Nevertheless, the attention to everyday things as well as to archaeological artifacts reflects the same interest in human activity, whether present or past. Indeed, the presence and emergence of things implies an absence of the human beings who, as in still lifes and artifacts, do not live in them but survive in them.

In the end, the generation that would leave its mark on the 1960s, the generation bound up with Pop and Minimal art, embraced objects and materials because it felt convinced that human actions and their dramatic expression—as embodied by Action Painting and Abstract Expressionism— had lost their value and run their course. It was not, however, a free choice, but one made of necessity in a culture that left the imagination to the mass media and mass society, a culture in which consumer products had become the primary objects of people's fantasies. For in a time when the society we are up against dominates all aspects of existence and yet has no development or meaning, what else can that society be if not a vast compendium of impersonal, anonymous objects, signs of death?

In all Pop and Minimal art, the idea of death, because of its crystallization of experience and thought,[2] recurs with incessant, obsessive insistence. The artists who made these kinds of art were prompted to seek in the ready-made or in the impersonal construct the boundary between this world and an equally problematic beyond, the moment where being passes into the absolute immobility of non-being. It is in this sense that the transition between body and thing, gesture and embrace, action and recording, presence and absence, is revealed—as demonstrated in the paths traveled by such artists as Yves Klein, Piero Manzoni, Oldenburg, and Dine. In their work, reality is entirely itself, and objects are mortal remains, fragments of an existence in which the human event comes to an end: they cut short all natural growth, fixing art in a rigid, absolute state. The object is the boundary of contrast and contiguity with non-being. Thus, it is transformed into a trace of existence, as in Klein's *Anthoropometrie*, 1960, Manzoni's *Artist's Shit*, 1961, Oldenburg's performance piece *Circus (Ironworks/Fotodeath)*, 1961, and Dine's *Green Suit*. Naturally, the theme of mortal remains must also be seen in relation to the sudden transition from one existential condition to another, as witnessed in the work of these artists by the separation and catharsis of the body—typical of performance pieces and Happenings—and its transformation into a thing, event, and energy flow from mobility to immobility, from flesh to industrial material, from truth to simulation.

Behind the crude and realistic obviousness of the thing, behind its congealed state, lies hidden an idea of much consequence for contemporary art. Life is dream, death is awakening, dream and illusion are history, while reality is its opposite: it is revealed and can be touched only when sleep is broken and its continuity is replaced by the non-being and immobility of the thing. Dine is conscious of this tragic nature of an art that wants to attain a borderline condition, and thus attempts to forge a bond between dream and object, history and thing, as he did when he created an ancient sculpture out of pieces of ordinary clothing in *Untitled (After Winged Victory)*. He seeks representation through what cannot be represented, resorts to the non-being of things to create the being of art, or at least of its memory.

In resorting to the use of a second skin—clothing—in *Untitled (After Winged Victory)* and *Green Suit*, Dine attempts to make the reality of art and its protagonist, the artist, autonomous, detached, indifferent, by making art out of

things that are external to history and to people. In so doing, he seeks to put Art and the Artist in front of himself, as objects that cannot be known or have yet to be known. And neither can art and the artist know themselves; they are always "other" even to themselves, possessing a reality that must be searched for and made concrete as a separate entity. This approach can be considered a first declaration of a conceptual detachment, or at least a first taking of a semantic position, in which the work is transformed into an objectified example of historical and individual language that must be analyzed for its logic and namings.

Dine thus proposes a shift in the order of the known in terms of art history and the identity of the protagonist. Knowledge is expanded, and both become objects subjected to the process of semiological reduction.[3] Both *Untitled (After Winged Victory)* and *Green Suit* are doubles; they signal a faithfulness to artistic tradition and to all that is life, and have significance as memory and self. Whoever wishes to make art must overcome the Action Painters' visceral identification with the object and instead assume a stance of deathlike indifference. One must fix one's sights on something without action or change, see oneself as an icon in the guise of an immutable image. Dine immediately found these in two realms: that of his prenatal memory up to the time of his becoming an artist, represented by a reconstruction (for what is reconstruction if not memory?) of the *Victory of Samothrace*, symbol of definitive, harmonious archetypes; and that of quotidian existence, at first in the form of masks that refer to his own face, in works from 1959 ranging from *Head (Hiding Face)* (fig. 18) to *Altar for Jeremiah* (fig. 24), which also features a protruding phallus. His is a journey toward the mystery of history that coincides with a return to preexisting forms and traditions, a journey toward the prenatal state that every artist knows or should know before stepping into the vast territory of contemporary artistic existence. This is a territory of amnesia where all that matters are the self and one's own existence on the chessboard of the present, which we can see in *Green Suit* and *The Checkerboard*, 1959 (fig. 20).

Between these two poles of historical removal and personal removal begins the artistic adventure of Dine, who pays absolute attention to the shadow of History and strict obedience to the inner law of his own existence as person. His painting, at the time, is an affirmation of existence and his own active presence in every fragment, every instant of the finite reality of life and the infinite reality of art, exemplified by *A 1935 Palett*, 1960 (fig. 26). It is an artistic procedure formulated moment by moment, to escape the pitfalls of non-creation and non-being, of physical and moral inertia and death. Precisely because his art is achieved by wrenching from nothingness the moment that immediately afterward will fall back into nothingness, Dine is not content for it to be only a contribution to history; it must also contain the pleasure of being, as in his performance piece *The Smiling Workman*, 1960 (figs. 1, 37–39), in which he declares, "I love what I'm doing."

Inside the Gaze

Moving back and forth between tradition and innovation, and interpreting them in his own way, Dine from the start creates his own bridge to the present, not a dream or chimera, but as a reality, however initially untouchable and unattainable. In 1959–60 he paints *Black Rainbow* (fig. 59), a kind of apparition that is simultaneously outside of time and in the present. The intention is to identify and trace an apparition that is a sign of passage between two poles:

movement in history and in one's own being. This combination of extremes, however, is also a transcendence of the ideal notion of an art detached from reality through reversion to the past and acknowledgment of tradition, and a movement toward an art that defines a reality connected to life.

Dine's unconditional, passionate connection to what art and the artist are about is openly affirmed in *The Smiling Workman*, staged at the Judson Gallery (as part of the *Ray Gun Spex* program of Happenings), and in *Car Crash* at the Reuben Gallery, later in 1960 (figs. 12, 13, 44–46). In both performances, the subject is the artist himself; thus, their symbolic representation should be seen as self-analysis. In *The Smiling Workman*, the artist is shown performing a job— that of painting to create happiness—while *Car Crash* presents a state of mind concerning the conjunction of life and death, past and future. The former is concerned with making a pleasurable future for oneself, and the latter with the need for a redemption from pain and sorrow, from memory and remembrance. Both are fateful situations, in that they point to the path to be taken, come what may, by the person who chooses to be an artist.

In Dine, the movement from art to the self is manifested in the notion of transport and transferral of psychic impulses and emotions, of feelings and behavior patterns, object relations and libidinal charges made explicit in the object. These are not its vehicle a priori, but are recognizable as such a posteriori, as the reincarnation of an existence that passes through objects. Thus, *Green Suit*, in which the libidinal, sexual charge is transferred onto the object, grazes the consciousness as the penis bulges from the pants. Here, art serves as catalytic ferment, with the clothing-being functioning both visually and theatrically, awakening our senses by highlighting singularity and strangeness. In *Green Suit*, the shift from self to painting is made manifest by their coinciding in a single object. The same shift is repeated in *The Smiling Workman*, where the artist immerses himself in the pleasures of color and paint, seminal matter that enables him to be reborn to another life, the happy or at least laughing, ironic life of the artist working and nourishing himself on painting, drinking it up. This aesthetic-psychological interpretation of the creative transfer between object and art, history and memory, emotion and body, is a movement toward an identity that can be conceived in different ways: for example, as subject in *Green Suit* and *The Smiling Workman*, or as memory in *Untitled (Winged Victory)* and *Car Crash*.

In all these works, a constant presence is conveyed by the clothing that passes from sculpture to painting in order finally to cover the body of the artist. And if we consider that clothing confers on the human being his anthropological and social identity—his very being—its prominence in Dine's work becomes fundamental to an understanding of his journey as an individual and artist. Being presented in sculpture and painting, it may acquire, as priestly robes do in the Old Testament, a sense of magnificence and honor, of something weighty and important befitting the status of the "priest" who performs the artistic rite. It is a solemn vestment dressing his body, a covering and a service to God, in the same sense that God himself "clothed" the world with the work of his Creation—as reflected in the magnificence of the kabod of Jahweh and, in turn, the magnificence of the sacerdotal vestment.[4] The use of clothing in Dine's assemblage *Untitled (The Winged Victory)* is essentially transcendent; the clothing refers to the divine power underlying an image of glory.

Dine also deals with a completely different aspect of clothing's metaphysical significance—the relationship between clothing and the naked body—in numerous works, beginning with *Green Suit*. For him, as for the Greeks, nudity is not something shameful, ridiculous, or dishonorable, but rather a symbol of the naked truth. Moreover, his green corduroy suit, aside from revealing the protuberant sex of its wearer (the artist himself), is also dressed with color. Thus, for him, painting is also an instrument of truth on which the entire process of knowledge is based. The gaze and vision of art pass through all clothing, all wrappings, all garments, to arrive at naked reality.

The poles of clothing and nakedness mark Dine's entire itinerary to the present day, to the point that his painting from time to time seems to focus on one to the exclusion of the other. In the works from before 1969, the metaphysics of clothing intersects with the metaphysics of the nude, or of some detail of the body, as a juxtaposition of dignity and freedom: on the one hand, the theme of clothing as human attribute, as in *Nancy's Tie*, 1960 (fig. 65), *Shoe*, 1961 (fig. 77), *Red Suspenders*, 1961 (fig. 70), *Three-Panel Study for a Child's Room*, 1961 (fig. 107), *White Suit (Self-Portrait)*, 1964 (fig. 125), *Red Robe with Hatchet (Self-Portrait)*, 1964 (fig. 128); and, on the other, the removal of the veils and wrappings from the body, merging the gaze and the nude on the same visual plane, as in *Hair*, 1961 (fig. 66), *Blonde Hair* (fig. 67), 1961, and a number of works beyond the scope of this book, including *Hair*, 1970, *The Cellist*, 1975, *Self-Portrait in Vermont*, 1979, *Venus*, 1981, and *Twisted Torso of a Youth (Illioneus, ca. 300 B.C.)*, 1989.

In the performance pieces that Dine created and staged in New York in 1960, the passage between body and clothing is constant. Dine appears in these with his face made up, always dressed—in *The Smiling Workman*, in a smock covered with traces of red paint; in *Vaudeville Collage* (figs. 40–42), decked out as a cabaret performer; in *Car Crash*, wrapped in a silver, almost spacesuit-like jumpsuit; in *A Shining Bed* (figs. 51–53), disguised as Santa Claus. But in these rites, also called Happenings—a term conveying a sense of "portentous" occurrences—the clothing has a deeper significance: that of a "clothed" reality (typical of an art that covers surfaces and reveals a message), which can be seen in all its magnificence by only a few initiates. In *The Smiling Workman*, clothing is an instrument for glorifying the gesture of the artist who paints and enters the canvas, covering himself, like a workman, with sweat and splotches of color; in *Vaudeville Collage*, he manages to include, in his vaudeville-like curtain, unusual elements such as rags and vegetables, and to cover a dual personality, half-male, half-female; in *Car Crash*, he plays the spacesuited acrobat, full of memories and stories of traffic accidents from which he liberates himself cathartically through narrative and drawing; and in *A Shining Bed*, stretched out on a bed and dressed up as a Nativity character, he carries out the "birth" of a new world.

These performances express the magnificence of the visible as much as they refer to the invisible, the hidden things that grow inside all the actors of a creative scene. Each of Dine's performance pieces rests on a tension between an amorphous, chance occurrence and an image evoked by a form or color. They imply a seeing and a non-seeing, a conscious and an unconscious condition, a figuration underlying a non-figure —a game between known and unknown that combines the blinding light of the stage with the deep shadow of the hidden meanings of a story between the personal and the public.

All of Dine's work hinges on this transition between visible and invisible, between clothing and clothed. Each painting or sculpture covertly designates something difficult to name yet clearly present and indicated: the artist's face lurking behind the object, turning its eyes to the audience, its users. If we accept this "inside-out" vision, Dine's art reveals itself to be as much a shutting out as an unveiling, keeping something hidden or veiled behind what is visible at the moment where the accident gives way to emotion and macabre memory—as in *Car Crash*—or where the body gives way to the suit or the bathrobe.

The works dealing with the body and nakedness move in the opposite direction. They tend to unveil, to clarify and illuminate interiority, which actually becomes concretized in the form of a heart in *Nancy and I at Ithaca (Straw Heart)*, 1966–69 (fig. 151). In between are the works based on a coupling of antithetical, complementary elements, those representing object and body, thing and gesture, in an ambiguous, twofold manner, where there is no more male or female, no idealized image or specific gender, but all converging toward a total representation of being as an instrument at once divine and human, erotic and functional, active and passive. I am referring to the *Tool* paintings, in which the tools can be considered a threshold between the realities of clothing and body. They are an essential, absolute truth: they are aspect and image, mask and body, mobility and immobility, identity and instrument, life and death.

They move in an intermediate space between clothing and the body, granting the second skin—the clothing—an objectual dimension equal in importance to the body, which here, by means of the hand or some other limb, becomes a support. The tools are veiled bodies, bodied veils; they combine extremes. They continue to be manifestations of human and divine creativity, thus revealing a higher essence. At the same time they are bare, naked entities that are one with the body, are part of it and extend its sensoriality and sensuality. The tools are thus simulacra of something that is at once present and absent. They therefore not only represent the object of consumption—an interpretation that has long distorted all of Dine's work by categorizing it as Pop art— but are a redemption of the object between being and non-being, conscious and unconscious, and echo the presence of an invisible substratum that is both erotic and spiritual, and unfolds from *Green Suit* onward.

In the end, the tools can be situated in a mimetic dimension, as the remains and phantasms of a body that is elsewhere: an extraneous clothing or corporeality that resembles the artist's identity. Indeed, Dine has always stressed the correspondence between his tools and his life experience. If we accept this concordance between tool and (artist's) identity, we will also understand Dine's reappraisal of nude statuary—the sculptural and painterly nude of traditional, academic culture—in his 1981 *Venus*. It was certainly not his intention (and this led him into exile and isolation) to enter into an avant-garde conception of art, which at the time was identified with Pop art, was opposed to corporeal anatomy, and strove to break free from all models that might lead to a Romantic vision or to classical or modern statuary. "I think the biggest inaccuracies that have been written about me have to do with Pop art and my relationship to it," Dine has pointed out. "There's been no real understanding of my strange voyage in art. My work had such a handmade look about it next to these manufactured images. I have always felt closer to those Europeans like Giacometti, Morandi, Balthus, Magritte— not stylistically, but those were careers that I thought were exemplary in art."[5]

What interests him is the passage between clothing and

the body, understood in the ultimate sense, however, as an exchange value between two realities. This is what underlies his erotic use of drapery in his 1981 *Venus*, whose peplos actually covers only her hips, leaving her torso and breasts naked; or his use of the bathrobe as a living remnant. In Dine's *Bathrobes* in particular, the artist's body has undergone a transformation emancipating it from the human figure by becoming dissolved in the fabric, as the body of Saint Theresa has in Giovanni Lorenzo Bernini's *The Ecstasy of Saint Theresa*, 1645–52. Making minor concessions to the passage, the bathrobe is the transition between the body and the object, between identity and clothing; it embodies the total dislocation of what lies beneath.

The object-remnant replaces the artist's body, even while conveying its subjectivity. As Dine has said, "There's no difference between shower heads and axes and hammers; they're all metaphorical, obvious stand-ins for human things."[6] He is present in "flesh and blood," not through his own corporeality but through a mediated corporeality, that of the thing representing him. The choice and inclusion of a shower head, a necklace, a bathroom fixture, or a knife thus becomes a kind of cloning at the limits of the biological and the mechanical. The choice of a thing as a replica of the self, forming a psychophysical "twin," represents a doubling that makes transparent the artist's desire to pass from first-personhood to the otherness of his own being-in-time, a transition from the ego to its shadow.

Dine explores the motif of the symmetrical double in *Two Nests*, 1960 (fig. 56), and in *Teeth*, 1960–61 (fig. 76), in both of which the composition consists of a form juxtaposed with its mirror image. The symmetrical sameness of the paired forms echoes the analogy between art and artificer, work and workman, vaudeville and actor, dream and dreamer, which Dine has been cultivating to this point, reinforcing the mimetic character of his visual poetics, which vacillates between a primary image and its shadow. One example of this dialectic between object and reflected image can be found in *Black Bathroom #2*, 1962 (see fig. 97), which the artist considers a "life drawing." The object is, in fact, surrounded by black, which is not a natural color but only a mental one; the object is thus transformed into a concept, becoming an unnatural "relief." In this phase the object quits the system of relationships and traditional proportions; it slips outside of space and off the stage, no longer subordinating itself to the spatial order of temporal and historical perspective; ceasing to have a value or function, it acquires the relationlessness of matter and chance. In this state, the object or thing is transformed into something utterly new and different, and here lies Dine's great perception: it presents itself as a being-in-itself replacing being-in-space and being-in-nature. His painting conveys the consciousness of a total otherness of the object and reality, which exists in the impossibility of a relationship.

Compared to the objects of Johns and Robert Rauschenberg, Oldenburg and Arman, George Segal and Daniel Spoerri, Dine's objects do not change or interpenetrate one another, they are not absorbed or cut, contextualized or altered; rather, they exist in an absolute state, just as they are. In this sense, the presence of shadow, which will find its reflection in the presence of light, is a further confirmation of their autonomous identity. It is part of their personality, their "dark side"—which is also their relationship to painting, as in *Red Knife*, 1962 (fig. 82), and to representation. Indeed, shadow even comes to assume the form of the drawing—that is, the contour defining the object—in, for example, *The Toaster*, 1962 (fig. 100).

To recapitulate what we have been saying, one primary significance that can be attributed to the object Dine introduces in his paintings is that it cannot be considered merely an industrial product evoking mass society and popular culture that lead indifferently to Pop and Minimal art. Rather, it must be assumed as a part and function of his life. In a transcendent dimension that can range from the commonest thing to ancient statuary, Dine's object crystallizes the form of a dialectic between consciousness and the unconscious; it is thus a fundamental structure of the eternal dialogue characterizing human nature.[9] In this respect, one can understand why, on the level of painterly language, Dine maintains an Abstract Expressionist relationship with the object: "I don't believe there was a sharp break and this [Pop art] is replacing Abstract Expressionism. Pop art is only a facet of my work. More than popular images I'm interested in personal images. . . . I tie myself to Abstract Expressionism like fathers and sons."[7]

His painterly application and technique continually echo the gestural quality of Art Informel, the color applied in a way that appears similar with the techniques of Willem de Kooning and Jean Dubuffet. In fact, his intention is to immerse the object in a purification of force and material action that echoes the human presence, its body and activity —for example, in *A Tie in a Red Landscape*, 1961 (fig. 69). Even if he attempts to stem its advance—as perhaps he does in *Hair*, 1960—the Expressionist heritage helps him to keep alive an organic dimension in painting, where the artist's corporeality and individual identity continue to exist. He is aware that by citing the object as a path of mediation for his existence as a person and an artist, he runs the risk of entering an inhuman dimension; and this is why he revives the agitated, gestural brushstroke of Abstract Expressionism.

The polarity of Pop art and Abstract Expressionism continuously creates another bridge between equivalents and complements; his operative and linguistic method is based on transition, which is the foundation of his artistic identity. Dine believes that art is a locus of relativization between subjects and objects, where the artist's responsibility is to take charge of both, and to make something at once personal and impersonal, positive and negative, feminine and masculine, conscious and unconscious, so that each entity will carry its own shadow behind it.

Among the shadows of objects falls their naming. Thus, to pose to oneself the question of the shadow is also to assume the meaning of the nominal destiny of a thing. We are no longer dealing with a projection, but with an amplification. Alongside the maximum intensity of reality and its double, which may assume both material and immaterial forms, stands the nominal doubling that broadens meaning and opens up new areas previously lacking in the analysis of the work. Yet, unlike the confusion Magritte introduces between the thing and its name—a confusion linked to Dada and Surrealist transgression—Dine goes back to establishing a clear equivalence between same and same. No imaginary or erroneous solution, nor a search for dissonance or disturbing extraneousness. The image of the shoe is accompanied by the word "shoe"; the necklace bears the label "pearls," as if he had no intention of saving the object from its banality. Dine does not enter into imaginary or symbolic realms, nor does he return to the displacement that in Duchamp, Magritte, Francis Picabia, and Breton sustained the manipulative, sublimating relationship between subject and object. He has no interest in the discordance between the idea of something and its appearance, or in a senseless relationship with things that would deny the prosaic reality of the object in favor of

some personal mirage or dream thereof. He is not in search of another universe; he wants only to be wholly present in his universe—to speak and be spoken to by the things he chooses and creates. But these need not necessarily be projected onto an incongruous meaning that distorts or negates the thing's existence as simply what it is. In Dine's universe, a shoe remains just a shoe, and a necklace is just a string of pearls.

The artist manifests himself, the thing manifests itself, and both constitute themselves at once as subject and object. The one is the other's shadow, and the one illuminates the other. Light, in Dine's work, serves to emphasize a thing's realness, which, although it may seem to fluctuate in real life, never turns into the imaginary or the dream. The light is intense, but not too much so, so as not to dispel the shadow. It is trained only on the object, allowing it to be accepted for what it is, without any slippage of meaning. In *Child's Blue Wall* (fig. 108) and *Flesh Bathroom with Yellow Light and Objects* (fig. 102), both 1962, the explicit light falls straight on the subject of the painting. Its truth hinders the functioning of the imaginary. It declares the urgency of not creating any hidden meanings, but rather of focusing one's attention on what is before one's eyes—as in *Green Shower*, 1962 (fig. 101), which presents to us a metallic simulacrum of rain, and *White Suit (Self-Portrait)*, in which the suit evokes a trace of the person who had worn it (the artist himself). No inner reflection is required. As in Caravaggio and Morandi, the lighting reinforces a state of non-imagination, a representation of the real. The picture is an object, its presence is another, and both participate in the same reality. They are interchangeable, and are apprehended by their placement in light.

Working on the threshold between complementary poles, Dine seems to move in the interstices between object and subject, but inevitably he manages as well to create a passage between object and painting, painting and tool, vision and display. Moving in the undefined territory between interior and exterior, personal and impersonal, wish-fantasy and objective reality, he continually slips into the marginal area of pure transition between things. On the opaque surface of the painting, one thus encounters realities of meaning and meaninglessness: objects that continue to have a function, such as light bulbs, and elements of simulation and substitution, such as the bathrobe. Dine thus manages to confuse the principle of reality with the identity of the subject reflected in it. In this sense, the objects are swallowed up by one another, in the plausibility of meaningless meaning. However, once again, the conjunction between things occurs not only on the surface—as in Duchamp's *Large Glass*, 1915–23 —but is truly and concretely embedded in them. No longer the anachronistic trompe l'oeil, which is mere appearance, but the objective reality of an axe embedded in the frame of a window made opaque by color, as in *Window with an Axe*, 1961–62 (fig. 93); or a metal rod extending from a table and entering the painting, as in *Vise*, 1962 (fig. 95); or a stovepipe that unites and connects two paintings like an umbilical cord, as in *Dream #2*, 1963 (see fig. 123).

And since the everyday object absorbs the subject as much as the painting, both painting and subject can incorporate the object. In many paintings, the objects are seduced by the color and absorbed into the painting's surface, to the point where they become, as it were, "visual sounds," intimate and familiar, components of a childlike, personal universe, as in *Child's Blue Wall*. They emerge and disappear as though swept away by a current of memories and emotions. They shimmer on the white or black page, like figures of a

potential narrative based on their randomly determined development as objects or as shadows, for example in *Colorful Hammering* (fig. 91) and *Summer Tools* (fig. 92), both 1962. But most surprisingly, they transform themselves into an illumination of the everyday, a touching participation in the immediacy of life. Everyday life appears and enters Dine's art. It finds an ambiguous grandeur in the fusion of painting and furniture. It is nourished by a double that erases boundaries and widens reciprocal margins. In *Four Rooms*, 1962 (fig. 109), turning the mutual absorption of objects and paintings into a spectacle actually creates an environment— a place of implosion between painting and sculpture, furniture and art. The result is a critical mass of forces that, as had previously occurred in *The House* and its domestic display, calls into question a field of intimate energy in which is enacted the transition between life and death, personal and impersonal, painting and object, compatibility and heterogeneity, reality and illusion. We are once again in search of a further equivalence between being and appearing, true and false, ego and world. Dine, the subject, grasps himself as otherness and uses art to reflect himself in it.

The Space of Intimacy

Intimacy, according to Heidegger, holds opposites together. It designates a condition whereby distant, contrary forces nevertheless unite and join. More than interiority, it qualifies not only experience but a way of seeing and combining things, one that is based on dialogue—that is, on a contradictory feeling that is a combination of adherence and uneasiness, of acceptance and perplexity. Intimacy makes it possible it go back and forth between one pole and the other; it establishes a movement among things, which thereby manage to belong to one another. Through the intimacy of himself and his world, made up of objects and paintings, Dine manages to create an art that fills the intervals between opposites, linking and balancing them. Just as Dine's rainbow and his suit, the light and the shadow, establish a connection between being and non-being, subject and thing, and thus manage to generate an intimate dialogue, some of his motifs link subjective, personal, individual experience with the outside. In these works, the art presupposes the existence of a partner (the viewer) who, consciously or unconsciously, will let him/herself become involved with or will abandon him/herself to the pleasure of objects.

In the 1962 *Bathroom* series, the artist's act of reflection moves into an intimate realm: the extremely subjective condition of domestic living. Dine cuts out portions of this aspect of life and makes them visually penetrable. He prepares a surface and incorporates in it various components of this intimate realm, such as toothbrushes, toilet paper, shower fixture, soap dish, towels, and mirrored cabinet. In certain works, the mirrored cabinet is placed at the extreme edge of the canvas, where it functions as a frame ready to hold the portrait of the person in front of it (and reflected there), like a visual womb. The choice of a space of personal existence as a physical extension of art transforms these works into a place in which the artist himself moves and lives. They are thus existential territories that should be perceived with all the senses, or at least through all the sensory modalities. Like *Four Rooms*, they participate in a multisensory dimension that conceives of art as something to be lived, not just admired.

Naturally the territory of intimacy and everyday life can be divided up into the different types of spaces connected to specific individual functions and sensory units. Focusing on the bathroom thus implies placing one's attention on the self

as a reflection of an inner and outer corporeality—on a subject at once limpid and obscure, tactile and visual. Included here are the tools of seeing oneself and defining oneself, the tools of touching and cleaning oneself, all the metaphors of an intimate, conscious and intense life. Let us look at a few.

First, the light. In *Flesh Bathroom with Yellow Light and Objects*, a light bulb illuminates the painting's fleshlike surface as well as the skin of the objects, including the toothbrush. *A Bathroom Study* (fig. 98) and *The Pink Bathroom* (fig. 104) deal with inner physicality, still entirely within the amniotic fluid of color, which makes the objects float in a universe of visual intensity. The chromatic splendor is food for the eyes and the senses; it purifies and makes the artist's "bite" shine. In *Small Shower #2* (fig. 110), the light is dispersed in a spray of water. In those works where Dine has placed a mirrored cabinet on the surface of the painting— including *Double Red Bathroom* (fig. 96), *Flesh Bathroom with Yellow Light and Objects, Black Bathroom* (fig. 103), *The Pink Bathroom*, and *White Bathroom* (fig. 105)—the mirror, in a tradition that runs from Jan Van Eyck's *Giovanni Arnolfini and His Bride*, 1434, to several versions of *Venus's Toilette* by various artists of the School of Fontainebleau, underscores the idea of an infinite space that begins in an enclosed, private room, descends into the smallest microcosm, and expands out to the macrocosm. Here, the mirror is not two-dimensional but three-dimensional; it belongs to the family of real, concrete things that occupy our everyday life and experience. It is a functioning object as well as a declaration of a space that opens up, to the point of absorbing in its reflections the artist, the viewers, and the surrounding context. If one considers the artist himself as the primary subject, it may be considered a potential expansion of his universe, the foregrounding of a double that is ever-changing. Its function as reflection also guides the logic of the painting, where what occurs on the painted surface is the double, or the "portrait" of the artist himself, who does not reveal himself completely, but leaves an inner space hidden, that of his cabinet. From the point of view of the observer, the mirrored cabinet is an object that multiplies one's capacity for seeing, which Dine's art confirms, and a multiplication of oneself and others. In fact, to place oneself before the mirror is to scrutinize oneself and the surrounding context, to see oneself narcissistically and historically. When one steps away from the mirror, one surveys the world, entering a completely existential dimension. All these themes are present in Dine's *Bathrooms*. As we have seen, his work has a breadth that exalts the magnificence of still lifes, while in the figure of the mirror he tends, as in ancient art, to "renew that idea of continuity between the painted space and the existential space which since the beginning of the fourteenth century had been a primary requirement of serious painting."[8]

The use of the mirror is a renewal of the question, "Who am I?" which the artist is continually asking in his painting, and the painting answers back, "You are your history." The need to continue the journey of self-discovery and self-narration through the mutual involvement of subject and object has its roots in the memory of things and in the drives and energies that come to the artist from the language of art. Dine sees himself projected in the mirror without being swallowed up by it. He confronts the inventory of his beloved things, such as the tools he used and admired in childhood in his family's hardware stores; but more than anything else, he demands a guarantee for his journey into the mirroring of a presence in the world as human being and as artist, into the tools of making and modifying, of tracing and painting.

In these tools—from the hammer to the paintbrush, the palette to the color chart—he finds the complete specular reciprocity that he needs to underscore the personal as well as social and communicative meaning that his delving into and reflecting on himself has brought to light. He brings into focus the conceptual as well as emotional labor of his otherness. It is a persistently autobiographical, and temporal, movement among objects. Since 1960–61, Dine has been incorporating into his works, alongside tools such as the hammer—as in *The Hammer Acts* (fig. 88) and *A Hammer Study* (fig. 90), both 1962—motifs related to his life as an artist: the palette and the color chart. The first such work, *A 1935 Palett*, 1960, (fig. 26), is a declaration of self-legitimation as an artist, which he conveys by equating the value of the palette with that of his own twenty-five-year existence. In subsequent works, his palette of colors is presented not only as the traditional wooden artist's palette but also as a house painter's color chart, a coldly organized keyboard ready for his visual concert. The first of these, *A Universal Color Chart*, 1961 (fig. 78), contains impasti and clots of material that underscore a physical and fleshly complexity, but Dine has eliminated the traces of such human touch in *A Color Chart*, 1963 (fig. 121), where the grid of colored rectangles represents the intellectual and rational potential of art, as opposed to its viscerality and drama. At times, though, the two approaches intertwine and overlap somewhat, as if to demonstrate that their union is a preamble to the more complex discourse of figuration and narrative, as in the hint of landscape in *Red Devil Color Chart No. Two*, 1963 (fig. 122).

The palette presents a further duality, casting an inward gaze on history and art, and an outward gaze on the present and on creation. In *Two Palettes (International Congress of Constructivists and Dadaists, 1922) #1* and *#2*, both 1963 (figs. 119, 120), the palettes burst into a multitude of fragments of figures, signs, forms, and colors that refer back to art's cultural and visual heritage. In *Hatchet with Two Palettes, State No. 2*, 1963, a wood plank the same length as the canvas is superimposed on the surface of the palette, and embedded in the plank is an axe, whose shadowy reflections project different densities of black onto the background. Here the dualism of the artist as distributor of objects and shadows reaches the height of its declaration of identity. The artist-palette moves between the poles of reality and representation, material and immaterial, introversion and extroversion, dualities that are reflected in the painting's division into two parts by the plank, and in such pairings as paintbrush and hatchet, palette and color, which mirror one another or are each other's shadow.

Another element that Dine uses repeatedly is the chain, often in combination with wire, string, stovepipe, or pulley, in works ranging from *Sickle*, 1962 (fig. 83), to *Isometric Self-Portrait*, 1964 (fig. 130). The chain sustains and individuates a relationship between the object and the painting. It functions as either an umbilical cord uniting two wombs, or as an energy channel connecting them and bearing witness to their complexity as opposites. As an energy flow, it highlights their linearity or transversality, acting as a ray of incidental light that puts objects and paintings on the same plane, while respecting their autonomy and territoriality. Whether it functions as a placenta or a more general connective is determined by where Dine places the chain, wire, or cord in relation to the suit or the bathrobe, metaphors of the artist in his role as public or private person, respectively. When it is attached at the center of the suit or bathrobe—i.e., the artist's abdomen—it is a placenta through which the

dialogue between the artist and things is transmitted. Dine uses this configuration in *White Suit #2 (Self-Portrait)* (fig. 126) and in *Palette (Self-Portrait No. 1)* (fig. 127), both 1964, but it attains its richest manifestation in *Red Robe #2*, 1964 (fig. 132), where the chain is part of a nexus of interlocking motifs, including the outlines of a chair, a bathrobe, and an axe, as well as an actual red penknife and a stick painted red, all against a red ground. It is difficult to establish a sequence for these motifs: if one starts from the center, with the bathrobe and the chair—in other words, human body and thing, one within the other—one notices a variety of different radiating elements. The chain supports, at its ends, the penknife and the stick, behind which Dine has painted "shadows"—a geometric one behind the knife, and a more organic one behind the stick. In the lower section of the canvas, seven straight lines radiate symmetrically down to the bottom from the midpoint of the diameter of a semicircle, while the bathrobe seems to float above them. Any interpretation of this would be complex, but in its full articulation it confirms Dine's dialectical premise: the ongoing quest to find, for art, an intermediate ground between action and behavior, being and appearance, male and female, memory and present time.

In his essentialism, Dine seeks a balance—from right to left, top to bottom—between historical vision and contemporary vision, quasi-mathematical perception and organic sensation, abstraction and figuration. He is always attentive to the interior of things, to the duality of being— to that which proceeds by chance and that which can be controlled, that which is governed by reason and that which allows for sensuality. In the extreme cases of *Two Palettes in Black and Stovepipe (The Dream)* (fig. 114) and *Dream #2*, both 1963, the loving communication between the parts occurs through the extension of a stovepipe connecting two paintings, one of which features two palettes. Here the passage from one thing to another covers the distance between them, fills up the space, and confronts every difficulty that might prevent a connection ensuring the circulation of energy between the two parts—thus bringing together day and night, waking and sleeping, nightmare and dream.

Amid these paradigms of the double, the bathrobe, along with the suit, reappears, soon to be followed—starting with the sculptures that he made in 1965—by boots (see figs. 113, 137), the shoe, the glove, the hat, and an envelope. Like the mirrored cabinet, the bathrobe suggests a hidden content as much as a self-portrait: "It was a way to make a self-portrait," said Dine, "but I didn't have the nerve to do it just [that way]—or didn't want to do it just that way—and I didn't look like I was inside of it. But no longer."[9] The bathrobe, like the suit, presents an umbilical center that generates rays and figures related to a person's anatomy, covering his private parts—his sex and muscles, nerves and heart. It functions as armor and as a form of enclosure that keeps him from wandering. It is a corset that supports him and a prison that suffocates him, a surface that envelops him and shelters the raw truth but also hides and denies it. Intertwined on top of it are colors and figures, decorations and motifs that speak of the tastes and culture, the history and interests of the person that wears it. It is a second skin that is never hermetically closed; from *Green Suit* to *Red Robe with Hatchet (Self-Portrait)*, it always admits, or threatens, the possibility of a sexual apparition or physical revelation. Indeed, as motifs that Dine uses in connection with self-revelation and self-exposure, the suit and the bathrobe foreshadow a complete stripping, or an amorous communication

of the sort linked to affairs of the heart. This is probably self-evident for the bathrobe; but the suit, too, implies both closing and opening, since the buttons and belt are ornaments that function as implements for fastening and unfastening a garment. The buttons, when fastened, hold two separate parts together—the left and right parts of the body, as well as its visible and hidden parts. Color and technique also play a part in the motif's dual or multiple signification: *White Suit (Self-Portrait)* juxtaposes black and white, and combines drawing and painting, as if to embody this multiplicity. Dine extends this idea further in works where he moves back and forth between two-dimensionality and three-dimensionality, between painting and sculpture, working in a halfway state that is further reinforced by the dualities of lightness and weight, raw and worked material, naturalness and artificiality, color and black-and-white, order and disorder—and leads him to superimpose the image of the bathrobe on the image of the palette in *Palette (Self-Portrait No. 1)*, and to present a drawing of a bathrobe next to a painted color chart in *Self-Portrait Next to a Colored Window*, 1964 (fig. 131).

The bathrobe is also related to the psychoanalytic treatment Dine underwent from 1962 to 1966.[10] It becomes the image of a lost covering, the rediscovered placenta, which closes the two sides of scars, and through which the artist gets close to the womb of his desires. It opens and closes a barrier to those desires, and serves to cover and protect his body. In the segment of chain or wire that unites the various aspects of the self lies the unity Dine continuously asserts: the strong social and aesthetic correspondence between dressing and painting. One might even go so far as to say that the artist and the fashion designer—with their similar cutting and shaping of materials and selection and juxtaposition of colors—both dress and bedeck the world.[11]

Every time Dine claims a painting as a self-portrait, he deliberately draws attention to himself as its author and invites observers to consider the communicative significance his analytic probing bears because it unfolds with and for the other, in an overlapping interchange of recognitions in which reality and the naked truth show each other the way, combining maximum singularity with maximum universality. With respect to introspection and otherness, artistic mirroring constitutes a third way, for, on the one hand, it prevents one from seeing without there being an object of one's sight, and, on the other, it prevents the object from being reified and deceptively surrendered to the inquiries of its investigator. As a third way, art is at first a frontal image on which all eyes converge to find a center that might be sexuality or identity, dream or desire. Later, when the visual therapy manages to capture, between the bathrobe and the palette, the figure of the self and its individuality, the art increasingly flows in the direction of the object, becomes itself sculpture and thing. The mirror as surface reflecting imaginary figures then turns into a transmitter outwardly projecting masses of materials and figures, which metaphorically are still descended from the double and the threshold, the reflection and the passage.

Starting in 1964, Dine renewed his project of self-portraiture through the use of certain parts of his own artistic "body," especially the tools and the bathrobe, beginning with the mixed-media assemblage *Stephen Hands Path*, 1964/98 (fig. 134). This juxtaposition of a sculpture (a wooden sawhorse supporting a log embedded with two axes) and a painting (of the right half of a bathrobe, oriented horizontally) represents a combination of seeing and acting, of image and object. The discharge of energy unleashed between these poles anticipates and leads to the motifs of mirroring and crossing between

different realms in Dine's freestanding sculptures. In *Double Hammer Doorway* (fig. 143) and *A Boot Bench Ochre #2* (fig. 113), both 1965, the questioning of the object and of its usual function in a real-life context, and in relation to the body, unfolds to form a whole that contains the entirety of Dine's various themes. In these and other of his sculptures, objective reality and subjective experience are merged in the formation of a hybrid object that blurs the lines between useful and useless, normal and abnormal, with a logic traceable to the interstices of difference between verisimilitude and truth.

To grasp the meaning of these sculptures, which continue the dualism of Dine's approach, one must bear in mind that the identification of the self through the use of opposites has the inevitable result of poeticizing the environment, as it had in *The House* and *The Smiling Workman* and has continued to have in his works since then. This means that the aleatory play between art and things, by 1965, finds a correspondence between objects and traditional sculpture. In this sense, the technique of casting should be seen as the reassertion of a method that, even with its connections to Giacometti, was not regarded very favorably within the avant-garde movements that run from Dada to Pop art.

Another aspect by which the object demands to be recognized is its sexual connotation—that is, its identity as a fetish and an emblematic expression of a desire. Dine's hybrid forms embody an absence essential to understanding the origins of a development that began erotically with the 1959 works *Altar for Jeremiah* and *Green Suit* and by the mid-1960s reached the point of feeding a desire for the other, in both the psychological and physical, intellectual and sensual senses. In sculptures such as *Summer Table* (fig. 145) and *Summer Torso*, both 1965, the distances between male and female disappear, and objects appear as aspects of a generalized scene of desire. These objects become sensual and sexual vehicles, setting in motion a concatenation of fantasies in which the conveyance of love reigns supreme.

At this point the eroticism of clothing, with its attraction of a second skin, can make way for the triumphant innocence of an intimacy that openly declares and reveals itself. As Dine has said, "The unleashing of inner thoughts in an exciting way, in an appropriate way, is never a problem. I love exposure."[12] One is liberated from the wrapping and passes directly to the contents, to what lies beneath the surface, both anatomically and sexually. The iconographic celebration of *Nancy and I at Ithaca (Green)* (fig. 150) and *Nancy and I at Ithaca (Straw Heart)* (fig. 151), both 1966–69, aside from recalling the odyssey of Ulysses the voyager and seeker, also communicates Dine's goal of revealing his inner self as an artist and a person. From this moment on, he sets about opening his heart, declaring his union with art, no longer as covering and analysis, but as the splendor of an ancient yet contemporary language. Before moving on to this neoclassical, or better yet, neocontemporary phase—in the sense that it conveys history into the present and the present into history—he completes a definitive journey inside his personal universe. In *Name Painting #1*, 1968–69 (fig. 155), and its sequel *Name Painting #2*, 1969, he records the names, and thus the embodiments, of everyone he has known or met. They are beings, mortal remains and statues, clothes and figures, that represent the division between life and death that he experienced prior to that point. The labor of sifting through his own memory for these names leads him to examine all the data—internal and external, beautiful and ugly, happy and troubled—in which his life has been enveloped. As a result, the *Name Paintings* serve as a shroud in which the old, heavy, opaque body is wrapped and abandoned. After the *Name Paintings*, all that will remain is transparency and lightness, as exemplified by *Five Chicken Wire Hearts (for James Peto)*, 1969/98 (fig. 154)—the manifestation of an effervescence that slowly manages to dissolve the landscape of objects in favor of a movement of inner and outer fluids, ancient and contemporary stories, built up with colors, lights, densities, and transparencies that continue to bespeak the radiant intensity of Dine's art: "My work is like me, I think. Definitely, it is me. I am it. I am the work. There is no question about that. I probably am as closely linked to my work as any artist I know. That is, if you know me, you know my work. I am closed off in that way."[13] The story continues.

Translated from the Italian by Stephen Sartarelli.

Notes

1. Giulio Carlo Argan, "Il 'realismo' nella poetica del Caravaggio," in *Scritti di Storia dell'Arte in onore di Lionello Venturi* (Rome: De Luca, 1956), vol. 2, pp. 25–41.
2. Germano Celant, "Il congelatore pop, memento mori dell'avanguardia," in *PopArt, evoluzione di una generazione* (Milan: Electa, 1980), pp. 11–30.
3. Jean Baudrillard, *L'Échange symbolique et la mort* (Paris: Editions Gallimard, 1976).
4. E. Haulotte, *Symbolisme du vetement selon la Bible* (Paris: Aubier, 1966).
5. Dine, quoted in Marco Livingstone, *Rise Up, Solitude! Prints 1985–86* (New York: Pace Prints, 1986), p. 16.
6. Dine, quoted in W. J. Beal, *Jim Dine: Five Themes* (New York: Abbeville Press, and Minneapolis: Walker Arts Center, 1984), p. 52.
7. Dine, quoted in G. R. Swenson, "What is Pop Art? Answers from 8 painters, part I," *Art News* 62, no. 7 (November 1963), p. 25.
8. Strinati, Claudio. "La cattura dello Spazio," in *Lo Specchio e il Doppio, dallo stagno di Narciso allo schermo televisivo* (Milan: Fabbri, 1987), p. 47.
9. Dine, quoted in *Jim Dine: Painting What One Is* (New York: Harry N. Abrams, 1981), p. 204.
10. Jim Dine, "From 1962 to 1966 I was psychoanalyzed," in *Jim Dine* (New York: Whitney Museum of American Art, 1970), p. 16.
11. Germano Celant, "To Cut is to Think," in *Art/Fashion* (New York: Skira, 1997), pp. 21–31.
12. Dine, quoted in *Jim Dine: Painting*, p. 206.
13. Dine, quoted in Susie Hennessey, "A Conversation with Jim Dine," *Art Journal* (London), no. 39 (1980), p. 174.

The Self Possessed: Jim Dine's Mixed-Media Works, 1959–1969

Clare Bell

Once upon a time and a very good time it was there was a moocow coming down the road and this moocow that was coming down along the road met a nicens little boy named baby tuckoo . . .

James Joyce, Portrait of the Artist as a Young Man [1]

From an embalmed memory of his childhood, Jim Dine created some of the most resilient subjects in American art. Made during the first ten years of his career, from 1959 to 1969, his paintings evoke the vestiges of identity and his partly conscious search to recognize a self from a multitude of discordant parts. They possess the kind of hypnotic flash that begins James Joyce's coming-of-age novel, *Portrait of the Artist as a Young Man* (1916), when the inchoate yearnings of Stephen Dedalus's childhood make razor-sharp contact with the acute sensations and pungent smells of having lived through it. Later in life, Dine recalled:

I lived with my grandmother and grandfather. I had a totally free adolescence. I lived with these two old people. They didn't say anything to me, I mean what I should do and shouldn't do. I was traumatized anyway — the death of my mother, the expulsion from my father's house. And it all worked out so beautifully, because these people I lived with, my grandma and grandpa, were so nice to me. In this climate of love I was able to live this pained existence. [2]

Like a Grimms' fairy tale, Dine's paintings from this early period can appear light-hearted or even beastly. Bodiless faces, faceless bodies, animated hand tools, smeared palettes, and cloistered hearts push their way into the conscious world like children caught between the depths of knowing and the limits of their own expression. It was an explosive combination that Dine proved a master at exploiting. Of the art of the Abstract Expressionists on which he was weaned, Dine once countered, "I don't think the privations of those [artists] helped them." [3] So, with remarkably little inhibition, Dine dove deep into the human psyche using paint and objects as personas of personal exposure. In their Cracker Jack toy style way, his mixed-media paintings were childlike without being childish. Objects frequently project out from the canvas support, or hang, hover, or are placed precariously close to it, in a relief style that Dine refined over these ten years, providing referential elements that blur the line between "reality" and painted "illusion."

Born in 1935, in Cincinnati, Ohio, Dine always knew he would be an artist. Instinct remained the cornerstone of his methodology. As a child, it led him to seek inspiration from his immediate surroundings; and as an adolescent, it pointed him in the direction of the Cincinnati Art Museum and to numerous art books and even an occasional class or two. After a few years of study at several universities in Ohio in pursuit of a degree in art, and attending a semester at the renowned School of the Museum of Fine Arts, Boston, it became clear to the young artist that, for him, serious formal training was a moot point. Thanks to purloined copies of *Art News*, acquired during his years at Ohio University from 1955 to 1957, Dine was already quite familiar with some of the work of the leading Abstract Expressionist painters, such as Willem de Kooning, Franz Kline, and Robert Motherwell. In its pages he had an opportunity to find out about the Combines of Robert Rauschenberg (see fig. 6) and learn about the encaustic *Flags* and *Targets* of Rauschenberg's friend and colleague Jasper Johns. Though several years older than Dine, Rauschenberg and Johns represented the kind of established artists that he could consider his peers. In fact, there was never a time during the first ten years of his career when he did not look at the art of others. Dine selected bits and pieces of the language of past and present art and used them the way he used paint and objects, mining them for their physical and emotional resonance. Before finally leaving Ohio for New York in 1958, Dine struck up a correspondence with Lester Johnson, a second-generation Abstract Expressionist

living in New York whose later claim was that he "repeatedly combined the actions [of] painting with the figure."[4] When Dine moved that summer to Patchogue, New York, a town on the south shore of Long Island, he had already assembled a lexicon of artists whose work he strongly admired.

After arriving in Patchogue, Dine got his first teaching position. By day, Dine taught art at the local elementary school; and at night, as often as he could, he drove into Manhattan and sought opportunities to meet some of the artists he had admired from afar and others like them. Through Johnson, Dine was introduced to Red Grooms, one of Johnson's art students, a maverick with materials and forms with whom Dine found an affinity. Dine also renewed his friendship with Marcus Ratliff, one of his classmates at Cincinnati Walnut High School, at that time an art major at Cooper Union who was living in student quarters at the Judson Memorial Church at 239 Thompson Street, at Washington Square in Greenwich Village. Through Ratliff, Dine met Tom Wesselmann, one of Ratliff's cronies from Cooper Union.

Earlier in 1958, Ratliff and several other Cooper Union students, including Eva Hesse, had cleared out the basement of the Judson Memorial Church to use as studio space, and by January 1959 an unused basement storage room was converted into a gallery space.[5] In February, with the unequivocal support of the church's associate minister, Bernard E. ("Bud") Scott, the church's basement became the Judson Gallery, an artist-run exhibition space. It was the kind of improvised space that came to define the burgeoning New York avant-garde art scene of the late 1950s and early 1960s. On February 13, the Judson Gallery was inaugurated with an exhibition of paintings, drawings, and collages by Dine, Ratliff, and Wesselmann. Ratliff and Wesselmann met Swedish-born artist Claes Oldenburg sometime in March 1959, according to Oldenburg, who, though not a student at Cooper Union, shelved books in its library. They sought Oldenburg out after seeing an exhibition of his figure drawings displayed on the walls around the library.[6] Soon after that, the then twenty-four-year-old Dine also met Oldenburg, six years his senior. Over the next year, the Judson Gallery presented several group shows that included works by Dine and others; and in November 1959, Dine and Oldenburg mounted a two-person show of their own works—the first joint exhibition by the two artists. This was followed, after a group show of drawings and prints in December, by the duo's ambitious exhibition of environmental installations, presented at the gallery from early January to late March 1960. It featured Dine's first environment, *The House* (figs. 34, 35), and Oldenburg's environment *The Street*. They called the exhibition *Ray-Gun* and described it as a "three-month period of experimental constructions, derived from American popular art, street art, and other informal sources."[7] The Judson Gallery was not the only space where Dine poured his energies during those initial years in New York. By December 1960, he was showing his works at Anita Reuben's downtown gallery as well. They were the kind of spaces that Time Inc.'s Rosalind Constable wrote about in her memos and monthly newsletters to the company's editorial board. The exposure did much to validate the goings-on at these two galleries, especially the Reuben Gallery, which, in Constable's opinion, constituted "easily the most aggressively avant-garde art group in New York today."[8]

Allan Kaprow was one of the more infamous names on the scene. An art historian and painter, Kaprow had made substantial inroads among artists of his generation after his article "The Legacy of Jackson Pollock" appeared in the October 1958 issue of *Art News*, two years after Pollock's death. This article about the influence of Pollock's radical transformation of painting was more than an assessment of the ramifications of Pollock's deployment of materials and spatial ideas. It contained a recommendation for young artists to go beyond Pollock by utilizing everything in the real world around them, including "the specific substances of sight, sound, movements, people, odors, touch" and "objects of every sort"[9]—a suggestion that became a talisman to a younger generation of visual artists who wanted to capitalize on the idea of creating something in real time. By the time he and Dine met in 1959, Kaprow was already deeply involved with performance-based work. "Happenings" was Kaprow's term for such performance pieces by artists, and it came to represent the works of many of his contemporaries. Of course, performance art was not a brand-new phenomenon: beginning in the late 1950s, devotees could be found in the United States, Europe, and Japan. By 1959, Grooms had opened his Delancey Street Gallery, where he presented a combination of his mixed-media works and performances. Artists such as Dine, Dick Higgins, Kaprow, Oldenburg, Lucas Samaras, and Robert Whitman were never a cohesive group, but they were often featured in the same program and some even performed in one another's pieces. Nevertheless, their works were decidedly individual in concept and spirit. While Dine's penchant for showmanship would later seem at odds with the serious bout of agoraphobia he suffered a few years afterward, it was clearly in evidence during his brief stint as a performance artist. In fact, it was the brazen physicalness of his four performances in 1960—*The Smiling Workman* (figs. 1, 37–39), *Vaudeville Collage* (figs. 40–42), *Car Crash* (figs. 12, 13, 44–46), and *A Shining Bed* (figs. 51–53)—that catapulted the young artist into the limelight. However, he all but abandoned the medium of performance art after December 1960, returning to it only once more, with *Natural History (The Dreams)*, in 1965 (figs. 138–40).[10]

During the heady years that Dine gave himself to performing, he never abandoned painting. The canvas consistently proved a much more satisfying testing ground for wrestling with his true passion, figurative painting. When asked once why he was attracted to the human figure as a subject, Dine responded, "Human makes it a lot more flexible."[11] In his mixed-media paintings, Dine exploited in greater depth many aspects of the mummery, masking, costuming, and other forms of identity shifting that he had seized on as a performance artist. After arriving in New York, Dine also became interested in experimenting with a variety of materials. In one of his earliest attempts at exploring unconventional mediums, he tried to paint with melted crayons in emulation of Johns's encaustic method, which he admired, but he abandoned the idea because he did not like the results he achieved.[12] His childhood passion for objects led him to look for usable materials on Manhattan's streets and on the shelves of the five-and-ten and other variety stores. In May 1959, Dine's first son was born, and to commemorate the event the artist created *Altar for Jeremiah*, 1959 (fig. 24), a vertically stacked three-panel canvas featuring harlequin-style faces that freely mix masculine and female characteristics, and containing assorted store-bought items such as a Halloween mask, aluminum foil, and patterned fabrics. Dine's faces (figs. 18–22, 25) were never meant as universal human symbols. While the preceding generation of Modern artists may have been preoccupied with the universals associated with primordial imagery, such things were of no consequence to Dine. His use of the face was closer in spirit to the more recent commentary of Susan

Stewart: "What remains invisible to us becomes the primary subject of figurative art: the head and shoulders of the portrait and bust. Because it is invisible, the face becomes gigantic with meaning and significance. . . . The face becomes a text, a space which must be 'read' and interpreted in order to exist."[13] For Dine, the face was a powerful metonymic device, a referent of the soul. Moreover, it anticipated his interest in a singular, central object, one of his signature devices. Throughout his work, Dine has focused his attention on mostly ordinary objects through which his memories and emotions were distilled. Like Stephen Dedalus's "baby tuckoo," Dine's motifs have been the center of his universe.

Today, almost none of Dine's works from the November 1959 exhibition at the Judson Gallery and from other of his earliest shows remain, since he intentionally discarded or destroyed most of them. *The Checkerboard* (fig. 20), *Untitled (After Winged Victory)* (fig. 29), and *Household Piece* (fig. 30), all 1959, provide a small glimpse of the types of work Dine was making then. Recalling this period of his career just a few years afterward, he said:

I had this idea that anything could work. I mean absolutely anything. . . . I just figured that if you worked on it long enough it worked and if it didn't you threw it away. There was enough trash to make enough other things work. . . . My show was reviewed at the Reuben a month before it went up and then it was a different show because I didn't feel like showing those things, and that month I made another whole show. Claes did that too. When my show was over I just threw most of it away. That's what almost everyone did that year. No one bothered—no one cared that much. It was based on a kind of expressionist tradition at that point because of knowing Kaprow and Segal and those people—and so it was big heads, things made out of trash and objects of clothing.[14]

Green Suit (fig. 27), 1959, marks a breakthrough in Dine's endeavors as a painter. It is his first assemblage featuring a totemic image of gender-role ambiguity, which he created by inserting a painted cardboard "shirt" and "tie" into the jacket of his corduroy suit, transforming the pants into a skirt and equipping it with a limp "penis" made from wadded cloth, and then using this mutant form of the suit as his canvas. Dine carried this epicene quality forth onto other images and even into the very language of his paintings. In several works featuring the necktie as a central motif, Dine conceived of the tie—a traditionally masculine item—as "a vaginal form"[15] (see figs. 65, 68, 69, 73). The same gender reversal can be found in the disjunction between the image in *Pearls*, 1961 (fig. 72), and the word "pearls" that Dine painted below it, which, because of its deliberately smeared stenciling, could be mistakenly read as "penis."[16] Rather than a statement on the nature of sexuality, these works testify to Dine's abiding interest in ambiguity.

When Dine incorporated an object in a painting, he regarded it as "this mysterious object that metaphorically could be turned into something that was anonymous, but then became personal. If I picked up what I considered neutral objects, they lost their neutrality when I put my hand to them, or when I put them in conjunction with something else."[17] In March 1963, in an interview Dine gave in connection with *The Popular Image Exhibition*, a group show in Washington, D.C., he said, "It's nice to start with some outward idea and turn in rather than start with some inward idea and turn out."[18] It was a platform of thinking that should have clearly distinguished his endeavors from the exterior concerns of what was eventually deemed Pop art, and yet Dine and several other artists of his generation were grouped with the so-called Pop artists frequently enough[19] for the rubric to become associated with their work, too—a misleading designation. Pop art's reach, even at the very beginning, was over-inclusive and too broadly defined to serve Dine's intentions or sensibilities. In retort to Rauschenberg, whose own work, along with that of Johns, was considered part of the vital infrastructure of Pop art, and whose goal was to bring art in line with life, Dine commented, "People always ask if you're one of those people who bridge that gap. Well, what gap? I mean there's art and there's life."[20] Although being tagged with the Pop label gave Dine international and national venues for exhibiting his work, it was a designation that merely skimmed the surface rather than grasping the essential nature of his mixed-media pieces.

In 1960, Dine moved back and forth between making paintings and assemblages and performing on the makeshift stages of the Judson and Reuben galleries. The year began with the last few days of a group show at the Reuben Gallery and his installation of *The House* at the Judson Gallery, followed by his first performance piece, *The Smiling Workman*, at the Judson. In April, he attended the opening of his first solo exhibition at the Reuben Gallery dressed in a variation on his persona of the Smiling Workman (fig. 55); one of the few remaining works from that show is the assemblage *Bedspring*, 1960 (fig. 58). That June, his assemblage *Chair*, 1960 (a work related to *Hanging Chair #2*, Spring 1960, fig. 57) was included in Martha Jackson's *New Media – New Forms*,[21] a group exhibition at her Sixty-ninth Street gallery, presenting sculptures and assemblages by seventy-one new and established artists[22]—works primarily from the preceding two years and constructed from a broad range of materials, some even with moveable parts. In the gallery's exhibition catalogue, Lawrence Alloway described most of the works as arising out of "New York junk culture" and stressed their connections to Dada and Futurism[23] (a point also made in the show itself by the inclusion of three collages by Kurt Schwitters done between 1917 and 1947). Another noted critic, Thomas Hess, described the show as representing a sea change in artistic sensibilities, in terms not just of the artists but of the audience and of social attitudes in general.[24] Jackson, a formidable figure on the gallery scene, was intrigued by Dine's work and even commissioned Dine's environment *Spring Cabinet*, 1961 (fig. 64) for another of her avant-garde spectaculars, *Environments – Situations – Spaces*, which was held in the spring of 1961. "We were crazy about Jim Dine," she later remarked. "He came to us and said that he just couldn't stand teaching anymore at the Rhodes School. . . . Nobody would give him the money to live without teaching except us. There was no foundation; there was no grant, nothing at that time."[25]

Dine never shied away from repeating himself either in the way he put down paint or the way he utilized certain motifs. On the contrary, there are numerous series from this period, each group of works resulting from an intensive elaboration of a single idea, like a theme and variations. This habit of investigating a particular subject at length was evidence of just how tenacious Dine's artistic focus would prove to be during those years. In 1961, Dine began to fully commit himself to the problematics of paint. In anticipation of his first solo exhibition at Jackson's gallery, scheduled for 1962, he embarked on what would become—in terms of their appearance—the most varied group of paintings within his concept of a series. Dine moved from an exploration of the color of human flesh, as in *Two Nests*, 1960[26] (fig. 56), to related body motifs in *Hair* (fig. 66) and *Tattoo* (fig. 75), both done in 1961, as well as subjects as diverse as

Fred Astaire and Ginger Rogers and *A Universal Color Chart* (figs. 62 and 78), both also 1961. During that same period, Dine also painted stand-ins for the body in works such as *Coat* (fig. 74), *Shoe* (fig. 77), *Pearls* (fig. 72), *The Red Bandana* (fig. 71), and *Green Ties in a Landscape* (fig. 73), all from 1961. The subjects he chose were not meant to be taken literally. "Dine's motifs are verbs more than they are nouns," wrote Max Kozloff.[27] This may account for the decidedly maladroit quality of the motifs depicted in many of these works, which project the fumbling awkwardness of children's art. However, despite tapping into the apparent simplicity of children's art and even appropriating a childlike writing style for the emblematic words, there was never any sense of childlike innocence in Dine's work.

While completing the paintings for his solo show at Jackson's gallery, Dine also began work on a suite of paintings featuring various tools suspended, nailed, or glued onto the canvas support, thus making what are actually assemblages (see figs. 80–95). When Ileana Sonnabend visited Dine's studio in 1962, the *Tool* paintings were what spurred her into giving Dine his own show at her Paris gallery the following year. Preceding that exhibition was a small solo show of *Tool* paintings at the Galleria Dell'Ariete in Milan in autumn 1962, providing Dine with his first foray into the European gallery circuit. However, severe emotional withdrawal and agoraphobia—which began about 1961 and lasted until 1964—kept Dine from traveling abroad to see either show. Throughout this period of great psychological stress, Dine applied himself steadfastly to his art, finding that it had a healing effect.

Dine's interest in tools goes back to a childhood fascination with them, linked to his grandfather's and father's hardware stores and his hours spent playing in a basement workshop. Tools first appeared as a motif in his work in 1960, when he made a hand-drawn announcement for his performance piece *The Smiling Workman* (fig. 36). The card is covered with outlines of a hammer, saw, screwdriver, trowel, and other handyman's implements. In the *Tool* paintings, his combining of real objects and a painted surface transformed by the material quality of house paint allowed Dine to engage all his senses. He had resolved by the end of 1961 to use primarily new, store-bought objects. And he liked using pre-mixed house paint because "the colors were without compromise and without subtlety" and because each color "is a found object . . . it's already there."[28]

A piece of red paint is no different than a pencil if I use it, or vice versa. If I use a yellow pencil, I use a yellow pencil. If I use a piece of yellow paint, that's another kind of object. They all have history. I know that. I know that when I put a hammer down, a hammer has an association for people, and if you have a new hammer, it's a different association than if you have an old hammer.[29]

He used paint and objects without hierarchy. As a result, what is real shares the same psychological space with memories of the real. His works are akin to what Jacques Lacan has categorized as subjective phenomena, such as a rainbow, a motif that Dine used in several paintings (including figs. 59, 60). "When you see a rainbow," wrote Lacan, "you are seeing something purely subjective. You can see it at a certain distance where it joins the surrounding scenery. It is not there. It is a subjective phenomenon."[30] Dine avoided using chiaroscuro effects on most of his central motifs and instead applied them to the painted backgrounds of his canvases; he was not concerned with

5. *Pablo Picasso,* Guernica, *1937*
Oil on canvas
11 feet 6 inches x 25 feet 8 inches
(350.5 x 782.3 cm)
Museo Nacional Centro de Arte Reina Sofía, Madrid

6. *Robert Rauschenberg,* Charlene, *1954*
Combine painting: Oil, charcoal, paper, fabric, newspaper, wood, plastic, mirror, and metal on four Homosote panels, mounted on wood, with electric light
7 feet 5 inches x 9 feet 4 inches x 3 1/2 inches (226.1 x 284.5 x 8.9 cm)
Stedelijk Museum, Amsterdam

modeling or with painterly effects of light. However, he often incorporated an *actual* light in his works, in the form of a light bulb or an entire light fixture. For precedents, Dine had Picasso's painted image of a naked light bulb in the antiwar masterpiece *Guernica*, 1937 (fig. 5), and Rauschenberg's use of a working electric light fixture in his monumental Combine *Charlene*, 1954 (fig. 6). Dine used a light bulb dangling from a wire to illuminate an environment he did at Judson called *Rainbow Thoughts*, 1961, and placed electrical plugs and sections of wire in the center of several paintings that year, such as *Fred Astaire and Ginger Rogers*. He utilized the glare of a working light bulb in *Green Shower* (fig. 101) and a working nursery lamp in *Child's Blue Wall* (fig. 108), both 1962. In addition to a light bulb, there are electric cords, outlets, a light socket, and two metal light fixtures in *Wiring the Unfinished Bathroom*, 1962 (fig. 106), and similar equipment appears in other *Bathroom* paintings. Lights also appear in several of his self-portraits from 1964. One such work, *White Suit #2 (Self-Portrait)*, 1964 (fig. 126), features a working light bulb as one of the predominant objects held by the imposing faceless figure. In 1965, when Dine returned to the stage to perform *Natural History (The Dreams)* (figs. 138–40) at the *First New York Theater Rally*, he lit his scene with a standing light fixture. Perhaps more important than its connections with Picasso or Rauschenberg, the light in Dine's mixed-media works is a distant cousin of the kind found in the works of fifteenth-century Flemish masters Jan van Eyck, his student Petrus Christus, and Rogier van der Weyden, all of whose work Dine had long admired. These Northern Renaissance artists sought a painstaking graphic clarity in their application of light, giving their works an uncanny etched quality that dovetails with Dine's interest in the two-dimensional. As he remarked recently, they treated everything in their paintings, even people, "as an object."[31] Dine uses the hard glare of artificial light the way they depicted the hard, clear light of day. When he does use light, it is not as a fleeting presence or to convey a warm glow, but as the Flemish masters did, as a psychologically weighted device. In *Child's Blue Wall*, for example, the gleaming light bulb of the shadeless nursery lamp triggers childhood memories of fear of the dark; while in *White Suit #2 (Self-Portrait)*, the light and its hardware project the sexual charge of a phallus. And when he incorporates unlit light bulbs in a tangle of wires, as in *Wiring the Unfinished Bathroom*, he presents them as artifacts of everyday life.

"My whole unconscious is depicted as a house," Dine said recently.[32] His identification with domestic spaces and their various furnishings carried over into future shows, starting with his first solo exhibition at the Sidney Janis Gallery, on Fifty-seventh Street (see fig. 97). Dine had left Jackson's gallery after his solo show there in January 1962 and accepted Janis's offer to represent him in New York, becoming one of the youngest in Janis's stable of artists. His debut with Janis was in November 1962, when *Lawnmower*, 1962 (fig. 89), was included in the much heralded group show *International Exhibition of the New Realists*. Dine's first solo show at Janis opened in February 1963 and consisted of works done in 1962 that were all related to the theme of domestic space. These included several *Bathroom* paintings, such as *Small Shower #2* (fig. 110); *The Toaster* (fig. 100); and several works from the *Room* series, such as *Three-Panel Study for a Child's Room* (fig. 107) and the monumental *Four Rooms* (fig. 109), his largest work to date. His growth as an artist was clearly linked to memories of the home, the initial site of his maturation. However, the accessories Dine mounted to his canvases in these assemblages are too generic, too gleaming,

too fresh to be construed as the artist's personal souvenirs. There is nothing romantic or nostalgic about them. They were new, bought expressly to be incorporated into these works. The *Bathrooms* and *Rooms* are temptations, their constructed appearance containing both an invitation to enter and a warning to be circumspect. There was something rawly intuitive about Dine's works that was distinct from those of his Pop art brethren, with the possible exception of Oldenburg, whose early sculptural pieces were imbued with a homespun quality that had none of Pop art's cool irony.

White Bathroom (fig. 105), *Green Shower*, and *Four Rooms*, all 1962, were among the works by Dine selected by Alan Solomon for inclusion in the United States exhibition at the 1964 Venice *Biennale*. Once again, Dine did not cross the Atlantic, out of fear of leaving his home and studio. In the fall of 1964, Dine had his second solo show at the Sidney Janis Gallery, featuring works that dealt with the idea of self-portraiture, using palettes, color charts, suits, and bathrobes as stand-ins for his own figure. In 1960, he had first used the image of a painter's traditional wooden palette—the curves of which Dine equated with the curving course of the Cincinnati River, as remembered from his childhood—to create *A 1935 Palett* (fig. 26). His birth year in the title made it clear that it was intended as a self-portrait. In 1962, Dine picked up the theme again in a series of drawings featuring images of palettes (stolen when his studio was broken into later that year); and in 1963 he began a series of paintings and assemblages with palettes as the central motif, often daubed with traces of impasto. At his 1964 exhibition at Janis, works made in 1963, such as *Two Palettes in Black with Stovepipe (The Dream)* (fig. 114), both versions of *Two Palettes (International Congress of Constructivists and Dadaists, 1922)* (figs. 119, 120), and *Red Devil Color Chart No. Two* (fig. 122), were shown together with a few of the 1964 *Suit* paintings and the first of his *Bathrobes*, including *Red Robe with Hatchet (Self-Portrait)* (fig. 128), *Self-Portrait Next to a Colored Window* (fig. 131), *Charcoal Self-Portrait in a Cement Garden* (fig. 133), and *Stephen Hands Path* (fig. 134), all 1964. The pleasure Dine took in nailing, screwing, or wiring objects onto the canvases in these works carried a Frankensteinian delight in the anatomical, while the drilling, cutting, and chaining of materials and objects displayed a fascination with the disembodied. Dine was frequently queried about his work's relationship to Surrealism's prankish, often macabre sensibility and disjunctive use of freely associated images and objects. Certainly no artist of Dine's generation was immune to Surrealism's legacy. While it would be impossible to single out one iconic work that defined the spirit of the movement unleashed by writer André Breton in 1924, Meret Oppenheim's *Objet (Le Déjeuner en fourrure) (Object {The Fur Luncheon})*, 1936 (fig. 7), was certainly one of its most notorious. In 1994, describing Oppenheim's assemblage, Marina Warner wrote:

The teacup and saucer and spoon of Chinese antelope hide wittily combine erotic innuendo, the outrageous and bristling inversions dear to Surrealist humour, and a deadpan comment on polite society's manners. It makes visible, with quite remarkable economy, the problematic presence of the wild in the civilized, the place of the animal in society, and the containment and ordering of female sexuality.[33]

Of Oppenheim's teacup, Dine once commented, "It seemed the most natural thing in the world."[34] Thus, the jolting effect of the Surrealists' "outrageous" juxtapositions was simply lost on Dine, whose own impulses had naturally led him to the margins of social propriety in his art.

Paint had always been Dine's primary medium, and he even incorporated it in one form or another into his environments and performances. Stains of dripping paint were in full view everywhere in *The House* (figs. 34, 35). *The House* was a rare invitation to experience a painter's bedlam, at once a paradise and hell of paint, debris, and accumulated memories. In his first performance piece, *The Smiling Workman* (figs. 1, 37–39), Dine startled his audience by drinking from a bucket of red "paint" (actually tomato juice) and pouring the rest over his head. For his performance piece *Car Crash* (figs. 12, 13, 44–46) eight months later, he had painted the word "HELP!" onto a roll of paper towels, one word per sheet, and unrolled the prepainted scroll during the performance. And for his environment *Spring Cabinet*, 1961 (fig. 64), he had planned to expose viewers to the risk of being splattered by paint while watching a "drip painting" in the making, by hanging buckets of green paint from the ceiling and having the paint drip onto a canvas on the floor while electric fans were blowing; but the gallery vetoed the "action" component of this "action painting."[35] In his mixed-media works, Dine embraced both dense and airy applications of oil paint, his pigment of choice. Although his works are far from traditional, Dine's dedication to figurative work and his continued preference for oil were clear signals that he considered himself to be part of the tradition of Western painting.[36] In fact, he did occasionally use acrylics or enamels on canvas, but oil paint remained his primary medium—until he turned to sculpture.

In 1965, Dine put aside his oil brushes and began to cast individual forms. This was something of a leap for the dedicated painter that Dine was, but it was not all that surprising, considering his abiding interest in objects. The sculptures that Dine cast—motorcycle boots and a table cast in bronze, and a bench, hammers, an air pump, and an axe cast in the lighter metal aluminum—repeat the predominant preoccupations of his paintings: clothes, furniture, and tools (see figs. 113, 137, 143, 145, 146, 149). After starting with junk found in the street and then using store-bought items, Dine was finally making his own objects. His sculpted forms are different from the real-world objects that enlivened the surfaces of his paintings, and function differently as well. In imitating the look of an object, Dine often created a hybrid rather than merely duplicating its form. For example, *Double Hammer Doorway* (fig. 143) and *The Red Axe* (fig. 149), both 1965, have something of the freakish quality of an elongated reflection in a funhouse mirror; and for *A Boot Bench Ochre #2* (see fig. 113), Dine used a pair of boots to support a wood plank, and cast the resulting "bench" in aluminum. However, these mutant versions of ordinary objects were never intended to create a breach between the object and the audience, for Dine never conceived of them as surreal or unnatural. It was more out of a feel for the pleasure of carnival that he tapped into the notions of monstrosity and mutation, where, as Susan Stewart has pointed out, "the grotesque is an exaggeration and celebration of the productive and reproductive capacities of the body, of the natural in its most sensual dimensions."[37] Indeed, for Dine, mutations are a part of nature. These longer, skinnier versions of everyday objects stand at the threshold of being and becoming, halfway between the ordinary and the freakish. Unlike most people, who might consider them "abnormal" and assume that such exaggerated characteristics would prevent the objects from functioning, Dine sees no reason why they could not be put to use.

In 1966, Dine placed his sand-casted replicas onto sections of canvases spray-painted with blue automobile lacquer in his suite *A.R. at Oberlin*, an ode to the German poet

7. Meret Oppenheim, Object [The Fur Luncheon], *1936*
Fur-covered cup, saucer, and spoon
Cup: 4 3/8 inches (10.9 cm) diameter; saucer: 9 3/8 inches (23.7 cm) diameter; spoon: 8 inches (20.2 cm) long; overall height 2 7/8 inches (7.3 cm)
The Museum of Modern Art, New York. Purchase

Rainer Maria Rilke. The works in this series, created after a ten-day teaching residency at Oberlin College, are the most enigmatic of all his mixed-media assemblages. The freedom to invent his own objects inspired him to test their conceits within the realm of painting. His objects appear more fragmented and disconnected from the whole. Instead of the taxonomy he had established in previous works, Dine risked the feeling of absence in order to confront the idea of loss. The textual signals of his earlier paintings gave way to a profound sense of quietude in *A.R. at Oberlin #4 (Putting Aside Reo Blue)* and *A.R. at Oberlin #5 (A Thing of Rilke)* (figs. 148, 147), which exude a tenderness and fragility previously unknown in his works. Not until 1968 would Dine paint again.

During his eight-month residency at Cornell University's College of Architecture, beginning in the fall of 1966, Dine created seven monumental objects for his installation *Nancy and I at Ithaca*. Two of them still exist—one (fig. 150) in the shape of a hand, and the other (fig. 151) in the shape of a heart, the motif that became the most famous of his career after it reappeared in several later works. When he resumed painting in 1968, Dine's work continued to grow more massive in scale.

The strains of living and working in New York prompted him to make a radical change in mid-1967. Heartened by his first visit to London, which he traveled to by boat in the spring of 1966—his first trip outside the United States— Dine decided to move there with his entire family in June of the following year. His decision to stop painting for a while arose from a financial disagreement with Sidney Janis, rather than from any artistic block on his part. When he returned to the medium that had sustained him since childhood, he embarked on a project that was a literal embodiment of autobiography, *Name Painting #1*, 1968–69 (fig. 155), his largest painting up to that time. A painting by way of a poem, it listed the names of all the individuals he could remember having known or met over the course of his life, from the year of his birth to 1965. He completed the project in a second, smaller canvas, *Name Painting #2*, which resumed the list in 1965 and brought it up to 1969.

Like Joyce's protean hero, Stephen Dedalus, Dine brought more questions than answers to this initial body of work, and it enriched the very core of his artistic endeavors. In the novel, Dedalus muses, "Here are some questions I set myself: *Is a chair finely made tragic or comic? Is the portrait of Mona Lisa good if I desire to see it? Is the bust of Sir Philip Crampton lyrical, epical or dramatic? Can excrement or a child or a louse be a work of art?* If not, why not?"[38] Rather than try to locate a truth, Dine interrogated its perimeters. His mixed-media works from 1959 to 1969 are a record of a developing mind, and represent the questioning spirit that continues to guide the course of American art.

Notes

1. James Joyce, *Portrait of the Artist as a Young Man* (New York: B.W. Huebsch, 1916). Republished from the definitive text corrected from the Dublin holograph by Chester G. Anderson, edited by Richard Ellman (New York: The Viking Press, 1964); revised and with an Introduction by Seamus Deane, ed. (New York: Penguin, 1992), p. 3.

2. Quoted in Jim Dine, "Jim Dine: Statements" in *New York Arts Journal*, no. 23, p. 30.

3. Quoted in ibid., p. 30.

4. Introductory remark quoted in the unpublished transcript (unpaginated) from the panel discussion "New Uses of the Human Figure," which took place on December 2, 1959, at the Judson Memorial Church, New York. The panel was held during the time that Dine's and Oldenburg's first joint show of mixed-media works was installed. Introduced by Bernard Scott, the participants in the evening's discussion included Jim Dine, Lester Johnson, Allan Kaprow, Claes Oldenburg, and Marcus Ratliff. Transcript in the Judson Memorial Church Archives, New York.

5. Ratliff recalled that Hesse had vacated her room at the Church just prior to the opening of the Judson Gallery. He also recalled that the first art exhibition at the Judson Memorial Church was one that he organized —a show of prints by the French painter Georges Rouault (1871–1958)— and that it probably took place in January 1959; conversation between Ratliff and the author, June 8, 1998.

6. Oldenburg in conversation with the author, December 21, 1998.

7. Jim Dine and Claes Oldenburg, "Spring Calendar at the Judson Gallery" (for the period from January 4 to May 27, 1960), p. 1 of an unpaginated typescript in the archives of the Judson Memorial Church, New York.

8. Rosalind Constable, "Scouting Report on the Avant-Garde," *Esquire* (New York/Chicago) 55, no. 6 (June 1961), p. 86. In 1948, according to a two-page, typed press release prepared by the Editors of Time Inc., Constable became

a full-time chronicler of new and sometimes obscure happenings in the vanguard of modern arts. . . . One product of the Constable researches {sic} is a fortnightly report for editors that sometimes provides story ideas for Time Inc. Publications. . . . An anthology of excerpts from the Constable newsletter is compiled by Time Educational Services and sent out quarterly to some 1500 educators—mostly university teachers—giving them a slightly tardy look at what was new in the past three months.

Unpublished, unpaginated copy in Time Inc. Archives, New York.

9. Kaprow's concluding statement in this article is worth quoting at greater length:

Pollock, as I see him, left us at the point where we must become preoccupied with and even dazzled by the space and objects of our everyday life, either our bodies, clothes, rooms, or, if need be, the vastness of Forty-Second Street. Not satisfied with the suggestion through paint of our other senses, we shall utilize the specific substances of sight, sound, movements, people, odors, touch. Objects of every sort are materials for the new art: paint, chairs, food, electric and neon lights, smoke, water, old socks, a dog, movies, a thousand other things which will be discovered by the present generation of artists. Not only will these bold creators show us, as if for the first time, the world we have always had about us, but ignored, but they will disclose entirely unheard of happenings and events, found in garbage cans, police files, hotel lobbies, seen in store windows and on the streets, and sensed in dreams and horrible accidents. An odor of crushed strawberries, a letter from a friend or a billboard selling Draino; three taps on the front door, a scratch, a sigh or a voice lecturing endlessly, a blinding staccato flash, a bowler hat—all will become materials for this new concrete art. . . . The young artist of today . . . will discover out of ordinary things the meaning of ordinariness. He will not try to make them extraordinary. Only their real meaning will be stated . . . these, I am sure, will be the alchemies of the 1960s.

Kaprow, "The Legacy of Jackson Pollock," *Art News* (New York) 57, no. 6 (October 1958), pp. 56–57.

10. Dine's five performances during the years 1960 and 1965 are discussed in detail in Julia Blaut's essay "A 'Painter's Theater'" in the present catalogue.

11. Quoted from the unpublished, unpaginated transcript of the panel discussion "New Uses of the Human Image in Painting."

12. Dine, in the "Walking Memory" interview in the present catalogue, p. 100.

13. Susan Stewart, "The Imaginary Body," in *On Longing: Narratives of the Miniature, the Gigantic, the Souvenir, the Collection* (Durham, N.C., and London: Duke University Press, 1993), p. 125.

14. Quoted in an unpublished transcript of an interview between Jim Dine and Bruce Duff Hooton, which took place February 26, 1965, p. 3. Sound-tape reel and unpublished transcript on deposit at the Archives of American Art, New York.

15. Dine, in the "Walking Memory" interview in the present catalogue, p. 114.

16. Ibid., p. 116.

17. Ibid., p. 208.

18. Quoted in the unpublished transcript from the Washington Gallery of Modern Art, Washington D.C., "The Tape Recorded Interviews with Artists in the Popular Image Exhibition, March 1963," p. 1; in the Archives of American Art, New York.

19. Examples of early group exhibitions that showed Dine's work along with works by Pop artists are: the *International Exhibition of the New Realists* at the Sidney Janis Gallery, November 1–December 1, 1962, which presented works by twenty-nine artists from the United States and France, including Roy Lichtenstein, Oldenburg, George Segal, Andy Warhol, and Wesselmann; and *Six Painters and the Object* at the Solomon R. Guggenheim Museum, March 14–June 2, 1963, which consisted of works by Dine, Johns, Lichtenstein, Rauschenberg, James Rosenquist, and Warhol.

20. Quoted in Robert Fraser, "Dining with Jim," *Art and Artists* (London) 1, no. 6 (September 1966), p. 52.

21. The June 1960 exhibition was called *New Media – New Forms*, but the exhibition catalogue—which was done after the exhibition closed—was titled *New Forms – New Media 1*. The words "media" and "forms" were transposed in the title of the catalogue, and the number "1" was added after Jackson decided to mount a sequel to the exhibition in September; the catalogue only covered the first exhibition. The second exhibition was called *New Media – New Forms, Version 2*.

22. In deciding on which artists to include in *New Media – New Forms*, Jackson sought the advice of Rosalind Constable (see n. 8, above) and several other colleagues: in the catalogue, she expresses gratitude to Constable and the others for "their active cooperation in making selections for this exhibition." My thanks to Stephen Robert Frankel for bringing this information to my attention.

23. Lawrence Alloway, "Junk Culture as a Tradition," in *New Forms – New Media 1*, exh. cat. (New York: Martha Jackson Gallery, 1960), n.p.

24. See Thomas B. Hess, "Mixed Medium for a Soft Revolution," *Art News* (New York) 59, no. 4 (Summer 1960), p. 45.

25. Quoted in an unpublished transcript from an interview between Martha Jackson and Paul Cummings, May 23, 1969, p. 68; on file at the Archives of American Art, New York.

26. If one were to look at the work very closely, barely visible across the upper portion of the two canvases are the words "Portrait of Two Persons By Jim Dine November 1960." Dine said he changed his mind about calling it that because the drill holes ended up looking like "two nests"; conversation between Dine and the author, August 11, 1998.

27. Max Kozloff, "The Honest Elusiveness of James Dine," *Artforum* (San Francisco) 3, no. 3 (December 1964), p. 39.

28. Dine, in the "Walking Memory" interview in the present catalogue, p. 114.

29. Ibid.

30. Jacques Lacan, *Le séminaire I: Les écrits techniques de Freud* (1953–54) (Paris: Seuil, 1975), p. 91, translated by John Forrester in Jacques Lacan, *Freud's Writings on Technique* (Cambridge, Eng.: Cambridge University Press, 1987); reprinted in Jacqueline Rose, *Sexuality in the Field of Vision* (London: Verso, 1986), p. 168.

31. Dine, in the "Walking Memory" interview in the present catalogue, p. 133.

32. Ibid., p. 48.

33. Marina Warner, *From the Beast to the Blonde: On Fairy Tales and Their Tellers* (New York: The Noonday Press, Farrar, Straus and Giroux, 1994), p. 385.

34. Dine, quoted in G. R. Swenson, "What is Pop Art? Answers from 8 painters, part I," in *Art News* (New York) 62, no. 7 (November 1963), p. 61.

35. Thus, although he still hung the buckets of paint from the ceiling during the exhibition, he had to pre-paint the "drip painting"; Dine, in conversation with the author, December 14, 1998.

36. Dine, in the "Walking Memory" interview in the present catalogue, p. 116, also identified the idea of pentimenti, the practice of working things out on the canvas "until you get what you want," as something that makes him "part of a Western tradition." Dine appears to have begun leaving pentimenti in his works around 1969, with the two *Name Paintings*, and it became a more significant part of his work after 1970.

37. Stewart, *On Longing*, pp. 107–08.

38. Joyce, *Portrait of the Artist*, p. 482.

A "Painter's Theater": Jim Dine's Environments and Performances

Julia Blaut

For a brief period in the early 1960s, Jim Dine produced several environmental works and four of his five theater pieces or Happenings, as this type of theater by artists was known.[1] His active involvement in creating and performing "painter's theater" took place between January 1960, when he constructed his first environment, *The House*, at the Judson Gallery, and May 1961, when his last environment, *Spring Cabinet*, was presented in the *Environments – Situations – Spaces* exhibition at the Martha Jackson Gallery.[2] The change in venue, in just under a year and a half, represented a shift from the margins of the New York art world into its mainstream. Environments—and specifically Dine's work—moved from an artist-run, alternative exhibition space in the basement of the Judson Memorial Church in Greenwich Village, to the elegant brownstone that housed the Martha Jackson Gallery on Manhattan's Upper East Side.[3] Subsequently, Dine stopped making environments and Happenings because "it was becoming so chic" and "it was taking too much from my painting."[4] With hindsight, Dine later told an interviewer that "the Happenings were about trying to become famous. We were having fun; we were still children."[5]

The environments and Happenings, however, were more than a way for Dine to fulfill his "big ambition to be heard all the way back to Ohio."[6] Although they constitute only a small portion of this prolific artist's overall production, the environments and related theater pieces reveal the various conflicting forces in the New York art world in the late 1950s and early 1960s. Dine's ambivalent relationship to Abstract Expressionism was played out in these works, often by reenacting the ritual of Action Painting in order to move beyond its example. For Dine, the environments and Happenings manifested artistic concerns that remain central to his work to the present day: preoccupations with figuration, autobiography, psychology, and the tools and practice of the painter. What set Dine's work apart from Abstract Expressionism, and later from Pop art, is its romantic subjectivity—precisely the quality that made his work so significant for developments in artist-made performances of the 1970s.

Dine arrived in New York in 1958, at the age of twenty-three, two years after the death of Jackson Pollock. While still a student at Ohio University, where he earned a B.F.A. in 1957, he "schooled [himself] on *Art News*,"[7] in the pages of which he witnessed the unfolding of the powerful mythology of both Abstract Expressionism and the painters associated with the movement. It was also through *Art News* that he learned about artists such as Robert Rauschenberg, Jasper Johns, and Allan Kaprow, who presented a challenge to the prevailing Modernist aesthetic. Dine did not reject Abstract Expressionism outright, instead maintaining a relationship to the New York School artists like that of "fathers and sons."[8] Indeed, the painterly gesture and high emotional content intrinsic to that movement have remained hallmarks of his own style. Dine, however, did not subscribe to the goal of creating universal statements about the human condition by means of an abstract idiom, as they did. His art is more idiosyncratically autobiographical and uses concrete, figurative images drawn from everyday life. It is, as he has said, about "the layers of myself" and "deal[s] with the things I'm familiar with, everyday objects, parts of my body, parts of my wife's body, the tools I grew up with, the bathrooms in my uncle's store."[9]

Kaprow, formerly an abstract painter himself and an art history professor at Rutgers University in New Jersey, was an important influence on Dine in loosening the stronghold of

Abstract Expressionism. Dine met him in 1959 through the Reuben and Judson galleries. Many years after he had returned to painting as his primary medium, Dine recounted how, when he first came to New York,

Kaprow particularly impressed me. . . . {He} exerted a strong influence on all of us in New York at that time, particularly me, because I was the youngest and probably the most impressionable . . . He influenced me as a teacher influences a student . . . Painting was dead; Jackson Pollock killed painting by dancing around the canvas and using rocks and other things from external sources—bits of glass and other things he could find—in his paintings. Kaprow wrote an article in Art News *about that. It was called "The Legacy of Jackson Pollock," I think. The legacy was us. The legacy was visual events—dancing around the canvas and using junk—but without the canvas. Those were the happenings.*[10]

Kaprow's now-famous article, "The Legacy of Jackson Pollock," published in 1958,[11] became a kind of manifesto for environments and Happenings and declared the direction of art in the 1960s. Here Kaprow argued that

by making mural-scale paintings, {Pollock's work} ceased to become paintings and became environments*. . . . the painting is continued on out into the room. And this leads us to our final point: Space. . . . The "picture" has moved so far out that the canvas is no longer a reference point. Hence, although up on the wall, these marks surround us as they did the painter at work. . . . Pollock, as I see him, left us at the point where we must become preoccupied with and even dazzled by the space and objects of our everyday life, either our bodies, clothes, rooms, or, if need be, the vastness of Forty-Second Street. . . . all will become materials for this new concrete art."*[12]

The ideas that Kaprow put forward in "The Legacy of Jackson Pollock" comprise a direct assault on the prevailing formalist theories articulated in the writings of art critic Clement Greenberg and the teachings of Hans Hoffman, with whom Kaprow had studied; environments and Happenings moved paintings off the wall and into real space and time, undermining the integrity of the picture surface and blurring the distinctions between different mediums and between art and life.

Kaprow illustrated his article with photographs of Pollock at work, taken by Rudolph Burckhardt from overhead, which compounded the impression that "Pollock . . . was 'in' his work."[13] Kaprow's book *Assemblage, Environments & Happenings* (ca. 1966) instead included the photographs of Pollock painting by Hans Namuth (see fig. 8).[14] These photographs, as well as a film by Namuth on Pollock, contributed to the discourse on the artist as an "Action Man."[15] It is this view of Pollock that had been developed by Harold Rosenberg in his 1952 article "The American Action Painters," where he argues that to the Abstract Expressionists "the canvas began to appear . . . as an arena," and "the painter had become an actor."[16] Rosenberg's article together with Namuth's photographs contributed to Kaprow's idea of Pollock setting a precedent for the artist as performer.[17]

Kaprow traced the lineage of environments and Happenings back to precedents that were primarily, though not exclusively, in the visual arts: from Cubist collage to Action Painting and assemblage of the mid-1950s.[18] The main practitioners of the earliest environments and Happenings were trained as painters: in addition to Kaprow and Dine,

there were also Claes Oldenburg, Robert Whitman, and Red Grooms. Their performances took place largely in alternative art spaces, particularly the Hansa, Reuben, and Judson galleries and the Delancey Street Museum.[19] Emphasizing the link to painting, Dine referred to his performances as a "painter's theater," in part to distinguish them from Happenings, which had become inextricably linked to Kaprow and the "rules" he established for them.[20] Rosalind Constable, a cultural correspondent at Time, Inc. during the 1950s and 1960s, also emphasized the painterly aspects of the Happenings, referring to them as "'live painting,' 'living pictures,' or 'painting as environment.'"[21]

Kaprow also pointed to precedents from outside the visual arts. These included the performances of earlier generations of artists—Dada, Surrealist, and Futurist theater as well as popular performance, such as "mime, the circus, carnivals, the traveling saltimbanques, all the way to medieval mystery plays and processions."[22] The class on experimental music taught by the composer John Cage at the New School for Social Research in New York, which Kaprow attended between 1957 and 1959, also proved to be extremely influential.[23] Attracting a wide range of students, including musicians, painters, sculptors, poets, and filmmakers, Cage advocated cross-fertilization between disciplines and an integration of everyday experience into art. His teachings reflected his own interests in Zen Buddhism, Duchamp, Dada, Surrealism, and Artaud's Theatre of Cruelty.[24] In 1952, at Black Mountain College, Cage had experimented with a spontaneous, interdisciplinary theater performance, which came to be known as *Theater Piece #1*, and which served as the immediate forerunner to the Happenings. During these years, Kaprow created his first environments and, in the context of Cage's New School class, took part in the first Happening-like events.[25]

It was Oldenburg who encouraged Dine to make his first environment. Under the exhibition title *Ray-Gun*, held at the Judson Gallery from January to March 1960, Dine's environment *The House* was presented together with an environment by Oldenburg called *The Street*.[26] The works were conceived as pendants, the house and the street respectively representing private and public domains.[27] "Ray-Gun" refers to a key motif in Oldenburg's work from this period, a cross between a child's toy and a phallus; it has been described as his "alter ego—as both a person . . . and an object." (It was illustrated in *The Village Voice* advertisement for the exhibition.) The "Ray-Gun" motif emerged as Oldenburg moved away from figurative painting and began making three-dimensional objects that "serve[d] as surrogates for the human body."[28] In his paintings and assemblage, Dine too would develop a vocabulary of objects that became metaphors for the body.

Dine and Oldenburg scoured the areas around Washington Square for used objects and street materials, out of which they fashioned both animate and inanimate objects for their environments. For *The Street*, Oldenburg made cars, people, and various urban objects from the same near-monochrome combinations of newspaper, rags, wire, cardboard, and spray paint. In contrast, according to *Time* magazine's review, Dine's *House* was "a shocking pink and green affair with bedsprings hanging from the ceiling and an umbrella protruding from the wall, with cardboard signs reading 'Breakfast Is Ready,' 'Go to Work,' and 'Why Can't We Be Friends?'"[29] Elsewhere it was described as

a blaze of color, its furnishings "derived from American popular art, street art and other informal sources." Close examination of

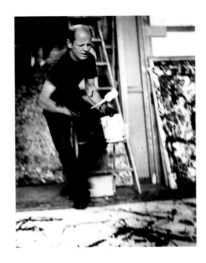

8. *Jackson Pollock in his studio, 1950.*
Photo by Hans Namuth

9. *Jackson Pollock,* Number 1, 1948, *1948*
Oil and enamel on unprimed canvas
5 feet 8 inches x 8 feet 8 inches
(172.7 x 264.2 cm)
The Museum of Modern Art, New York.
Purchase

the walls reveal{s} that one is a kitchen (beer cans, egg boxes, bottles), and another Mother's room, with jewel box, mirror and bronzed baby shoe. All through the house is the sound of breathing and heart beats, as well as more intimate (and decidedly less attractive) sounds, and an occasional voice asking: "Why can't we be friends?"[30]

Ray-Gun was Dine and Oldenburg's second joint exhibition. The first, held at the Judson Gallery a few months earlier,[31] had already revealed both artists' shared interest in human subjects. While Oldenburg showed figure paintings, Dine exhibited works from his "expressionist heads" series (figs. 18–22, 25)."[32] Dine had begun these at his uncle's cabin in rural Kentucky during the summer of 1958, before meeting Oldenburg, and continued the series at the cabin the following summer. The roughly drawn and painted images, often interpreted as self-portraits, would have appealed to Oldenburg, who was interested in figuration, masks, the art of Jean Dubuffet, and *art brut.*[33]

During the course of their first joint exhibition, Dine and Oldenburg participated with Kaprow and figurative painter Lester Johnson in a panel discussion held at the Judson Gallery, entitled "New Uses of the Human Image in Painting."[34] Throughout the discussion, Dine and Oldenburg expressed a continued desire to show the human form in art, which went against the current trend of abstraction. Beyond showing the subject illusionistically on canvas, they aimed at depicting the figure in its environment as a way to reach their audience.[35] Oldenburg declared that, unlike artists before him, who wanted "everything to happen on the picture plane," his impulse was "to make it come to life—to be an actual living thing." As Kaprow stated, this was not "to repudiate the past art that has preceded us, {but} to keep art alive."[36] This is the concept that lay behind the environments that Dine and Oldenburg would begin in the following month.

In theory, visitors to the *Ray-Gun* show were asked to participate in the construction of *The House* and *The Street*, lending a performative aspect to the otherwise static environments. In the "Judson Gallery Spring Calendar," Dine and Oldenburg indicated that the exhibition space would be open during construction, "in order to encourage participation and development of the RAYGUN idea." Furthermore, they stated that "while RAYGUN is begun by two artists, it is hoped others will join in during the RAYGUN period."[37] Audience participation was something that Kaprow had fostered, and was integral to his concept of how Happenings evolved out of environments. In his statement in Michael Kirby's anthology *Happenings* (1965), Kaprow wrote:

I immediately saw that every visitor to the Environment was part of it. . . . And so I gave him occupations like moving something, turning switches on . . . this suggested a more "scored" responsibility for that visitor. I offered him more and more to do, until there developed the Happening.[38]

Although Oldenburg did not assign particular tasks, as Kaprow did, he "invited the audience to add its own debris to the floor of *The Street* and encouraged other artists to pin up anything whatsoever on the 'communication board' he had set up adjacent to the gallery."[39]

Dine was more reticent about audience involvement with his work, later saying: "I never wanted anyone to be part of my art other than to take from it, . . . but I don't want anyone to participate."[40] However, in photographs of

The House when it was under construction and after it was officially opened to the public (figs. 34, 35), one can see real people occasionally incorporated into Dine's "habitable sculpture" and treated as found objects.[41] Among the newspaper, rags, and painted references to the human body, Dine's real human subjects are carefully placed by the artist and become completely integrated into the environment. On the tickets to the *Ray Gun Spex* (fig. 33)—three evenings of Happenings held at the Judson Memorial Church, February 29 through March 2, during the course of Dine's and Oldenburg's *Ray-Gun* installations—*The House* is described as "inhabited," a likely reference to live figures as well as to suggestions of a human presence in the form of painted body parts, objects for human use, and the audio of breathing, heartbeats, and voices.[42]

Just as Kaprow had traced the lineage of environments back to Pollock's mural-scale paintings, so Dine and Oldenburg invoked a similar heritage for *The House* and *The Street* when they called these constructions "painting in the shape of a house" and "painting in the shape of a city street."[43] The dispersal of materials in *The House*, the expressive handling of paint, and the allover composition (walls, floor, and ceiling), have often been equated with the "temperamental thrust . . . of abstract expressionism."[44] The heads, eyes, and other references that emerge from the layers of paint-saturated fabric and paper collage in *The House* can be compared to the hidden images of eyes and teeth that Willem de Kooning included in many of his allover abstractions, such as *Excavation*, 1950 (fig. 10).[45]

Yet the differences between works by the New York School and Dine's and Oldenburg's environments are at least as great as their similarities. Rather than merely expanding upon Abstract Expressionism, the environments are also a critique of its doctrine.[46] Even though Pollock often embedded pebbles and other small objects, such as the tops of paint tubes and cigarette butts, into the layers of paint he poured and dripped onto his canvases, his paintings did not break from a flat, rectilinear picture surface; Dine's willful inclusion of found, three-dimensional materials that clearly reflected the history of their former use represented a radical departure.[47] Made from junk materials and lasting only as long as the exhibition, the environments completely undermined the concept of the rarefied art object.[48] Finally, for other artists who came to be associated with Pop art in the early 1960s, Dine's *House* set a precedent for focusing on subjects drawn from the home; this emphasis on the traditionally domestic domain of women has been interpreted as a challenge by this new generation of artists to the hypermasculinity that was inscribed in the critical discourse on Abstract Expressionism.[49]

Dine resumed his dialogue with that movement in his first theater piece, *The Smiling Workman*, presented as part of the *Ray Gun Spex* program of Happenings. Another version of this theater piece, staged for Stan Vanderbeek's short silent film with the same title, took place in the environment of *The House*. Dine is shown moving through the "rooms" of his house, performing such everyday activities as eating a banana.[50] Wearing a full-length, paint-spattered smock and with a mask painted on his face, he is nearly camouflaged amidst painted rags and images of masklike faces. In contrast to the passive "inhabitants" of *The House*, Dine takes an active role as performer. On a large, blank sheet of paper resembling a canvas, he sets about painting a series of cartoonlike heads, writes the words "I love," drinks from a bucket of "paint,"[51] pours the remainder on his head, and then completes his sentence to read: "I love what I'm doing,

HELP!" He then dives through his painting—an act that has been interpreted as a parody of the perceived athleticism of "Action Painting," of Pollock being "in" his canvas, and a literal puncturing of the picture surface.[52]

There are some apparent differences between the filmed version of *The Smiling Workman* and the performances of it done in the context of *Ray Gun Spex*. Martha Holmes's photographs of one of these performances (figs. 37–39) closely match Dine's description of the piece in his statement in Kirby's *Happenings*:

I had a flat built. It was a three-panel flat with two sides and one flat. There was a table with three jars of paint and two brushes on it, and the canvas was painted white. I came around it with one light on me. I was all in red with a big black mouth: all my face and head were red, and I had a red smock on, down to the floor, I painted "I love what I'm doing" in orange and blue. When I got to "what I'm doing," it was going very fast, and I picked up one of the jars and drank the paint, and then I poured the other two jars of paint over my head, quickly, and dove, physically, through the canvas. The light went off. It was like a thirty-second moment of intensity. It was like a drawing.[53]

In *The Smiling Workman*, the end product for Dine is the performance of making art, rather than a durable art object; this became a recurrent theme of Dine's theater works.[54] Dine played the role of the Action Painter and, as recorded in Holmes's photographs, produced and then destroyed the quintessential Abstract Expressionist canvas. Like the painting he made in the Vanderbeek film, it also incorporated the human image, but this time it is a direct trace of himself. Surrounding a uniform color-field of gestural strokes, Dine is shown slapping his handprints around the edges of the canvas. The painting seems to be a response to works by Pollock, such as *Number 1, 1948*, 1948 (fig. 9), where handprints mark the edge of the canvas and refer to the artist's act of creation by leaving an imprint of his physical presence in the work. Dine's inclusion of the handprints is like the "diaristic gesture" to which Kaprow refers in "The Legacy of Jackson Pollock," where he writes that Pollock's "so-called 'dance' of dripping, slashing, squeezing, daubing and whatever else went into a work, placed an almost absolute value upon a kind of diaristic gesture."[55]

Throughout the twentieth century, artist-made performances have resisted prevailing "high" art conventions.[56] In keeping with this assumption, *The Smiling Workman* is a parody of Abstract Expressionism and the notion of Action Painting. Dine's use of the mask furthers this interpretation; he appears as a clown, and as such, belongs to the culture of carnival and its emancipating function. In *Rabelais and His World* (1965), Russian cultural critic Mikhail Bakhtin established that the aesthetic category of the grotesque, to which clowns belong, is linked to the annual celebration of carnival, which allowed for a "temporary liberation from the prevailing truth and from the established order."[57] The mask, according to Bakhtin, "reveals the essence of the grotesque" and is fundamental to the carnival as "it is connected with the joy of change . . . with the merry negation of uniformity and similarity; it rejects conformity to oneself."[58] The carnival spirit, Bakhtin contended, "offers the chance to have a new outlook on the world . . . and to enter a completely new order of things."[59]

It is in this liberating spirit of destabilizing cultural norms that Dine performed his "painter's theater." But, as Bakhtin argues, carnival laughter is ambivalent—"he who is laughing

also belongs to it"—as opposed to the satirist whose laughter "is negative [and who] places himself above the object of his mockery."[60] Certainly Dine had an equivocal relationship to Abstract Expressionism; he embraced its emotive and gestural aspects, yet he looked for ways, in all mediums, to move beyond its example, by his incorporation of concrete objects and his adamant emphasis on autobiography.

Dine once stated that *The Smiling Workman* was not meant to be funny: "I do not think obsession is funny or that not being able to stop one's intensity is funny."[61] Fellow artist Al Hansen later referred to *The Smiling Workman* as Dine's "first psycho-drama."[62] The phrase Dine scrawled across the canvas—"I love what I'm doing, HELP!"—might refer to the famously angst-ridden art-making practices of the Abstract Expressionists, but more likely to his own intensity about painting. The feverish pace, underscored by Dine's chanting throughout the performance, seems to reflect his attitudes about the ritualistic act of making art, as expressed in such comments as "I paint out of a compulsion" or "I do what I do because I have to. I can't stop myself."[63] When speaking to a *Time* Magazine reporter in 1960, Dine put a positive spin on this aspect of his works, saying that the performance was "meant to show 'the feeling of being a happy compulsive painter, which is what I am.'"[64] Dine later revealed that during this period, just as he was beginning to experience success, he abandoned making Happenings, in part because he was undergoing a nervous breakdown.[65]

Although the performance itself was short-lived, the persona of the Smiling Workman lived on as a reflection of Dine's obsessive art-making practices and his intense identification with the craft of painting. For example, for the opening of his solo exhibition at the Reuben Gallery on April 1, 1960,[66] Dine dressed the part of the Smiling Workman (fig. 55; see also fig. 1). Like the clowns of François Rabelais's novel, he was not merely an actor playing a part, but remained a clown beyond the performance, standing "on the borderline between life and art, in a peculiar mid-zone."[67] Although Dine replaced the smock—the working attire of the artist—with the more festive clothing of a jacket, knickers, high boots, and a red bandanna around his neck, he retained the Smiling Workman's painted mask. Two years later, Dine was referred to as "The Smiling Workman" in an exhibition review, and decades later he told an interviewer how physically hard he worked, saying "I'm very proud to be a workman."[68]

Dine continued his dialogue with Abstract Expressionism in his site-specific environment *Spring Cabinet* (fig. 64), made for the *Environments – Situations – Spaces* exhibition held in the spring of 1961 at the Martha Jackson Gallery.[69] Here, the Smiling Workman is replaced by inanimate objects: the artist's tools of palette and paint cans. The palette, which also appeared in a collage-painting from 1960 and in a series of mixed-media assemblages that Dine made in 1963–64, served as a surrogate self-portrait,[70] as his bathrobe did in another series in 1964. In *Spring Cabinet*, the environment that Dine created was supposed to include a component of performance, but this time without a human agent: Green paint, contained in cans suspended from the ceiling, was supposed to drip onto a large "floor pallet" [*sic*] (a palette-shaped canvas placed on the floor); however, in the end, the gallery did not allow the paint to drip.[71] The action of the "drip painting" would have been augmented by the blowing of electric fans placed in the environment. An allover abstract composition on canvas covered the walls, the result of rubbing pigment onto the canvas after placing it over a patterned tin ceiling panel. The final effect was an enclosed

space completely taken over by the work of the artist, much as Pollock's works became all-encompassing environments, as documented by Namuth (see fig. 8) and described by Kaprow.

Following *The Smiling Workman*, Dine's next performance piece was called interchangeably *Vaudeville Act* or *Vaudeville Collage* (figs. 40–42) a one-time event held at the Reuben Gallery on June 11, 1960.[72] Although a few years later Dine described *The Smiling Workman* as "a blackout or a vaudeville act,"[73] the term "vaudeville" better suits this second performance work's lighthearted spirit, which was closer to that of American nineteenth- and early twentieth-century popular theater. This comes across in Dine's description of it:

I had a stage built. It was like an old-time stage with two flats of canvas on each side, and over the top it said, "Jim Dine's Vaudeville" in Dayglow color. There was a tape recording made for that. It was all kinds of crazy things: organ music, me talking—it was a collage on tape. I came out with a red suit on and cotton all over me, my face painted yellow. To the music that was going on, I pulled the cotton off and just let it fall to the floor until there was no cotton on me. Then I walked out. As soon as I walked out, inanimate objects became actors. Two people behind the flats operated a dance of strung cabbages and carrots and lettuce and celery. That stopped quickly, and red paint was poured down the flats on each side and onto the floor. That was another "act." The final act was: I came out with my red suit on and a straw hat on this time. On each arm I had a nude girl made out of cardboard so that each of my arms became their inner arms. These were made like puppets—Javanese puppets. I did a dance.[74]

The name *Vaudeville Collage* makes explicit the longstanding relationship in the avant-garde between popular theater and the Cubist tradition, two of the primary sources for the fast-paced, montagelike structure of the Happenings.[75] Several evenings of early Happenings, in which Dine participated, referred to popular forms of performance. For example, *The Smiling Workman* was part of *Ray Gun Spex*, and "spex" is an abbreviated form of the Swedish word for burlesque[76]; and Dine's performance work *A Shining Bed* was part of a larger program called *Varieties*, variety being the English counterpart to American vaudeville.[77] In *Vaudeville Collage*, the term "collage" refers to the splicing together of disparate, short acts as well as to the sound-collage played throughout the performance. According to Hansen, the use of collage was integral to the structure of Happenings: "Happenings . . . are theater pieces in the manner of collage and . . . each action or situation or event that occurs within their framework is related. . . . The happening is a collage of situations and events occurring over a period of time in space."[78]

The program to *Vaudeville Collage* lists a cast of characters that combine vaudeville and art references: "Jim Dine as The Strawpuller and The Dancer; The Juggler played by Leafy Vegetables; Two Chorus Girls played by Two Pieces of Cardboard; Red Paint played by Powdered Tempera." The pouring of the red paint in this performance piece, as in *The Smiling Workman*, is a reference to the paint pouring that Pollock established as an iconic gesture of Abstract Expressionist art-making practice. The Leafy Vegetables, which Dine refers to as "inanimate objects [that] became actors," anticipate his later work where objects, particularly parts of the body or objects for human use, such as clothing, furniture, or tools, are used as metaphors for the human body as a whole.[79]

The high energy of *Vaudeville Collage* made it an enormous popular success. Dine was particularly pleased with its effectiveness in reaching his audience: He would recall:

I do not even understand how I did that dance. I could never do it now. But I did this dance that people cheered. And they tore my clothes off. Encores! And I ripped off my tie and threw it into the audience. It was an incredible scene. In the sense of audience participation, I have never felt it stronger — with someone else or with me. People remember it as a fantastic night.[80]

Dine's next performance piece, *Car Crash,* held at the Reuben Gallery in November 1960[81] (figs. 12, 13, 44–46), involved the audience in a different way. Unlike his earlier pieces, in which the performer and the audience had been divided, Dine arranged the seats for *Car Crash* in a U shape around the space; and, instead of the audience being asked to participate, as they had been in other Happenings by several of Dine's peers, the performers moved freely among the members of the audience. It was the first of Dine's theater pieces where he used performers besides himself: the cast of *Car Crash* included Pat (Muschinski) Oldenburg, Judy Tersch, and Marcus Ratliff. Dine retained full artistic control over the other performers: scripting the spoken parts, producing costume designs,[82] and subjecting them to three one-hour rehearsals.[83]

Car Crash was the first of Dine's theater works to come "not directly from nightmares . . . [but] from a life of bad dreams."[84] It was based on two car accidents in which Dine was involved in 1959, the first while he was driving alone and the second with his family.[85] The personal nature of the subject matter is underscored in the announcement card for the performance, where the central image is stamped several times with Dine's fingerprints;[86] these autographic marks are combined with car imagery and crosses, which form the recurrent iconography of the performance as well as of the assemblages, paintings, drawings, and prints inspired by the car crash theme (see figs. 43, 48, 49).[87] On entering the Reuben Gallery, "the visitor found himself in a small room, the walls of which were solidly lined with drawings and paintings by Dine. All the works contained crosses—usually the blocky symbol of the Red Cross—and some had tirelike circles." Like the solo exhibition at the Reuben Gallery the preceding spring, the installation of artworks constituted a kind of environment; Dine did not conceive of these artworks as dispensable, however, but rather as "permanent objects."[88]

Passing through the small room, the visitor entered the space where the performance would be given. Using materials left by the previous tenant and adding a coat of white paint throughout, Dine created a set that he later described as "as strong an environment as I ever built."[89] In her review, Jill Johnston wrote: "Mr. Dine literally encloses everyone within a collage room. It includes objects relating to cars and crashes, and one side consists of large hunks and rolls of cork and cardboard strewn about in shelves. Everything is drippingly white-washed. A mess, yet ghostly pristine."[90] Dine had even considered giving the viewers "white caps and smocks to wear in an attempt to preserve the purity of the Environment." By all accounts, the whiteness gave the room a kind of sepulchral or hospital feeling, with tires, tubing, gloves, and other objects that implied body and car parts evoking the debris of an accident.[91] A recording of honking horns and other street noises played throughout the piece, providing yet another sensory dimension.

Dine was the protagonist of *Car Crash,* playing the leading role of the "Car" as well as that of the artist. Whereas all the

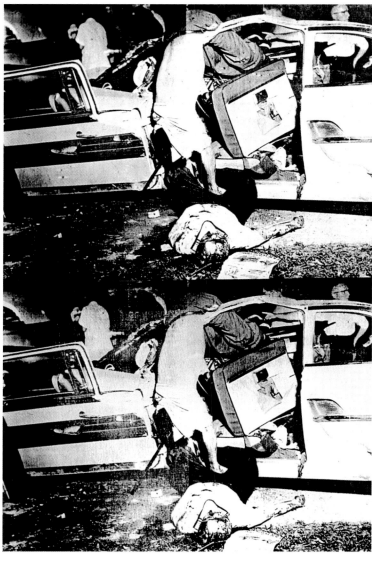

10. Willem de Kooning, Excavation, 1950
Oil on canvas
6 feet 9 3/16 inches x 8 feet 5 5/16 inches
(206.2 x 257.3 cm)
The Art Institute of Chicago.
Gift of Mr. and Mrs. Noah Goldowsky
and Edgar Kaufmann, Jr.;
Mr. and Mrs. Frank G. Logan Purchase
Prize, 1952.1

11. Andy Warhol, Saturday Disaster,
1964
Synthetic polymer paint and silkscreen ink
on canvas
9 feet 10 7/8 inches x 6 feet 9 7/8 inches
(301.9 x 207.9 cm)
Rose Art Museum, Brandeis University,
Waltham, Massachusetts
Gevirtz-Mnuchin Purchase Fund,
by exchange

other players wore white costumes, like animated objects in the all-white environment, Dine was dressed completely in silver, with silver face paint, black circles around his eyes and nostrils, red lips, and flashlights jutting from his cap. Described as "half carnival clown, half avenging angel,"[92] Dine, as the "Car," tried unsuccessfully throughout the performance to express himself verbally, but all he produced were grunts of despair; where words failed him, he obsessively drew on the blackboard a car with "a monster jaw"[93] and human eyes; he repeatedly erased and re-drew the car. On a roll of paper towels, in advance of the performance, he had painted the word "HELP" on each sheet, and during the performance he unrolled it like a scroll.[94] Hansen described *Car Crash* as sad because Dine

packed it with the quiet anxiety of frustrated communication. . . . Dine . . . seemed to be choking. He was trying to tell us something; then he tried to write with fat chalk on a blackboard. The chalk kept breaking; he was trying too hard. It crumbled and the dust and chips came through his fingers, as he gurgled, trying so hard to communicate. Red chalk, then green chalk. I cried.[95]

Dine's soul-baring, ritualistic self-portrait posed a stark contrast not only with the Abstract Expressionists, who strove for universal myths of experience, but also with the apparent deadpan manner of the Pop artists. Nevertheless, beginning in 1962, curators and critics would align Dine's work with Pop art because of his emphasis on everyday objects and images, despite his gestural style. Dine maintained that "I'm not a Pop artist . . . I'm too subjective. Pop is concerned with exteriors. I'm concerned with *interiors*. When I use objects, I see them as a vocabulary of feelings."[96] It is revealing to compare Dine's handling of the crash theme to the paintings by Pop artist Andy Warhol from his *Death and Disasters* series begun in 1962 (see fig. 11). Warhol's repetitive and dispassionate representation of an anonymous automobile accident simulates the barrage of violent images reproduced in the media. Warhol would say, "When you see a gruesome picture over and over again, it doesn't really have any effect."[97] The imperviousness to death and violence as well as the unemotive mechanical production of the surface of Warhol's paintings came to epitomize Pop art cool. In contrast, Dine was aptly characterized by Alan Solomon as a "hot artist in a cool time."[98]

The roles Dine wrote for the other performers in *Car Crash* were as emotionally fraught as his own. Pat Oldenburg's two-part monologue, which seems to be an improvised stream of consciousness, was in fact a precisely scripted speech by Dine. Seated high on a ladder, draped in white muslin and with her face painted white, Pat Oldenburg was a ghostly figure, appearing to levitate above the other players. Her utterances began, "The car in my life is a car with a pole in the harm of my soul which is a pretty clank . . . My car is my Hertz spot of love to zoom through the whole transmission of my lovely tire . . . "[99] After finishing this part of her monologue, she repeated it. Two minutes of "traffic sounds (crash)" followed, and then she called out the word "help" over and over, as the "Car" (Dine) unwound the roll of paper towels, on which the word "help" had been painted. Her erotic babble, laced with driving metaphors, seems to be a parody of the American postwar passion for automobiles. In the United States during that period, well-publicized statistics about highway deaths, as well as newspaper and television reports that revealed the dangers of fast driving, were countered by Hollywood films that idealized "heroes who drove wildly and experienced libidinous thrills and manly power at deadly speeds."[100] William Seitz, in the catalogue for the exhibition *The Art of Assemblage* (1961) at the Museum of Modern Art, New York, reproduced a photograph of *Car Crash*, pointing out:

For the first time since the period of the futurists, the automobile . . . has been effectively dealt with by the plastic arts, but with an emotional tone that is not at all the same. By now, the automobile has become a mass killer, the upholstered love-boat of the adolescent, and the status symbol of the socially disenfranchised. . . . It is no longer delight with mechanization that is represented. . . . Dine . . . has dealt with the automobile as a symbol of love and death.[101]

In Dine's performance, the accident was simulated when Tersch and Ratliff, playing male and female cars respectively, bumped into Dine's "Car" and caught him in the beams of their flashlights; they also collided with each other, "always using one light on the sex organs, the other on the face."[102] Tersch wore a man's white pants, shirt, and tie, her hair in a ponytail and her face concealed by a sad-faced papier-mâché mask. Ratliff, also masked, wore a low-cut woman's dress that revealed his dark chest hair. Marvin Carlson, in his recent survey of performance, points out that there is a "long . . . history of men playing women and women playing men within conventional theatre," as well as "within the tradition of popular performance such as vaudeville, burlesque, circus, and minstrelsy, [where] the man dressed as a woman [is] used for comic or grotesque effect."[103] To Dine's audience, however, gender crossing would have suggested transgression against larger social and art-world norms. Even within avant-garde circles, in the late 1950s and early 1960s, male and female roles were rigidly defined. Only with the rise of the feminist and gay-rights movements, later in the decade, were gender roles more widely called into question.[104]

The grotesque image of the body is explored again in Dine's final theater work of 1960, *A Shining Bed* (figs. 51–53) which was performed as part of a Christmas program of Happenings held at the Reuben Gallery in December.[105] The audience was seated in darkness and clustered closely around a spotlit bed, like characters in a Nativity scene. With spikey bedposts covered in aluminum foil and decorated with Christmas lights, the bed literally shone. Dine lay on the bed

as Santa Claus with a blue face and no beard, under the covers of the bed. I lay there for a few minutes as if I were waking up, while the music—The Chipmunks—was playing softly in the background. Then I quickly pulled a piece of polyethylene . . . over my face and made certain movements with a flashlight in my crotch very quickly. Throwing the plastic off, I sat up, went to the end of the bed on my knees, took batter out of a bowl, and put it all over the spikes. It was a repulsive situation. When that was over, I reached down with my head between my legs into a bowl of flour and pulled my face up quickly. It was white instead of blue. The lights went off. . . . From underneath my pillow, I pulled a gold baby doll and put it on the pillow. I disappeared. The Christmas-tree lights, which blinked, came on, and the Palestrina music on 78 got very loud. The baby was just sitting there. Then it was over. That was my best {performance}—the one I liked best. It was the most beautiful one.[106]

Dine describes his performance in seemingly contradictory terms: as both "repulsive" and "beautiful." The images of the clown-faced Santa immersed in flour and the spotlit genitals exemplify Bakhtin's concept of the body in grotesque realism: "ugly, monstrous, hideous from the point of view of

'classic' aesthetics."[107] Such an emphasis on the "bodily lower stratum, the zone of genital organs,"[108] subverts the classical canon, which gives precedence to the upper region of the head and to mental control over bodily action. Dine's grotesque images transgressed against the perceived high cultural ideal of the abstract and the spiritual, and instead stressed the concrete and the figurative. As such, the images of *A Shining Bed* were so fundamentally liberating as to have anticipated aspects of body art and performance that would be explored by an increasing number of artists only a few years later. Sally Banes, in her history of the avant-garde in New York in the 1960s, observed that around 1963 artists began to focus on explicitly visceral subjects that previously had been considered off limits and thus been concealed;[109] she points to such performance works as Carolee Schneemann's *Meat Joy*, 1964, for emphatically bringing them into public view.[110] Banes observed that "the body in the Fifties and early Sixties mainstream culture was almost always controlled and covered up" but that around 1963 "the avant-garde arts produced a new image—unruly, festively promiscuous, candid, and confident—that by the late Sixties had become the cultural norm."[111]

While not thematically linked to *A Shining Bed*, Dine's environment *Rainbow Thoughts*, shown at the Judson Gallery in January 1961, was visually related to the performance of the previous month. In both, there is a single, illuminated object at the center of a small, darkened space. One reviewer described *Rainbow Thoughts* as a place of quiet contemplation and self-reflection:

Dine's new "Environment" . . . is really a place to go and empty your mind. Once you register the fact of a small room washed down with black house paint, which you barely note before closing the door behind you, . . . there is just one thing left to . . . look at. That is the neat semi-circle of a rainbow suspended just above eye level and illumined by a dangling blinking light. . . . the blinker with rainbow has entered the realm of assumed data . . . like the ticking heart.[112]

The aesthetic of *Rainbow Thoughts*—completely lacking the expressionistic clutter of *The House* from the year before— was representative of Dine's new, pared-down style. The rainbow became one of Dine's signature objects, which he imbued with personal meaning and in late 1959 began to isolate on his canvases (in two- or three-dimensional form) against a single color ground.[113]

After *A Shining Bed*, Dine abandoned performance, with the exception of a one-time return in May of 1965, having been solicited by Alan Solomon to create a work to be presented as the opening event of the *First New York Theater Rally*. The rally, which showcased various kinds of theater (primarily Happenings and dance), was organized by Solomon together with Steve Paxton, a founding member of Judson Dance Theater.[114] Unlike Dine's earlier performances, his new work, *Natural History (The Dreams)* (figs. 138–40), was much longer (approximately forty-five minutes), slower-paced, and lacking the expressionistic exuberance of the earlier performances. Under a blinking tungsten lamp, Dine, wearing a black turtleneck, pants, and motorcycle boots, sat or paced silently. Throughout the performance, a tape recording played of Dine reading from a book of dreams he had written down during the summer of 1963.[115] Four silent, dreamlike sequences were simultaneously acted out around him on the large, darkened stage; each of the four groups of performers were defined by a blinking lamp and carried out redundant, mundane activities:

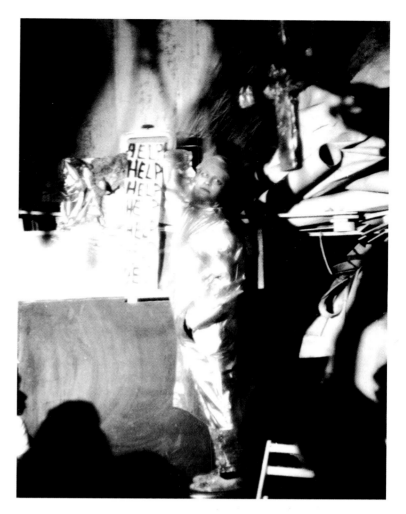

12. Dine in a performance of Car Crash, Reuben Gallery, New York, November 1–6, 1960. Photo by John G. Ross

13. Pat (Muschinski) Oldenburg in a performance of Dine's Car Crash, Reuben Gallery, New York, November 1–6, 1960. Photo by Robert R. McElroy

Three girls sit exchanging items from their handbags . . . a man and a woman in underwear together pound huge wads of torn newspaper, flour and water over a gynecologist's examination table . . . a man in chef's uniform saws a steel pipe . . . two young men in tennis clothes make themselves snacks, drink Coca-Cola and watch T.V.[116]

The ritualistic movements—passing hand to hand, kneading, sawing, snacking—contributed to the hypnotic effect. Dine later said of this performance work:

The images in the theater piece were only meant to supplement the voice . . . Probably if I had any nerve at all I would have just played the tape because the images were the most ephemeral part of it even though to me they were meaningful . . . The tape was powerful enough, I think a man's dreams of a summer . . . {are} so powerful . . . I trust so thoroughly the meat of . . . the unconscious.[117]

Dine's recital of dreams came at a time when he was intensely engaged in psychoanalysis.[118] Even the length of the performance was virtually the same as a psychoanalytic session.[119] Furthermore, it was the first performance where Dine is literally unmasked, as though the act of not wearing a mask is a way to reveal his inner self.[120] The acute focus on the self and on the psyche put Dine's work in general—and this performance in particular—at odds with the contemporary art movements of Pop and Minimalism, as well as with the more psychologically restrained work of the Judson Dance Theater, which dominated the *New York Theater Rally.*[121]

Natural History (The Dreams) was a critical failure. Dine was well aware that the personal nature of his work made it untenable for much of his audience in the mid-1960s:

I used exposure of myself as a medium . . . I knew people wouldn't like it, they'd say they were bored . . . when they meant they were nervous, and they didn't want to hear it . . . They said things like "We don't want to see his problems" . . . but I believe that exposure can be used as a medium and I was . . . totally pleased with what I did, it was completely successful because it was about exposing yourself. Making it difficult for the audience through exposure. Asking them to relate to you rather than you relating to them.[122]

Yet for Carolee Schneemann, whose own work of the 1960s proved to be formative, particularly for feminist performances of the following decade, Dine's *Natural History (The Dreams)* was a revelatory experience. At the time, she was a member of Judson Dance Theater and she recalled:

Dine {was} the first man to use explicitly personal material—his psychoanalytic tape, uncensored self-exposure . . . just the voice in the dark. The audience didn't approve of that much actuality! A turning point for me. He had stripped it all down to bare desire, anger, the lived life. Audience didn't get it or couldn't stand it.[123]

More recently, Schneemann has said of the audience response to Dine's performance: "The negative reaction is what prepares the territory for what's going to come next. These are signal works. These occur in a kind of physical-psychological space that hasn't been occupied in our culture before."[124]

Exposure of the self, in the early and mid-1960s had isolated Dine from his peers; by the end of the decade, however, it had become standard fare in artist-made performances. While *Natural History (The Dreams)* was

Dine's final performance, self-exposure remained Dine's primary subject in a variety of creative endeavors, but especially through the medium of painting.

Notes

1. After a nearly four-and-a-half-year hiatus, Dine did one final performance, *Natural History (The Dreams)*, which was part of the *First New York Theater Rally* in May 1965. Dine frequently uses the term "painter's theater"; for example, see Dine quoted in Caroline Windish-Graetz, "It Happened," *The New York Herald Tribune*, May 5, 1965, p. 24. The term "Happening" was first used for this kind of work for a score written in 1958 by Allan Kaprow, called "something to take place: a happening," and published in the Rutgers University *Anthologist* 30, no. 4 (Spring 1959). Letter from Kaprow to art critic Jill Johnston, January 24, 1962; the letter is in the Jean Brown archives at the Getty Center for the History of Art and The Humanities, Los Angeles.

2. Joseph Ruzicka's "Jim Dine and Performance"—published in *American Art of the 1960s* (New York: The Museum of Modern Art, 1991), pp. 97–121—has been the only comprehensive overview of Dine's performance works to date. In the present essay, I have focused only on Dine's own performances, and on his environments—both those related and those that are unrelated to the performances—and have not considered his participation in other theater works, either as a performer or, later, as a stage and costume designer. Ruzicka provides an in-depth analysis of Dine's stage and costume designs for a 1966 production of Shakespeare's *A Midsummer Night's Dream* at the San Francisco Actor's Workshop and of his designs done in 1967–68 for a production (never staged) of Oscar Wilde's *The Picture of Dorian Gray*. See also William S. Lieberman, ed., *Jim Dine: Designs for A Midsummer Night's Dream*, with an Introduction by Virginia Allen (New York: Museum of Modern Art, 1968); and Jim Dine, *The Picture of Dorian Gray* (London: Petersburg Press, 1968), a limited-edition book of lithographs and etchings.

3. The Judson Gallery, located in the basement of the Judson Memorial Church, 239 Thompson Street, near Washington Square South, was started in February 1959 through the efforts of Marcus Ratliff, Dine, and others, under the leadership of the church's associate minister, Bernard E. ("Bud") Scott. Dine was also included in *New Media – New Forms* and *New Media – New Forms,Version 2* at the Martha Jackson Gallery, 32 East 69th Street, June 6–24 and September 27–October 22, 1960, respectively; these were large group exhibitions of mixed-media works (made primarily from "junk" materials) by more than seventy artists, most of them contemporary, but with a few historical examples (such as Hans Arp and Kurt Schwitters). In the Preface to the catalogue for the first exhibition (published after it closed; there was no catalogue for the second one), Martha Jackson wrote of the huge public response to the show, in attendance and in the media, which included both press and television coverage. Although a condensed version of Kaprow's then forthcoming book, *Assemblage, Environments & Happenings* (New York: Harry N. Abrams, ca. 1966), was included in the exhibition catalogue and introduced the concept of environments, it was not until the *Environments – Situations – Spaces* exhibition at the Martha Jackson and David Anderson galleries (May 25-June 23, 1961) that environments were showcased uptown; this exhibition was much more selective, featuring only six artists: George Brecht, Dine, Walter Gaudnek, Kaprow, Claes Oldenburg, and Robert Whitman.

4. Statement by the artist, in Michael Kirby, *Happenings: An Illustrated Anthology* (New York: E.P. Dutton, 1965), p. 188.

5. Interview with Constance W. Glenn, in *Jim Dine Drawings* (New York: Harry N. Abrams, 1985), p. 37. Even the earliest reviews of environments and Happenings, often in highly visible publications, would sometimes combine an awareness of the shock value of these works with a sense that they were also entirely new and worthy of notice. For example, Suzanne Kiplinger in her review for *The Village Voice* of Dine and Oldenburg's joint exhibition of environments, *Ray-Gun*, in the winter of 1960, remarked that "'Ray-Gun' . . . is one of those things which produces paroxysms of rage in too many beholders. They can't take it or leave it alone, but feel it must be stamped out immediately or civilization will be in peril." She continues, however, by stating that "if you stick around for a while and give it a chance, I think you'll end by admiring the idea . . . this form—that of art enveloping the viewer-might go places" (p. 11). While a *Time* magazine review of early environments and Happenings stated that "real children might do it better" ("Up-Beats," *Time*, March 14, 1960, p. 80), Rosalind Constable, a cultural correspondent at *Time*, countered in an unpublished memo that "while these comments are not without truth (they *are* messy, and thoroughly confusing to the uninitiated) the fact remains that these 'Happenings' have been the most talked about off-beat art event of the season" (p. 6). Constable's memo, "Some Trends in American Art," dated May 5, 1960, is in the Time Inc. Archives. For more on the critical reception to environments, see Julie H. Reiss, "From Margin to Center: The Spaces of Installation Art, 1958–1993," (Ph.D. diss., City University of New York, 1996), pp. 71–86.

6. Statement by the artist, in Marco Livingstone, *Jim Dine: The Alchemy of Images* (New York: The Monacelli Press), 1998, p. 9.

7. Dine, in an unpublished interview with Bruce Hooton, February 26, 1965, p. 1. A transcript of this tape-recorded interview is in the Archives of American Art, Smithsonian Institution, Washington, D.C.

8. Dine, in an interview with G. R. Swenson, "What is Pop Art? Answers from 8 painters, Part I," *Art News* (New York) 62, no. 7 (November 1963), p. 25.

9. Dine, in the interview with Hooton, p. 4 (see n. 7 above), and interview transcript of Dine speaking in the N.E.T. film *U.S.A.: Artists, Jim Dine* (1966), produced and directed by Lane Slate, p. 1-2. The transcript is in the Alan Solomon archives at the Archives of American Art, Smithsonian Institution, Washington, D.C.; Alan Solomon, former director of the Jewish Museum in New York and a champion of Dine's work, acted as consultant for the N.E.T. film.

10. Dine, in an interview with Thomas Krens, "Conversations with Jim Dine," in *Jim Dine Prints: 1970 – 1977* (New York: Harper & Row Publishers, 1977), pp. 13–14.

11. Allan Kaprow, "The Legacy of Jackson Pollock," *Art News* (New York) 57, no. 6 (October 1958), pp. 24–26, 55–57. In his letter dated January 24, 1962 to Jill Johnston (see n. 1, above), Kaprow stated that the article was actually written in 1956, in the month following Pollock's death, but that Thomas Hess, the editor of *Art News*, chose not to publish it until two years later.

12. Kaprow, "The Legacy of Jackson Pollock," pp. 56–57.

13. Ibid., p. 26. See Fred Orton and Griselda Pollock, "Jackson Pollock, Painting, and the Myth of Photography," *Art History* (Oxford, England, and Boston, Mass.) 6, no. 1 (March 1983), pp. 117–18.

14. The Namuth photographs included as figs. 8 and 111 in Kaprow's *Assemblage, Environments & Happenings* are not identical to the Namuth photograph included here as fig. 8, although they are of the same series and illustrate the same point.

15. Orton and Pollock, "Jackson Pollock, Painting, and the Myth of Photography," p. 116.

16. Harold Rosenberg, "The American Action Painters," *Art News* (New York) 51, no. 8 (December 1952), pp. 22–23.

17. For further discussion of this idea, see Paul Schimmel, "Leap into the Void: Performance and the Object," in *Out of Actions: Between Performance and the Object, 1949–1979* (Los Angeles: Museum of Contemporary Art, and New York: Thames and Hudson, 1998), pp. 19–21.

18. Kaprow confided to Alan Solomon that "The Legacy of Jackson Pollock" was in part inspired by a visit to Rauschenberg's studio; since the mid-1950s Rauschenberg had been making works he called "combines"—which combined aspects of painting and sculpture and where collage and three-dimensional objects were incorporated onto the picture surface; Calvin Tomkins, *Off the Wall: Robert Rauschenberg and the Art World of Our Time* (Garden City, N.Y.: Doubleday, 1980), p. 151, cited in Susan Hapgood, "Neo-Dada," in *Neo-Dada: Redefining Art, 1958–62* (New York: American Federation of Arts and Universe Publishing, 1994), pp. 21, 61, n. 62. Kaprow fleshed out his ideas about environments and Happenings being descended from collage and assemblage in *Assemblage, Environments & Happenings*. Though not published until about 1966, it was largely written in 1959, finished in 1960, and revised in 1961; the unpublished manuscript was apparently widely circulated well in advance of its publication. A condensed version was included in the catalogue for the *Environments – Situations – Spaces* exhibition at the Martha Jackson and David Anderson galleries (see note 3, above) and is quoted in William C. Seitz, *The Art of Assemblage* (New York: Museum of Modern Art, 1961), pp. 90–91; cited by Reiss, "From Margin to Center," p. 43, n. 11.

19. Johanna Drucker's "Collaboration without Object(s) in the Early Happenings," *Art Journal* (New York) 52, no 4 (Winter 1993), pp. 51–58, is based on the premise "that Happenings have more to do with the art world than with alternative theater, music, or dance" (p. 51). This is in contrast to Kirby, who maintains that Happenings find their origin in "every field of art (not just painting and sculpture)"; Kirby, *Happenings*, p. 42. The influences that Kirby cites in his Introduction (pp. 31–32, 37–38) include, in addition to theater sources, the music of John Cage and the choreography of Merce Cunningham and Paul Taylor. The Hansa Gallery had been started as an artists' cooperative in 1952 by students of Hans Hoffman who turned away from Abstract Expressionism. The Reuben Gallery was opened by Anita Reuben in 1959 to carry on the agenda of the Hansa Gallery, which had closed that year; Reuben remained a center for figurative art, environments, and Happenings through 1961. Delancey Street Museum was opened by Red Grooms in 1959 in his studio, where he showed environments and Happenings created by himself and by other artists. See Sally Banes, *Greenwich Village 1963: Avant-Garde Performance and the Effervescent Body* (Durham, N.C., and London: Duke University Press, 1993), p. 53.

20. In the interview with Hooton, p. 11 (see n. 7, above), Dine stated: "I don't like the word 'happening.' It's Kaprow's word and it means Kaprow's things and that's not what I did." The vast majority of the

rules that Kaprow established retrospectively for the Happenings—for example, that there should be no distinction between performance and audience, that Happenings should only take place once, or that there should be no rehearsals for the Happenings—were not strictly followed by Dine and most other artists associated with the Happenings. Kaprow's guidelines for Happenings are outlined in his article "The Happenings Are Dead—Long Live the Happenings," *Artforum* (Los Angeles) 4, no. 7 (March 1966), pp. 36–39.

21. Constable, "Some Trends," p. 6, in the Time, Inc. Archives.

22. Allan Kaprow, "'Happenings' in the New York Scene," *Art News* (New York) 60, no. 3 (May 1961), p. 39.

23. Kaprow, in his letter to Jill Johnston from January 24, 1962 (see n. 1, above), wrote that he "attended the class with profit during '57 and '58 and visited it frequently during '59."

24. Antonin Artaud's collection of essays *The Theatre and Its Double*, was first translated from his native French into English in 1958 and was widely read by this generation of artists. His theories were particularly influential for Cage and his students. Artaud argued for a visceral theater that would serve as a kind of psychological catharsis for the audience, a theater emphasizing myth and dreams; to accomplish this, he used dramatic lighting and de-emphasized language, instead stressing human noises such as screams and groans. As Kaprow advocated for the Happenings, Artaud encouraged a dissolution of the space that traditionally separates actors and audience.

25. For more on Cage's class, see Robyn Brentano, "Outside the Frame: Performance, Art, and Life," in *Outside the Frame: Performance and the Object, A Survey History of Performance Art in the USA since 1950 to the Present* (Cleveland: Cleveland Center for Contemporary Art, 1994), pp. 35–37. Although Dine is often cited as having regularly visited Cage's class, he told me in a conversation on August 13, 1998, that he never attended. Moreover, Cage emphasized the element of chance, which played such a significant role in Dada and in the work of Kaprow, but would not have appealed to Dine. Cage's class, however, did bring performance to the forefront of art-making practices. In addition to Kaprow, many of the artists who came to be associated with Happenings as well as with Fluxus, such as George Brecht, Al Hansen, and Dick Higgins, did attend Cage's class. Happenings and Fluxus were both part of the international art scene in the late 1950s and early 1960s, where the emphasis shifted from the finite art object to the performing body and the act of creation itself, as in Gutai in Japan and Nouveau Réalisme in France.

26. An advertisement for the *Ray-Gun* exhibition ran in the January 27, 1960 edition of *The Village Voice* (p. 11); here, the opening date for both *The House* and *The Street* was stated as January 30. According to the "Spring Calendar at the Judson Gallery" put out by the "Raygun Deputies, Jim Dine [and] Claes Oldenburg," the original intention was that *The House* would open first on January 30 and *The Street* would not open until March 5; However, the installation of *The Street* was certainly well under way by February 29, the first evening of the *Ray Gun Spex* program of Happenings that included Oldenburg's *Snapshots from the City*, which was performed in Oldenburg's *The Street*. Although the exact dates of the *Ray-Gun* exhibition are not definitive, the "Spring Calendar" indicates that construction of *The House* was scheduled to begin on January 4 and that the gallery space would be open to the public throughout the installation, and that the end date for the exhibition would be March 23. A copy of the "Spring Calendar at the Judson Gallery" is in the archives at the Judson Memorial Church.

27. See Pierre Restany, "Une tentative américaine de synthèse de l'information artistique: les Happenings," *Domus* (Milan), August 8, 1963, p. 40.

28. Barbara Rose, "The Origins, Life and Times of Ray Gun: 'All will see as Ray Gun sees . . . ,'" *Artforum* (New York) 8, no. 3 (November 1969), p. 52.

29. "Up-Beats" (see n. 5), p. 80.

30. Entry for "Thursday, 25th" from Rosalind Constable's unpublished notes from 1960, pp. 5–6. Constable quotes from Dine and Oldenburg's "Spring Calendar at the Judson Gallery."

31. The two-person exhibition was held November 14–December 3, 1959, according to the review by A[nita] V[entura], "Claes Oldenburg, James Dine," *Arts Magazine* (New York) 34, no. 3 (December 1959), p. 59.

32. Interview with Glenn, p. 36.

33. Livingstone, *Jim Dine: Alchemy*, p. 41.

34. A transcript of the panel discussion that took place on December 2, 1959 is in the archive at the Judson Memorial Church. In *The Village Voice* (November 25, 1959, p. 3), an advertisement for the discussion does not list Kaprow as one of the panelists, although the transcript reveals that he was one of the discussants. The transcript begins with one of the panel organizers introducing Dine, Kaprow, Oldenburg, and Johnson, with Johnson described as "one of the only men who has repeatedly combined the actions [*sic*] painting with the figure."

35. Oldenburg stated, "Expressionists—I had the feeling they avoid the people. My aim is not exclusive. I would like to reach as many people as possible." Dine followed by saying, "I want them [the audience] to be reached immediately and know they are being reached." Transcript of panel discussion, p. 6.

36. Ibid, p. 4.

37. Dine and Oldenburg, "Spring Calendar at the Judson Gallery," n.p.

38. Kaprow's statement in Kirby, *Happenings*, p. 46.

39. Oldenburg conveyed this information to Barbara Haskell in a conversation on January 25, 1984; Barbara Haskell, *Blam! The Explosion of Pop, Minimalism, and Performance 1958–1964* (New York and London: Whitney Museum of American Art in association with W.W. Norton & Company, 1984), pp. 26, 110, n. 35, quoted in Reiss, "From Margin to Center," pp. 50–51.

40. Dine, in a telephone conversation with Reiss, May 11, 1995; Reiss, ibid., pp. 51, 89, n. 24.

41. Germano Celant, in his article "Artspaces," *Studio International* (London) 190, no. 977 (September/October 1975), p. 121, coined the term "habitable sculpture" to describe this kind of environment.

42. For Reiss, environments are distinguished from Happenings by their "lack of human presence other than the viewer." I am more in agreement with Kaprow that "the differences [between environments and Happenings] will eventually blur and matter less," as this example of the "inhabited" *House* supports; Reiss, "From Margin to Center," p. 22; the original source for the Kaprow quote is from *Assemblage, Environments & Happenings*, p. 185. *Ray Gun Spex*, an evening of Happenings organized by Oldenburg, took place on February 29, March 1, and March 2, 1960; performances included Dine's *The Smiling Workman*, Oldenburg's *Snapshots from the City* (performed in and thematically linked to *The Street*), Dick Higgins's *Edifaces Cabarets Contributions*, Al Hansen's *Projections*, Kaprow's *Coca Cola, Shirley Cannonball*, Red Grooms's *The Big Leap*, and Robert Whitman's *Duet for a Small Smell*. The program is reproduced in *Happening & Fluxus* (Cologne: Kölnischen Kunstverein, 1970), n.p.

43. Dine and Oldenburg, "Spring Calendar at the Judson Gallery," n.p.

44. John Russell, "Jim Dine," in *Jim Dine Complete Graphics* (Berlin: Galerie Mikro; Hannover: Kestner-Gesellschaft; and London: Petersburg Press, 1970), n.p.

45. It is not surprising that Willem de Kooning, with his predilection for figurative subjects, is often cited by Dine as among the artists he admired most.

46. See Reiss, "From Margin to Center," p. 72.

47. Ruzicka traces the lineage of Dine's environments to his mixed-media works from the previous year, using the example of his *Household Piece* from 1959. Ruzicka points out that the "irregular shape" of this piece "break[s] from the rigid corners and edges of the traditional rectangular format. The natural next step, then, was to transform, both spatially and emotionally, the white walls of an entire room." Ruzicka, "Jim Dine and Performance," p. 98.

48. Drucker, "Collaboration without Object(s)," pp. 53, 56. This was reinforced when Dine and Oldenburg made play money on a stencil machine and handed out one million dollars to each member of the *Ray Gun Spex* audience so that they could buy junk objects during the intermission. Haskell, *Blam!*, p. 37.

49. See Kenneth E. Silver, "Modes of Disclosure: The Construction of Gay Identity and the Rise of Pop Art," in *Hand-Painted Pop: American Art in Transition 1955–62* (Los Angeles: Museum of Contemporary Art, and New York: Rizzoli International Publications, 1992), especially pp. 201–02. Silver states that "the trope of the 'anti-domestic' was inscribed in the discourse of Abstract Expressionism by at least the early 1950s, if not sooner." Silver cites as an example Robert Goodnough's "Pollock Paints a Picture"(*Art News* [New York] 50, no. 3 [May 1951], pp. 38–41, 60–61), in which Goodnough emphasizes Pollock's connection to the out-of-doors and the American West. According to Silver, this "excessive need to insist upon the wide-open expanses of the virilizing American landscape, the need to affirm what is neither domestic or commercial, is precisely the same need which so many Pop artists . . . took such pleasure in parodying." Other Pop artists who mined the interiors of the house for subjects for their work included Oldenburg—beginning with his streamlined, room-scale *Bedroom Ensemble*, 1963—as well as Andy Warhol, Roy Lichtenstein, and Tom Wesselmann. Although by 1962 Dine was no longer making site-specific environments or incorporating previously used materials or objects in his works, he returned to domestic subjects in what were essentially environmental paintings, representing kitchens, bathrooms, children's rooms, and living rooms. These are large-scale, sometimes multi-panel canvases which became "the wall of each room" with new household objects attached to their surface. In her review of the exhibition held at Sidney Janis Gallery, New York, February 4–March 2, 1963, Jill Johnston (in "Jim Dine," *Art News* [New York] 62, no. 1 [March 1963], p. 14) called

this "[Dine's] project of interior decoration." When several of the environmental paintings from 1962 were shown in *The Popular Image Exhibition*, held at the Washington Gallery of Modern Art, Washington, D.C., April 18–June 2, 1963 as part of the *Pop Art Festival* staged by the gallery, a reviewer reported that "confused guests sat down on the armchair that was part of *Four Rooms* . . . and piled champagne glasses into the porcelain sink . . . that is part of . . . *Black Bathroom No. 2*"; "Happenings: Pop Culture," *Time* (New York), May 3, 1963, p. 73. *Four Rooms* is illustrated in fig. 109 of the present catalogue, and *Black Bathroom #2* in fig. 97.

50. I am extremely grateful to Johanna Vanderbeek, Stan Vanderbeek's first wife, who showed me this film and has made it available for research in connection with the current Guggenheim Museum exhibition. Stan Vanderbeek's films, including this one, are currently in the process of being archived at the Museum of Modern Art, New York.

51. Dine was actually drinking tomato juice; Brydon Smith, "Jim Dine—Magic and Reality," *Canadian Art* (Toronto) 23, no. 100 (January 1966), p. 34.

52. Ibid., p. 34; Drucker, "Collaboration without Object(s)," p. 55; Jean E. Feinberg, *Dine* (New York: Abbeville Press Publishers, 1995), pp. 15–16; Schimmel, "Leap into the Void," p. 66. Schimmel asserts that the action of jumping through the paper "canvas" is "no doubt in homage to Murakami," referring to the Japanese Gutai artist Murakami Saburō who in the mid-1950s was making ephemeral environments out of paper screens, through which he threw his body. Gutai activities were known to some members of the New York art world, particularly through an article entitled "Japanese Innovators" by Ray Falk in the Sunday *New York Times* (December 8, 1957, Section 2, p. 24) and an exhibition held at the Martha Jackson Gallery in October 1958. While Dine was aware of the exhibition at Martha Jackson, he was not familiar with Murakami's performance works (conveyed to me by Dine in our conversation on August 13, 1998). Similarities between their works were, most likely, the result of a broad trend that was emerging in the mid-1950s to the early 1960s among international artists who challenged Abstract Expressionism and sought out alternatives to painting by employing their bodies in performance pieces and other actions.

53. Kirby, *Happenings*, p. 185.

54. In Dine's performance works and many of the early Happenings, the act of making art—usually painting—was integrated into the performance. For example, according to Barbara Moore, Grooms's first performance in 1958 consisted of the artist painting before an audience, and Kaprow's *18 Happenings in 6 Parts* included several artists painting; Moore, "New York Intermedia: Happenings and Fluxus in the 1960s," in *American Art in the 20th Century: Painting and Sculpture, 1913–1993*, Christos M. Joachimides and Norman Rosenthal, eds. (Munich: Prestel Verlag; London: Royal Academy of Arts; and Berlin: Zeitgeist-Gesellschaft, 1993), p. 100.

55. Kaprow, "The Legacy of Jackson Pollock," p. 26. A detail of the hand-prints in Pollock's *Number 1, 1948* is reproduced in William Rubin, ed., *"Primitivism" in 20th Century Art: Affinity of the Tribal and the Modern*, 2 vols. (New York: Museum of Modern Art, 1984), vol. 2, p. 645.

56. See Brentano, "Outside the Frames," p. 31.

57. Mikhail Bakhtin, *Rabelais and His World*, translated by Helene Iswolsky (Bloomington: Indiana University Press, 1984), p. 10. Bakhtin's book was not published until 1965, and not translated into English until 1968. However, his arguments proved useful to my understanding of Dine's performance. For further discussion of Bakhtin's theories on the carnival-grotesque form, see Ariella Budick, "Subject to Scrutiny: Diane Arbus's American Grotesque," (Ph.D. diss., Institute of Fine Arts, New York University, 1996), pp. 13–25.

58. Bakhtin, *Rabelais*, pp. 39–40.

59. Ibid., p. 34.

60. Ibid., p. 12.

61. Dine statement in Kirby, *Happenings*, p. 186.

62. Al Hansen, *A Primer of Happenings & Time/Space Art* (New York: Something Else Press, 1965), p. 64.

63. The chanting can be heard on an audiotape made by Alan Solomon of the *Ray Gun Spex* performances on the evening of March 2, 1960. The tape was generously lent, for research purposes, by Jon Hendricks. The quotes are from the panel discussion "New Uses of the Human Image in Painting," n.p., and from the transcript of *U.S.A.: Artists, Jim Dine*, p. 1-2.

64. "Up-Beats," p. 80.

65. Interview with Krens, p. 14. See also Livingstone, *Jim Dine: Alchemy*, p. 16.

66. The exhibition was held at the Reuben Gallery, 61 Fourth Avenue, New York, April 1–14, 1960. A grinning, masklike face—presumably a reference to the Smiling Workman—appears on the announcement for the exhibition (fig. 54 in the present catalogue). In a review of the exhibition, Irving Sandler describes the mixed-media assemblages as

"crowded together on the walls to create an environment; rock-and-roll music will be played during gallery hours"; I[rving] H. S[andler], "Reviews and Previews: New names this month: Jim Dine," *Art News* (New York) 59, no. 2 (April 1960), p. 17. Like the objects from Dine's environments, the pieces he conceived for this exhibition were destroyed; the final presentation included a new body of work, also destroyed.

67. Bakhtin, *Rabelais*, p. 8.

68. "The Smiling Workman," *Time* (New York) , February 2, 1962, p. 44; Glenn, p. 51. The artist's identification with the role of workman is also reflected in the presence, in his mixed-media works (including the environments), of such traditional artists' tools as paintbrush and palette together with tools for more mundane purposes, such as hammers, saws, and drills. The art and non-art tools appear together in Dine's comic of "The Smiling Workman," held in the Jean Brown archives, the Getty Center for the History of the Humanities, Los Angeles.

69. The press release for this exhibition is reproduced in *Happening & Fluxus*, n.p.

70. The first *Palette* painting, *A 1935 Palett* (fig. 26), 1960, was named for Dine's date of birth; see the transcript of *U.S.A.: Artists, Jim Dine*, pp. 1-7 and 1-8. Livingstone described "the palette and the robe as [Dine's] 'projections of himself' in place of more literal renderings of his appearance, to which he felt able to return only in the following decade"; Livingstone, *Jim Dine: Alchemy*, p. 316.

71. Dine, from his own description of *Spring Cabinet* in the exhibition catalogue (*Environments – Situations – Spaces* [New York: Martha Jackson Gallery, 1961] n.p.). Here he indicates that green was chosen because of its associations with springtime: "The spring cabinet is meant to be very green and much like a color-value of this time of year." The gallery, however, did not allow the green paint to drip as Dine had intended; see the review "Jumping on Tires," *Newsweek* (June 12, 1961), p. 92, and Al Hansen's description in his *Primer of Happenings*, p. 68. Dine explained in our conversation on August 13, 1998, that he therefore pre-painted the palette-shaped canvas, using many colors; this is evident in color slides of the installation taken by Robert McElroy.

72. *Vaudeville Collage* was part of *An Evening of: Sound – Theatre – Happenings*, held at the Reuben Gallery, 61 Fourth Avenue. Dine's performance was the finale in an evening that included Allan Kaprow's *Intermission Piece*; Richard Maxfield's *Electronic Music*; George Brecht's *Gosoon*; and Robert Whitman's, *E.G.*, an opera in which Dine was part of the cast. Dine's performance piece is usually referred to as *Vaudeville Show* (see, for example, Ruzicka, *Jim Dine and Performance*, p. 99). However, on the typed announcement from the Reuben Gallery, it is called *Vaudeville Act* and on the program from the evening it is listed as *Vaudeville Collage*; the stage set itself had a sign that read "Jim Dine's Vaudeville." The Reuben Gallery announcement and program are held in the Jean Brown archive, the Getty Center for the History of Art and the Humanities, Los Angeles.

73. Kirby, *Happenings*, p. 186.

74. Ibid.

75. See Jeffrey S. Weiss, "Picasso, Collage, and the Music Hall," in Kirk Varnedoe and Adam Gopnik, eds., *Modern Art and Popular Culture: Readings in High & Low* (New York: The Museum of Modern Art and Harry N. Abrams, 1990), pp. 82–115. Weiss shows how Cubist collage was linked to the music hall in not only content but also structure. He argues that the cutting and pasting, which brings together otherwise unrelated sources on the surface of a collage, is comparable to the "structural principle of the music-hall *revue* . . . [where] the jumbling and splicing of current events . . . occur in rapid succession and [with] utter disregard for continuous narrative" (p. 100). I am grateful to Emily Braun for pointing out the significance of Weiss's essay for my own arguments regarding Dine, collage, and performance.

76. Haskell, *Blam!*, p. 37.

77. The circus was a particularly important source of inspiration for Grooms in his performances such as *The Burning Building* and *The Magic Train Ride*; ibid., p. 35.

78. Hansen, *Primer of Happenings*, p. 24.

79. See Marco Livingstone, *The Body and Its Metaphors: Jim Dine* (Art Life Ltd., 1996), and his *Jim Dine: The Alchemy of Images*, the chapters entitled "Obsessive Images" and "Go Between," pp. 184–230 and 234–92. Dine, in our conversation on August 13, 1998, remembered that the two people, behind the scenes who manipulated the vegetables to make them move were Nancy Dine (who is listed on the program) and perhaps Lucas Samaras. Jill Johnston's review of the performance, however, suggests that "two girls on either side at the top dangled lovely big cabbages; then poured a pail of red paint each over the sides of the theatre"; Johnston, "New 'Happenings' at The Reuben," *The Village Voice*, June 23, 1960, p. 13.

80. Kirby, *Happenings*, p. 186. The "audience participation" that Dine refers to here is the audience's response to the performance, not participation as players in it. The critics also remarked on the positive

response of the public to this event. Johnston wrote, "The crowd really like [*sic*] it,"; Johnston, ibid. Alan R. Solomon wrote,"It is difficult to evoke in such a description the intensity of the audience's response, which was electrifying; Dine on stage had a charismatic effect which depended on the intensity of his projection of himself and the activities he was involved in; Solomon, "Jim Dine and the Psychology of the New Art," *Art International* (Paris) 8, no. 8 (October 20, 1964), p. 52, quoted by Ruzicka, "Jim Dine and Performance," pp. 100, 118, n. 23.

81. The performance took place at the new Reuben Gallery space at 44 East 3rd Street, where Dine had his studio upstairs. He had found the space for Reuben, and according to the press release for this performance and several following it, the 1960–61 season was devoted "exclusively to a series of evening exhibitions of art in a new medium. A workshop for 'happenings' has been created by the artists who last year began to explore this new form." The fifteen-to-twenty-minute performance (Kirby, *Happenings*, p. 199) of *Car Crash* was held six times, from November 1 to 6, and with no other performances appearing on those evenings. The press release is reproduced in *Happening & Fluxus*, n.p.

82. The costume designs are reproduced in Ruzicka, "Jim Dine and Performance," p. 101.

83. Kirby, *Happenings*, p. 192. Two scripts for the performance, one describing the action and the other with the text of Pat Oldenburg's monologue, are combined and reprinted in Kirby, pp. 189–90. Kirby's detailed account of the performance appears on pp. 191–199.

84. Dine, quoted by Ruzicka, "Jim Dine and Performance," p. 99.

85. The car accidents on which the performance was partially based have been reported differently in various written accounts. Dine, in our conversation on August 13, 1998, clarified the sequence of events: The first accident occurred in Kentucky. Dine was at the wheel when he heard the news on the radio that his college roommate had died in a car accident. At the same moment, a bee flew in the window and stung Dine, and he lost control of the car and went through the windshield. Another accident happened a month later, when he was driving with Nancy (his wife) and their infant son to see Nancy's parents in Cleveland; Dine swerved the car, and Nancy reached back to secure the baby in the car bed and broke her arm.

86. A copy of the announcement card is in the Jean Brown archives, at the Getty Center for the History of Art and the Humanities, Los Angeles.

87. For an extensive analysis of the artworks produced on the same theme as this performance, see Russell, "Jim Dine," n.p., and Ruzicka, "Jim Dine and Performance," pp. 101–02. The car crash was the first of what would become a career-long commitment to working in series.

88. Ruzicka, p. 101.

89. Dine, quoted in Reiss, "From Margin to Center," p. 55.

90. Jill Johnston, "Art: Car Crash," *The Village Voice* (New York), November 10, 1960, p. 8.

91. See Fred W. McDarrah's photographs of the objects from the *Car Crash* environment (and the relevant caption) in McDarrah's book *The Artist's World in Pictures: The New York School,* with text by Gloria S. McDarrah (New York: Shapolsky Publishers, 1988), p. 187. See also fig. 13 in the present catalogue.

92. Russell, "Jim Dine," n.p.

93. Johnston, "Art: Car Crash," p. 8.

94. This is described by Kirby (*Happenings*, p. 195).

95. Hansen, *Primer of Happiness*, p. 30. Kristine Stiles, in "Uncorrupted Joy: International Art Actions," in *Out of Actions*, p. 243, describes the "performative language of trauma," which has particular relevance for this performance by Dine; she establishes that "tropes of pain and suffering" can include, for example, repetitive physical actions and "whimpering, sobbing, and other sounds of distress." While Hansen found *Car Crash* to be sad, he described having run into Dick Higgins in the lobby, who was "drying his eyes, . . . [saying] 'Wasn't that funny? It was *so* funny!'" Hansen, pp. 30–31.

96. Dine, quoted in John Gruen, "All Right, Jim Dine, Talk!" *World Journal Tribune Magazine* (New York), November 20, 1966, p. 34.

97. Swenson, "What is Pop Art?," p. 60. For an interpretation of Warhol that challenges the artist's claims of neutrality and emotional numbness, see Thomas Crow, "Saturday Disasters: Trace and Reference in Early Warhol," *Art in America* (New York) 75, no. 5 (May 1987), pp. 129–36.

98. Alan Solomon, "Jim Dine: Hot Artist in a Cool Time," in *Dine / Oldenburg / Segal: Painting/Sculpture* (Toronto: Art Gallery of Ontario, and Buffalo: Albright-Knox Art Gallery, 1967).

99. Kirby, *Happenings*, p. 189.

100. Sidra Stich, *Made in U.S.A.: An Americanization in Modern Art, The '50s & '60s* (Berkeley: University Art Museum, University of California and University of California Press, 1987), p. 172.

101. Seitz, *Art of Assemblage*, pp. 87–88. A John Ross photograph of Dine's *Car Crash* (fig. 12 in the present catalogue) is reproduced by Seitz on p. 91, facing a photograph of Jean Tinguely's *Homage to New York*, a mechanical assemblage that Tinguely rigged to destroy itself in the garden of the Museum of Modern Art, New York, in March 1960. *The Art of Assemblage* was an important exhibition for bringing art-world attention to assemblage; however, it overlooked the mixed-media works of many young, lesser-known contemporary American artists of that period, including Dine, as well as Oldenburg, Grooms, and Whitman; see Livingstone, *Jim Dine: Alchemy*, p. 118, n. 23.

102. Ruzicka discusses Dine's complex use of lighting in this performance, combining flashlights, spotlights, and houselights for dramatic effect. Ruzicka, "Jim Dine and Performance," pp. 103–04. Dine, in his interview with Barbaralee Diamonstein (in *Inside New York's Art World* [New York: Rizzoli, 1979], p. 98], discusses how he, Oldenburg, and Grooms were doing "a kind of expressionist theatre . . . influenced by early films." He goes on to say that Grooms was particularly impressed by the German Expressionist film *The Cabinet of Dr. Caligari* (1920), directed by Robert Wiene. The use of spotlighting on white figures in an essentially dark stage set in that film seems comparable to Dine's use of light in *Car Crash*. There are numerous other visual similarities between Dine's *Car Crash* and this film, including the prevalence of crosses, the use of masks, integration of the written word with visual images, and the Expressionist stage set.

103. Marvin Carlson, *Performance: A Critical Introduction* (London and New York: Routledge, 1996), p. 155.

104. See Budick, *Arbus*, pp. 58–66.

105. *A Shining Bed*, performed at the Reuben Gallery at 44 East 3rd Street, on the evenings of December 16, 17, and 18, appeared together with *See Saw* by Simone Morris and two Happenings by Oldenburg, *Chimneyfire* and *Erasers*. The announcement for *A Shining Bed* is reproduced in the present catalogue, as fig. 50.

106. Dine's statement in Kirby, *Happenings* p. 187. Here Dine explains that the music "was a 33 record of a Palestrina chorale played on 78, and it sounded like The Chipmunks singing it" (p. 186).

107. Bakhtin, *Rabelais*, p. 25.

108. Ibid., p. 28.

109. Banes, *Greenwich Village 1963*. Banes maintains that the liberating social and cultural climate that has come to be associated with the 1960s as a decade began only in 1963. A counterculture in the art world developed against a highly charged social and political landscape, which in that year included the assassination of John F. Kennedy, the civil-rights march in Washington, D.C., and the stepped-up involvement of the U.S. in Vietnam (pp. 1–2). Based on Bakhtin's concept of the grotesque and the work of the British anthropologist Mary Douglas, Banes coins the term "effervescent grotesque body" to describe these visceral works that "poke holes in the decorum and hegemony of official culture" (p. 192).

110. Ibid., pp. 216–17.

111. Ibid., p. 232.

112. Jill Johnston, "Reviews and Previews: Jim Dine," *Art News* (New York) 59, no. 10 (February 1961), p. 15. Johnston's review in *Art News* is the only extant documentation of *Rainbow Thoughts*; no photographs of the environment exist.

113. Ruzicka, "Jim Dine and Performances," p. 105. *Rainbow Thoughts* is closely related in subject to *The Black Rainbow*, 1959–60 (fig. 59 in the present catalogue).

114. The rally was held at a former television studio on Broadway and 81st Street in Manhattan. For more on the rally, see Nancy Spector, "Rauschenberg and Performance, 1963–67: A 'Poetry of Infinite Possibilities,'" in *Robert Rauschenberg: A Retrospective* (New York: Solomon R. Guggenheim Museum, 1997), p. 244, n. 59; and Joan Young with Susan Davidson, "Chronology," in *Robert Rauschenberg: A Retrospective*, p. 565. According to Ruzicka, Dine's performance piece *Natural History (The Dreams)* took place May 1–3, 1965; Ruzicka, "Jim Dine and Performance," p. 119 n. 57.

115. Neither the book nor the tape survive; however, a small portion of the performance is preserved in the film *U.S.A.: Artists, Jim Dine.*

116. Elisabeth Novick, "Happenings in New York," *Studio International* (London) 172, no. 881 (September 1966), p. 156. According to Windish-Graetz, "It Happened," the actors included (in addition to Dine) Colleen Bennet, Bob Brown, Coci Calderon, Nancy Fish, Judith Hidler, and James Silvia.

117. Interview transcript of *U.S.A.: Artists, Jim Dine*, p. 3–9. Some of these dreamlike images carried over into his paintings. For example, a stovepipe is combined with a painting of a palette—Dine's metaphoric self-portrait—in *Two Palettes in Black with Stovepipe (The Dream)* and *The Dream #2*, both 1963 (figs. 114 and 123 in the present catalogue).

118. Dine's first period of sustained psychoanalysis was from 1962 to 1966; Livingstone, *Jim Dine: Alchemy*, p. 20.

119. The photographer of this performance, Elisabeth Novick, commented on this in a conversation with me on July 30, 1998.

120. Carl Jung, for example, used "the metaphor of the actor and his

mask . . . to indicate the public self of the individual, the image he presents to others, as contrasted with his feelings, cognitions, and interpretations of reality anchored in his private self"; Christopher F. Monte, *Beneath the Mask: An Introduction to Theories of Personality* (New York: Praeger Publishers, 1977), p. 19.

121. Yvonne Rainer, a founding member of Judson Dance Theater, remembered being criticized by her peers within the group for exploring issues of female identity—a subject perceived as too personal; Carlson, *Performance*, p. 147. While by the early 1970s Rainer's work became involved in autobiography, in the 1960s she described herself as a "neutral purveyor of information"; Norma Broude and Mary D. Garrard, eds., *The Power of Feminist Art: The American Movement of the 1970s, History and Impact* (New York: Harry N. Abrams, Inc. 1994), p. 161.

122. Interview transcript of *U.S.A.: Artists, Jim Dine*, p. 3-7. Dine's narration of this film is itself a kind of self-revelatory performance; as in *The Dreams*, he is nearly motionless throughout, delivering his candid monologue while smoking and slouching in his chair.

123. Carolee Schneemann, *More Than Meat Joy: Performance Works and Selected Writings* (Kingston, N.Y.: McPherson & Company, 1979, 1997), p. 56. I am thankful to Clare Bell for having pointed this passage out to me.

124. Schneemann, in a conversation with me, September 17, 1998.

TRACES

Everyday I meet you on the street
I am
 with you
 I think.
Well
 I'm not
 and you know it.
Also
 let's face it
 you're not on the street.
Your mirror has flown away.

RUBBER HEART BUSTS APART!
My tracks are on your dust.

Instead of forgetting a few lousy minutes
 I pull up the shade
 I let it down
 I pull up the shade
 I let it down
 I pull up the shade
 I let it down
 I pull up the shade
 I let it down
 I pull up the shade
I put my tongue
 on your dust tonite
 good nite

(Jim Dine, 1969)

Walking Memory

A Conversation with Jim Dine, Clare Bell, and Germano Celant

Clare Bell: I remember reading once that you said "to paint was a compulsion." Did that compulsion go all the way back to your childhood?

Jim Dine: I painted since I was two years old. I've always painted. It's what saved me. It was my way of speaking through the black times.

Germano Celant: What kind of painting did you do as a child? Nature studies? Still lifes?

JD: I was not making childish paintings. I was trying to depict nature or to depict still life, or in the third grade when we were studying China, I remember trying my best to make a watercolor of a Chinese man in a blue suit, a worker's suit, and trying so hard to draw it right. And it was always a struggle, a struggle to get my hands to work, and I am left-handed. In those days, you know, we had penmanship classes, and I smeared my writing every single time because my hand would drag across the page. Because that's the way a left-handed person writes.

CB: As a child would you try to render a mirror image?

JD: I was trying to achieve a relationship between my eyes and my hand. And it wasn't working. It took me a long time. It was like weight lifting. I had to practice.

GC: Besides grammar school, where were you drawing? Were you going to some special place?

JD: It was always in my house and when I was eleven, I went to the art museum in our town, and studied with a man who was a Mexican-American veteran of the Second World War and wanted to be an artist. He taught at the Art Academy. His name was Carlos Cervantes.

CB: Did your parents encourage your art studies?

JD: My mother was a "culture vulture" and had a lot of ambition for me, and she thought it was great. My father, on the other hand, never thought much about my interest in art and let me go to the museum simply because he thought it brought some kind of social prestige to our family.

GC: So your mother was your point of cultural reference?

JD: She was my muse.

CB: Did you ever draw her?

JD: No. My mother was the woman who lit the flame. My grandma was my mother; my mother was my lover. It was like that. It was a complicated, confused childhood.

CB: Where were your grandparents from?

JD: My father's parents were from Lithuania. My mother's father was from Poland, and her mother was Hungarian. She wasn't from Hungary—her mother was. She was actually born in Richmond, Virginia, but she was a woman of Europe, a peasant farm woman.

GC: Did they show you images of the past? Their country? Did they bring with them memories of those places?

JD: That's all we ever spoke about. We only spoke about memories.

CB: Had your grandparents lost family in the Holocaust?

JD: No, we all came over before the war. My grandfather came at the end of the nineteenth century, as an indentured man to a cousin, who brought him over, and then he owed him for years.

CB: What kind of jobs did you have growing up?

JD: When I was in high school, I worked at construction in the summer time building houses. I watched carpenters a lot. I had always watched plumbers particularly. You know, there is something about how plumbing is done, what plumbing is about. The bowels, the underground of things. To be a plumber now is to be rather clean. You use plastic pipe. It's put together with glue, it's no problem. It's cut easily. To be a plumber when I was growing up you had to be somebody. In the first place, you are lifting pipes. You're lifting a sewer pipe that was cast iron. We called it "soil pipe." And every summer at my uncle's store, working there, I had to lift those things off trucks. It was really, really tough work. Then, being a plumber was tough work, because to put that together, a piece of pipe together, there was a male and female end, you put that male end to the female, and then you packed it like a tooth cavity with oakum, which is hemp soaked in tar, and you packed that around it and then they melted the lead and poured the lead and sealed it. To have been a plumber meant digging in shit all the time. It smelled terrible. I mean, to be around plumbers, they always stunk like shit, and my father, because he worked in a tool store, we all knew how to do this, but the toilet would get stuffed up or the drain would get stuffed up, my father would bring out the snake, shove it down there and bring up crap from the thing. It was disgusting, but this all had something to do with how art is made. The same way my grandma put together meals in some sort of intuitive way. It was the same thing. It was this putting together of things.

GC: So do you think that your work is about memory too?

JD: My work is totally about memory. And my memory is very good. I mean I have a very vague memory of everything. There were times when I could remember everything that ever happened to me. And I can't anymore, but I relish my memory, I cherish my memory. My memory is my vast vault of experience.

CB: It's not a selective memory?

JD: No. Absolutely not. I don't want to control it. It's all there.

GC: It's life memory, which is why I feel your work is so aligned with European ideologies. Your subject matter is difficult, because memories are something you don't want to remove.

JD: They want to remove them in America.

GC: That is why I feel your acceptance in Europe is stronger in some ways, because our goal as Europeans is memory, and you always bring your bag of memory full on your back. And that I understand, and also why you so adamantly refused being labeled a Pop artist. It was offensive.

JD: It had no romance. For me it was just what it was. I need the romance.

GC: You needed the flexibility of time and history.

CB: Materials, patterns, and textures, which were so clearly important to your early work, are imbued with an air of domesticity as opposed to a laconic manufactured quality. What was it about the house or home itself that inspired you?

JD: We lived in houses with basements. I was always in the basement, going through the old paint cans, using the old paint—and just stirring the old paint turned me on! It was some connection between shit and food and paint. As a child, it had to be like that.

GC: Would you paint on any surface?

JD: I painted sometimes on the basement concrete wall, or I'd paint on a paint stirrer, or I'd make designs. I didn't know the word "collage." I'd make designs. My aunt has a painting that I made in high school after I had discovered Nicolas de Staël. I loved de Staël because he was a romantic figure and I loved the way he put the paint on so thick. It looked to me like modern art. Eventually, when I left home, and ran away from the evil stepmother and went to live with my grandma, I worked in her basement and painted on anything I could find. I knew a rich girl I went to high school with, who I

liked and she liked me, and she took me to her grandma's huge mansion in Cincinnati, and we went to the basement and there I saw her grandmother's canvases. So, I took away a lot of canvases of very bad paintings of people, and I painted over them.

CB: So the basement operated as something secret and liberating as well as abject and furtive?

JD: It's been in my dreams all my life. My whole unconscious is depicted as a house, and the basement is where it takes place, and then you go upstairs.

GC: What kind of formal art training did you have after high school?

JD: I was untrainable. I went to the University of Cincinnati just because I didn't want to go into the army, and I hated it. There were no art classes there to speak of. Then I found out that I could go to Ohio University, which also had few art classes, but you could get a degree in it. It was very cheap—eighty-five dollars a semester. I had no money, but my grandma could pay that for me, and I worked in the summer. But I never went to classes. All I did was paint at Ohio University, and they were frightened of me. They never had anybody like that, because mostly everybody wanted to be an art teacher.

CB: Where did you paint at college?

JD: My apartment or in the school. The school had rooms, but they were hardly used, and I painted like crazy all the time. And I got through it. I cheated, and got through college.

CB: Did you receive any formal instruction?

JD: There were instructors, but they treated me like an equal. Some were threatened by me, some were excited by me. But I was nineteen years old, and they were thirty-five and sixty. I just painted.

CB: In 1955 you enrolled for one semester at the School of the Museum of Fine Arts in Boston. Why did you want to go to Boston?

JD: When I graduated from high school I gave myself a present. I bought a book called *Modern Prints and Drawings* by Paul Sachs, who was at Harvard's Fogg Art Museum. I still have that book. And I thought, well Boston must be the place to go, so I went to the Museum School for a semester. It was horrible. It was like the army—rigorous, old-fashioned, academic training that I didn't want. What made me different from other artists—not that every artist isn't different—but what set me apart is that my subject matter was myself.

CB: Had the figure played an important role in your work prior to your coming to New York?

JD: Well, I was fairly glib with my hands—that is, I could draw a self-portrait of myself and make it look like myself, which in New York seemed terribly radical and no one wanted to do it, because it wasn't so *au courant*. After the year I spent in Patchogue teaching school, which was 1958–59, I would come into the city three or four times a week, a two-hour ride each way at night after teaching school, and talk and drink with Claes [Oldenburg] and Red Grooms and see Lester Johnson. The art of Lester Johnson was really important to me. His paintings were so beautiful. It was like pulling out of the canvas, out of oil paint, out of material, out of sand, out of shit, out of tar—pulling it out, pulling out an image. Out of somewhere else rather than out of France, or rather than out of Rothko. That kind of refinement.

CB: Were you involved with the unconscious?

JD: Well, I didn't know it, but of course I was. I have pretty good access to my unconscious—that's the way I was born, and painting for me has helped me undemonize myself. So,

18. Head (Hiding Face), *1959*
Mixed-media collage: Oil and pasted cloth
on gesso board
26 3/4 x 23 inches (67.9 x 58.4 cm)
The Metropolitan Museum of Art,
New York. Gift of Stanley Posthorn, 1979
(1979.552)

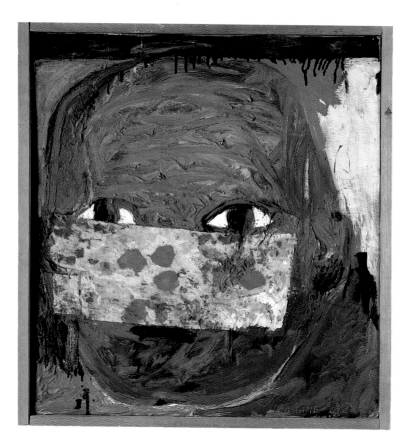

you could say it's cathartic what I do. But fortunately, I am a conscious enough person to have not just been a lunatic, and I've tried to elevate my desire to work to what I call art.

CB: Did you feel that Abstract Expressionism gave you, on some level, permission to work with the unconscious?

JD: I felt I always had access.

GC: So it's very primitive.

JD: I am not a heavily defended person. I have an access to my childhood that many people are jealous of. I can access childhood very easily. I don't mean just memory. I mean feeling. And I am very much in the head of the child—not that I am childish, but in the sense that I remember and that my childhood stayed with me. When I started to toddle around and look at the world, I started to catalogue and accumulate in my mind experiences and sensations. I remember when I was maybe three years old, sitting with my mother's emery boards and taking a pencil and making a whole emery board black. I wear down the pencil for no reason other than the physical thing of making the emery board black. Then, I get the idea. I realize the sensuality of graphite. I touch it, and it's beautiful. Graphite is silvery, and I use it for makeup. And I put on a mustache and a beard, and I start to literally paint. The same with my mother's makeup. I was always in my mother's places—in the closet, under her bed, in her bathroom—playing with stuff. I was painting. I was experiencing changing something.

CB: Are the faces you painted early in your career [figs. 18–22] an attempt to confront the demons of your childhood?

JD: The faces were generic faces. They were me. They were me getting the emotion out of me. I began them the summer after I taught school in Patchogue when I used to come in to New York City all the time and see Red Grooms, and I was being introduced to people from the Hansa Gallery, which I didn't feel very comfortable with, but I was sort of affected by. Like Lester Johnson, and things Claes and I talked about. And then I went down to Kentucky, where my uncle had a little cabin on a lake in the midst of tobacco fields. And Nancy and I had a little boy, who was just a baby then. We went down to Kentucky, because we had no money, but it was a cheap place to live, and we stayed down there and I took watercolors and crayons and whatever, and I just started to draw faces. And every day I drew faces. And the whole summer I'd make a face a day, or two faces a day, and the more faces I made, the happier I was. There were so many of them. And then I started to make paintings down there. And by the end of the summer that's what I had, and I left a lot of them there. I brought back some of the drawings and showed them at the Reuben Gallery, in the back room. They were all pinned up, maybe thirty of them, and Dick Tyler took wine at an opening and threw it all over half of them, and I hit him. It was an incredible scene.

GC: To me, the faces represent an osmosis between the personal and the idea of repetition, the personal being a representation of yourself and repetition the idea of a copy. Your work is thus both an integration and association of many levels of perception. Tell us about the idea of the mask and the theatrical elements of your early work. Did you know about Bertolt Brecht and the Living Theater?

JD: I always thought of myself as an actor/artist, and I could've always been that, except I am not very good at interpreting others' work. I don't get any pleasure from that particularly, although I have appeared as an actor at times, besides the Happenings. And I've enjoyed that, and I could still be an actor today. I enjoy that! I enjoy looking at actors, watching actors. I don't enjoy the theater particularly, but I

19. Small Head, *1959*
Oil on canvas
14 x 10 inches (35.5 x 25.4 cm)
Private collection, New York

20. The Checkerboard, *July 1959*
Mixed-media collage: Oil on dishrag
on checkerboard
18 1/4 x 18 1/4 inches (46.4 x 46.4 cm)
Private collection, New York

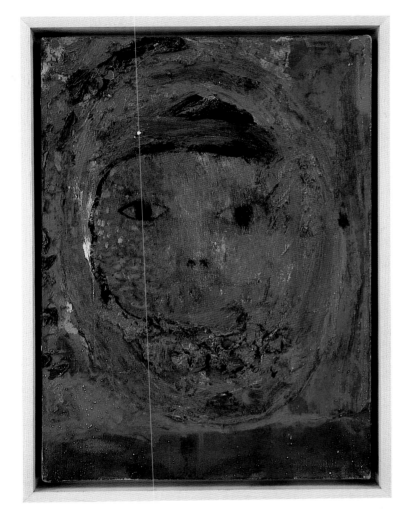

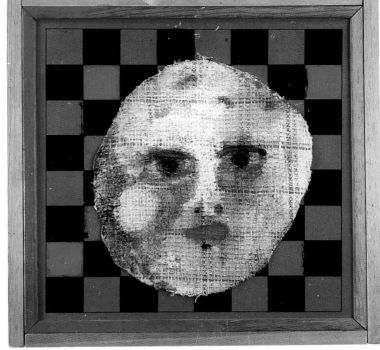

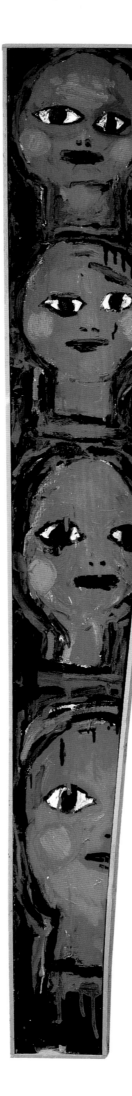

21. Untitled, *Summer 1959*
Oil on wood
68 x 10 1/2 x 1 1/2 inches
(172.7 x 26.7 x 3.8 cm)
Collection of Nancy and Dolph Berman,
Cincinnati

enjoy the craft of what one can do.

CB: Were you involved in acting prior to 1960 when you first performed at Judson?

JD: I did a little bit in high school, but more than that I made my own theater in my head and it had to do with all sorts of things. It had to do with growing up with a grandfather who was highly amusing for us kids. He was obviously a brute, and an abuser of a lot of things. But he was great fun as a grandfather. And it was theatrical. My mother was totally theatrical. Everything was a mass-drama, and it was very sad, because she said she was going to die, and she did die. You know, she said she was going to get the cancer, and she got the cancer. But it was done in such a flowery, theatrical way, and I was part of the team, part of the show that was going on. And also my experience with God, and in the synagogue. And the dichotomy of that— where I came from these people who were first-generation Americans, who wanted to leave their Orthodox Judaism behind. So we went to this Reform Temple, which was like Episcopal Church, but even less devout, more like Protestants. And all it did for me was make me feel two ways. My mother was ashamed of being Jewish, and on the other hand, my grandfather cried in the synagogue. I come from a strong God; a Jew comes from a strong, cruel God— Yahweh. And every night, I thought he was going to strike me down if I didn't say my prayers. My grandma told me, "You got to say your prayers, or he is going to punish you." And there is a lot of theater in that. The only time I ever enjoyed going to the synagogue was when there was a lot of music and they brought out the Torah, and everybody paraded around with these beautiful objects. I got into that. Otherwise, it was a nightmare for me. And of course, in the end, it was a nightmare because as a twelve-year-old, I had to stand up for the memorial service after my mother died, and that was an embarrassment to me, and I didn't know how to behave. All this informed me as a performer.

GC: So, your acting comes from inside. There is a process of your inside becoming a gesture, an action, or a visual element.

JD: Taking an unconscious thought and bringing it to consciousness.

GC: And that's why the mask is the second skin of your face, which comes out of performing as a jester or an actor.

JD: I think it's like a miracle. One of the things I like about Jesus is that Jesus's existence makes God conscious. It's the first time we talk about God as man, God in man. I relate to it so much. It didn't seem absurd to me, but rather a great moment.

CB: Because it made something that seemed abstract into something tangible?

JD: Yes, making something tangible.

CB: So that's why you liked the part of the service when they brought out the Torah.

JD: You got to see something. I love an object! I am obsessed with objects—I mean every object. I spent my whole life playing with objects. I was two years old, playing with every tool, every object I found. My grandmother's sewing kit, the basket of thread with every different color. My father's condoms; in those days, Ramses and Trojans came in packages that had beautiful drawings. Playing cards, the backs of playing cards. The beautiful ivory tiles used in the Chinese game of Mah-Jongg, which are like dominoes but with Chinese marks on them instead of dots. My mother's sense of decor in the house.

CB: Does *The Checkerboard* [July 1959, fig. 20] come out of your interest in games like this?

JD: The checkerboard doesn't come from my thing with

games, it comes from what red and black look like together. I've always loved red and black, and it's a very basic pattern.

CB: Was it specifically the grid that interested you, or the notion of pattern in general?

JD: The grid, that's partly it. I like the square thing, but for instance, in Scottish tartans, which I am a big student of, there is one called Rob Roy. So it goes back to the eighteenth century and probably even before. I've been interested in tartan all my life. It thrills me.

GC: I noticed that the imagery in *Altar for Jeremiah* [1959, fig. 24], is much more complicated than the first face paintings.

JD: But it's also very ordered, in an altar kind of way.

CB: In fact, the overall shape of the piece is reminiscent of a crucifix.

JD: I always loved a central image. And although *Altar for Jeremiah* is quite sophisticated in technique, the imagery is more like primitive painting than something out of Abstract Expressionism. There is this huge penis in plaster, and some of the objects are found Halloween masks. All of us were fascinated with just about everything in the city, even with someone ejaculating on the subway. It was like collecting an experience in this underworld. We were collecting another experience of someone making their mark a different way, of someone being crazy, of walking down the street looking just like everyone else and then being able to do this to make themselves individuals. It was like lifting up a rock and discovering all these worms. It was really great!

CB: Was Halloween an inspiration to your work?

JD: Halloween in Ohio, when I was a child in the late 1930s, scared the shit out of me. And my mother and father were embarrassed by me crying when kids in costumes came to our house on Halloween. It's the frightening masks of pumpkins for heads, it's "The Legend of Sleepy Hollow," it's the headless rider, and it's also listening to adventure serials on the radio and being scared. I still love looking at masks and things. Puppets, masks—all that interests me.

CB: Does chance play a role in any of these works?

JD: When I heard Kaprow and John Cage talking about chance, I thought to myself, "What? This is like reinventing the wheel. An artist does that every day!" When Whistler put down a brushstroke, was it chance? Since you have the opportunity to remove it after it's done. We're free men. But, it's always been there for artists. Chance! You find things in the ether.

GC: It was just a theory about chance.

JD: Yeah, but they loved the theory. It was like a dogma.

GC: I see a connection with the altar, the penis, and the notion of dress in *Green Suit* [1959, fig. 27].

JD: There was a toy when I was a kid called Bill Ding. It fascinated me. It was all the same guy, made out of wood, but he was in different colors, with a suit and a tie on. And you could put him on top of each other like an acrobat. It was endless fun to do for kids. And I thought about this toy while I was making *Green Suit* at the time of *The House* [1960, figs. 34, 35]. I just took that suit, I ripped it up, I shredded the legs, because the seat was all worn out and so were the knees. I shredded that to sort of make it hang in a certain way, and then it seemed to me the most natural thing to do was take some of these things and tie it into a penis. I don't know why, but that's what artists do. That's called inventing.

GC: Yeah, but you transformed it in a certain way that imbues it with a female connotation.

JD: I've always been comfortable with the woman in me. Always comfortable. As a child I often wondered what it meant to be both. I really always felt that. I've never in my

22. Untitled, *1959*
Oil on wood
54 1/4 x 5 1/8 x 2 inches
(137.8 x 13 x 5.1 cm)
Collection of Mr. and Mrs.
Charles H. Carpenter, Jr.

23. Altarpiece, *1959*
Mixed-media assemblage: Oil, metallic paint,
cardboard, petticoat, and newspaper on canvas
70 x 49 inches (177.8 x 124.5 cm)
Collection of Anita Reuben Simons

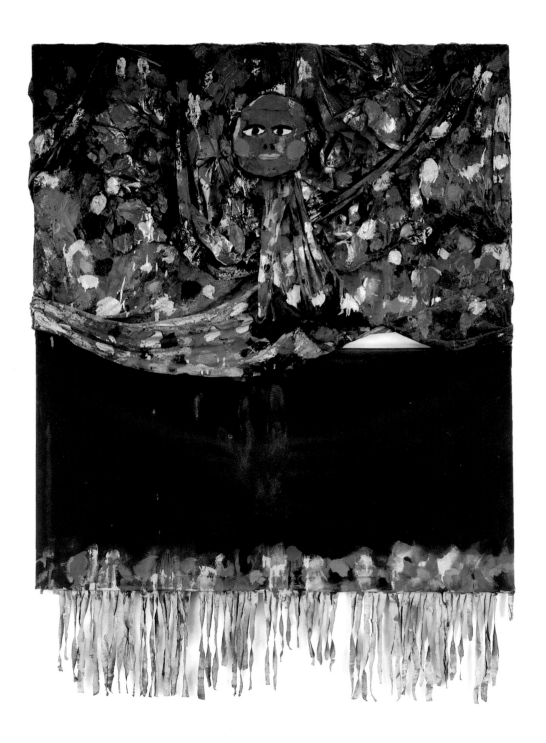

24. Altar for Jeremiah, *1959*
Mixed-media assemblage: Oil, cardboard, paper,
cloth, gauze, and glue on canvas
45 1/16 x 49 x 12 inches (114.5 x 124.5 x 30.5 cm)
Collection of Jorge and Marion Helft, Buenos Aires

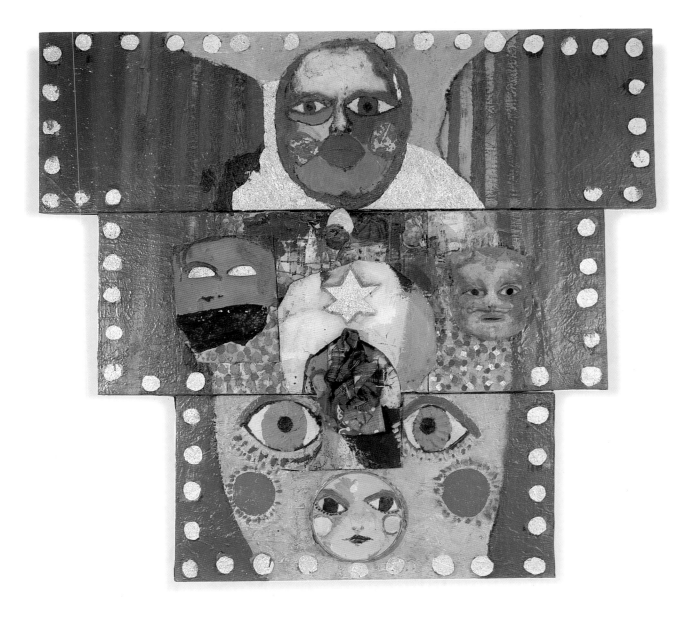

25. Untitled, 1959
Mixed-media assemblage: Oil on plaster
over wire armature from an electric fan
Diam.: 16 inches (40.6 cm)
Collection of Stanley Posthorn

life, quite honestly, felt an attraction to men sexually. But that has nothing to do with feeling male and female.

CB: Were you always interested in the idea of drag and masquerade?

JD: I've always been fascinated with how one dresses. One puts on what one owns. The possibilities of a different variety of things, not unlike color charts. Back then when you went to Brooks Brothers, they never had men's suits on hangers. They had them lying on tables, all over the store, one on top of the other, and next to each other. The subtlety of the fabric was so fascinating. I would go on my lunch hour from teaching just to look at the fabric. I still go to fabric stores wherever I am to look at material. Because there is something about material—first, that somebody made it, and also that it has a different quality, like humans.

GC: There are so many different definitions of dress now. Looking back, this element of your work has nothing to do with fashion; it has to do with identity.

JD: Exactly. I used dress as a hedge against social fear. If one had a lot of clothes, one was more armored against the world.

GC: Meaning you could change your identity.

JD: Yes, absolutely. And you didn't need to expose your nude self.

GC: But Joseph Beuys said that if you stayed always the same, it was better, because your identity stays fixed and recognizable. He created the felt suit to keep fashion immobile; you saw dress as just the opposite.

CB: And there is an ambivalence in your work between exposing yourself and using dress as a kind of armor.

JD: Yes, but I am not walking around with my fly open. That's the luxury of being an artist. You don't have to.

GC: Do you think that at the time your idea was to restrict the territory of your compositions in the way that clothing outlines the perimeters of the body? Certainly the previous generation, artists like Pollock, Rothko, de Kooning, aimed at enlarging the scope of their actions as artists. They wanted to talk about the war, they wanted to break through to the outside. And your generation was trying to deal with the territories of dress, houses, shops, as icons of self.

JD: Don't forget that the Abstract Expressionists were landscape painters, and we were not. We were internalized. And if there was a landscape, I carried it on my back. It's my landscape. It's the landscape inside me. That's what I am interested in.

GC: In *Green Suit* the object becomes your body and it is a moment of leaving traces. Why such a fascination with making a stamp?

JD: It's like a dog who pees on things. I am always moved by how a dog leaves traces. It claims it. "See, that's mine. I was here!" In the 1980s I went to see an unfinished Palladian villa called La Serasina outside of Venice, in a town called Noventa. It's now been bought, but it's never been finished. It's been lived in; it was never electrified, there was never water in it, but people had lived in it. They were peasants. It came with peasants, can you imagine! I went up into the attic, and on the eaves there was graffiti from that time until now. There was graffiti from builders, Palladio's builders. There was fascist graffiti from Nazi soldiers who stayed there on the way out, retreating. It was so moving to me that humans had touched something and wanted to leave their mark.

26. A 1935 Palett, *1960*
Oil and charcoal on wood
6 feet 2 1/4 inches x 4 feet 1/4 inch
(188.6 x 122.6 cm)
Collection of Ralph and Helyn Goldenberg

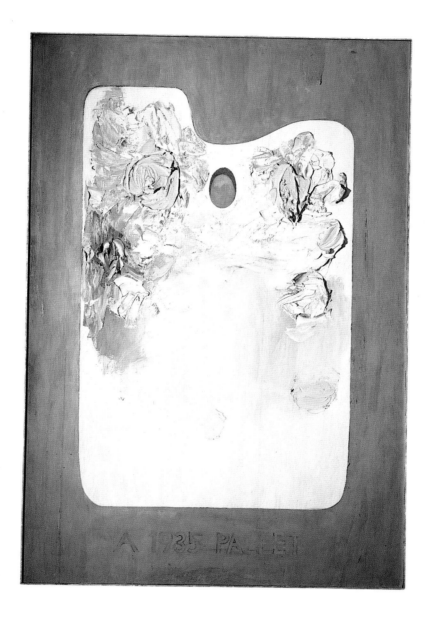

facing page:
27. Green Suit, *1959*
Mixed-media assemblage: Oil, cardboard,
and man's corduroy suit
65 5/8 x 28 3/4 inches (166.7 x 73 cm)
Private collection, New York

IN A GREEN SUIT

The implications are that I just got to have
this small large little
just put your thumb and index finger together
to see how small.

Dear one the world is waiting for the sunshine.
Well or sick you never call on my abilities
 to talk in a crazy way.
The energy this is taking equals the sensation
 of making this period.
I am shot physically.
 so?

(Jim Dine, 1969)

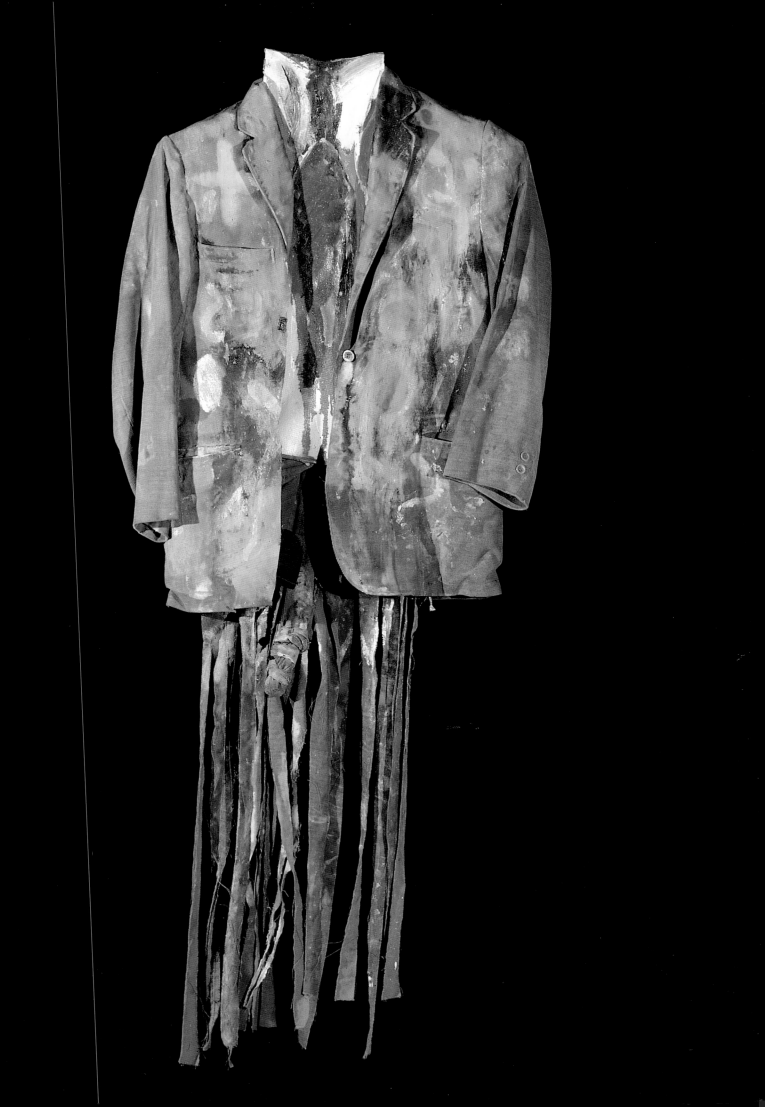

28. Shoes Walking on My Brain, *1960*
Mixed-media assemblage: Oil, leather,
and cloth on canvas
40 x 36 x 6 inches (101.6 x 91.4 x 15.2 cm)
Sonnabend Collection

facing page:
29. Untitled (After Winged Victory),
1959
Mixed-media assemblage: Cotton and
nylon cloth, enamel, and wire over metal
armature
52 x 24 x 12 inches (132.1 x 61 x 30.5 cm)
Private collection, New York

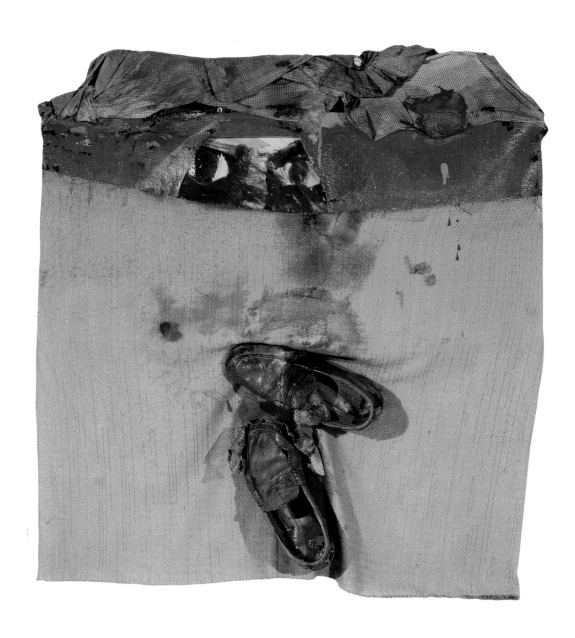

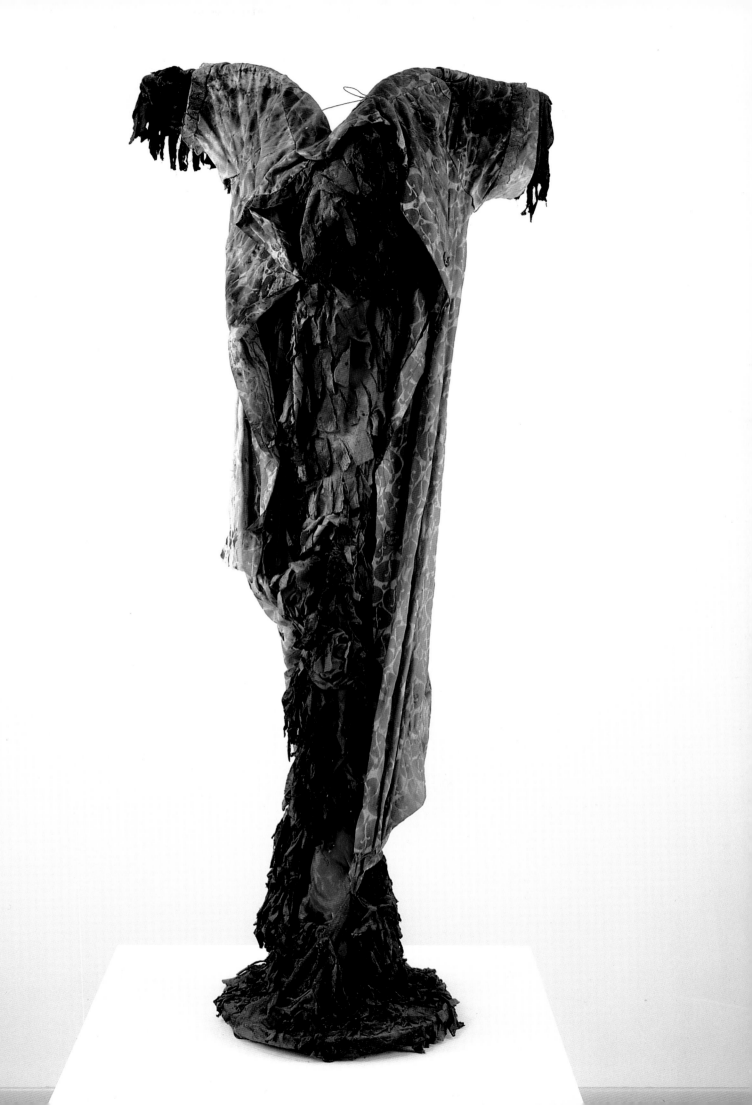

30. Household Piece, *1959*
Mixed-media assemblage: Wood, canvas, cloth,
iron springs, oil and bronze paint, sheet copper,
brown paper bag, mattress stuffing, and plastic
54 1/4 x 44 1/4 inches (137.8 x 112.4 cm)
The Museum of Modern Art, New York.
Gift of John W. Weber

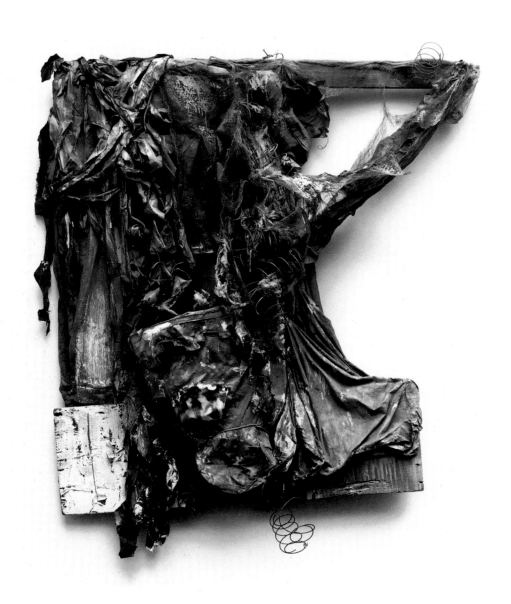

CB: You've told us about being frightened by many things when you were a child, but you seemed to have faced up to those childhood fears as an artist working at this time.
JD: Exactly. I had no fears as an artist. I had fears as a human. I was very aware of how distant and unrelated I was to everyone else. That I was something else, something quite unto myself. I felt it was a fact of nature that I am different from everyone else. Not as an artist, but as a human. We probably all know that we are all different, but I am speaking about it in an interpersonal way. I found it difficult to relate to anyone.
CB: Your work constantly went back and forth between using the real and then the illusion. You have the real suit, and then in a number of your paintings later on, you actually have the illusion of the suit. Why the jump? Are they two very different things, the real and the illusion?
JD: It's the question of what's real. For me, my sense of reality sometimes is one thing and sometimes it's the other. It's like an emotion. How in touch am I with how I really feel or how in touch am I with what reality is, what's going on with my sense of reality? That interests me always. Also, what looks best. Remember, I am a visual artist.
GC: How did you go from the idea of painting or objects to building *The House* [1960, figs. 34, 35]? Of course, the phallus and the *Green Suit* itself is a protrusion, but could you talk about the physical leap from painting to constructing an environment?
JD: Well, the Judson had a lot of crap in storage from the theater, like stage flats. And Claes and I were going out all the time onto the street at night, and pulling in junk. Going out in the snow. And we were pulling in stuff we found on the street, just to use. I was teaching school, he was working in the library at Cooper, we didn't have any money. I was living uptown on First Avenue and was coming down at night, and he was meeting me, and we buy a little beer, and we get a little high, then we go out on the street and we pick up all this stuff. We go back in, and we talk and we build. We drink, and that's what we did. That was the process. I built this like I built anything. I built *The House* like I built a painting. It just happened to have more things.
CB: How did it evolve into the idea of a show?
JD: We thought that slot at Judson was ours. It was probably Claes's idea, because that's the way he thinks. Theoretically. He probably said, "You do the house. I'll do the outside, you do the inside, because that's the way you are."
GC: How did it come to life?
JD: I was given an area. This was a great thing to have happened to an artist like me. An artist like me—I didn't have a studio. I was painting in my living room, which wasn't even a living room. I just turned it into my studio, and we lived in the kitchen, and in between was this railroad flat; we slept in one little cubicle and my kid slept in the other, which would've been where the living room was. It looked just like *The House,* and that's where I made *Bedspring* [1960, fig. 58] and all that stuff.
GC: And did you know about Schwitters at the time?
JD: Certainly, I knew about the *Merzbau.* And I loved Schwitters. But I didn't think of this as the *Merzbau.* When I think of Schwitters, I think of Cubism. *The House* was a depiction of my inner life of chaos
CB: Is *The House* the first time you began to incorporate writing into your work?
JD: I always had writing. I used it all the time in my painting then.
CB: Do you remember when you first seized on the idea of merging the spaces of theater with the act of painting?

JD: I was born that way. I had already spent my late teenage years and my early twenties in Ohio in school acting the same way. Going to a building as the year ended and spring came to Ohio, going to an abandoned house in the country, and just drawing on the walls, and jumping off the roof, and getting drunk and making something part of the whole thing. Making it all part of life.
GC: Did you have specific influences from TV or the movies?
JD: In my family, TV didn't come until I was about fifteen, about 1950–51. But I hate TV. Movies for me are the thing. And I always preferred black-and-white movies. Because of my generation, and also because of who I am, I never took a movie any other way but like that it was real—that I had a real experience. But during the early '60s, when I was having a breakdown and unable to leave the house, I didn't go to movies. I didn't do anything. I couldn't sit in a movie without going nuts. So, I was watching television all the time. I looked at everything. Through the day, I watched everything. Actually, Bob Whitman and I used to speak about it, too. Because we had little children, we watched children's TV in the late '50s, early '60s, and that said something about the kind of performances we made. There was a kind of repetition to little children that both of us used, an obsessiveness that both of us used.
CB: Would you model your performances on specific ideas you got from these programs?
JD: We would refer to Captain Kangaroo. Whitman and I referred to him a lot. We listened to his way of speaking and the way the characters spoke. It put the performances out of the realm of literal theater by these characters for children speaking to them in this odd way, which wasn't naturalistic. We were able to look at that as a kind of performance, too. Plus also, I don't think I've ever said this before, and it would be hard to write about, but George Segal's son Geoffrey is autistic, and I knew him as a young boy, when he was maybe ten or eleven. And he would watch those programs. I was always drawn to kids who did not fit in. Even when I was a kid, I was fascinated by children who had deformities that were not fixed, like they are today. There was a kid I went to school with who had two thumbs. Today, you wouldn't allow two thumbs. They would take one off at birth and that would be that. This kid had two thumbs, and he kept his bus money between the two thumbs. And I thought this was like art—it was another kind of sculpture. And the same with Geoffrey Segal. He and I had conversations at picnics I went to at Kaprow's with Segal and Whitman and Claes and everybody. Geoffrey Segal and I would stand there laughing about these children's programs, because we were both involved in watching them on TV. Because he couldn't stop repeating himself in his autism, he kept calling out, "Mr. Green Jeans." And he would say, "Hello, Mr. Green Jeans! Hello, Mr. Green Jeans! Hello, Mr. Green Jeans!" and I took it totally seriously, as though it was a form of narrative and a form of conversation. So that's what I was looking at.
GC: So you think that this kind of coming together of Kaprow, Oldenburg, Dick Higgins, Richard Tyler, etc. was strategic in a certain way because it reinforced what you were already thinking. You know, we are totally different, but in the end, you need the impact of not only yourself, because at the end you believe in yourself, but you need energy around you.
JD: And you need validation. Friends give it to you. Red Grooms couldn't be more of a different artist, but when I saw him perform *The Burning Building* it confirmed my idea of *The Smiling Workman* [figs. 36–39], and Claes was interested in doing similar kinds of work. And even Kaprow, who was

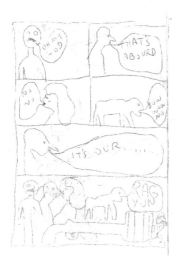

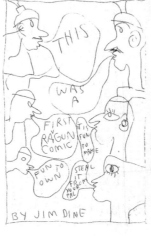

an artist of no interest to me whatsoever except that I liked his paintings. I liked his paintings in the mid-'50s, which I saw in reproduction in Ohio. Kaprow had something, because he wasn't really a painter. He was more of a theoretician. The art he made was kind of primitive in a way, untutored. But I had no interest in *18 Happenings in 6 Parts*. But to meet somebody like Bob Whitman was a trip! Every year Whitman made one painting. He just made it. It was his thing to do once a year, to make a painting. He had Rauschenbergs on the wall. He bought Rauschenbergs, and he was making this mad stuff. I thought, What's going on here?

GC: What strikes me about this period in your work is the very short time that you were doing the performances.

JD: You mean the duration of each performance? Or the short period of time over which I did them?

GC: Both. But, as distinct works they feel more like a gesture. Not as a gesture as a poly-gesture, but it's more as in life. You say a phrase and you leave. It's again very personal. It's not a long story, it is something happening in real time. How do you see this idea of time now, today?

JD: You mean, why did I do that then?

GC: Yeah.

JD: Because I couldn't sustain the passion any longer. It was like the male orgasm versus foreplay.

GC: So, no plateau. Just ups and downs.

JD: Right. It was the power of an object, of a single, central image. It was one thing. I made an object. In this case it was a play, whatever it was. This performance. But it was within a certain time, and it kept the power. Otherwise, like you say, you have ups and downs. Now you have to remember that Bob Whitman and me, Lucas Samaras, Marcus Ratliff, almost everybody around us were of the same age, except for Claes, who was older. He was a formed, sophisticated, European man with all sorts of irony and all sorts of references. References and fine schooling. He'd gone to Yale. Everything Claes took in about America, he took it in as an outsider. He's not an American. Now as Americans, we're all from somewhere else, but in his case, he matured with these parents who were diplomats, and he was a gentleman. Whereas I came from Europeans, but we lived an American experience in the Midwest and aspired to that, and then of course, I always aspired to Europe in another way. So, Whitman and all of us, we did something that was like television, like early television, or like the movies. We were not doing Molière.

GC: The kinds of performances you were engaged in were more akin to advertising—a thirty-second sales pitch.

JD: It was like driving on a highway, and you saw a billboard and you went by it. Or like the Burma Shave signs.

CB: Did you rehearse any of the performances?

JD: I rehearsed mainly with myself, because I was mainly in them alone. I rehearsed the technical parts with somebody else to put the tape-recorder on, and those sort of things. In *Car Crash* [figs. 12, 13, 44–46], I rehearsed, but I already had it in my mind what was going to happen, and I told people what to do, and they did it. It was not hard. It was not complicated.

CB: Was it scripted?

JD: It was scripted in terms for myself. I was the one who carried the power of it anyway. It was my acting, even in *Car Crash*. The others were neutral figures that were like objects in a landscape, Patty Oldenburg, and Mark, and Judy Tersch. They were objects for me, but I was the living force. It was like making a drawing.

CB: Were you conscious of the audience when you

performed? Did you play to their emotions?

JD: Well, they weren't improvisation. I responded to the audience's response, and the audience always responded. The audience was there looking for a thrill. As people go to the theater. You want to be entertained. And this particular audience, which was mainly a crowd of our peers, even though they were sometimes much, much older, were ripe to be amused and to be titillated, and to be informed in some way.

CB: Would you interject humor where you may not have thought about having it before?

JD: No. I never even thought they were funny, but everybody laughed all the time.

GC: From nervousness?

JD: From being embarrassed. They laughed like crazy. Personal things make humans nervous.

GC: Were you interested in the idea of shamanist? The silver paint on your head in the performance of *Car Crash* evokes the idea. Of course in Europe, Beuys was combining fat, felt, and copper in his works. Did you know about Zen theory?

JD: We knew about it.

GC: Because of Cage? And not only Cage . . .

JD: Not just Cage, but there was "Zen in the Art of Archery." I knew about that in the '50s.

CB: Did you know much about existentialism?

JD: I never quite understood it. As a student I read Camus, but I read it as a story, not as a manifesto.

GC: Did you have any knowledge about Fontana and the Gutai Group?

JD: The only knowledge I had of the Gutai group was when we first came to New York, there was talk of them among the Abstract Expressionists, and Martha Jackson might have shown them or maybe they had a festival of kites or something like that. Fontana I saw because Martha Jackson showed Fontana, but I never really responded to it. I thought it was mannered, very handsome, and chic.

GC: Very formalistic.

JD: It was so elegant, and it was my idea of what Italy was like. I didn't know. I'd never been to Italy.

CB: Did you feel that in order for your audience to really understand your work they really had to understand you as the author?

JD: No, if they get the work, they understand me better, but they don't have to get me. You don't have to know me to get the work. There is a universal quality to it. I know this, because I know how people respond to the work, both bad and good. I never get a neutral response. It's always *a* response. I always get kissed or fucked, or I get stabbed in the back.

GC: The difference with the other so-called Pop artists such as Roy Lichtenstein and Andy Warhol was that their works were so detached. They didn't talk about themselves. Andy was the extreme of unexpressiveness, of what is supposedly "objective."

JD: I am everybody's nightmare. A provocateur.

facing page:
31. Ray Gun Comics, *1960*
Mimeograph on paper, four sheets, folded
Collection of Jon and Joanne Hendricks

32. Ray Gun, *1960*
Paint on plaster cast
4 x 2 x 1 1/2 inches
Collection of Marcus Ratliff

"The terrific thing about New York was all this garbage. Ohio is like everywhere else, there is still a nature scene. New York is different, there is no natural environment as such, it's a man-made landscape of garbage."
(Jim Dine, 1969)

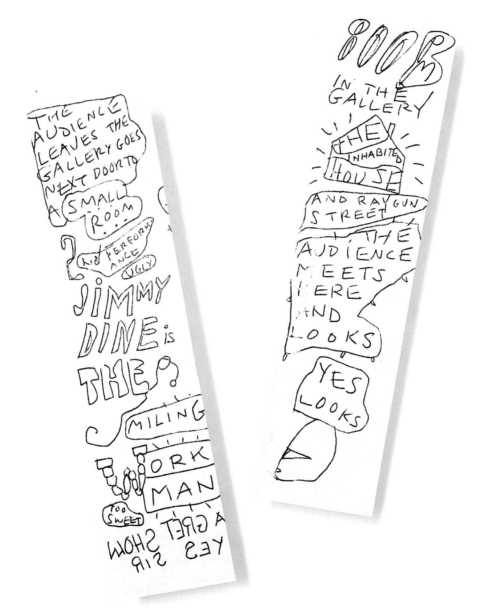

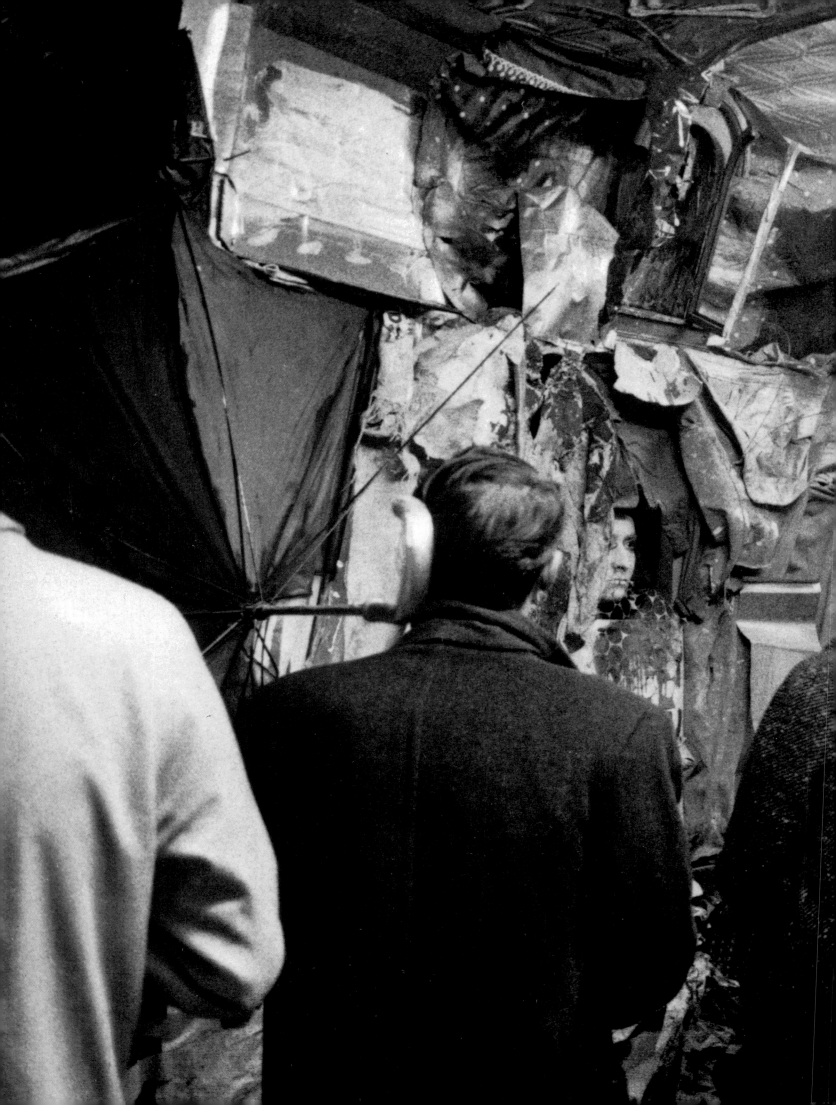

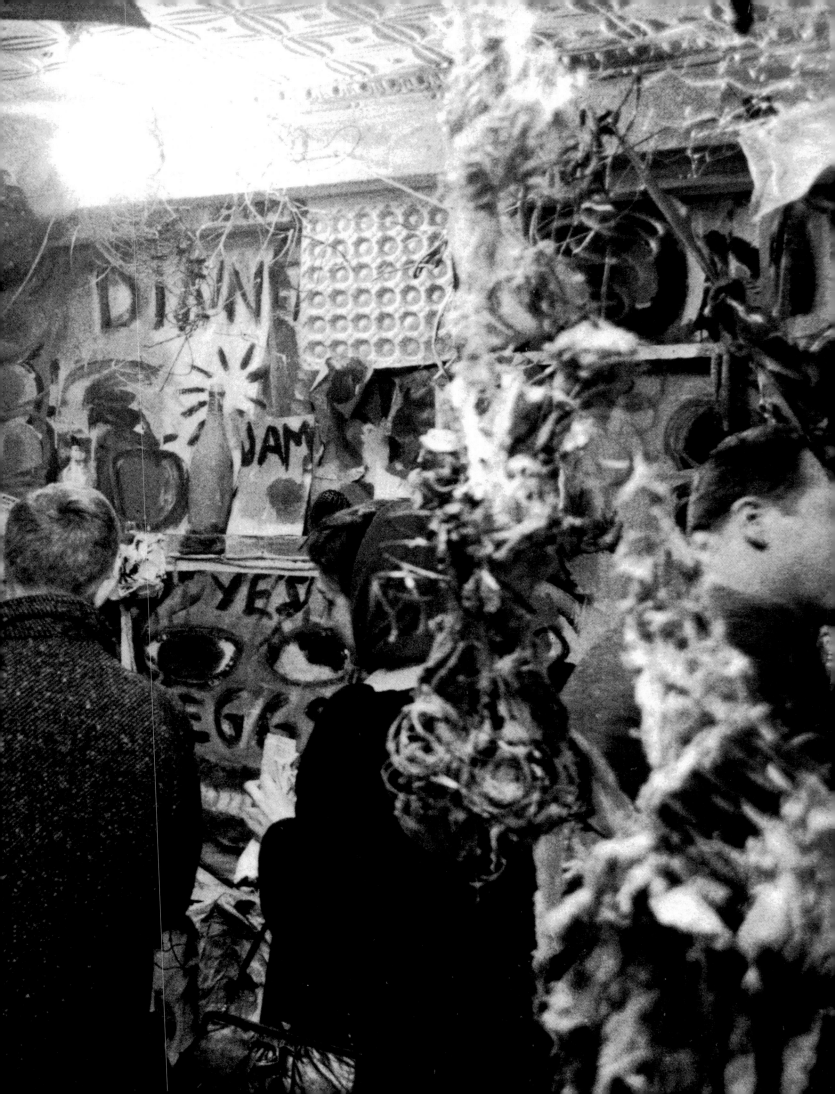

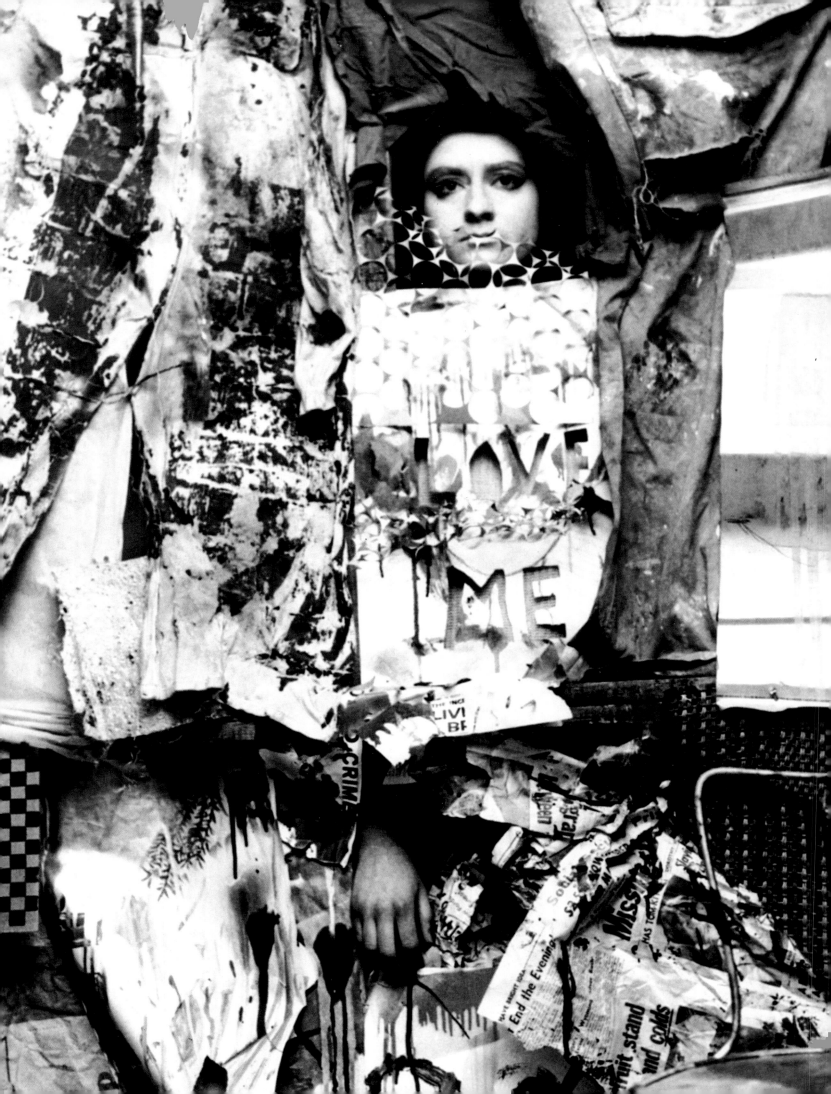

36. Cardboard announcement for Dine's
The Smiling Workman, *part of* Ray Gun
Spex, *a series of performances*
held at the Judson Gallery, New York,
February 29–March 2, 1960
Collection of Jon and Joanne Hendricks

following four pages:
37, 38, and 39. Dine in a performance of his The Smiling Workman, *Judson Gallery,*
New York, February 29–March 2, 1960. Photos by Martha Holmes/Life Magazine
Collection of Jon and Joanne Hendricks

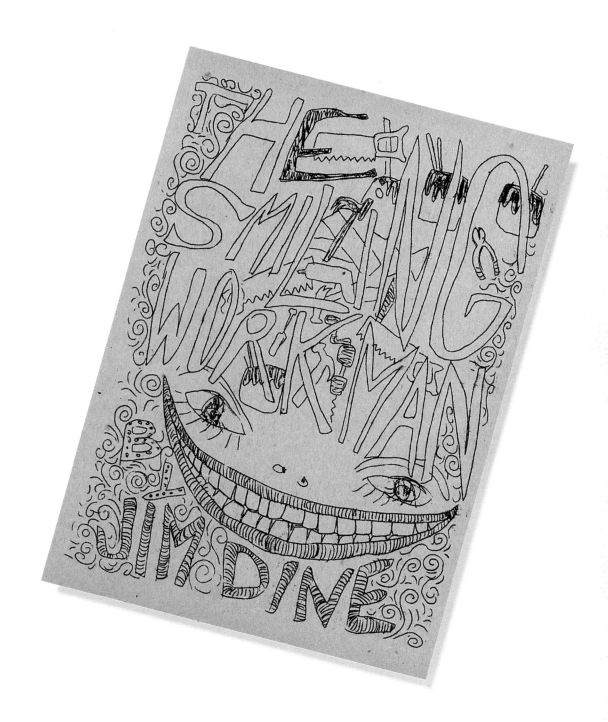

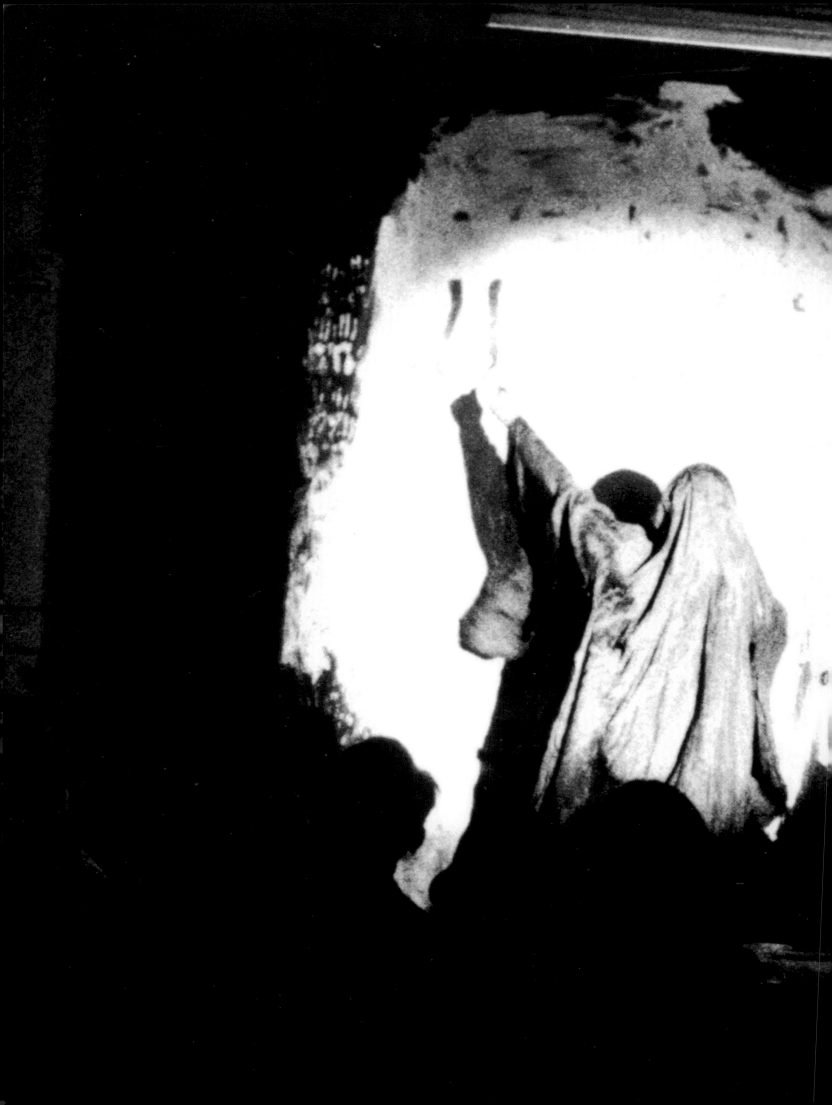

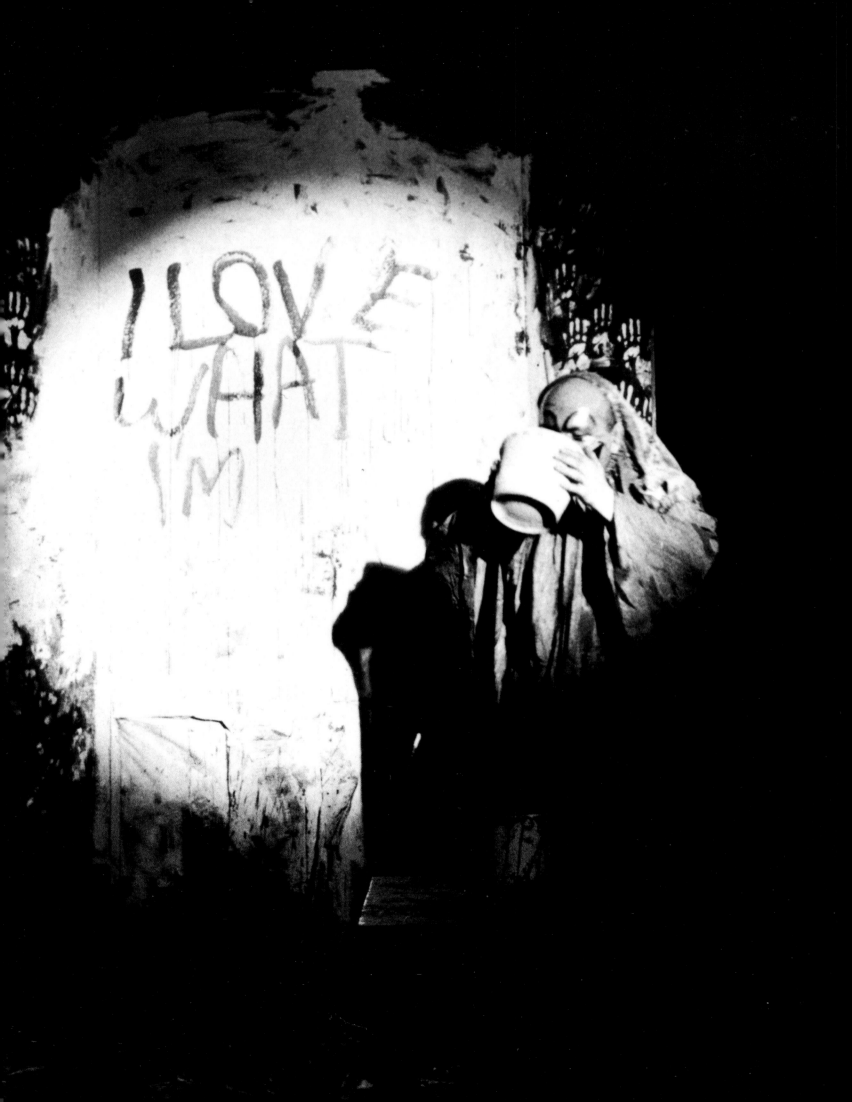

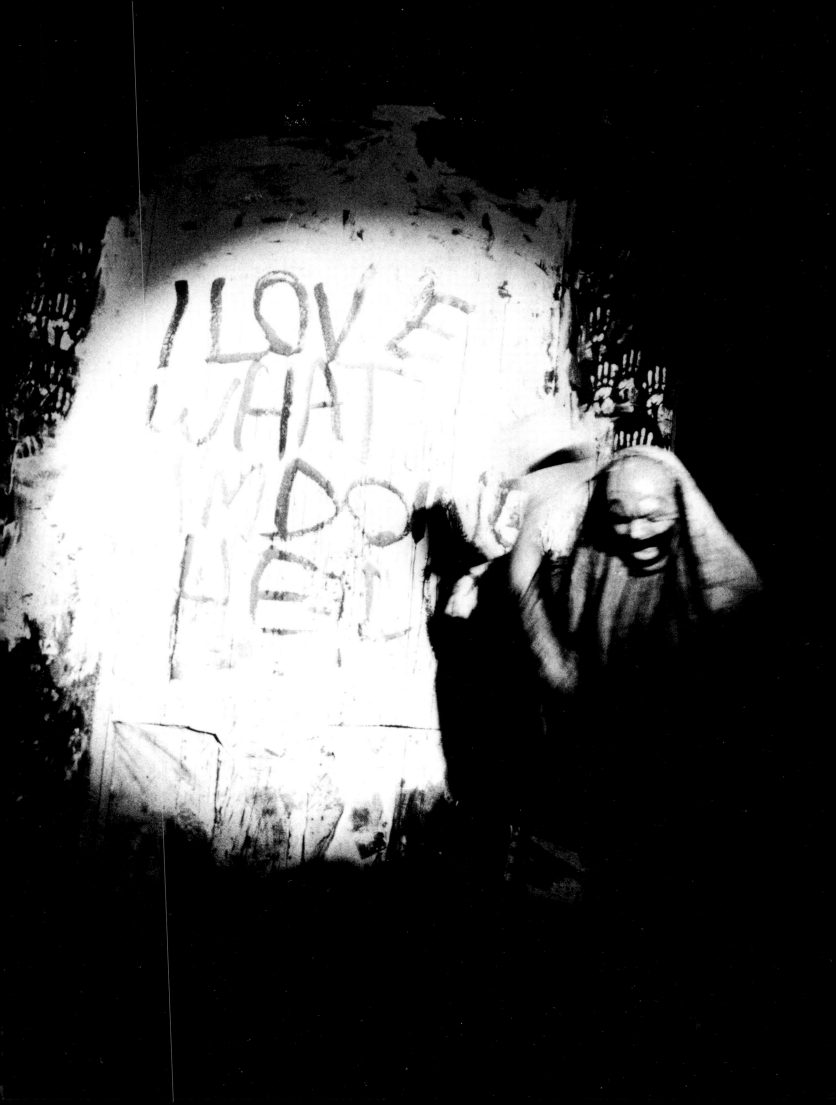

40. Dine in a performance of his
Vaudeville Collage, *part of* An Evening
of: Sound – Theatre – Happenings,
*an evening of performances held at the
Reuben Gallery, New York, June 11, 1960.
Photo by Robert R. McElroy*

June 11: HAPPENINGS AT THE REUBEN

PROGRAM

GOSSOON a chamber-event arranged G. Brecht
 (for Rrose and John)

 movement set by: James Waring, performed
 by: Jean Baker and Jerry King
 sound score: G. Brecht, performed
 by: John Coe and Jackson Maslow
 lights and light score: G.Brecht, operated
 by: Barbara Gilmartin and Adrienne Montgomery

 (Five-minute Intermission)

E.G. by ROBERT WHITMAN
 Starring: JIM DINE as BALL MAN
 ROSALYN DREXLER as WOMAN
 PAT OLDENBURG as WOMAN
 LUCAS SAMARAS as STICK MAN
 (no supporting cast)

INTERMISSION PIECE by ALLAN KAPROW

ELECTRONIC MUSIC by RICHARD MAXFIELD

VAUDEVILLE COLLAGE by JIM DINE

Cast of characters: JIM DINE as THE STRAWPULLER
 and THE DANCER
 THE JUGGLER
 played by LEAFY VEGETABLES
 TWO CHORUS GIRLS
 played by TWO PIECES OF CARDBOARD
 RED PAINT
 played by POWDERED TEMPERA

 some sounds by NANCY DINE
 also some unseen movements
 by NANCY DINE

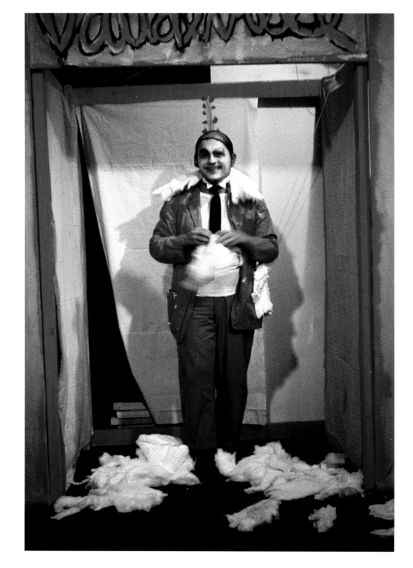

41. *Dancing vegetables in Dine's*
Vaudeville Collage, *Reuben Gallery,*
New York, June 11, 1960.
Photo by Robert R. McElroy

42. *Dine in a performance of his*
Vaudeville Collage, *Reuben Gallery,*
New York, June 11, 1960.
Photo by Robert R. McElroy

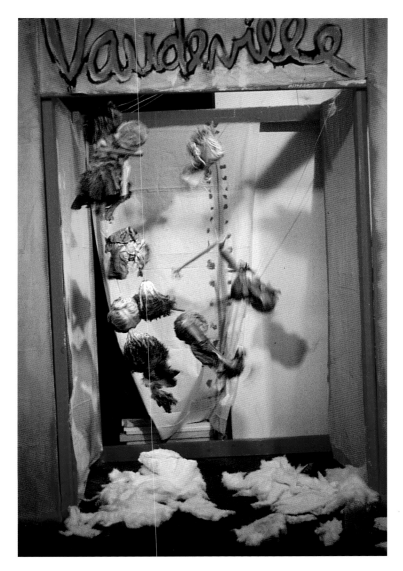

41. *Dancing vegetables in Dine's*
Vaudeville Collage, *Reuben Gallery,*
New York, June 11, 1960.
Photo by Robert R. McElroy

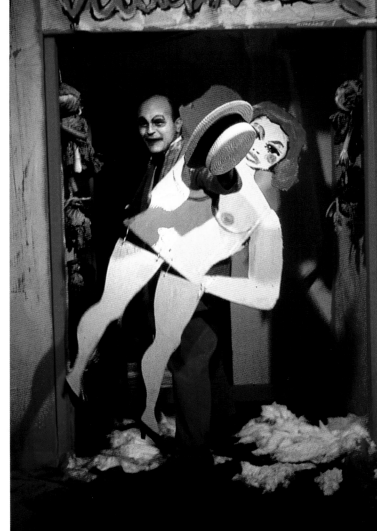

42. *Dine in a performance of his*
Vaudeville Collage, *Reuben Gallery,*
New York, June 11, 1960.
Photo by Robert R. McElroy

OH MY OH MY GUM SHOT DAMN DAMN
DAMN OH SHOT OH CROTCHO OOOOOOH
MY CAR IS THE WARM PART OF A SOUL
BEARING THE GOOD OH MY GAAAA. . .

(from Car Crash, *1960)*

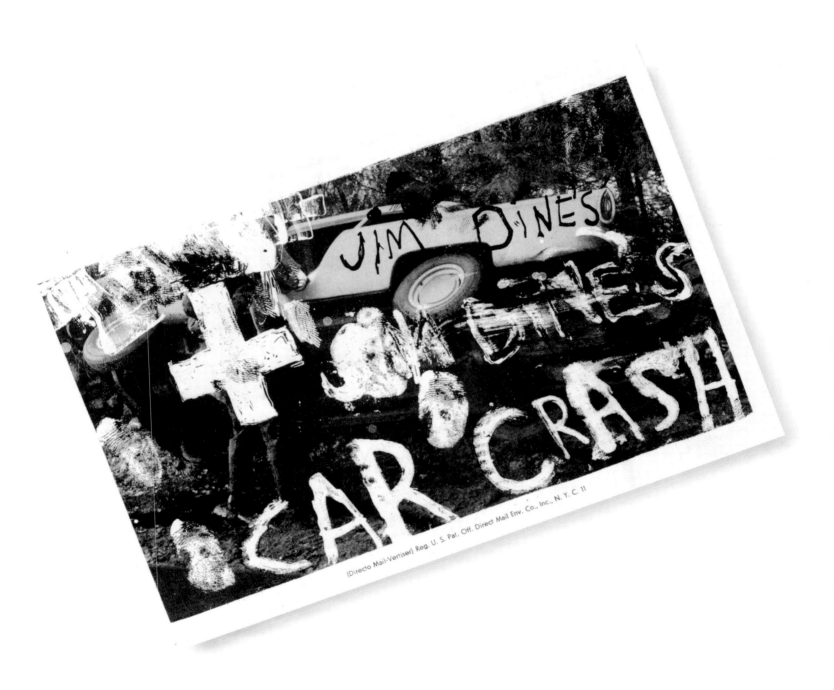

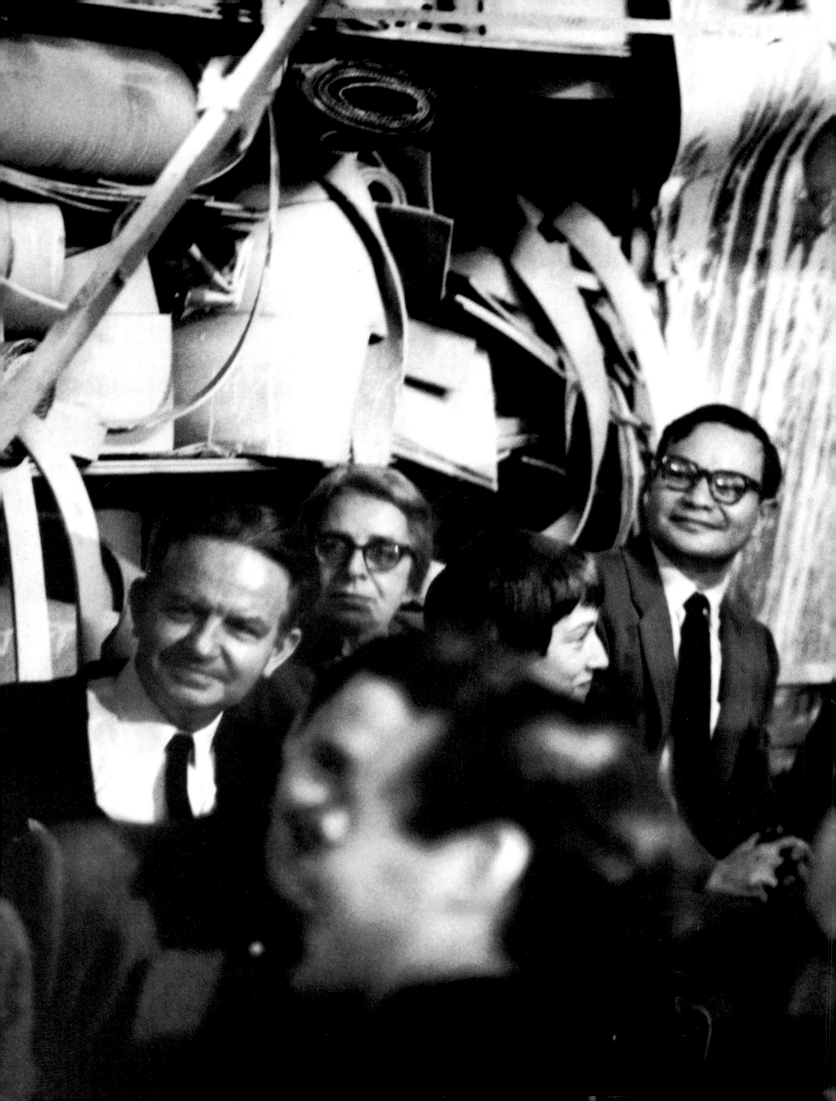

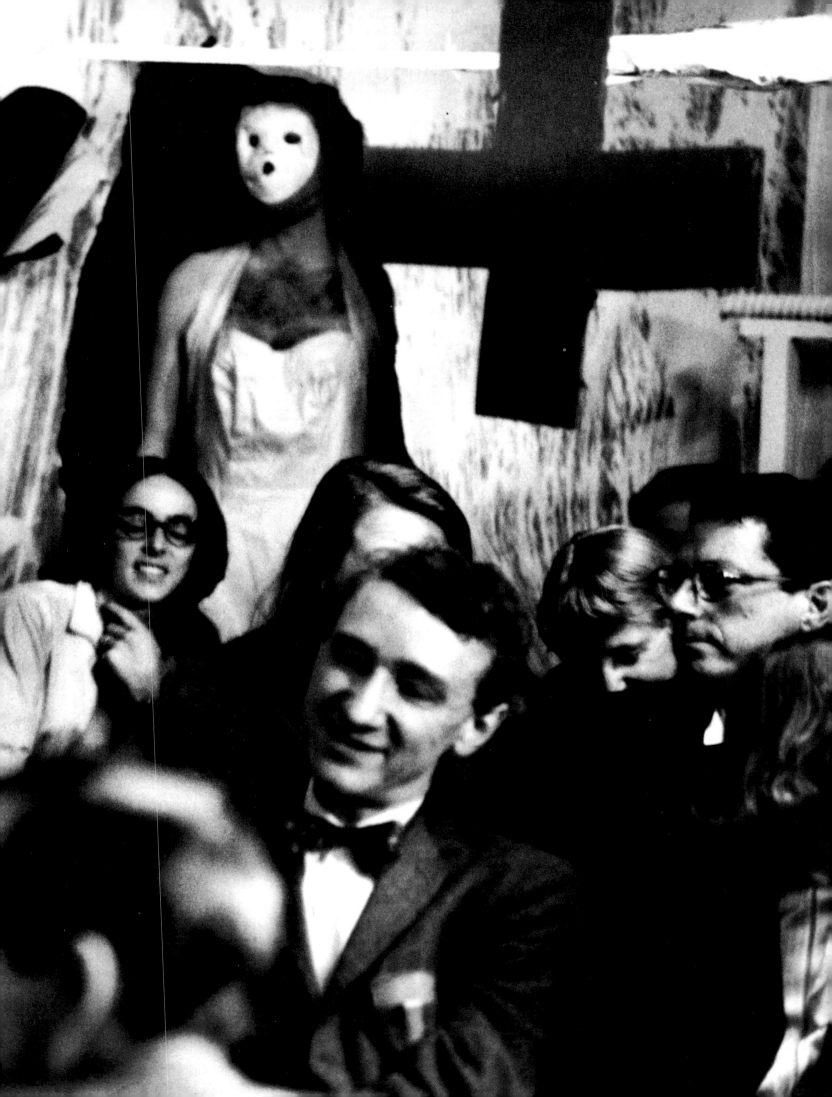

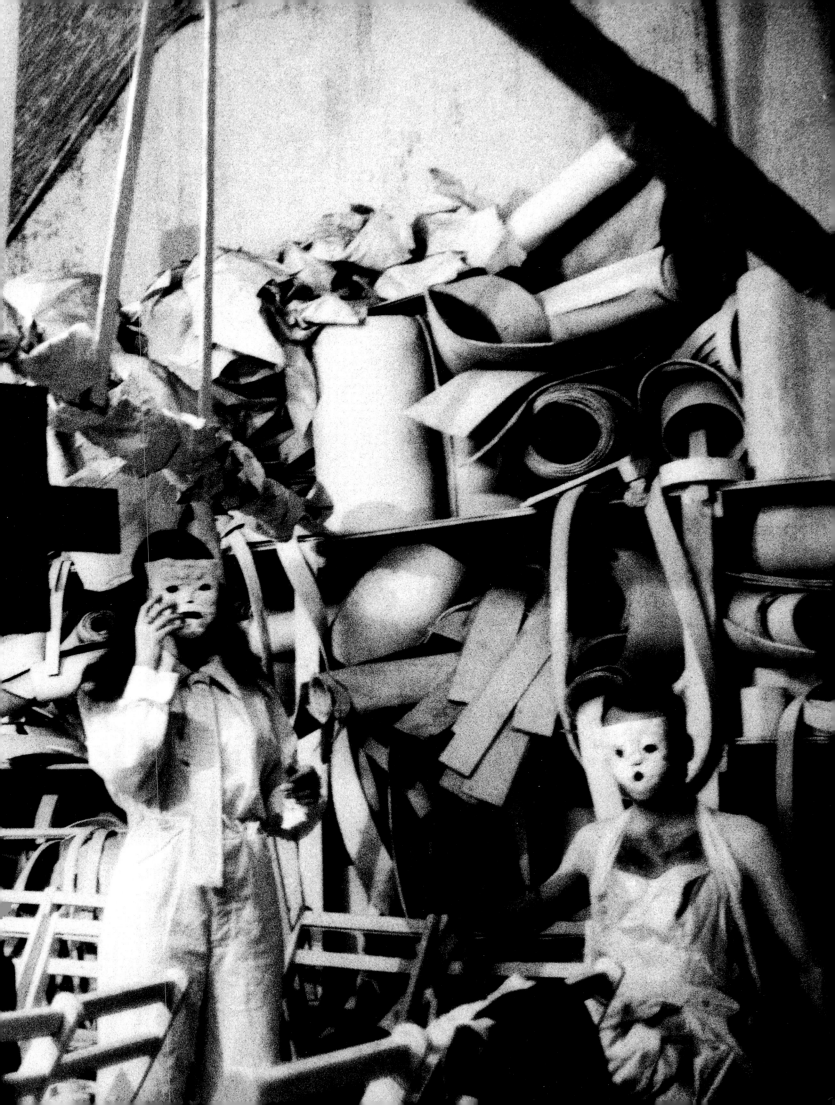

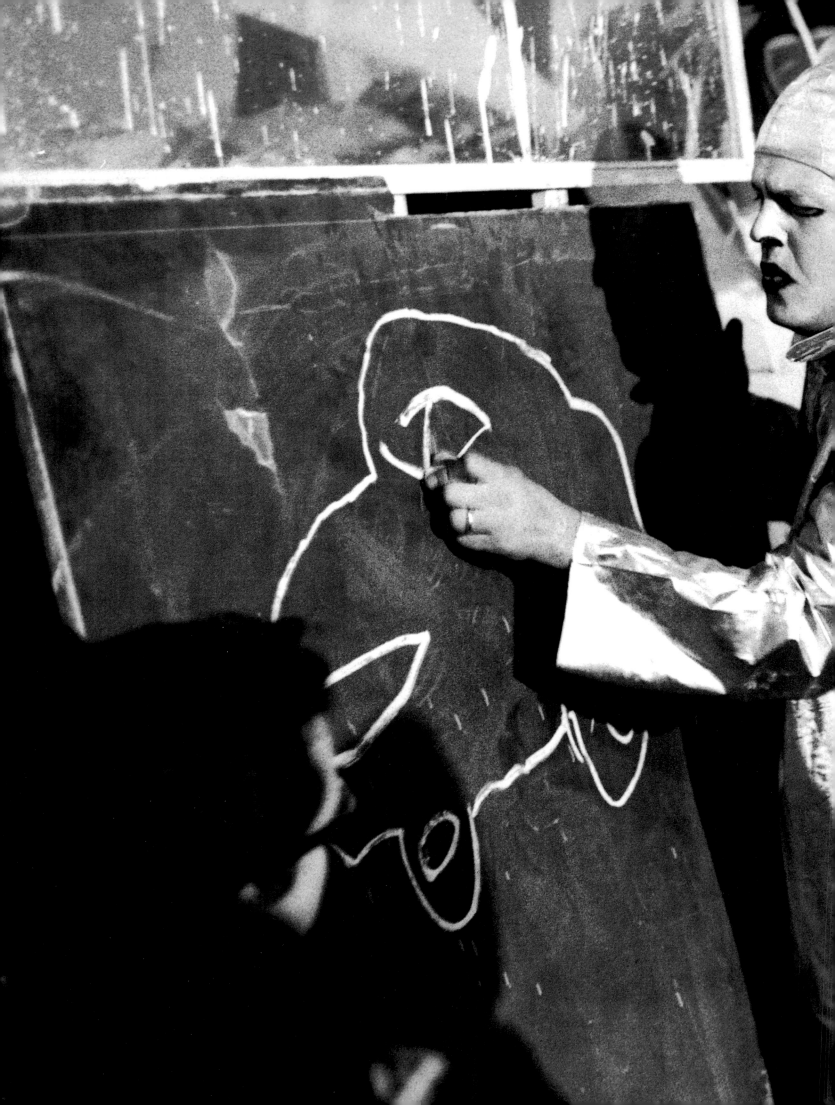

47. Untitled, *1959–60*
Mixed-media assemblage: Oil, gauze,
cardboard, baby-carriage wheels, and staples
on canvas
1 foot 5 inches x 10 feet (43.2 x 304.8 cm)
Herbert F. Johnson Museum of Art,
Cornell University. Gift of Inez Garson
in Memory of Alan R. Solomon (1920–1970)

48. The Valiant Red Car, *1960*
Oil on canvas
4 feet 5 inches x 11 feet (134.6 x 335.3 cm)
National Museum of American Art,
Smithsonian Institution, Washington, D.C.
Gift of Mr. and Mrs. David K. Anderson,
Martha Jackson Memorial Collection

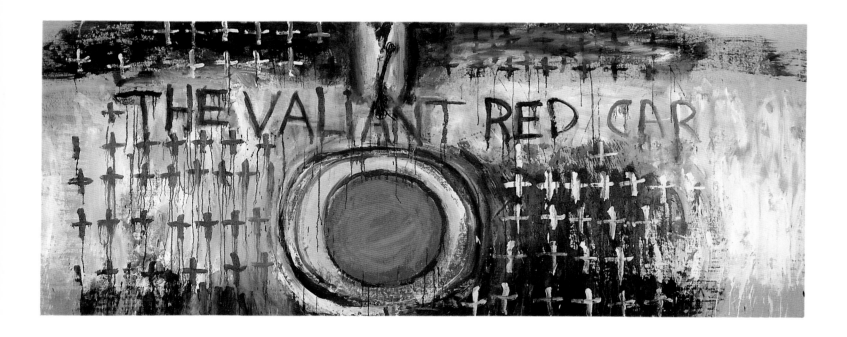

49. Car Crash, *1960*
Oil on canvas
6 feet 2 inches x 6 feet 10 5/16 inches
(188.9 x 209 cm)
Private collection

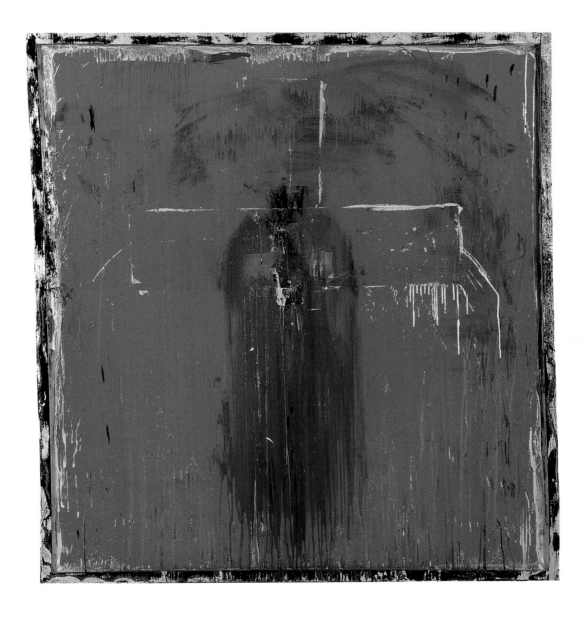

"That was my best one — the one I liked the best. It was the most beautiful one
(Jim Dine, 1965)

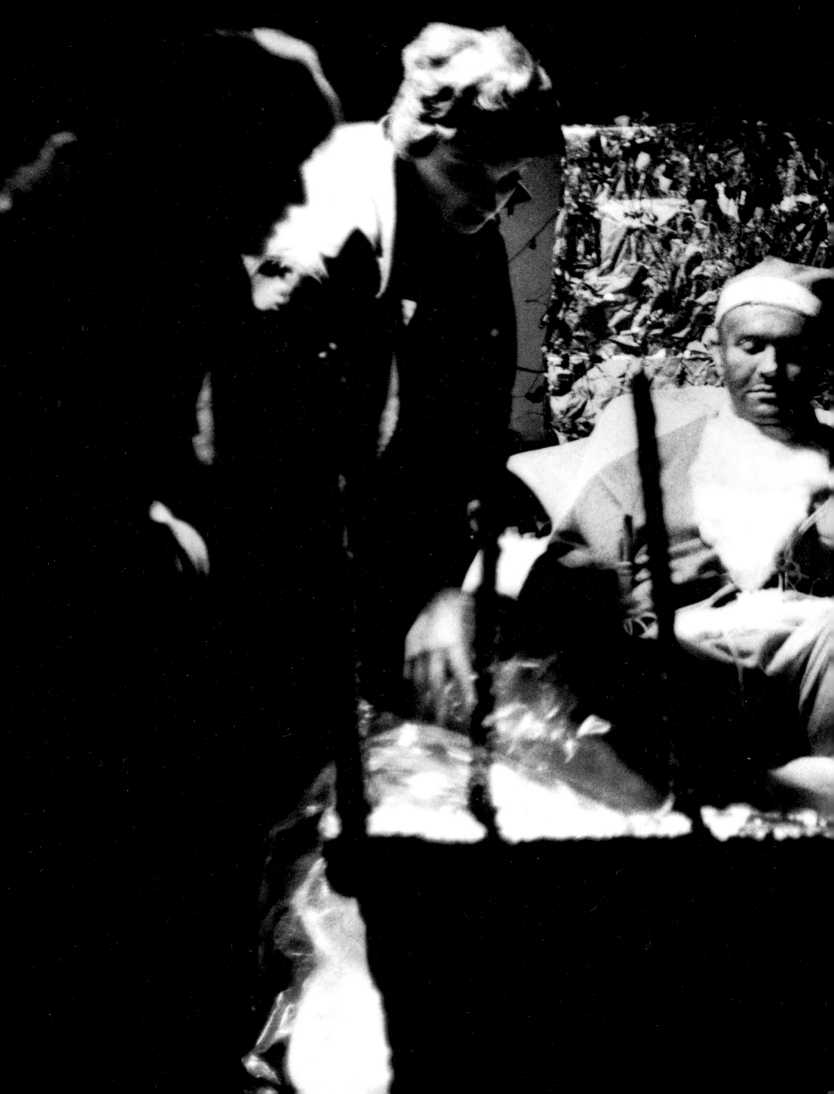

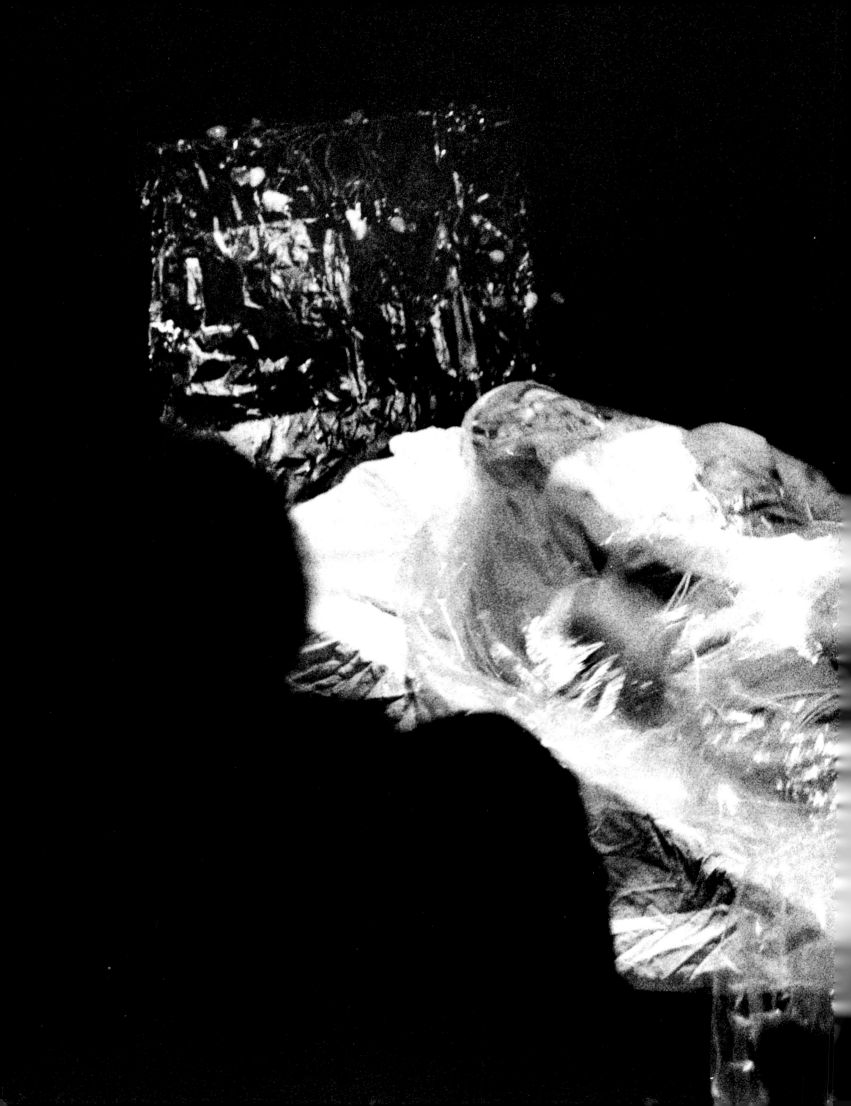

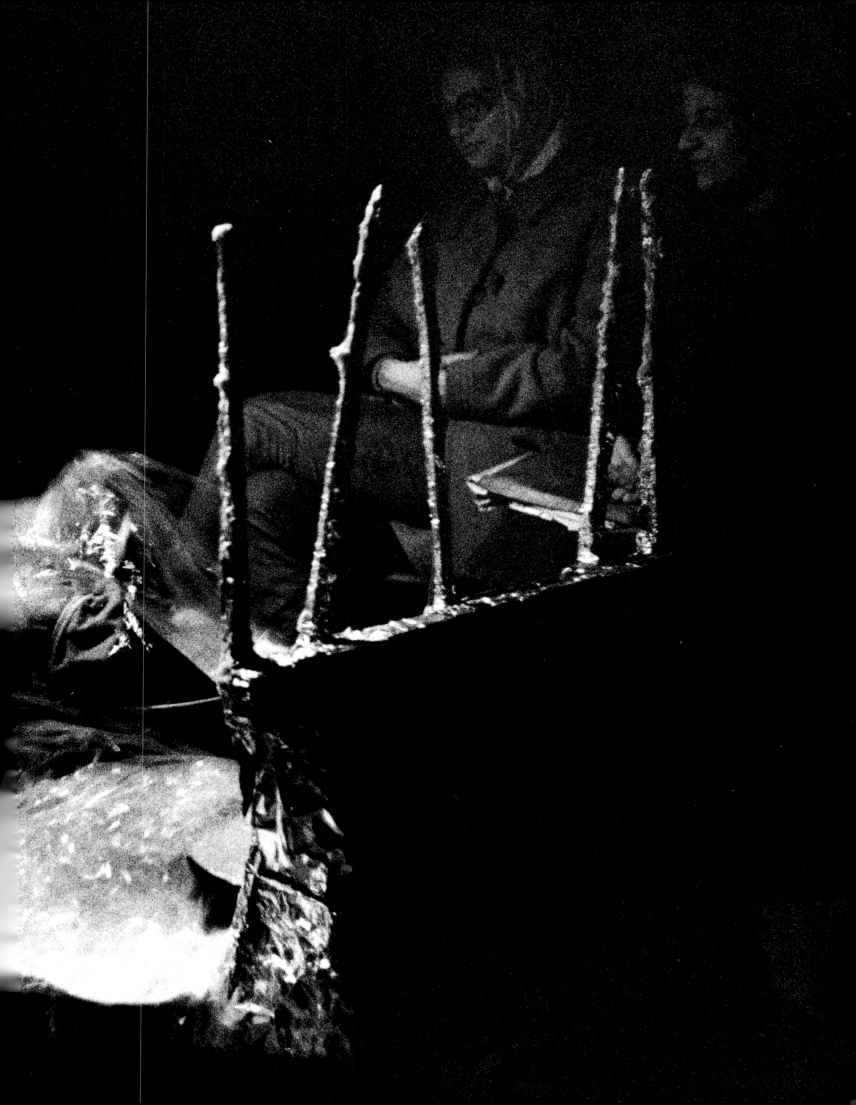

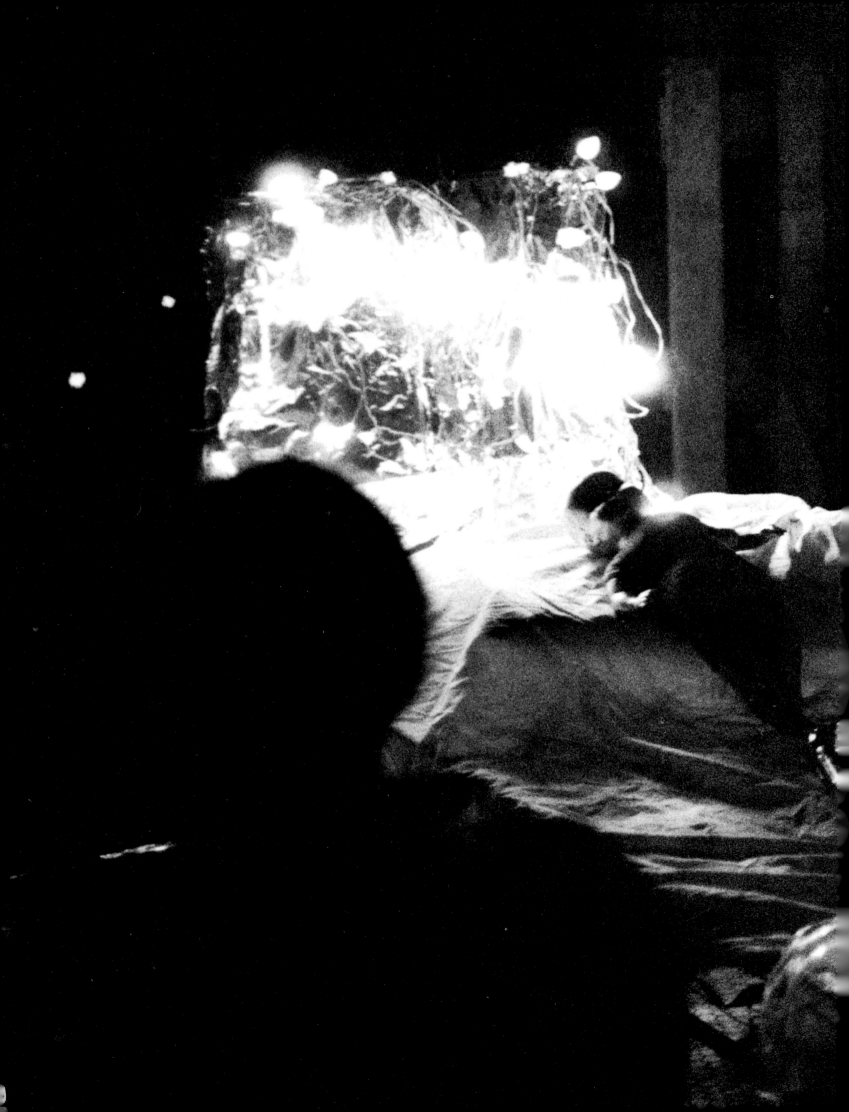

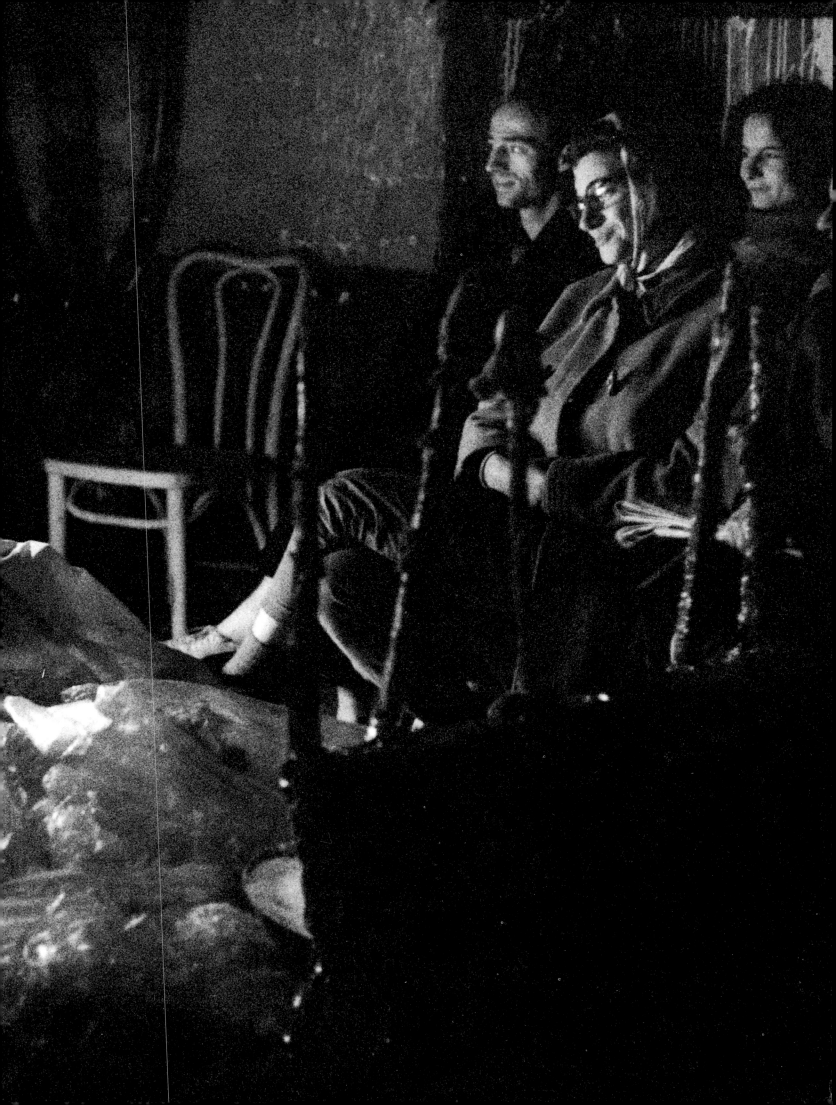

PORTRAIT

I was the boss of a bar in the fifties when he came in with that canadian and started keeping poets time Just at that moment this big stevedore intellectual came up behind him and lifted him up by his good eye He went splat Years later he was still frantic and feeling like things dont go together easily at all

(Jim Dine, 1969)

54. *Announcement for* Jim Dine
exhibition held at the Reuben Gallery,
New York, April 1–14, 1960
Collection of Anita Reuben Simons

following two pages:
55. *Dine in costume at the opening for the*
Jim Dine *exhibition at the Reuben*
Gallery, New York, April 1, 1960. Photo
by Robert R. McElroy

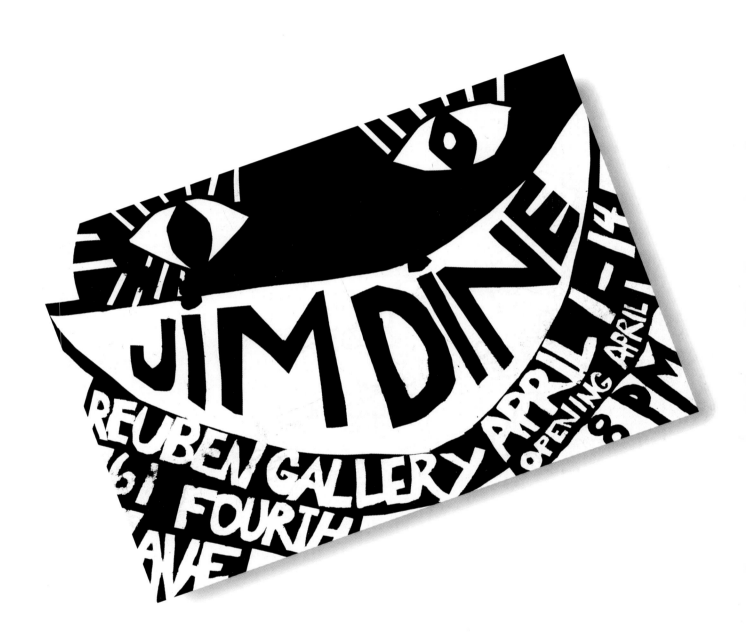

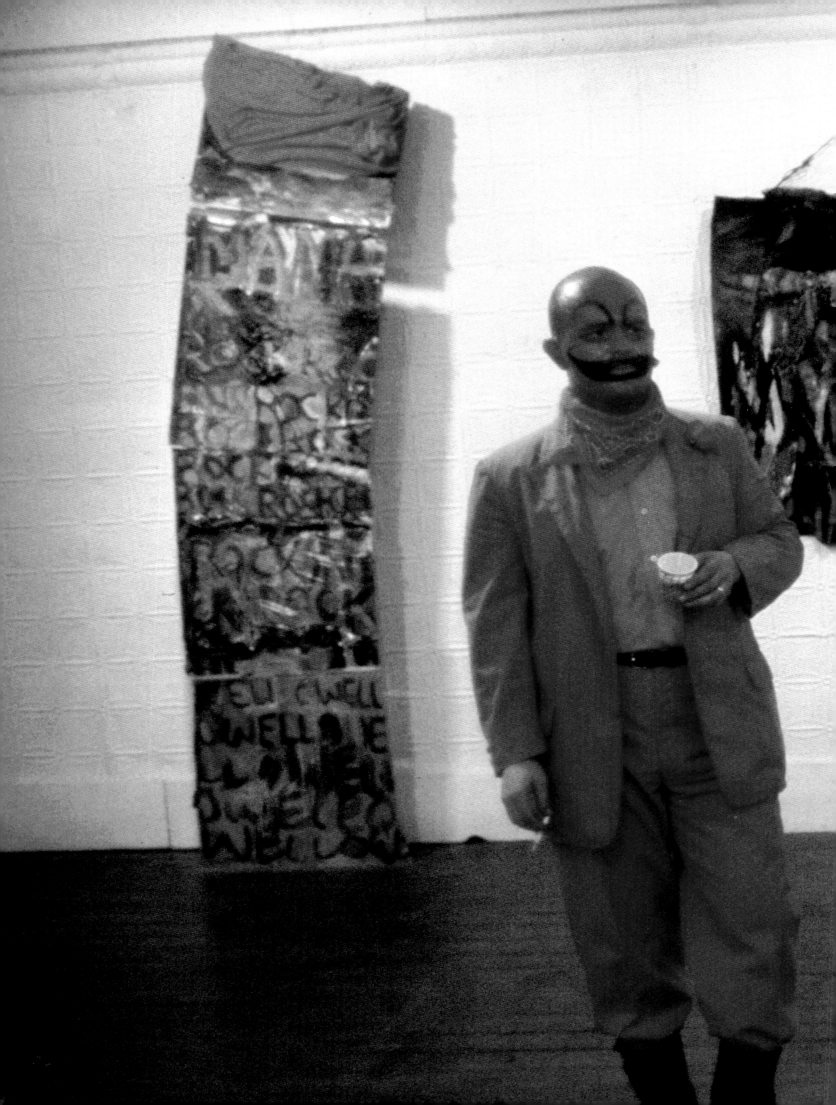

CB: Why did you dress up for the opening night of your show at the Reuben Gallery in the spring of 1960 [fig. 55]?

JD: It was a one-man-show, and I remember Irving Sandler had reviewed the show by looking at the work two months earlier, and then I made all new work. I just made all new work, and I dressed up in my khaki suit that I had dyed red. I wanted to be in the work. I wanted to be part of the work. It was part of the time; you felt like you could do that. Take what you like, but it's me.

GC: It was a gesture that the previous generation would never have attempted.

JD: They would have been embarrassed by it. They would've said, "This isn't serious. We are not actors. We are serious intellectuals. We are not circus performers, we are serious people. We are intellectuals." Whereas I said, "I am what I am." You know, I am what I am—I am the art, and I am also the man who makes the art, and I look at the art, and that's it. I am in it! That's me!

CB: Some of your earliest paintings made during the time of the performances, such as *Two Nests* [November 1960, fig. 56] and *Green Lips* [1961, fig. 61], treat the central image as a reduction of form. The images operate as holes that allow for closer introspection to the canvas itself. In *Two Nests,* it is possible to read: "This is a Portrait of 2 Persons by Jim Dine November 1960." Were these, in fact, portraits?

JD: *Two Nests* is on Masonite, and I remember making it, and painting it, and trying to make a painting. Then I took a drill, and I started to drill these little holes and I made it look like bees' or wasps' nests. And so, then this whole thing became this object.

CB: Were you at all conscious of trying to undermine the idea of the masterpiece by literally drilling right in the middle of the painting?

JD: I don't have any of those kind of what I would call destructive aspects of undermining the masterpiece. That's a little too political for me. One of the things that I use as a medium in my work and have always used is anger. I get pissed off. All my life I've had anger, and when I get pissed off and I'd see a thing doesn't work, or say I'm pissed off about something else, I have put axes through canvases, I've kicked them in half, I've balled them up, I've taken drawings and soaked them in water, made them into a ball and threw them against the wall, and that's all I need to do, and then it's over, and I peel the drawing open, put it up and I start again. And I never ever think of that as a method; but thinking about it now, it was a method.

GC: So the object is morbid in a certain way?

JD: It's an old alchemical idea from the Middle Ages. You make gold from shit. You turn sand into gold. *Green Lips* and the others are what I would call "interior paintings." They were much more focused on this primary small central object. I was trying to harness my craziness, and I was trying to be cool. And you know, you can't make somebody "be cool," but for a few months I was. I did them before I was able to burst out with *Hair* [1961, fig. 66] and make something that was more strong.

GC: So they were a kind of training?

JD: Yeah, but also I was not pleased with being this Expressionist boy. I mean, I've come to accept that about myself, that's what I am, a Romantic Expressionist artist, but in those days, I wouldn't want to have had that title. I wanted to be cool!

GC: Let's talk about the language of painting that you developed over those three years following the waning of Abstract Expressionism.

JD: In the first place, I am a student and a child of Abstract Expressionism. I simply learned to paint by looking at those paintings. I would come to New York City from Ohio University in Athens at least once a month. Drive all night, go to about a hundred shows, see de Kooning dead drunk on the street, on Tenth Street, go home, try to do it again. Try to do it! Try to get that freedom, try to get rid of those regional brushstrokes I had. Purposely! Because I thought it was beautiful painting. Already I knew how Picasso put the paint on. It's like I was born with certain facilities, and one of them is I *can* paint. I don't have an awkward hand, particularly. Sometimes. In fact, I had to make it awkward at times, so that I could live with it. It becomes too glib. So, I tried that. Then I saw—whenever that show was, but I think it was '57, maybe it was '56—Jasper's show with the *Target* with the penis and all this stuff, and the *Flag*. The *Flag* meant nothing to me. I still don't think it's such a brilliant thing. I thought the *Targets* were something amazing, with the objects above them, the way he did that, and the way I saw it, and the use of this encaustic, which was so much his. That's why I consider someone like Serra a beautician. He looked at Johns and threw some lead, because that was Johns' aesthetic, you know. Johns had a kind of cuisine that he developed in paint. I am not speaking content; I am speaking purely painting. That for me is some of the most beautiful painting probably since Titian. Some people may be offended by it. I don't think I even like the way he paints particularly now, but it's the relationship his hand and eye have to paint. And encaustic worked well for him, lead worked well for him. So, I saw all that work, and in my youthful, childish ambition, I wanted to do something like that. But I knew I didn't want to use encaustic, because that was already Johns's. And I had used it, funny enough, I did use it once, but those things don't exist anymore. I stole crayons, wax crayons, when I was teaching little kids, and I used to steal them by the carton. And I'd boil them on the stove and I'd paint with them. Because I didn't have any money anyway, but I hated it. I wasn't getting what he was getting. He was a master of this. So I started to use paint in a way as though paint was an object itself.

56. Two Nests, *November 1960*
Oil on Masonite, with drilled holes
Two panels: 7 x 4 feet (213.4 x 121.9 cm) each
Private collection, New York

57. Hanging Chair #2, *Spring 1960*
Mixed-media assemblage: Oil, three-legged
chair, jewelry, purse, undershirt, string,
and polyethylene plastic
34 x 19 1/4 x 15 3/4 inches (86.4 x 48.9 x 40 cm)
Allen Memorial Art Museum, Oberlin College,
Ohio. Gift of Tom Wesselmann, 1972

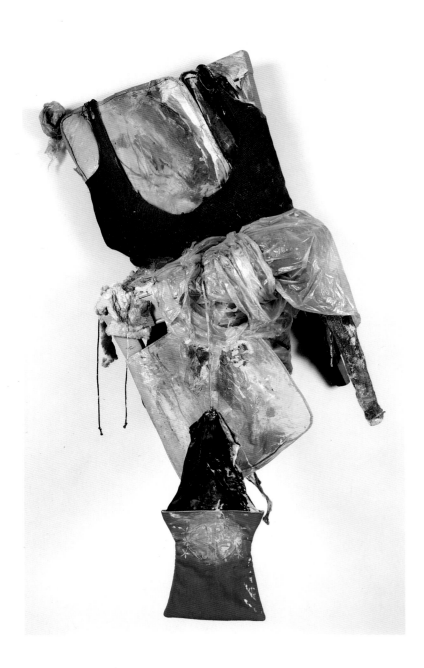

58. Bedspring, *1960*
Mixed-media assemblage: Oil, metallic paint,
candles, metal candle holders, paper,
corrugated cardboard, canvas, newsprint,
waxed paper, tissue paper, tape, rags, burlap,
corduroy, wool, plaid cloth, bowtie, carpet,
aluminum foil, and light bulb on steel-wire bedspring
4 feet 4 1/4 inches x 6 feet x 11 inches
(132.7 x 182.9 x 27.9 cm)
Solomon R. Guggenheim Museum, New York.
Purchased with funds contributed by
the Louis & Bessie Adler Foundation, Inc.,
Seymour M. Klein, President

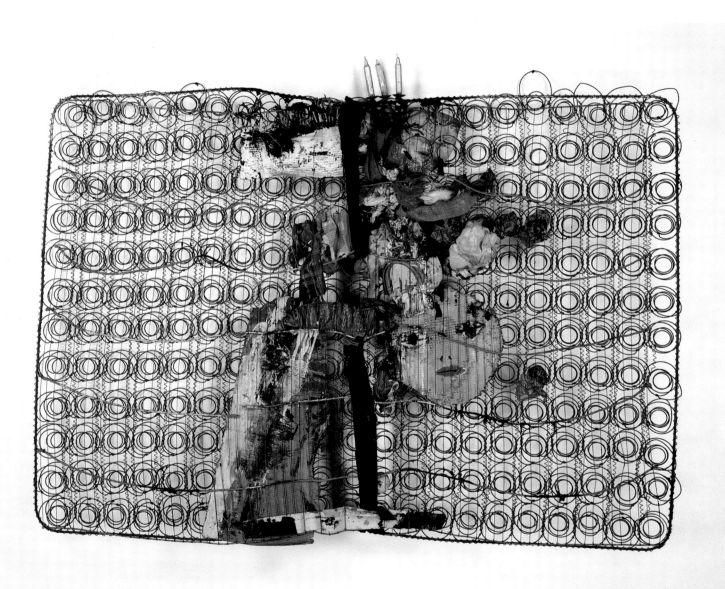

59. The Black Rainbow, *1959-1960*
Oil on cardboard
39 5/8 x 59 3/4 inches (100.7 x 151.8 cm)
Whitney Museum of American Art, New York.
Gift of Andy Warhol

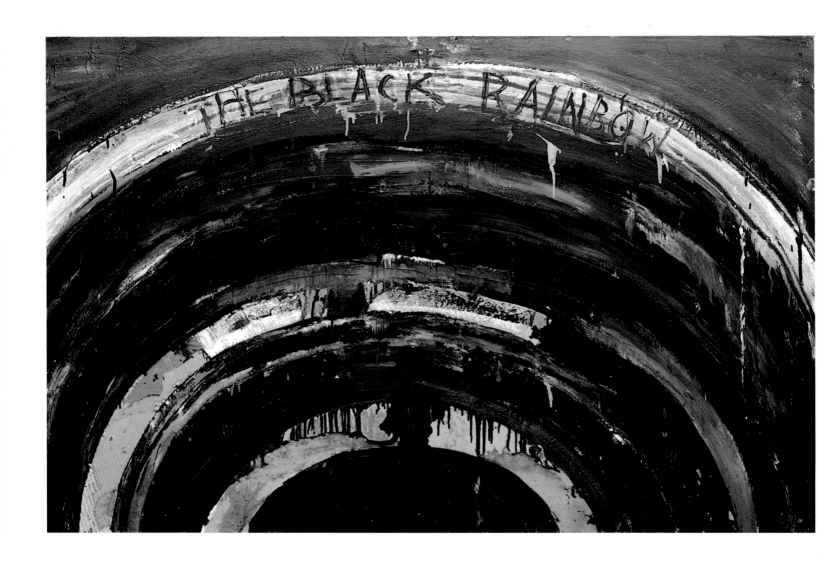

60. The Birth of the Black Rainbow, *1960*
Mixed-media collage: Oil, pastel,
and torn cardboard on wood panel
39 3/4 x 59 3/4 inches (101 x 151.7 cm)
The Museum of Modern Art, New York.
Gift of R.L.B. Tobin

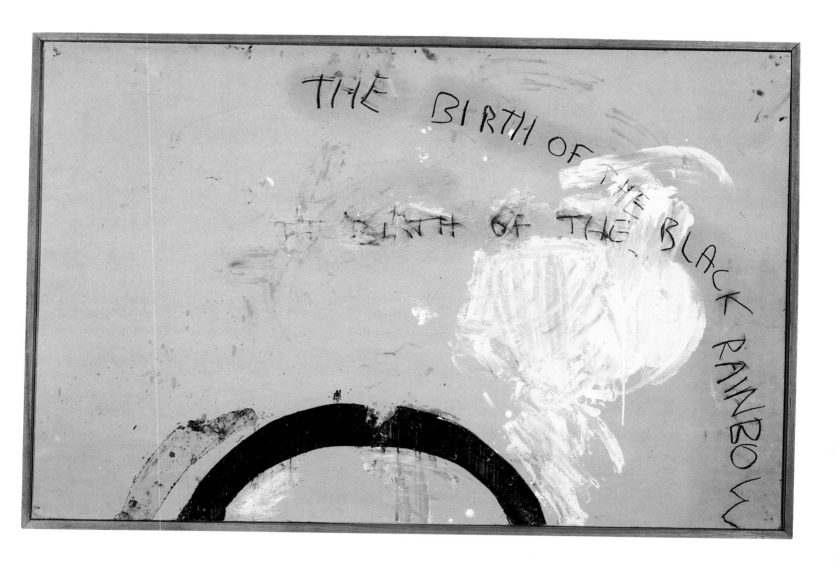

62. Fred Astaire and Ginger Rogers,
February 1961
Mixed-media assemblage: Oil and electrical cord
on plywood
6 feet 1/4 inch x 4 feet 1/2 inch (183.5 x 123.2 cm)
Private collection, New York

"I trust objects so much. I trust disparate elements going together."
(Jim Dine, 1966)

63. *Statement by Dine in the catalogue*
for Environments – Situations –
Spaces, *an exhibition held at the*
Martha Jackson Gallery, New York,
May 25 – June 23, 1961
Whitney Museum of American Art,
New York

following two pages:
64. *Dine pictured in his* Spring Cabinet,
an environment included in the exhibition
Environments – Situations – Spaces,
held at the Martha Jackson Gallery,
New York, May 25 – June 23, 1961.
Photo by Robert R. McElroy

This SPRING CABINET is made of canvas
and acrilic resin paint. There are also
behind the scenes electric fans who work
for it.

There is also a goodly amount of lights and
switches and plugs.

There are visible paint cans with liquid
coming out of them.

The spring cabinet is meant to be very green
and much like a color-value of this time of
year.

The cabinet is nourished by the floor pallet
which eats the green paint.

The colors used are natural to paint and used
by it to make it a part of art–nature.

My wish is that you see the SPRING CABINET
like it was made.

JIM DINE

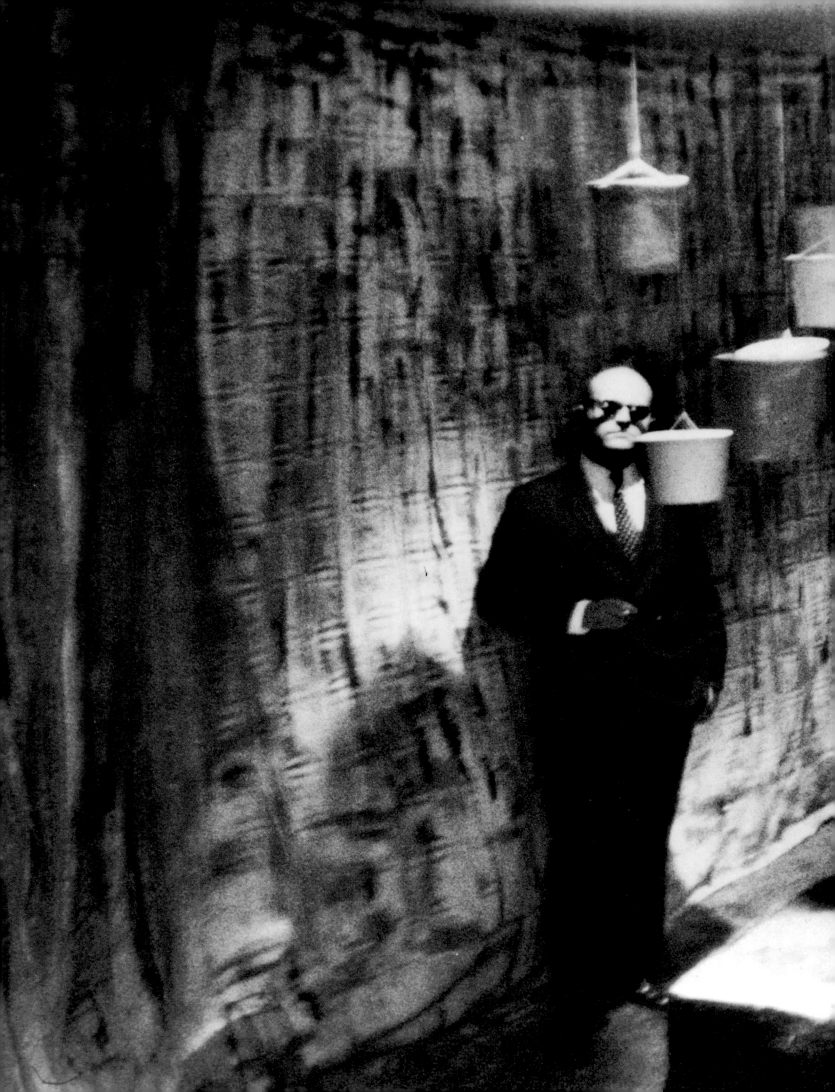

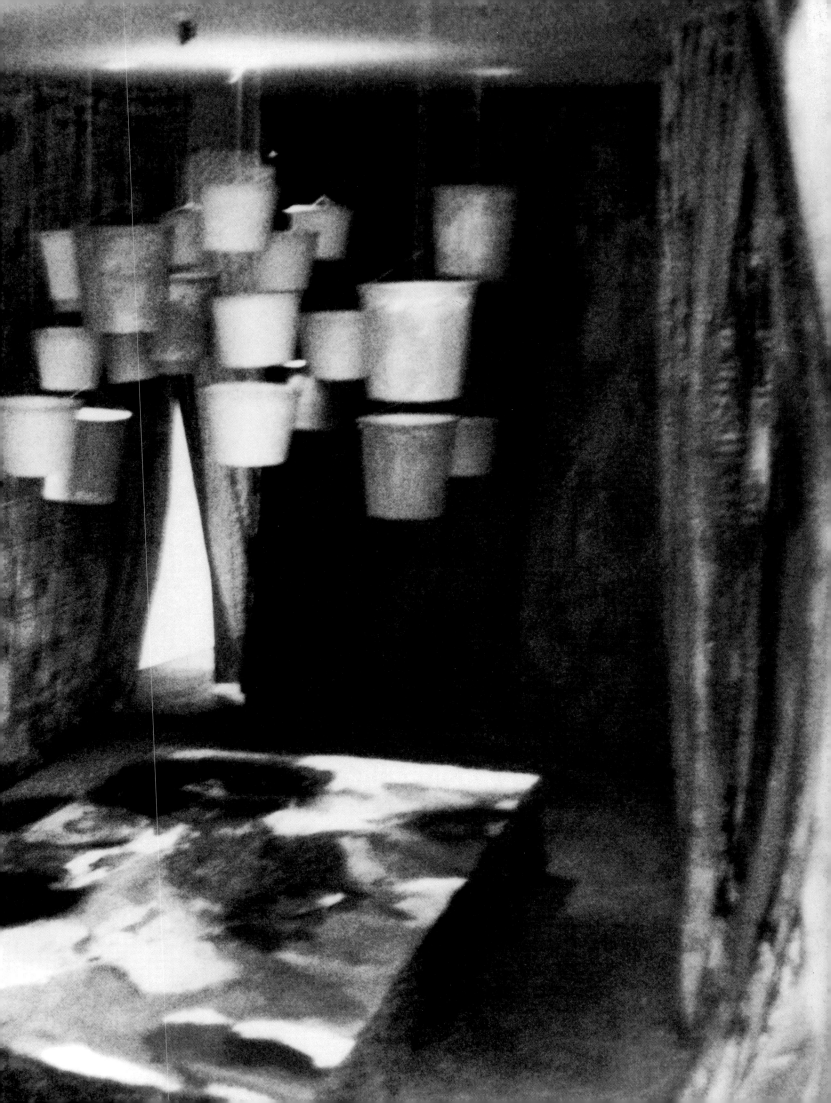

facing page:
65. Nancy's Tie, *1960*
Mixed-media collage: Aluminum paint,
gesso, and cloth appliqué on canvas
63 1/4 x 39 1/2 inches (160.7 x 100.3 cm)
Private collection

EXPRESS

For years i plan what ill wear for overnite As the
 time to leave gets closer i panic and change it all
 Some of my advisers think im hysterical My voice
 gets louder and sharper like a rat I leave and go
 thru the wet ice passage to board the train that will
 go on land and water to put me in the city My
 companion in my compartment is a large southern man
 with a gruff cough Before we get into our beds the
 train pulls out and a woman walks down the hall and
 we both eye her so that the other one will see This
 reassures both of us that neither one is queer We
 now can sleep At a certain point i am woken by the
 rolling and pitching of sea Next door there is the
 sound of stainless steel vomiting I eat a pear I
 wake up on an icedover window speeding forward route
Two hours later the train gets us to the city Oh yes
 once during the night i forgot to say that the man
 sharing my compartment breathed heavily and i thought
 for a second since it was dark and all i could see
 was my green glowing watchface that he was my wife
 and i was at home in my own bed and i wasn't moving
 and i was afraid

(Jim Dine, 1969)

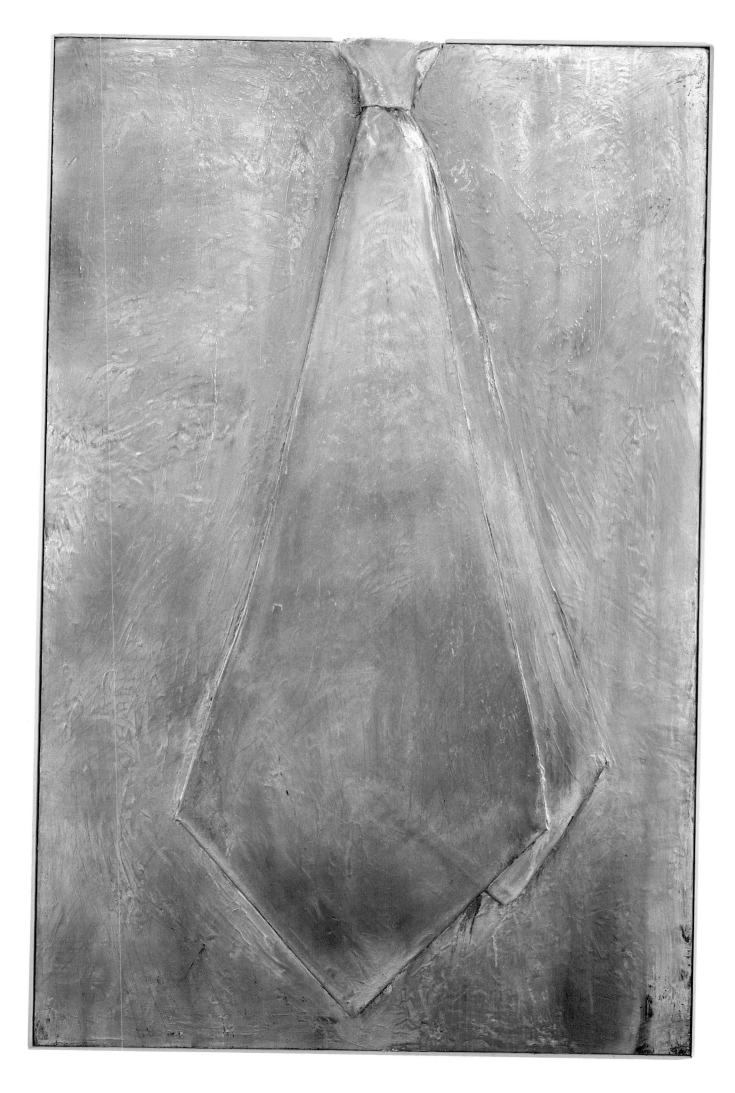

GC: You sometimes have a calligraphic way of handling paint. Where does this come from?

JD: In *Hair* [fig. 66], the ribbons of paint do not come from Jackson Pollock at all. If it comes from anything, it comes from *Dick Tracy*, the American comic book. The cartoonlike depiction of hair. That's what I was trying to do—to find a way to depict hair in paint rather than in wood or steel or whatever. I thought that by squeezing it out of the tube, I would get this feeling.

CB: Was it the graphic quality of the comic strip that you were trying to achieve?

JD: I was going for a quality of the relationship of paint as a physical object.

GC: So you were specifically looking for three-dimensionality.

JD: Yes. A piece of red paint is no different than a pencil if I use it, or vice versa. If I use a yellow pencil, I use a yellow pencil. If I use a piece of yellow paint, that's another kind of object. They all have history. I know that. I know that when I put a hammer down, a hammer has an association for people, and if you have a new hammer, it's a different association than if you have an old hammer.

CB: So, it's about the object and not the gesture.

JD: It's not gesture. Exactly. It is memory, it's a collective memory. I was confident, always confident, that somewhere one person would understand it, because it was in the human consciousness. A hammer, it's a primary object.

GC: And why the addition of the name?

JD: I think it was sometimes a lack of confidence I had that people would understand what it was. Because if I didn't say "hair" on there, what would you think it would be? You could say it's a flesh-colored landscape. I mean, it was like saying, "This is what it is." It was purposely dumb in a way.

GC: Is it tautological?

JD: It is tautological. I was going to use that word, but I didn't know if I should. Öyvind Falström used that word to describe my work when he wrote about me in '62. He talked about tautology.

CB: Were the works you made in 1961 conceived in series?

JD: I remember making a group of paintings at one point that year—*Tie Tie*, *Green Ties in a Landscape* [fig. 73], and *Hair*. Now, I made those in the course of maybe two weeks altogether. All in one time. Each one is painted differently. The idea that those paintings painted so differently are painted at the same time doesn't mean that I was schizophrenic, it means that I had one intention and a lot of ideas around the intention. And that there were some ways to make certain things one way, and in another idea you do another way. There is a way to make a poem, there is a way to sing a song, there is a way to write a novel. It can come from the same person.

CB: What does the tie represent?

JD: What did occur to me was that the tie was a vaginal form.

CB: Not a phallus?

JD: No, the tie was a vaginal form. The tie was also a beautiful object in itself, because of the patterns that could be done.

CB: Many of the works feel as if you are looking at the object under a microscope. The idea of territories or parameters enter the work. Why the idea of the close-up?

JD: *Blonde Hair* [1961, fig. 67] is made this way. I wanted to make something more formal than *Hair*. Literally more formal, so I used my hands to paint with. But not in a gestured way, I used my hands as though they were a tool for making vertical lines in the paint. A tool like a comb. And

in *Red Knife* [1962, fig. 82], I thought I was doing something like Johns with the red background, but in fact it was nasty and ugly, because I painted it in a way, not like Johns with love, but with anger. And it came up looking different, really different.

GC: The idea of hanging that pervades these works is really powerful because there are so many connotations.

JD: Castration. Or the hanging of limbs?

GC: They are also an offering, or a sacrifice.

JD: I always was interested about the relics of the saints too. Fingers of the saints. You know, this is so-and-so's finger. I thought that was amazing. To worship, to get a frisson from an object was fantastic to me.

GC: It is like trying to reconstruct the history of the detail. By zooming in you start to look at details, and from details you recognize perhaps a person, perhaps the human being. Zooming from the outside to uncover the inside.

CB: Can we talk more about your choice of materials in your work?

JD: I had a long romance, and still do, with house paint. Long before I even heard of Jackson Pollock, in the late '30s when I was three and four years old, I was using house paint. And that's the first paint I ever saw. I didn't see oil paint for many, many years. Actually, I once found in my grandpa's attic a set of oil paints from the '20s that somebody had had, and I squeezed them out like toothpaste. This had power for me. The house paint had power for me, and the color charts of house paints had power for me. Because the colors were without compromise and without subtlety. American colors were not so much about decoration.

CB: Did you often use house painter's brushes to apply the paint?

JB: Oh, I still do. I always use house painter's brushes. Always.

GC: And by using house paint, did it mean that you didn't have to compose a color, that it was already found?

JD: It is a found object. Each color is an object for me. But I mix. It's also because of my hyperactivity and my speed, and speed is very much a metaphor for me, for myself, I feel. Because that's how I compose, through speed. And I am confident about that. House paint, you open it up, and you got light green, it's already there, so I don't have to fuck around with making it. I am confident it will work somehow. You open it, it's there. It's like walking down the street. Everybody is there.

GC: So, you trust color immediately?

JD: I trust anything walking down the street. I trust what is out there. I never in my life consciously thought about color. I pick up a tube; if it doesn't work, I'll take it off then. Sometimes if it works, I take it off and do it again with another one, because I figure, if I could do it the first time, I'll do it the second time.

CB: Did you know what your paintings were going to look like before you painted them, or did they change during the process of creating them?

JD: It's always in the process of making them that I know what they are going to look like. I never know what they are going to look like before. It's always in the process. I never made a sketch for anything. I never planned anything out that ever turned out the way it was intended. It's always in the activity of working. I thought *Teeth* [1960–61, fig. 76] was an abstract painting that said "teeth" on it. There was so much painted underneath it of what it was going to be. I didn't know it was going to be teeth until the end.

GC: So, when you paint, you reveal to yourself?

JD: To myself. Yes, that's how I think.

66. Hair, *1961*
Oil on canvas
72 x 72 inches (182.9 x 182.9 cm)
Collection of Reinhard Onnasch, Berlin

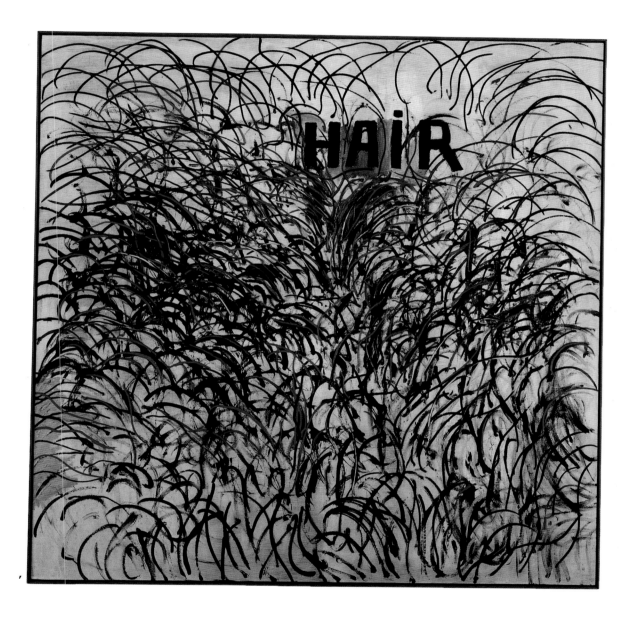

GC: You take it off, instead of building.

CB: You erase.

JD: Oh, I always erase. I believe in erasing. Erasing for me is like taking the sacrament.

CB: And are there traces underneath the paintings that you want people to understand? Do they carry the history of the work?

JD: No, the history is going to be there anyway. It's absolutely going to be there. I mean, pentimento for me is everything. It is the memory of the work—what happened before.

GC: It is a classical tradition that you paint over and over until you get it.

JD: Until you get what you want. Yes. It's an old way of thinking. It is what makes me, without breaking it, part of a Western tradition. And that is important to me.

GC: And when do the objects start to come in as icons or images? I see bodies and a sequence that you have slowly built—shoes, the hat, and all this. How did you get to these images? After you build up, then what is left is a detail, is a trace, is a memory of human being passing there in essence? What is the object now? Because it's not anymore a product for me.

JD: It's not a product at all. It's my mark. I am leaving my mark to say I was here.

GC: That's why the Pop definition doesn't fit.

JD: Exactly. And it's so obvious to look at the hat in my painting *Hat* [1961] and say, "Yes, he got it from Magritte." And I honestly didn't. I really didn't think about that. I thought about tautology. Instead of writing *hat* under that one, I put a hat. And the derby was all involved with vaudeville. It was something we talked about, Claes, and me, and Ratliff, and all these people. The derby came from our little period of show business.

CB: I'm struck by how there is so much concentration on the background or field of the canvas. For instance in *Pearls* [1961, fig. 72] the necklace is the smallest element of the canvas, the main focus is not on the object per se, but on the ground of representation itself.

JD: It was a way to paint without exposing too much of myself, and yet, it was a way to be *au courant*. It was a way to be part of a group, such as it was, and it was a way to belong as a young man; it was a way to possibly get famous. I found this very personal work. In fact, whenever I looked at the words on the bottom, I thought it said "penis." And then other people said it to me too, without me ever saying it. And I didn't make that. I said "pearls." This was like the beginnings of my exploration of my unconsciousness.

GC: Your subject matter often refers to extremes of the body, things that stop at the body's perimeter, such as shoes or a hat. *Red Suspenders* [1961, fig. 70] is almost a definition of a soul or limitation or constriction, if I look at the way the straps cross the canvas symbolically. The works speak to defining the territory of the inside.

JD: When I got to that point, past the tie, and I got to the suspenders or the shoe, I think I was like on a roll of association. I would just say "shoe," and I made *Shoe* [1961, fig. 77]. Now, the reason I made that kind of shoe, that brown-and-white shoe, was because in those years, a lot of us were talking about Art Deco in the '30s and talking about Fred Astaire, and talking about haberdashery. I was trying to reconstruct a history for myself of where I came from. At thirty-five, I was trying to figure out where I came from, I mean, this miracle that I appear, because of the union of two people.

GC: Because you were thinking about what connects you as

an adult to the limbo of your tough childhood, and so you were trying to do that in your painting by appropriating a cultural reference. Did you look at Fred Astaire as a symbol in trying to create a patchwork of your own history?

JD: Of my own mythology. A personal mythology that I tried to make for myself, so that I am in this world. So I am not of ether, I am not of vapor. I have two feet on the ground, I am trying to say, "It's me." Friends could not help me, my wife could not help me, having children could not help me. I had to finally come to myself, and always find ways to hold on; otherwise, I float out into the atmosphere. Art saved me. Art grabbed me and held me.

CB: Your objects often function like holders?

JD: They held me in place.

GC: So you were trying to say, "This is my memory," or "This I would like to have as a memory, because of my drama," whatever it was.

JD: This personal drama that maybe nobody else would have found dramatic, but I found it dramatic.

GC: And what about the small kind of shelf?

JD: I don't know. I was getting ready to put objects on it, but didn't. I still think it's such a convenient thing, and a way to make something very pleasant-looking. Furniture for your self.

CB: Up to this point, a lot of the works are about the flesh, the idea of the tattoo, hair, the skin as covering. Is the background in these works flesh? Is it skin?

JD: Well, probably it was thought to be flesh, as though it was a close-up, but it's not like that. I only used the color of flesh, maybe for that reason, but it also gave me a way to paint. Just paint, work it out with paint somehow.

CB: So it's about surface.

JD: Yes, it can be about surface.

CB: The surface seems to take you from a very classical painterly formal idea in your work to a more theoretical idea involving the body and memory.

GC: It's about the object coming in. And some of the objects you painted over, yes?

JD: Yes.

CB: Did you feel that painting over the objects was a way of changing those objects into a painted illusion?

JD: No, it made them mine. And sometimes I didn't paint over the objects, because I liked the way they looked without painting on them. In the end, my final reasons for doing things a certain way are what I see.

GC: And there is—to use a word I don't like—a *realistic* aspect to this.

JD: It was a certain kind of realism, though. I was very much a fan of certain nineteenth-century American realists like James Peto or William Harnett. Because I was amazed by them. Because I felt they were collagists. They were, in their way. They just happened to be *painting* objects. Putting it together, making arrangements. They were sometimes like Schwitters. I was thrilled by that. They inspired me. The combination, the mood, the little scene that they built within a certain stage. It was a staged thing. They weren't looking out the window. I figure anybody could do that. That's the way I was born. You know, if I looked out the window today, and I took a canvas upstairs, I'd make a beautiful painting for you, but it doesn't interest me. Peto and Harnett made a setting for something, and it was enclosed in this very tense space.

GC: But your arena of expression in each work is a single object, which is a relic of your own traces?

JD: Yes, my own traces.

GC: So, you construct your universe through detail.

67. Blonde Hair, *1961*
Mixed-media collage: Oil and wood plank
on canvas
65 3/4 x 50 1/4 inches (167 x 127.6 cm)
The Metropolitan Museum of Art, New York.
Gift of Stanley Posthorn, 1984 (1984.560)

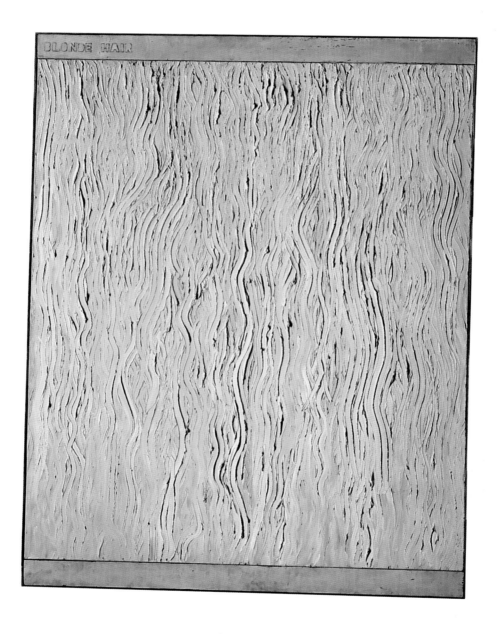

68. Orange Tie, *1961*
Mixed-media collage: Oil and necktie
on canvas
16 1/2 x 12 inches (41.9 x 30.5 cm)
Collection of Mr. and Mrs. Charles H.
Carpenter, Jr.

69. A Tie in a Red Landscape, *1961*
Mixed-media collage: Oil and necktie on
canvas
16 x 12 inches (40.6 x 30.5 cm)
Richard Gray Gallery, Chicago/New York

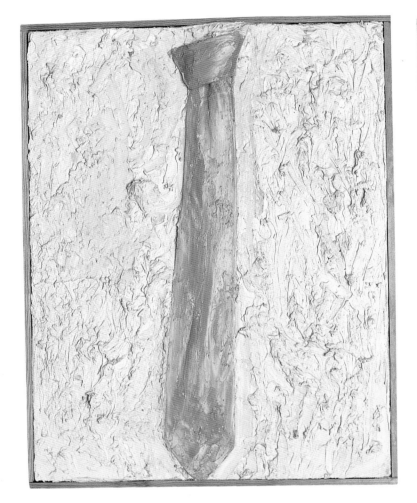

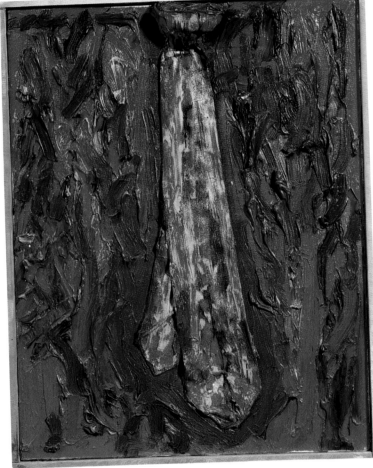

70. Red Suspenders, *1961*
Mixed-media collage: Oil and suspenders
on canvas
33 7/8 x 27 15/16 inches (86 x 71 cm)
Private collection, Italy

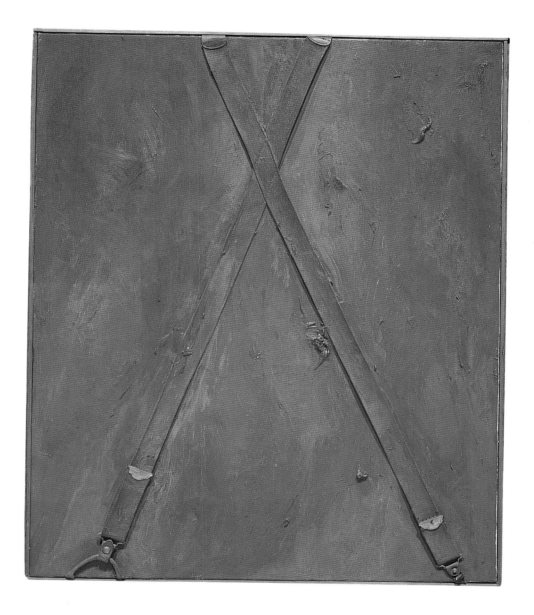

71. The Red Bandana, *1961*
Oil on canvas
62 x 54 inches (157.5 x 137.2 cm)
Collection of Nancy Dine

72. Pearls, *1961*
Mixed-media assemblage: Oil, metallic paint,
and metallic-painted halved rubber balls
on canvas
70 x 60 inches (177.8 x 152.4 cm)
Solomon R. Guggenheim Museum, New York.
Gift, Leon A. Mnuchin, New York, 1963

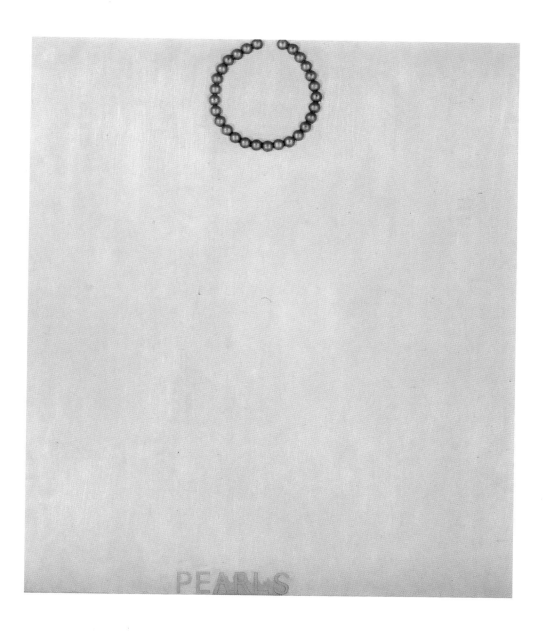

73. Green Ties in a Landscape, *1961*
Mixed-media collage: Oil and neckties
on canvas
7 feet 1 inch x 5 feet 1/2 inch
(215.9 x 153.7 cm)
Collection of Marcia and Irving Stenn, Chicago

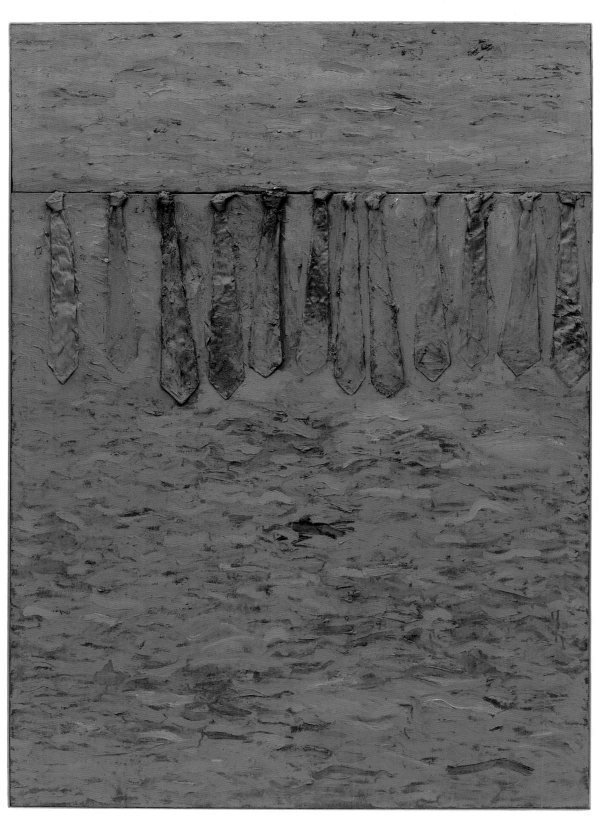

74. Coat, *1961*
Mixed-media assemblage: Oil and plastic
buttons on canvas
6 feet 8 inches x 5 feet 1/4 inch
(203.2 x 153.4 cm)
Collection of Mr. and Mrs. Charles H.
Carpenter, Jr.

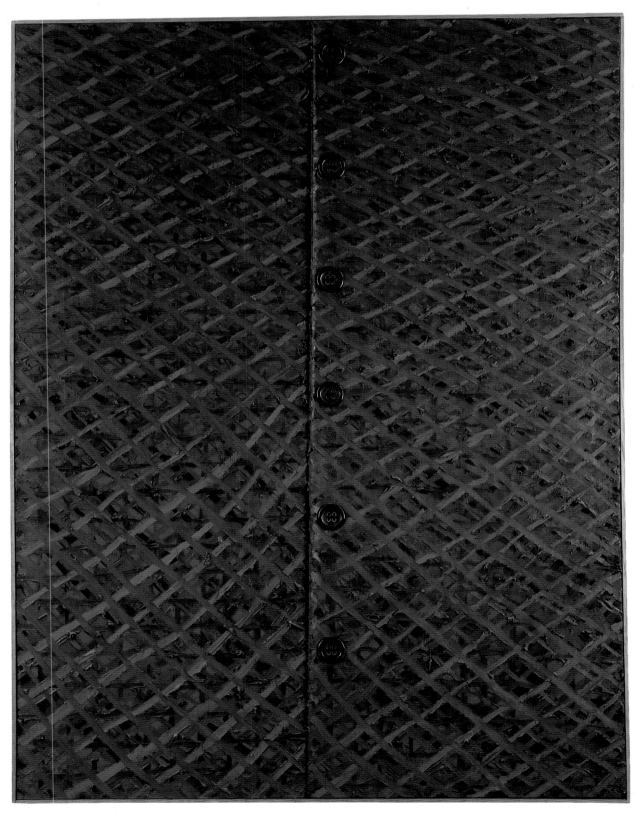

76. Teeth, 1960–61
Oil on canvas
40 15/16 x 60 7/16 inches (104 x 153.5 cm)
Private collection

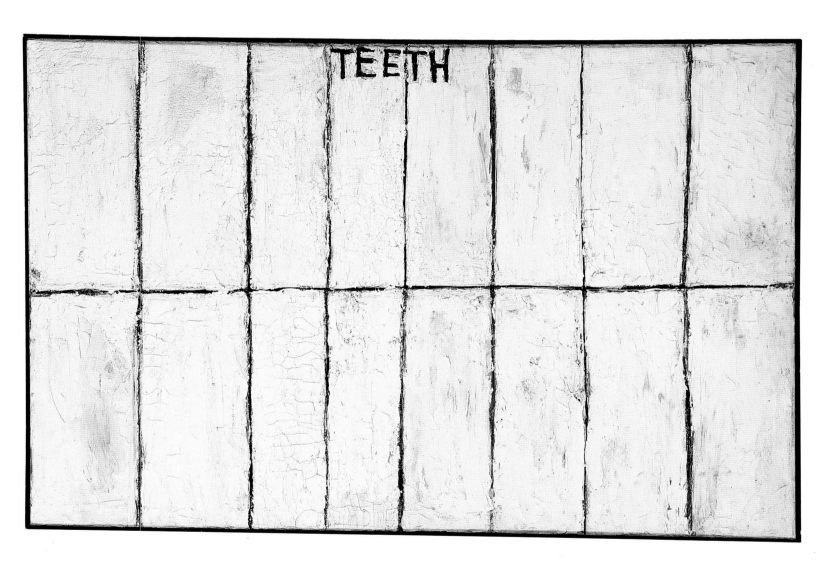

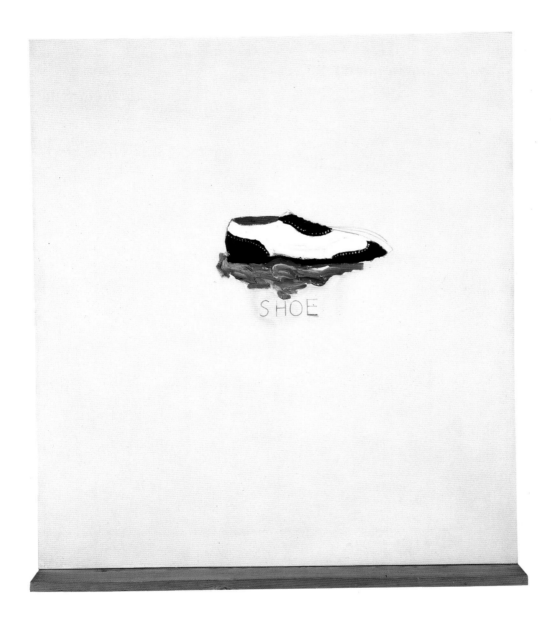

78. A Universal Color Chart, *1961*
Oil and wood strip on canvas
70 1/4 x 60 inches (178.4 x 152.4 cm)
Collection of Sydney and Frances Lewis

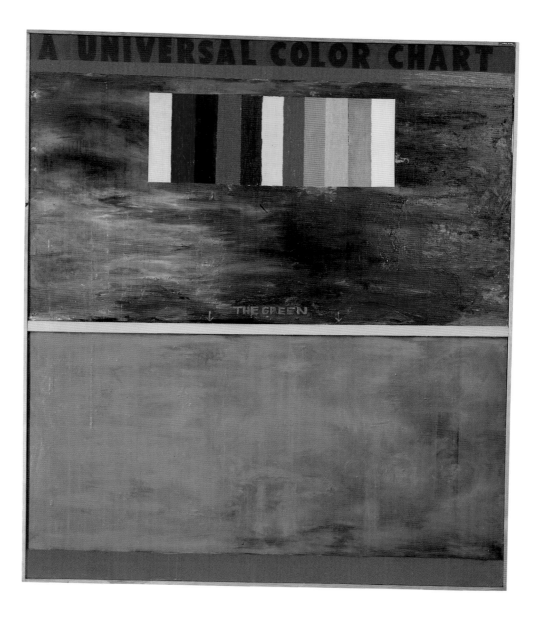

facing page:
79. The Composer's Yellow Tie, *ca. 1962*
Mixed-media assemblage: Two wood planks,
two wood strips, two neckties, and oil on
canvas
6 feet 1 1/8 inch x 1 foot 5/8 inch x 2 3/4
inches
(185.7 x 32.1 x 7 cm)
Private collection, London

"There's a kind of state of dumbness
that I like, too, which is not
unrelated to children, child art, or
mad art. Maybe putting yourself into
a naive state, which—and I'm not
that naive—I know that it can't be
done purely, but I like to use it like
one would use paint. It's another
way, another medium."
(Jim Dine, 1966)

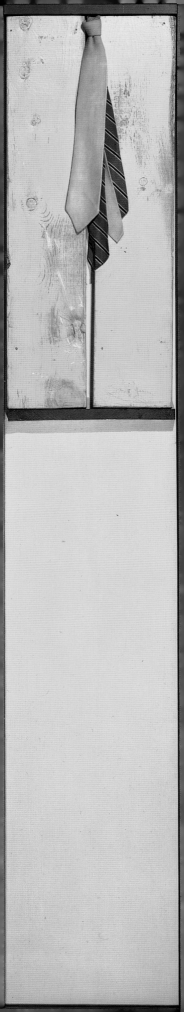

"In about three months, I made about thirty painti

s of tools. It was a great burst."(Jim Dine, 1966)

GC: Was *Big Black Work Wall* [1961, fig. 80] the first piece you did with tools?

JD: I don't know if it's the first one, but I made that first group of *Tool* paintings in about a month. And I must have made thirty paintings, which Ileana showed the first time in Europe in '63.

CB: Was going to a hardware store and buying all of this stuff part of a process, that when you were in the store you had in your mind what kind of paintings you wanted to do with the objects?

JD: For years I would go to the hardware store and I would steal some things; I'd look for the cheap things. By 1962, when I began the *Bathroom* paintings [figs. 96, 98, 99, 101–06], we went to East Hampton for the summer and rented a house, when East Hampton wasn't very fancy. I went to the hardware store out there and it became a sensuous experience, like a child being let loose in a candy store, except it was a hardware store. I couldn't believe what the possibilities were. And I got the ideas in the hardware store, rather than coming to the hardware store and needing something to put onto a painting. I had to be in a hardware store to get the charge. You can never get that same charge again. It's like virginity, you know. And actually, the first time I could buy something there was when they let me open a charge account.

CB: Did you buy the same thing over and over?

JD: Sometimes I'd buy dozens of hammers. But also, I got so excited to find something that was inspiring. A tool can be inspiring. Not just because it's some sort of phallic symbol, but because this tool is a beautiful object in itself. It has been refined to be an extension of one's hand, over the centuries, in a process of evolution. And it can inspire you that way. It has all this history.

CB: Did you recognize the authorship that went into the making of each tool itself? That there was an artist behind those objects?

JD: No. I recognized the human hand. The need in the human hand that created those objects. There was no author. There were authors. It was every time anybody used one, they found a better way to make it.

GC: So, is the tool an extension? Does it represent the extension of your arm? And in a certain way it's the same as dress?

JD: Exactly.

GC: Like the hat or a shoe is an extension, it's the aura of your body extending out?

JD: A tool is like a bone.

GC: Joseph Beuys was using a stick as an extension of a finger, but that was a totally different connotation, because it was about the notion of holding. For you, is the tool the design of the body? Were you also interested in the beauty of the object on the plastic level?

JD: Yeah. For me, the beauty of it is first on the plastic level. Sometimes I can almost go to my knees, it's so beautiful!

GC: So you're really strongly involved in the design of it?

JD: Yes.

CB: What was your relationship to technology at the time?

JD: It was and is a non-relationship. I don't have a computer. I don't know how to work a VCR properly. I am unable to put things together except by my way. It's all about dyslexia. It's about not being able to perceive instructions, lest I create the instruction myself. That is why I read backwards. That's how I can drive a car. I am quite handy, actually, but I have to be able to do it with my hands.

GC: So, tools for you were not a conceptual element. They were about labor.

JD: They were an extension of my feelings. They had nothing to do with the conceptual. That is why I always felt like such an outsider in a conceptual age.

GC: In 1965 Joseph Kosuth showed the tools along with their definition, which avoided the physical in favor of the idea of the tools in a human relationship. The importance of isolating an object in a background and making it into a relation between the word and the name comes out of your works.

JD: It seemed so natural for me. As I said, I never questioned why I did this, could I do that. Should things be like this? Should they be formal? Are there formal rules? It just was a natural extension of my feelings. A tool was the memory of this working person who worked it out. That's how it evolved.

GC: Many of the objects emit brushstrokes as if they are radiation. Does it come from your looking at Futurist painting, this idea of energy passing through form, or from your use of lamps and light in the works?

JD: I never thought of that. I always thought it was texture.

GC: In a work like *Window with an Axe* [1961–62, fig. 93] you again play with the idea of the double. Why do you always select a double kind of mirroring? And in this period, there is a lot of black. Black window, black door, black painting. Does black evoke for you, consciously or not, the idea of dying in order to be reborn?

JD: I don't know. The art store around the corner was selling some strange black oil paint that came in cans, which I never saw before, and I used to buy a lot of it. And I used a lot of dark gray, which refers to lead, and to gray putty, and gray paint or gray linoleum for the floor. The linoleum was always gray. When I was growing up, it was a time of black and white. I was not living in Mexico, you know. This was Cincinnati, Ohio. The color was black and white. What I mean by that is the color of working is black and white. Nothing was painted bright colors to make it attractive to sell.

CB: How did the notion of working enter your paintings as an idea at that time? Were you thinking along the line of building?

JD: No. I was thinking of depicting work, the act of working. It was the idea of rather than painting someone working, how about painting the job itself. Making a painting of a job itself. In *Big Black Work Wall*, I was trying to make a painting, flatten it out, but to speak about the act of working, and to see how I could make art of it. To compose. *Proposed Still Life* [1962, fig. 94] was in the same vein. Instead of making a painting of tools arranged in a certain way, I thought, Why not make a painting of the act of making a still life? So I attached a bunch of tools at the top and wrote instructions at the bottom.

GC: From a European point of view, your position to qualify the workman was ideologically very strong at the time. It's an interesting shift from the previous generation.

JD: I didn't think of working class, I thought of workmen. The dignity of it. There is no greater thing you can do than to work with your hands. That is what I do.

GC: Pop art could be interpreted as expressing a more democratic attitude, whereas Abstract Expressionism was aristocratic.

JD: I am very aristocratic. I am not asking for an art of the people.

GC: So, in a certain way, Pop art can be interpreted in this way—as popular image, but dealing with a low level of democratic elements, something that everybody can understand.

JD: But de Kooning, who was a house painter, who was trained as a decorative house painter, I think he must have felt that a bit too about his painting—the way he painted, the kind of material he used, etc.

CB: So, part of it was about getting away from the cult of the artist-genius.

JD: It's what the New York School artists did, too.

GC: It is the same as Leonardo da Vinci dealing with technical drawings. Leonardo had the same attitude toward drawing machinery, and applying the knowledge of practicality to anatomy. Do you think that being democratic comes from being an American also?

JD: It's totally American.

GC: As an American, you create your own territory, while the structure in Europe is still totally aristocratic.

CB: You once said that when you were working on the *Tool* paintings, you did them all in a tremendous burst of creative activity. Was that all you did then, *Tool* paintings?

JD: Yeah. And I ended up feeling that together they all could have been considered one work, particularly the monochromatic ones.

CB: Did you think of them as being in dialogue with one another?

JD: Yes.

GC: And in each of them, you created a dialogue between the tools and the canvas.

JD: Right. The canvas was a stage for it.

CB: Did you think of theater design when creating the *Tool* paintings?

JD: No, I thought of making a theater for myself.

GC: And you thought of the tools as actors?

JD: Yeah, just like the vegetables were in *Vaudeville Show* [1960, figs. 40–42].

CB: In the paintings, the tools maintain on some level their usual role in the world. You don't put them in a context in which they are doing something they don't normally do.

JD: That's right, they are not doing something in a Surrealist way. It's not the "Dance of the Brooms." Like everything else I do, the *Tool* paintings are self-portraits.

GC: In *Colorful Hammering* [1962, fig. 91], the energy is very futuristic. It's really the energy of the tool, not in the futuristic sense of technology, but the idea that the object has an energy of diffusion, which is like the theories of Rudolf Steiner.

CB: It's translucent, like a film negative.

JD: It is a dream.

GC: It's kind of an army. It's also a cartoon. You extend the idea of being a child and playing, and having these actors on your stage and being funny and real and not real, and a phantom. In this case, you are tracing the gesture as an object?

JD: Yes, as an object.

CB: There is something apocalyptic about the way the hammer hangs downward and the fires consume it. The hammer reminds me of Peter's cruxifixion, of Peter hanging upside down on the cross.

JD: No, all that is is the hammer itself. It's hung up like a hunting trophy. It's a still life.

CB: And there is the reference to Johns.

JD: Well, he was looking at my work at the time, and I was looking at his.

GC: In *Hammer Study* [1962, fig. 90], the object exists as a drawing, a shadow, and an object, as if you were breaking the object into different fragments.

JD: It's a study of a hammer, a dissection of a hammer. The handle, the head, the drawing, shades of being. It's my primitive attempt at some sort of analysis of an object.

CB: Your drawing as opposed to your painting seems to be about the way light hits an object, since your drawings are never flat, but modeled.

JD: That's because I hold on to classical drawing.

GC: Were you going to museums to hone your technique?

JD: Not specifically for that. But I always went to museums, and I love drawing and I love painting. When I went to museums, I was trying to reaffirm that I came from something and was moved by the genius of the past, so I have two things going. I want to be a modern man, I want to be a modern artist, and I couldn't care less. I would rather be, you know, Tiepolo.

CB: You've said that you were more influenced at that time by the Flemish masters than by the Italian masters. What was it about the work of the Flemish painters that was so significant for you?

JD: The isolation of each person as an object. Everything was treated as an object. They painted as though it was a melange of hammers and saws, except it's people. It's Christ and it's Mary and it's all this. But they are painted in a space that is isolated, floating in the space. What they did formally with people, I thought I was doing with tools.

80. Big Black Work Wall, *1961*
Mixed-media assemblage: Oil, tools,
paintbrush, wood strip, nails, bolts,
wood plank, and saw handle (with partial
saw blade) on canvas
6 feet 3/4 inch x 9 feet 1/8 inch x 4 1/2 inches
(184.8 x 274.6 x 11.4 cm)
Richard Gray Gallery, Chicago/New York

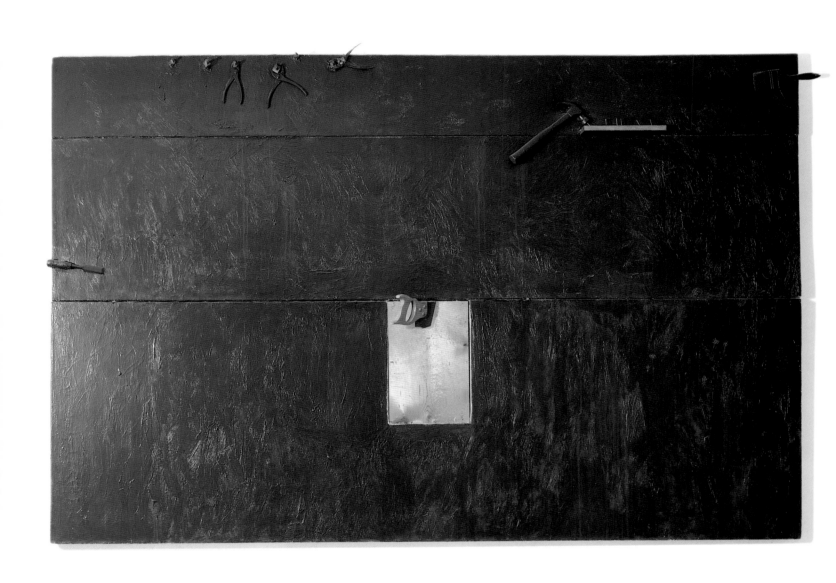

81. Yellow Oil Can, *1962*
Mixed-media assemblage: Oil on canvas,
with rope and oil can
31 1/2 x 20 1/16 x 12 3/16 inches
(80 x 51 x 31 cm)
Museum Moderner Kunst Stiftung Ludwig,
Vienna

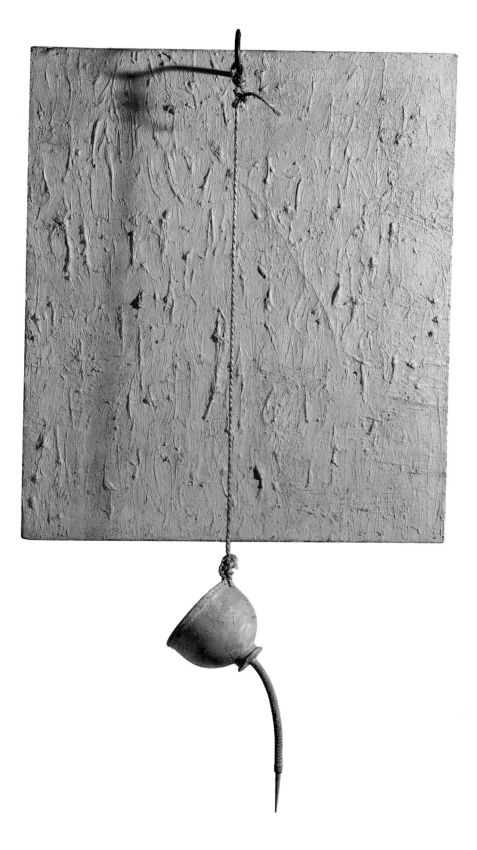

82. Red Knife, *1962*
Mixed-media assemblage: Oil on canvas,
with hook, wire, and mat knife
23 5/8 x 19 11/16 x 2 inches (60 x 50 x 5 cm)
Collection of Ronny Genco, Milan

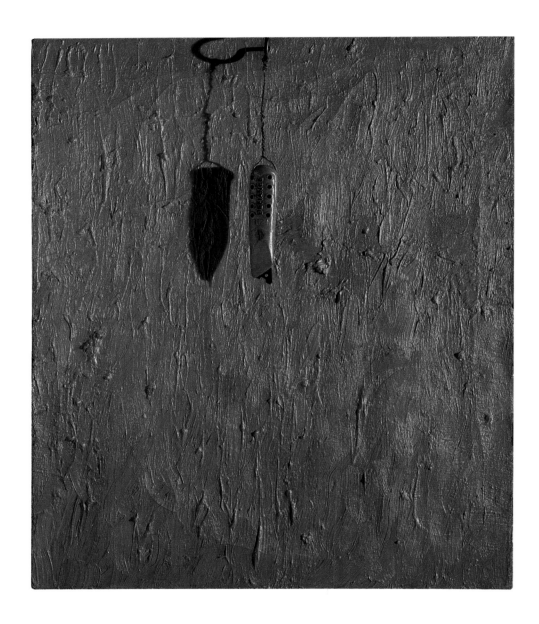

83. Sickle, *1962*
Mixed-media assemblage: Oil on canvas,
with pulley, oil, twine, and sickle
51 3/8 x 40 15/16 x 3 15/16 inches
(130.5 x 104 x 10 cm)
Private collection

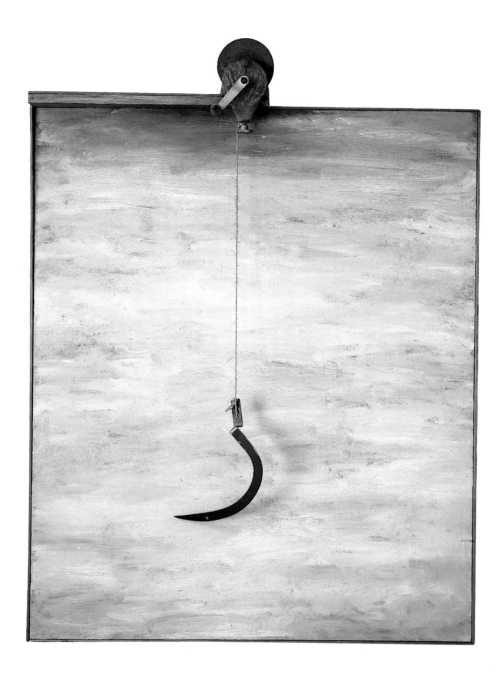

84. Torch, *1962*
Mixed-media assemblage: Oil, asbestos
ceiling panel, and torch parts on canvas
60 x 50 1/4 inches (152.4 x 127.6 cm)
Douglas S. Cramer Collection

85. Black Garden Tools, *1962*
Mixed-media assemblage: Oil, pitchfork,
rake, two shovels, and three edgers
on wood panel
60 x 60 inches (152.4 x 152.4 cm)
Collection of Patsy Orlofsky

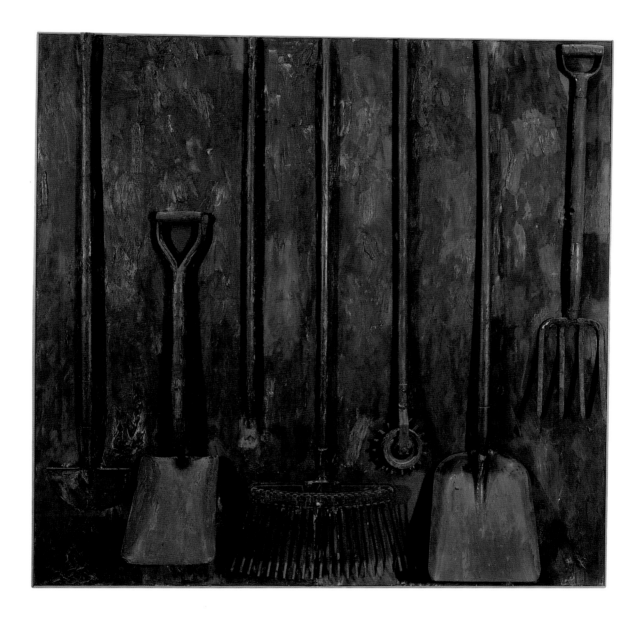

CB: When I see the objects that you use in a lot of your works, I can't help thinking of the gender differences between workshop tools—objects from the man's playground, so to speak—and kitchen utensils, which are traditionally the woman's arena, which don't appear much in your work. Did you think of combining these tools and all these related objects as making inventions?

JD: Yeah. That's a good point. Finding all those things and inventing. I was like the mad scientist. It was like the wizard was down in the basement. Remember in "The Sorcerer's Apprentice" with Mickey Mouse? But I also felt that whatever I found down there would be useful. I knew I could make something great, and of course I never did, but the mystery of it, the mystery of finding objects and working with them, and the idea of accumulating things, a lot of things together. During the war, everybody I knew hoarded canned goods in the basements because we thought there would be no food, and there would be shortages and things. So, there was always a closet. Everybody had cans of tuna fish, cans of pineapple, cans of beans. But you open up that door and it was just beautiful. I liked to see that. Really beautiful!! But I always had this aesthetic appreciation of things in stores, not just objects, but in food stores. All the vegetables together.

GC: What about the idea of gravity and weight, because it seems to me so evident in the works. Does it have to do with the idea of the image as a very heavy element? As if the present, the past, everything, whatever you do is heavy, not physically, but in the sense of profound? Heavy in a metaphorical sense.

JD: You mean, was I conscious of doing something heavy? Well, I am not interested in something light. I don't want a snack!

GC: That gravity means you are anchored to something.

JD: Yeah. Yeah.

GC: Lichtenstein and Warhol and others at that time, they were not anchored. They were dealing with perception in a different way, in a linguistic way, not in an emotional way. They were refusing any heavy element of the picture, while you and Claes were more sensual, completely physical.

JD: Absolutely.

CB: What was your relationship to artists such as Johns and Rauschenberg during the early 1960s?

JD: Johns and I had somewhat of a friendship, for about a year or so, and we fell out, but not really fell out. But you know, he is a difficult man and I was a difficult man. So, it didn't work out so well. We really weren't meant for each other.

CB: Were you closer to Rauschenberg during those years?

JD: I was close to Bob, too, and Bob very generously says somewhere about *Barge* that he went home and painted after he saw *Four Rooms* [1962, fig. 109], but that's because we would come over to people's studios. It was more of that, but it wasn't matey bar life, and it wasn't that we were great friends.

GC: And did you feel separate from the previous generation? De Kooning and all these people. Did you visit them?

JD: No, but de Kooning was so nice.

CB: Did he come to your studio?

JD: No. The first time I met de Kooning was at the vernissage of Sidney Janis's *New Realists* show. So, it must've been in the autumn of '62 or something like that. I remember he said to me, "You know, Dine," and he was really sweet about this, he said, "you know, you are a real painter. The way you put that paint on." He made fun of a lot of things, because it wasn't his way using these real

objects and things, but he was always so generous and sweet about that with me. But I had no relationship with that other generation until a little bit later. I knew Motherwell a little bit, and Rothko, I met twice. And I knew Newman a little, too.

GC: Were you going to galleries to see all the shows?

JD: I'd see Rothko at every show.

GC: What kind of relationship with the French did you have?

JD: I met Yves Klein at Martha Jackson's gallery at openings for my shows and other artists' shows. I knew Arman, and I would see him quite a bit. He was very interested in knowing everybody, and he entertained a lot. So, I saw him quite a bit for a while, and then Tinguely I knew later. I knew Niki de Saint-Phalle. She came to my studio with Pontus Hulten and Billy Klüver.

CB: Did you know Daniel Spoerri?

JD: He frightened me a little bit.

CB: Did you come into contact with any of the assemblagists working on the West Coast?

JD: I remember John Chamberlin had a show at Martha Jackson's about '62, and Billy Al Bengston was in town for that and I met him there, and we had a conversation, but Bengston was also a bit older. I was a yokel, and those guys were sharp. Bengston was sharp. He was sharp about his career, he was sharp about life; he was a bit of a Hell's Angel kind of person. I was nothing compared to these guys.

CB: Did you feel you were part of a group?

JD: The last time I felt comfortable in a group was when I was showing at the Reuben Gallery.

GC: Because you were sharing all the experiences together?

JD: Maybe. It was artists who I liked, and while we were all different, I was proud to be a member with them. I was proud to be showing there.

GC: What kind of collaborative situation was it for you?

JD: We were always there. It was like a clubhouse too. We'd go and meet there. Every time I'd go to see Anita Reuben, somebody else would be there, sitting there talking to her. That's the way it was. I'd be teaching at the Rhodes School, and then I would come after school. Take the subway down.

GC: What about the label of Pop itself?

JD: As far as Pop was concerned, I didn't want to drown in somebody else's movement. I wanted to be myself, too. I didn't want to be called part of this thing. I wasn't part of it. In the first place, it seems stupid to me. All my life I was a student of popular culture. I was involved with Pop music, I was involved with the radio, I was involved with television, I was involved with billboards, I was involved with commercial art. I was also involved with real objects. Don't forget I had grown up, since I was a little boy, with real objects. I did think the cereal box was beautiful. I really did. But that was my veneration of American advertising, too. All those things. The first Pop art things I saw were at the collector David Hayes's, somewhere on the Upper East Side. And there was Andy's work, and Roy's and mine, and just in this one house, these huge paintings. He was just buying wholesale almost. And I didn't think I had anything to do with it. I felt like a real outsider. And Cage would be there, and they would always say, "Oh, how marvelous this is. Oh, how marvelous! Isn't that marvelous!" What the fuck is marvelous? How do you know what's marvelous?

GC: There was a decided shift in the art world right after The New York School, from the bar to the artist-run gallery. Artists like you began to incorporate their studios into their own galleries. For instance, the Green Gallery gave Claes the

possibility to do a show directly in the space; and Reuben, in your case, the same with *Car Crash* and other shows.

JD: I never thought I was going to be able to support myself. I thought I'd always have to teach school or something. I had stopped teaching because Martha Jackson gave me a stipend when I joined her gallery. She gave me four thousand dollars a year, and that's what I was making teaching, and for that Mrs. Jackson got all paintings for a hundred dollars. All drawings twenty-five dollars. So, she gave me four thousand dollars a year for that. Fine with me. I thought, This is a great gift, but then I couldn't stand being at her gallery anymore.

CB: Did Sidney Janis come to the show at Martha Jackson?

JD: He and his wife, Harriet Janis, came in with Rudy Blesh and he said to me, "I wish we could do something like this at the Janis Gallery." And so, Janis approached me in the summer of '62. He called me up and said "Could I visit you in East Hampton?" At that point Leo Castelli had already given me two hundred and fifty dollars, and it was where I desperately wanted to be. And he said, "We can start this as an allowance toward pictures, and in the fall we'll start to work you in, probably." Now Janis's Gallery was like being at MGM in Hollywood, with artists like Giacometti and Philip Guston. This was everything that I was thinking about. These were the stars. I never even actually thought that I was going to make any money there. That was not the issue. It was this famous gallery, and he came out and he said, "Listen, you will be the first young artist I am going to take. I am going to take a lot more. I am making this *New Realists* show. Here is what I am going to give you. I'll give you an allowance each month." Now, I got two little kids, and I didn't feel like living like shit. I didn't feel like living on the Bowery. I wanted to live someplace comfortable. Nothing grand. Leo was on the fence, because I gather Ivan Karp didn't want me in the gallery. Nobody at Castelli would make a decision. I needed a decision. I had little kids. I mean, I don't want to fuck around like this. Either I am going to teach school or not teach school. Particularly when Leo was dangling this thing for me, you know, and then Janis comes up and that's what I did. I went to Janis and I stayed there. I never regretted it. I was much more comfortable.

CB: When you went to Janis, did it change your relationship with the artists who you were socializing with at the time?

JD: I never socialized that way anyway. You have to understand that I was having bad mental problems. I mean bad phobic problems. I had swept under the carpet so much of my childhood without really dealing with it. I had invented myself without the help of parents really. So by about 1961, I am having trouble leaving the house, and I am developing agoraphobia, and claustrophobia, and vertigo, and I cannot drive a car half the time, and I can't go on a bridge, I can't do anything, you know. So I start to see a psychiatrist in the fall of '62 and I could hardly go out and see people, and so I missed a lot of action in those years. I stayed home and worked. I was pretty much house-bound. And I stayed home mainly because I couldn't go out until about '64 when I sort of kicked in with the therapy. Painting saved me. It was the safest thing I could do, since I didn't have to relate to others.

CB: Was there any sense of camaraderie between your peers that you could tap into during this difficult time in your own life?

JD: It stopped by '61. From the time I came to New York in the winter and was coming in from Patchogue in that winter of '58–'59, and through '61 there was this scene. With the Reuben Gallery and all. By the time I did *A Shining Bed*, I was out.

GC: Did you feel you had a constant source of support within the art world?

JD: I got the most backup, the most support from Alan Solomon early on. He came to my studio in 1960, and he came with a woman who was his assistant at the time. He was the head of the museum at Cornell University, and he came with a woman, Inez Garson, who bought *Untitled* [1959–60, fig. 47] at that first visit; she bought it for a hundred dollars. So, Solomon's take was always that what I did—and he had been friends with Bob Rauschenberg in the '50s—what I did, he kept saying to me, is repressed dirty, dirty in the sense of smutty like that, dirty, ugly, difficult, tough work. And he said, "You don't make it easy for the viewer. It's nasty. You have this tendency to curb your natural instinct for beauty or your natural glibness." And then I, of course, almost put one arm behind my back, and painted with a brush in my teeth if I had to, to please him, because he's the only person who was supporting me. I thought, Here is the guy, he does understand some of the psychic unhappiness I am living under, and he thought it was a virtue.

CB: What work was going on in your studio at the time?

JD: I was making a show for Martha Jackson's gallery. I made *The Red Bandana* [1961, fig. 71] *Pearls* [1961, fig. 72], *Hair* [1961, fig. 66], *Green Ties in a Landscape* [1961, fig. 73], *Coat* [1961, fig. 74], all that sort of objective work, and at the same time, I was making a whole other body of work, the *Tool* pictures, which Ileana Sonnabend eventually took to Europe.

GC: Where did you met Ileana—in Europe, or in New York?

JD: I met Ileana through Leo Castelli or Bob Rauschenberg. She was looking at new artists, and I remember she came with Michael Sonnabend. He was living on the West Side in his little brownstone one-room, which was just books everywhere and you couldn't walk. You never saw art. I mean, it was just a mess. But they really courted me, and they came around a lot. I remember they came to dinner and Bob came to dinner with her a lot, and she said, "I've got this idea. I want to take American art to Europe." She chose things for the show in Europe, and then suddenly I went to Janis. And that threw everybody into a panic, because then she couldn't control much. She wanted me to come for the opening, but I couldn't get on a train or a car, let alone a plane, so I never went. I never went to Europe until '66. I looked to Europe and knew a lot about it, but I never could go until '66, when I took a boat.

86. Flesh Chisel, *1962*
Mixed-media assemblage: Oil and chisel
on canvas
6 feet 11 7/8 inches x 5 feet 1/4 inch
(213 x 153 cm)
Collection of Reinhard Onnasch, Berlin

facing page:
87. Black Shovel, *1962*
Mixed-media assemblage: Oil on canvas,
with rope, shovel, box, and soil
Canvas: 7 feet x 3 feet 1/4 inch (213.4 x
92.1 cm); box: 9 1/4 x 37 3/4 x 9 5/8 inches
(23.5 x 95.9 x 24.5 cm); 8 feet 5 inches x
3 feet 1 3/4 x 9 5/8 inches (256.5 x 95.9 x
24.5 cm) overall
Sonnabend Collection

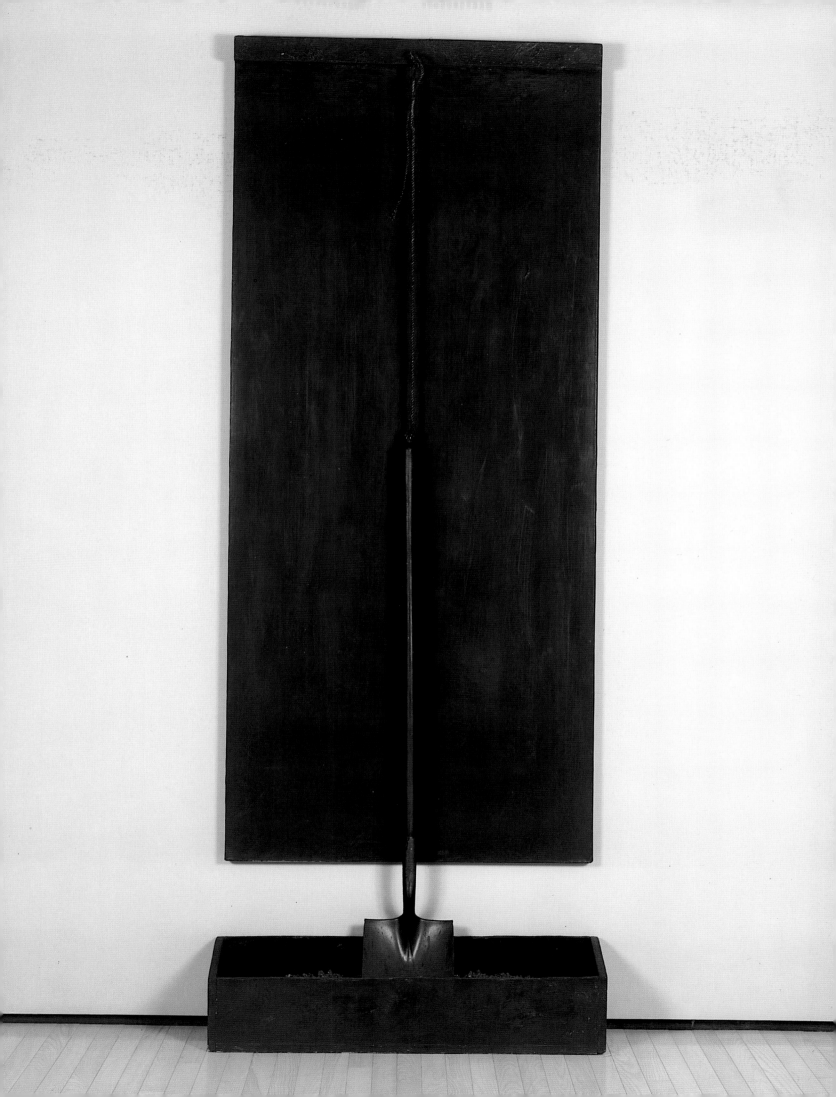

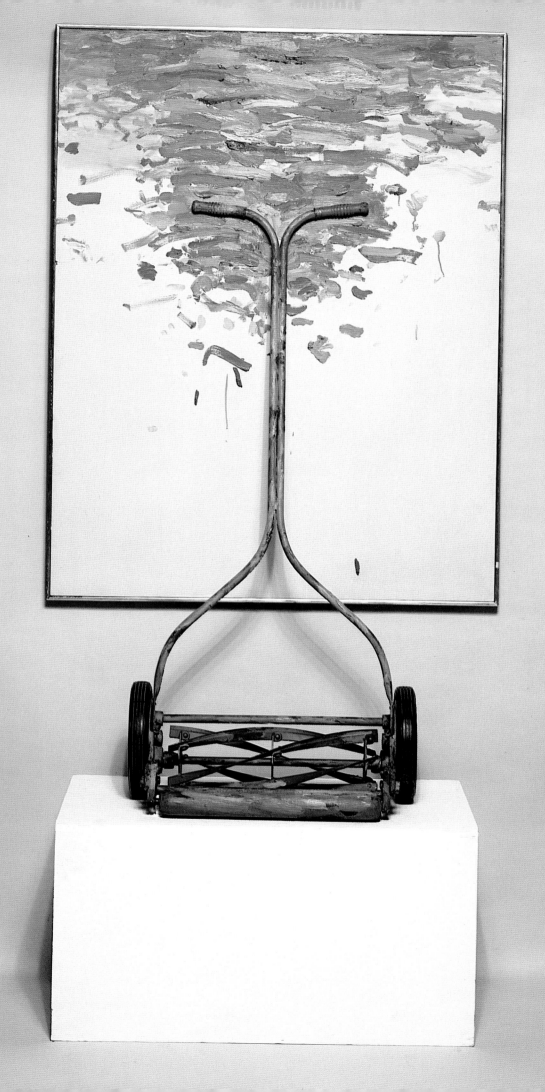

90. Hammer Study, *1962*
Mixed-media assemblage: Oil, pencil, metal
hammer head, and wooden hammer handle
on canvas
60 1/8 x 50 inches (152.7 x 127 cm)
Museum of Fine Arts, Boston.
Theresa B. Hopkins Fund

91. Colorful Hammering, *1962*
Mixed-media assemblage: Oil on canvas,
with wood strip, nail, oil, and hammer
60 3/8 x 51 inches (153.4 x 129.5 cm)
Collection of Mr. and Mrs. Robert B. Goergen

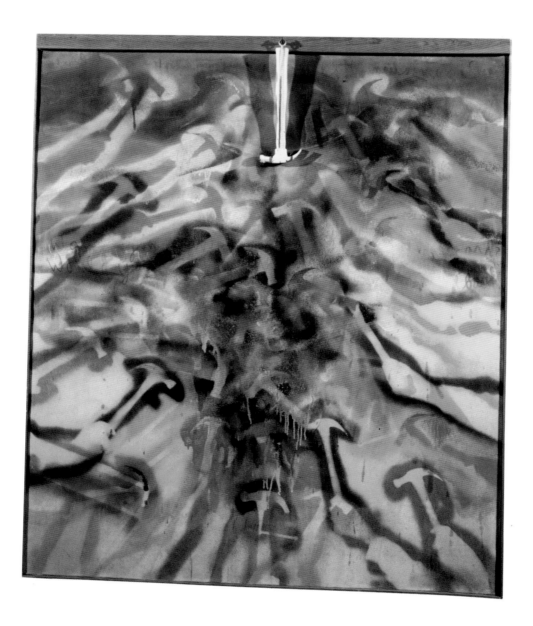

92. Summer Tools, *1962*
Mixed-media assemblage: Oil, tools, string,
glue bottles, and plastic light fixture
on canvas
6 feet 8 inches x 9 feet (203.2 x 274.3 cm)
Richard Gray Gallery, Chicago/New York

facing page:
93. Window with an Axe, *1961–62*
Mixed-media assemblage: Oil on glass
window in aluminum frame with wood strip
and axe, mounted on wood plank base
63 1/2 x 32 x 13 inches (161.3 x 81.3 x 33 cm)
Private collection, New York

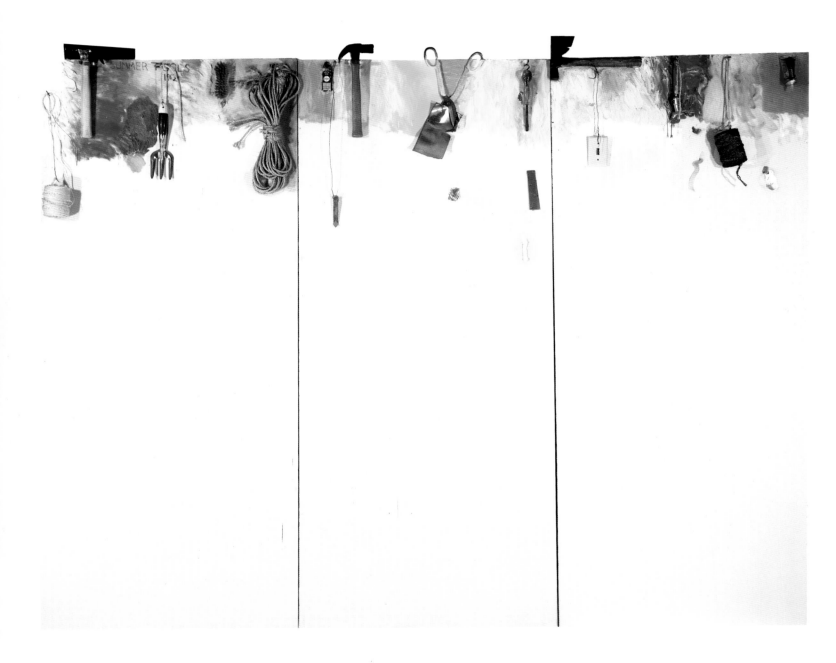

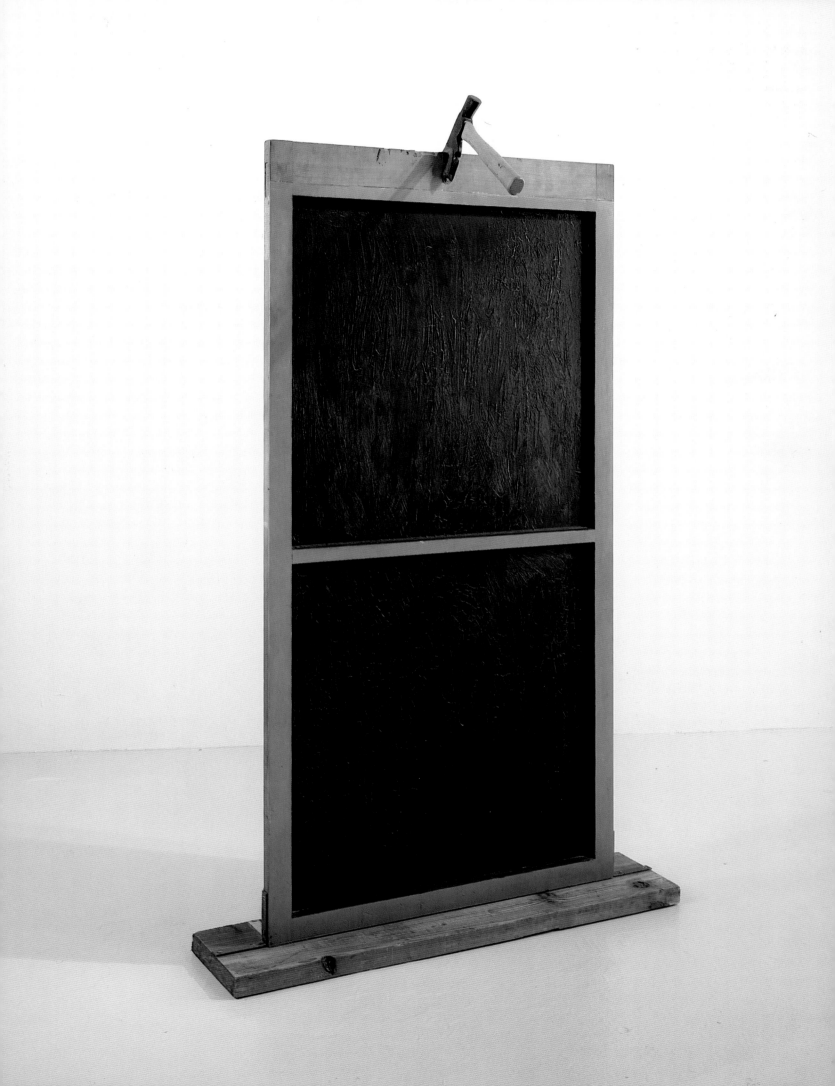

94. Proposed Still Life, *1962*
Mixed-media assemblage:
Oil and tools on canvas
7 x 3 feet (213.4 x 91.4 cm)
Sonnabend Collection

facing page:
95. Vise, *1962*
Mixed-media assemblage: Oil on canvas,
with wooden table and metal vise
6 feet 8 inches x 3 feet x 2 feet 6 inches
(203.2 x 91.4 x 76.2 cm)
Private collection, New York

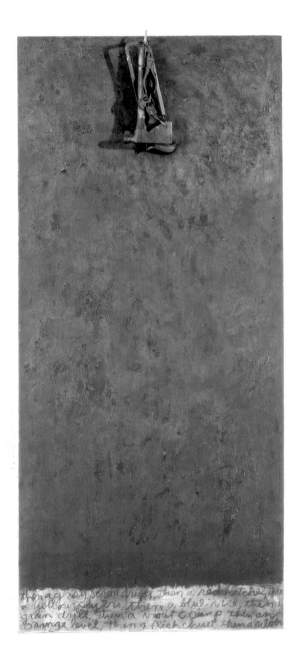

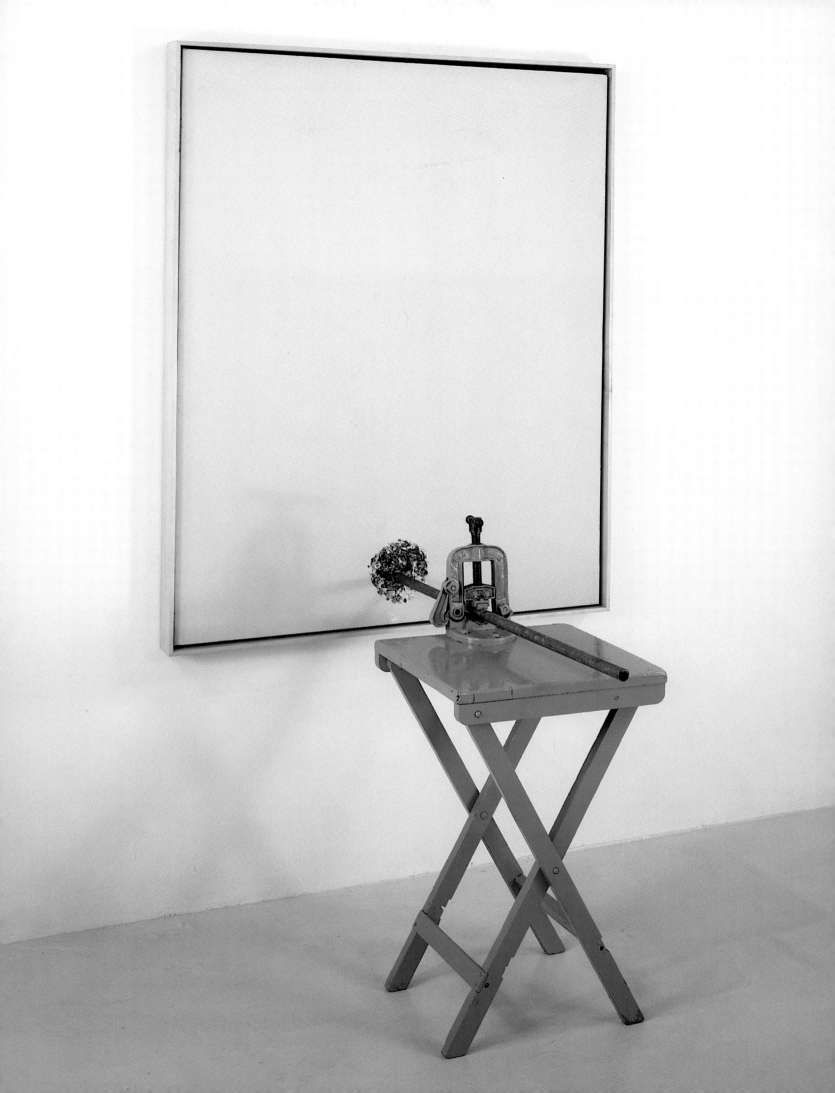

SQUARE

working along thinking things at a million second rate
talk makes me hoarse so do cigarettes
black jet of fun i cant stop seeing it
red breaks out of the tape touch my fingers dont yes
 touch all over
shake my head no my eyes out never thinking at the fast second
pace our limbs are strained jet black crease look young
too tender now tomorrow the gray violet just broke
funny songs waste the time there goes the yellow dye
my hands balloon gloves i want to

(Jim Dine, 1969)

96. Double Red Bathroom, *1962*
Mixed-media assemblage: Oil, two mirrored cabinets, metal toothbrush holder with plastic toothbrush, metal towel rack, and metal toilet-paper holder with painted toilet paper on canvas
4 feet 2 inches x 6 feet 8 inches x 7 inches
(127 x 203.2 x 17.8 cm)
Rose Art Museum; Brandeis University, Waltham, Massachusetts.
Gevirtz-Mnuchin Purchase Fund, 1962

following two pages:
97. *Installation of* New Paintings by Jim Dine *exhibition held at Sidney Janis Gallery, New York, February 4– March 2, 1963.*
Pictured (foreground, left to right):
Three-Panel Study for a Child's Room, *Summer 1962 (fig. 107);* Black Bathroom #2, *1962;* Green Shower, *1962 (fig. 101)*

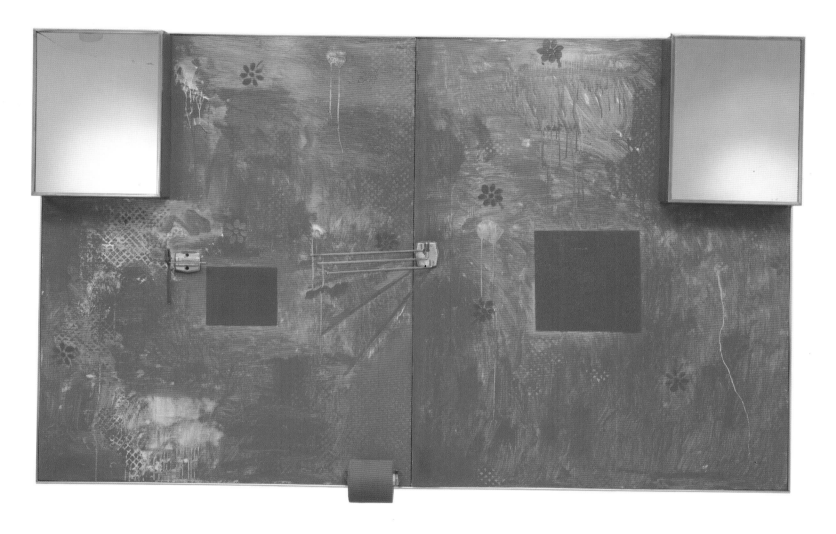

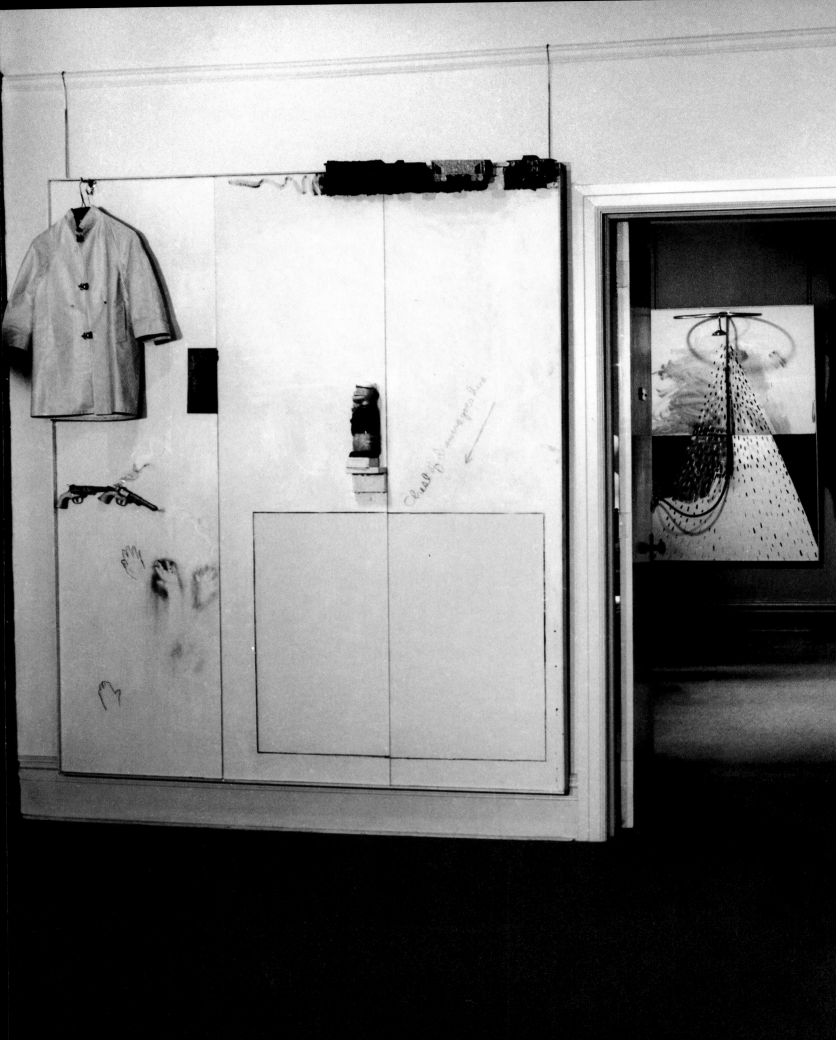

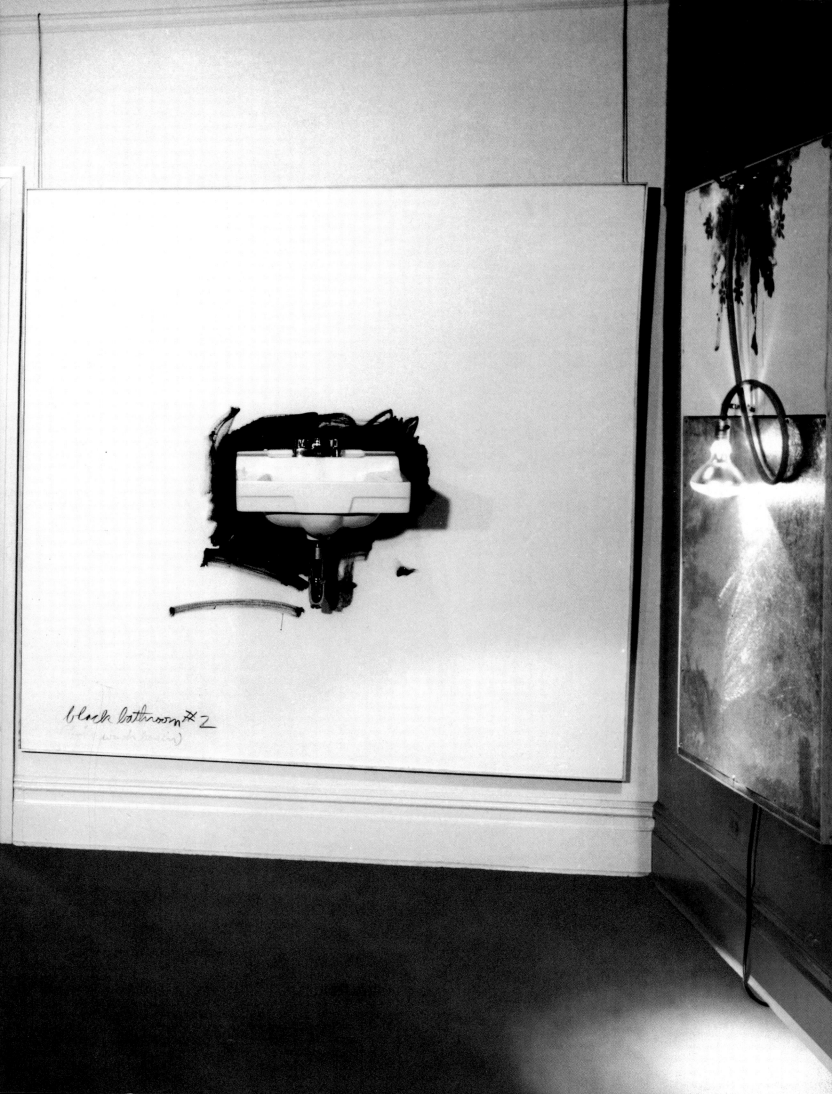

GC: In the series of *Bathroom* pictures, the first clear action I see is a kind of Mondrianesque way of composing. Why do you need this structure to include the objects? Is it because of the idea of details, or because it is very symmetrical?

JD: It's how I compose! When I was working on these pieces, I was in my late twenties, and I had looked at a lot of what we called in America "Neo-Plastic Painting"—Mondrian, etc. I found that an interesting way to compose a picture, and when you get a medicine chest (which is essentially a rectangle), and a hanging towel, and these other objects, it's a way to arrange them. Actually, if one makes that decision in a house, and you were the contractor for the house, I think you would probably say, "Well, the medicine chest goes here, the towel rack goes there," but you wouldn't jam them all together in one place, because it would be confusing. All these objects come out of my childhood, and when I say that, I don't mean just because I went and looked at this in the bathroom every morning. It's because they were primary objects that my family was selling. They had them on display in the stores. There were two stores—my father's and then my grandfather's. My father had been hired by my grandfather to run the smaller store. But the point is they were always displayed the same way, without art, in the most direct way. This was stuff that I lived with every Saturday when I went down there to work and all summer long as a boy.

CB: Were you attuned to the display of objects?

JD: Not just display, not in the Rauschenberg sense, like his Tiffany windows. This is the lower end of the scale. What I was attuned to, as the child/artist which I was, I was never in doubt that these things were all grist for my mill. They were all objects of affection for me, and just as if my family had been in the art-supply business, then I would've maybe only felt that way about tubes of paint or colors. Here I had color charts for house paint. Beautiful! I had toilets, sinks in beautiful white glaze. Beautiful! It all had to do with the object as an object of beauty to me. And that's why I composed it.

GC: In your paintings, did you create a drawing for the pattern?

JD: No, I just did it. I arranged it, and if it didn't work, I unscrewed it and put it somewhere else.

CB: Were you trying to create a sense of mood or atmosphere in the *Bathrooms*?

JD: Just to differentiate, to make variations on a theme.

CB: Are all the rooms psychologically the same place for you?

JD: As far as I am concerned, the place is right there.

GC: Why do you keep the objects open, like the toilet paper hanging off the canvas or the protruding soap dishes?

JD: I wanted it to be casual and human.

GC: Are they invitations to act? Emotionally I have a feeling that I can take the toilet paper or soap, what have you, and it's part of the work—or was it for you just a kind of frozen momentum?

JD: They are not frozen in time, because otherwise, I would have used just rectangles, not the objects.

GC: *Wiring the Unfinished Bathroom* [1962, fig. 106] is extremely complex compared to the others from the series.

JD: I was going to make another *Bathroom* painting, because it was all there in the studio. But instead, it became more informal. It became more occasional. I just had this idea that it was a "job," rather than a place.

GC: What is the yellow square at the top of the composition?

JD: It's just a square of paint. I took masking tape, and masked off a square there, and I did the same thing with the red strip above the light, and that's all about composing.

CB: Did geometric abstraction interest you in the same way that painterly expressionism did?

JD: I always talk about Kline and de Kooning, and Rothko, but I never thought they were very abstract.

GC: And what about Walter Benjamin and the idea of the stripe? Did you know about it?

JD: Oh, I knew it, but I never thought about that. It's just, I needed a stripe there. I felt I needed it.

GC: I see a kind of convergence of three different periods of your work in this painting. The black panel, which is a reference; then the light; and all this kind of disorder.

JD: You could say that.

CB: The other thing I see in these works is your integration of drawing. Even the wire itself is a drawing, and then you have this scroll. So, in all of these works, it feels like you're introducing the idea of drawing.

JD: Right.

GC: Is the black outline in the work suppose to be your shadow? Is the drawing a shadow of you in a certain way? What does it mean for you to draw? Leaving your shadow?

JD: No, leaving my traces.

GC: But it's a physical shadow. It's very romantic.

JD: You could say that. I'd love it if it was. I don't know.

CB: Is the medicine chest itself a self-portrait?

JD: The whole thing is a self-portrait, because it's me not wanting to make a self-portrait, but not being able to help it. I use flesh paint, I use toothbrushes. I also felt that in using flesh paint, catching color right out of material, the flesh paint was a kind of found object itself, because it was a generic flesh—Caucasian, but generic. It's more like a doll's flesh; it's not the color of my flesh or your flesh. And so, for me, it was exciting to use that color. I used it in *The Toaster* [1962, fig. 100] and several other works as well as in *Wiring the Unfinished Bathroom*.

GC: What about the idea of the inside of the cabinet? The toothbrushes, etc.? Were you conscious about being inside or communicating with these objects, especially in a cabinet? Was it a question of opening up the box, and projecting what could be inside? It was only an object?

JD: It's an object we all experienced. I thought it would make an interesting painting. That's it.

CB: In *Car Crash* you created a whole hospital environment, and then with the *Bathrooms* you invoke the medicine cabinet and another antiseptic environment. Was the hospital in some ways a safe haven for you?

JD: No, it's dangerous. That's why I made *Car Crash*.

GC: Were the children's rooms a way of recreating your childhood through a kind of self-analysis?

JD: All these things came about because I had children when I was very young. In *Child's Blue Wall* [1962, fig. 108], that was Jeremy's lamp. Because I had these little kids, I remembered childhood more. And therefore things like Erector sets and other toys appear in *Three-Panel Study for a Child's Room* [Summer 1962, fig. 107].

GC: I noticed that in some of the works that precede these there is this kind of geometric figure that lies on the surface of the composition—a kind of three-dimensional rectangle. Had you started to look at Constructivism at the time?

JD: There are Constructivist connections. I had already looked at Mondrian and Malevich a lot.

CB: You often refer to the grid in works such as *The Checkerboard* [fig. 20], and *A Color Chart* [1963, fig. 121] as a grid, and the same with the medicine cabinets of the *Bathrooms*, which function on the plane of the canvas as

geometric abstract forms.

JD: And as a way to get the mirror on the wall, which would add another dimension to the painting.

GC: Were you familiar with Rauschenberg's *White Paintings* at the time?

JD: Probably not, because they were not available to be seen, although I did know about them.

CB: Was the scale of *Four Rooms* [1962, fig. 109] a breakthrough in your work, since you're activating space there in a way you hadn't done since *The House*?

JD: After that summer in East Hampton, I came back to New York and I went to town with the *Bathrooms*. The *Bathrooms* led to *Four Rooms*. I just thought: four panels, four rooms. And I wanted to make a really beautiful painting. I wanted to recreate the surface of David Smith's sculpture by using an aluminum panel. I thought that it was beautiful the way he polished stainless steel. I used aluminum and tried to create his surface.

GC: The wall is still the primary element; it's not architecture. So you still read it as a two-dimensional painting.

CB: *Black Bathroom #2* [1962; see fig. 97] is another work where you oscillate between the two-dimensional quality of drawing and the three-dimensional object.

JD: I saw that sink, put it on the canvas, and it was obvious that all it needed was some paint around it.

GC: So you created this kind of dispersion of energy around it, this radiation. Steiner has this idea at the time that the aura of reality comes from inside you and it radiates outside into the world. Your brushwork in these paintings remind me of this notion.

CB: You feel it happening in works as diverse as *Car Crash* [1960, fig. 49], where the shroud is similar to the spray of water in *Small Shower #2* [1962, fig. 110] and other works from the period.

98. A Bathroom Study, *Summer 1962*
Mixed-media assemblage: Oil, plastic
toothbrush holder, plastic tumbler,
and three plastic toothbrushes on canvas
24 x 17 7/10 inches (61 x 45 cm)
Collection of Barbara and Richard S. Lane

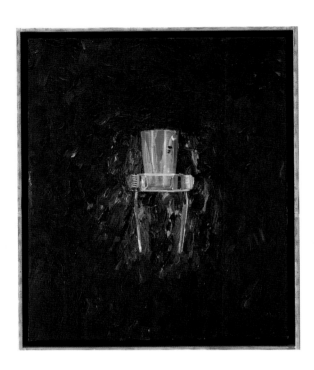

99. Four Soap Dishes, *1962*
Mixed-media assemblage: Oil, four metal
soap dishes, and four painted wooden soaps
on canvas
48 x 40 inches (121.9 x 101.6 cm)
Sonnabend Collection

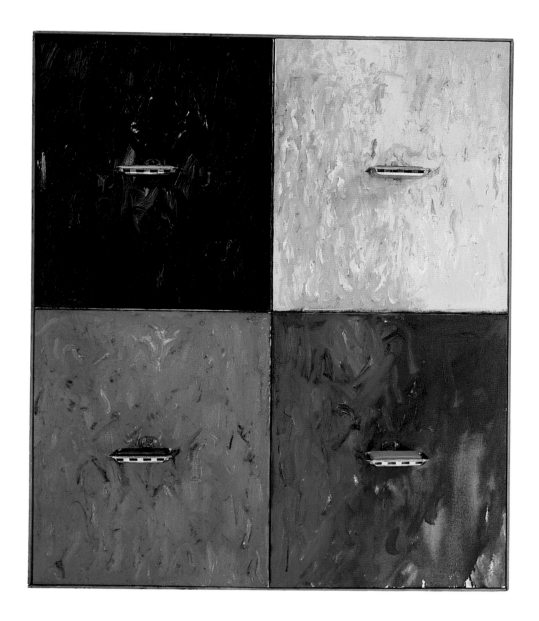

100. The Toaster, *1962*
Mixed-media assemblage: Oil and metal
toaster (with electric cord) on canvas
8 feet 4 inches x 6 feet 8 inches x 7 inches
(254 x 203.2 x 17.8 cm)
Whitney Museum of American Art, New York.
Gift of the Albert A. List Family.

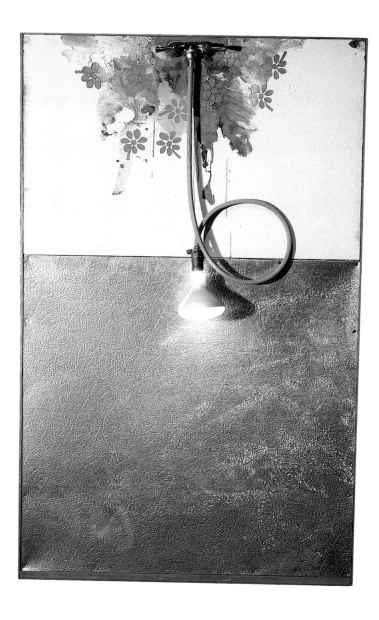

102. Flesh Bathroom with Yellow Light
and Objects, *1962*
Mixed-media assemblage: Oil, mirrored
cabinet, metal toothbrush holder with
plastic toothbrush, metal toilet-paper holder
with toilet paper, and functioning light bulb
on canvas
6 feet 1/2 inch x 5 feet 1 inch x 7 inches
(201.9 x 154.9 x 17.8 cm)
Collection of the Saint Louis Art Museum.
Purchase: Funds given by the Shoenberg
Foundation, Inc.

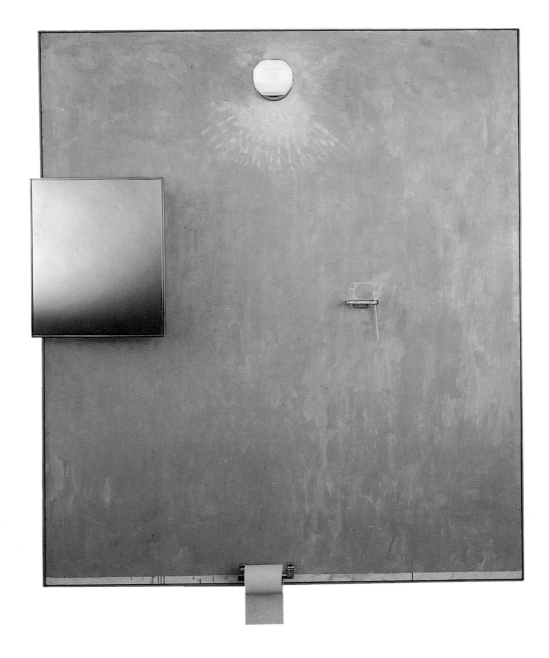

103. Black Bathroom, *1962*
Mixed-media assemblage: Oil, mirrored
cabinet, metal faucet, metal toothbrush
holder, and metal object on canvas
6 feet 2 3/16 inches x 6 feet 13/16 inches
(188.5 x 185 cm)
Museum für Moderne Kunst,
Frankfurt am Main

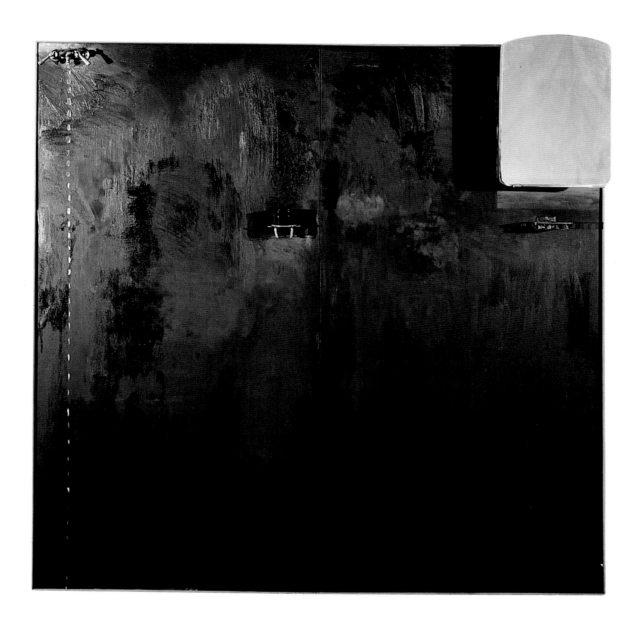

104. The Pink Bathroom, *1962*
Mixed-media assemblage: Oil, mirrored
cabinet, metal toothbrush holder
with plastic toothbrush, and metal-painted
soap dish on canvas
6 x 4 feet (182.9 x 121.9 cm)
Private collection

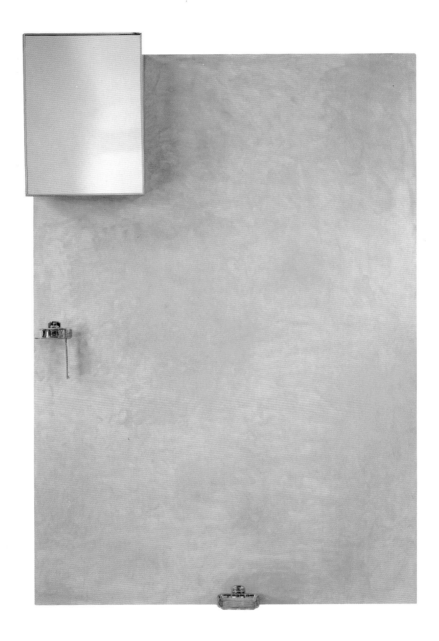

105. White Bathroom, *1962*
Mixed-media assemblage: Oil, mirrored
cabinet, three metal towel racks, bath towel,
hand towel, metal soap dish, toilet paper,
metal toothbrush holder with two plastic
toothbrushes, metal toilet-paper holder
with toilet paper, and wood strip on canvas
6 x 6 feet (182.9 x 182.9 cm)
Louisiana Museum of Modern Art,
Humlebaek, Denmark

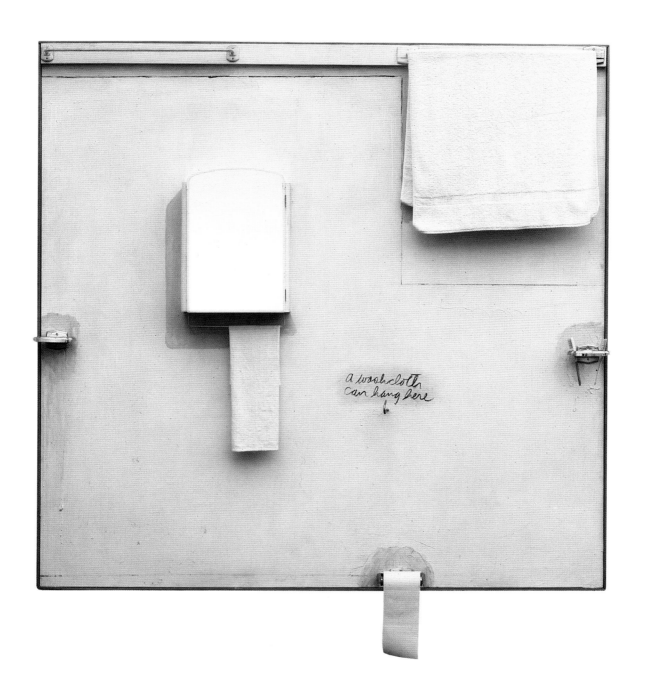

"Actually I'm interested in the problem and not in solutions. I think there are certain Pop artists who are interested mainly in solutions. I paint about the problems of how to make a picture work, the problems of seeing, of making people aware without handing it to them on a silver platter."
(Jim Dine, 1963)

106. Wiring the Unfinished Bathroom, *1962*
Mixed-media assemblage: Oil, wood strip,
metal toothbrush holder with four plastic
toothbrushes, electric cords, extension cord,
electrical outlets, light socket, and two metal
light fixtures with clamps and light bulb
on canvas
6 feet 8 1/16 inches x 8 feet 1/16 inch
(178 x 244 cm)
Louisiana Museum of Modern Art,
Humlebaek, Denmark

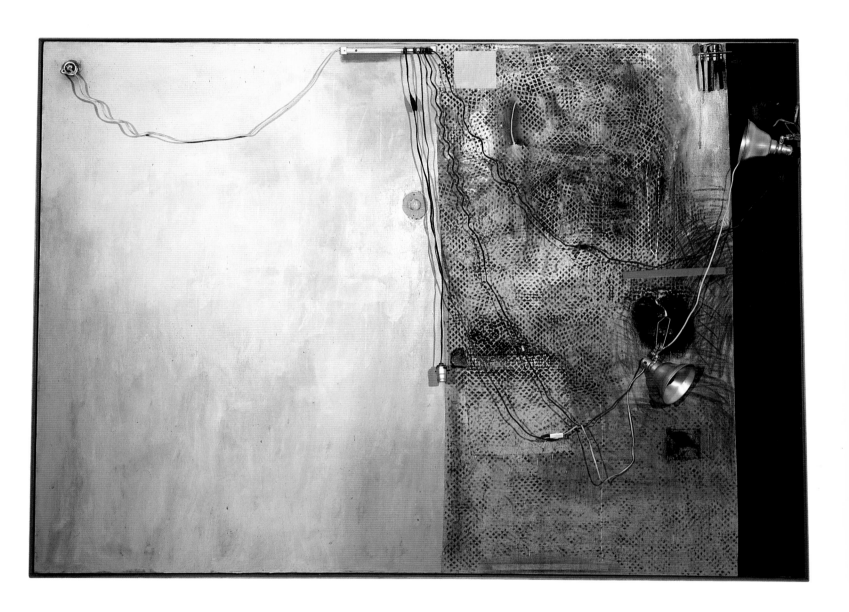

107. Three-Panel Study for a Child's Room,
Summer 1962
Mixed-media assemblage: Oil, charcoal,
child's rubber raincoat on wire hanger, toy car,
model train, Popeye doll, metal hook, and two
toy guns on canvas
7 feet x 6 feet 3/8 inch (213. 4 x 183. 8 cm)
The Menil Collection, Houston

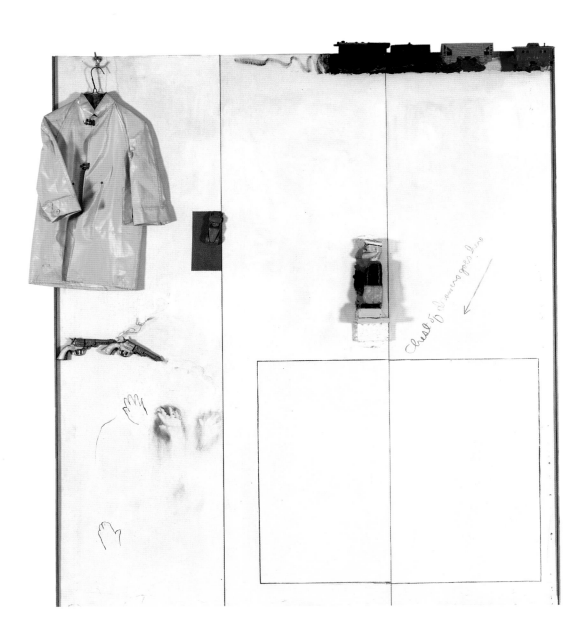

108. Child's Blue Wall, *1962*
Mixed-media assemblage: Oil and light
switch on canvas, with painted wooden shelf,
and lamp with functioning light bulb
5 x 6 feet (152.4 x 182.9 cm)
Albright-Knox Art Gallery, Buffalo,
New York. Gift of Seymour H. Knox, 1963

following two pages:
109. Four Rooms, *1962*
Mixed-media assemblage: Oil, metal shower fixture,
and rubber tubing on canvas; aluminum panel; and
upholstered chair below
Four panels. Panel A: 6 feet 1/16 inch x 5 feet 3/16 inch
(183 x 152.9 cm); panel B: 6 feet 3/16 inch x 3 feet
(183.4 x 91.4 cm); panel C: 6 feet 1/4 inch x 4 feet 1/8 inch
(183.5 x 122.2 cm); panel D: 6 feet x 3 feet 1/4 inch
(182.9 x 92.1 cm); 6 x 15 feet (182.9 x 457.2 cm) overall
Private collection, New York

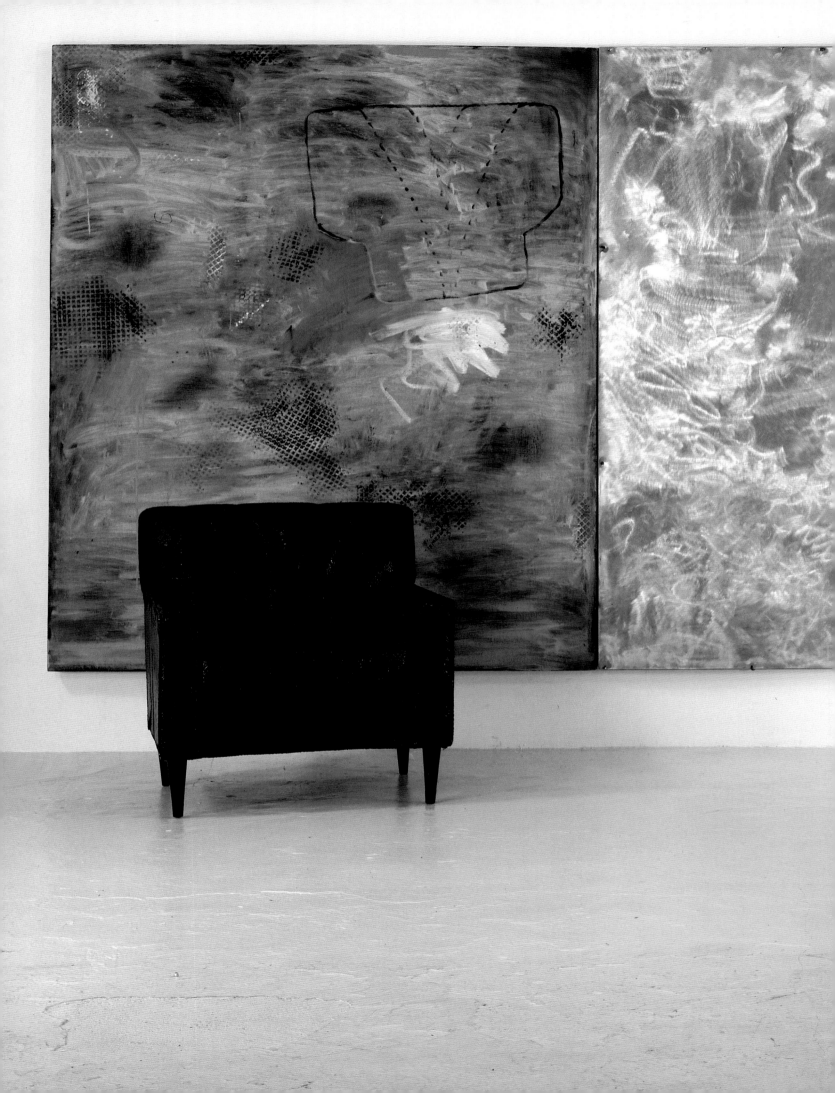

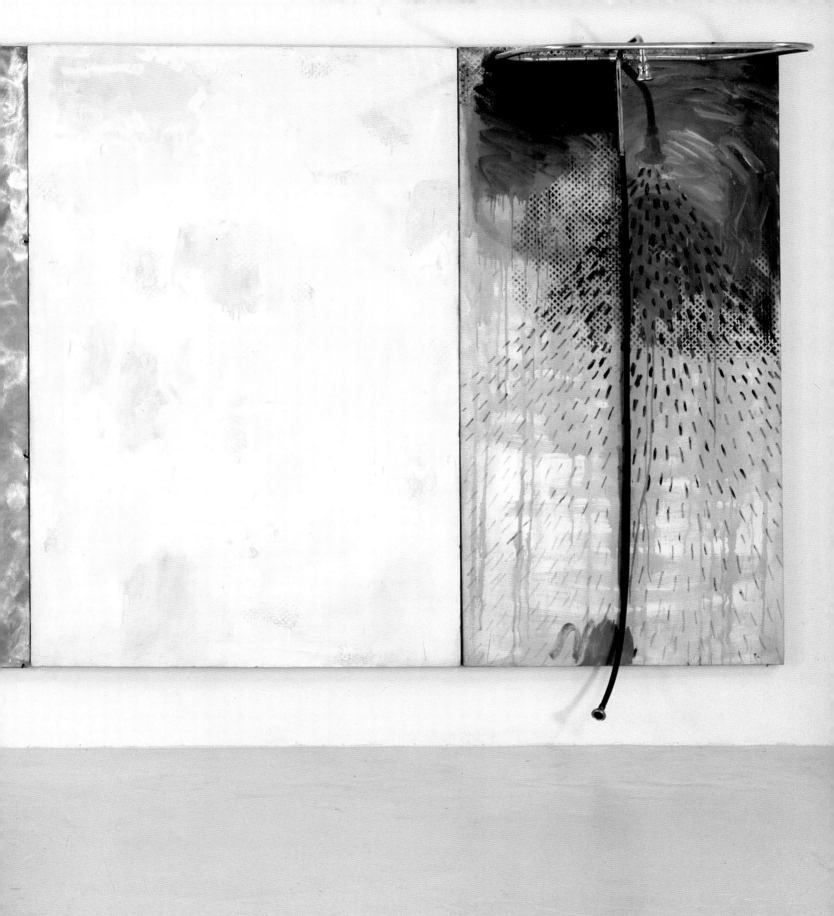

JANE

The shower is on hard
and I'm soaping up like mad
and the police come in and grab
me (mine)
AND SAY IT'S A GIRL'S SHOWER
and I say my name is JANE
and they say
you don't look like a JANE
and I say that I don't feel like one
and this one cop
with a miner's lite on his head
tells me to open my mouth
and I say (pause)
 JANE
meanwhile they've shut off the water
and I'm cold as hell
and I ask for a towel
and they say stuff it
 JIM (GEEUM)
and I say
how did you know
my name and they say
we thought it was JANE
AND I SAY WHAT A GREAT IDEA

(Jim Dine, 1969)

facing page:
110. Small Shower #2, *1962*
Mixed-media assemblage: Oil, enamel, metal
letters, and metal shower head on canvas
48 x 36 1/4 inches (121.9 x 91.4 cm)
The Art Institute of Chicago. On loan from
the Morton G. Neumann Family Collection,
1.16.1988

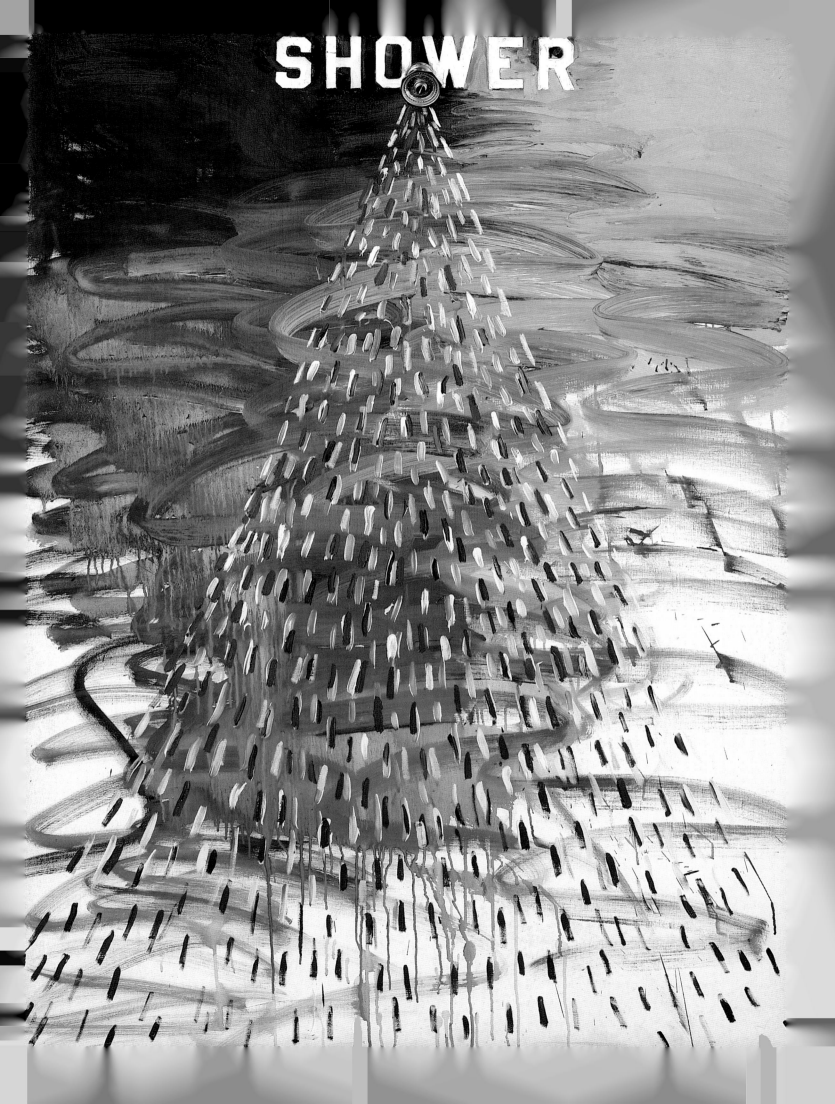

112. The Studio (Landscape Painting),
1963
Mixed-media assemblage: Oil and acrylic
on canvas, with glass and metal objects
on wooden shelf
5 feet x 9 feet 1/2 inch (152.4 x 275.6 cm)
Collection of A. Alfred Taubman

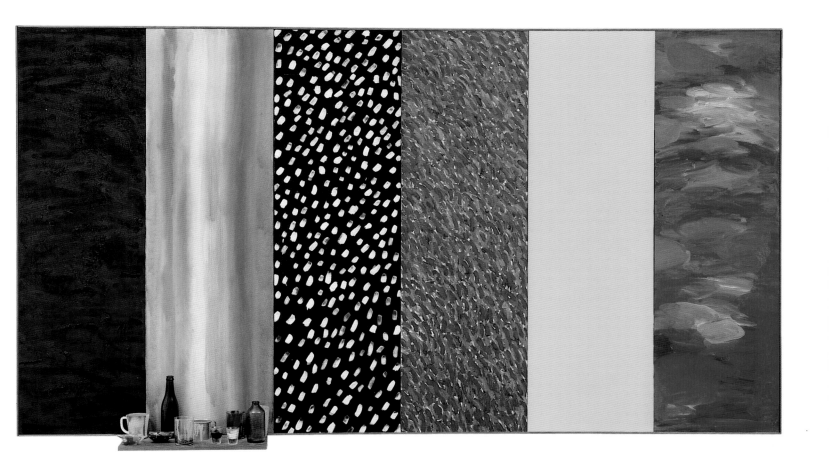

CB: Tell us how you came to paint such sensuous treatments of landscape as *The Studio (Landscape Painting)* [1963, fig. 112] and *Long Island Landscape* [1963, fig. 111].

JD: They are about weather, and nature. I made *The Studio* after I looked out my window where I was living, on the ground floor apartment in the back of the apartment, when it was snowing, and it was black outside, and there were these big white flakes coming down. So I thought to myself, Why not make a painting that had elements of landscape, just elements of landscape, not wanting to make a landscape. And I just thought it would be a good idea to compartmentalize, like a color chart, like a glossary of terms, like a dictionary of landscape, but then also to include objects in the studio, like a little still life. And I made *Long Island Landscape* in the summer of '63. The house we'd rented in East Hampton by the railroad tracks had a big backyard and a barn, and I just wanted to make a landscape painting. It's pretty realistic. I was thrilled to make this painting, because it was like expressing what I saw, the beauty of Long Island, before the rich people came. Right now, I am making a landscape in my studio. It's taken all this time to have the nerve to do it.

GC: A real one?

JD: I make it out of my mind, but I am having the greatest time. But as always, I look out of the window, I am totally involved with weather. All my life, I respond to weather. There is no such thing for me as bad weather. I like it all.

CB: In 1963 what was your emotional state like?

JD: I was not doing too well. It took a lot to get down to the studio to do this, but I remember being in the studio and doing and feeling great about it.

CB: Did this in some way help you break from inside to want to go out?

JD: No, but art has always been for me a *security*. It's been my hedge against depression.

GC: What does a change of time or a change of emotion mean to you at the time?

JD: It means for me another example of the divine.

CB: After the landscapes, you began a series of *Palettes*, yet you did the first one in 1960 in honor of your birth year, 1935. Why did you drop the subject and then pick it up again three years later?

JD: Actually, I made a whole bunch of *Palettes* on paper in 1962, but they were stolen from the studio where I made them, along with an actual palette, and they never turned up. The thieves broke into my studio and took all the works on paper, and the *Bathroom* paintings were in the midst of being worked on, so they took some of the objects off the paintings, and they ruined the backs of the paintings with sticks. I was so stupid in those days! My studio had been the young Socialist League before I began renting it, and I never changed the locks, so, one morning, I got there, and it was empty. I mean, I knew. My door was open. What's going on? The door is open; somebody came in. Very neat, there was no vandalism. They took the objects off very neatly, and they took all the works on paper. So, I called the cops. And the cops thought I was the asshole. I am the artist, right? I felt like I'd been raped, I really did. I never had an experience like this before. I was absolutely depressed. I ran home in my car. By the time I got home, Sidney Janis had already called the newspaper, and there is Tom Wolfe sitting in my living room, not famous then, but there he was, Tom Wolfe, working for the Herald Tribune, which was the better paper in New York, and with a photographer. And I said, "Who are you? What are you doing here?" He wanted to talk about the robbery. I said, "Get out of my house. I don't want to talk

about it." He said, "No, no." And the photographer said, "No, you have to understand, this is Tom Wolfe. He's just done the obituary of e. e. cummings. He's a great writer." I said, "Get out of here. I've already been intruded upon once today. I don't want to see you." And finally they left, and that was that. Nobody found anything. Ever! I still look at auction catalogues . . . it's always in my mind.

CB: And are any of the paintings that you did in '63 an attempt to redo the drawings that were stolen?

JD: No. I was in the midst of making *Bathroom* paintings. I'd just come back from East Hampton in the fall of '62.

CB: Where was your studio?

JD: On the corner of Second Avenue and Fifth Street.

CB: Was *A 1935 Palett* [1960, fig. 26] the only painting you made of a palette before 1963?

JD: No, there was another one, owned by Ted Powers. It was a colorful one, with a black background. One night, I showed it to John Cage, and that was the night he gave me his leather tie which I used in *The Composer's Yellow Tie* [ca. 1962, fig. 79].

GC: There is a sensuous element to most of the 1963 *Palettes*, and yet, like the cabinets in the *Bathrooms*, there is a feeling of sequence to them. And what about the idea of the double? Is it about reflection, or sequence?

JD: Sequence, probably, since they are all so different.

CB: You mentioned a palette that was stolen from your studio. Did you work with a palette to mix your colors when you were painting?

JD: I used a palette, but I usually mix colors on the canvas or I mix them on the floor. The smaller palette in *Red Palettes* [1963, fig. 115] is a real one. Some of the *Palette* paintings are full of objects, real objects.

GC: So the objects are your palette in a certain way?

JD: Yes.

CB: Your *Color Charts* [see figs. 121, 122] are so hard-edged compared to the *Palettes*, which have such expressionistic exuberance. So much of your work plays off the idea of vacillating between geometric abstraction and a more figurative abstraction, which can be considered different states of perception. And then you literally activate an entire room by introducing a stovepipe in some works, such as *Two Palettes in Black with Stovepipe (The Dream)* [1963, fig. 114] and *Dream #2* [1963, fig. 123].

JD: It's a way to turn the corner too. I wanted to do more than just mechanics.

CB: And unlike the *Color Charts*, which are very straightforward, the *Palettes* are quite complex. You don't know how to enter the work, and you don't know what's hidden and what's revealed.

GC: And there is stratification in terms of the work's depth; you don't know which is background and which is foreground. And stratification in time, too. In ancient times, stratification meant time, history, all these kind of things. It seems to me that you stratify your own history by working with levels of cultural memory, contemporary memory, object memory, everything your memory constitutes as in between.

CB: The *Palettes* of 1963 are so different from *A 1935 Palett* because of your practice of redoubling and recombining different states of perception. In fact, did Surrealist practice ever play a role in your work?

JD: Well, I was interested in the first place as a natural inheritor of a tradition. Just like I am a natural inheritor of a Realist tradition. I mean, it was all part of me. But I never felt that I was a Surrealist.

GC: You've often quoted Giacometti. The aspect of your

work that seems to have found a source in Giacometti is all about obsessions.

JD: Yes, about his obsessions. And about his purity and his life in art. I found that exemplary. And so I looked at Giacometti, like sometimes people look to Christian martyrs.

GC: In the *Palettes* there is an invitation to look through. Because while the holes may be for holding the palette, they become holes for looking deep inside the canvas itself.

JD: I wanted to comment on art history, but also I am really at this point feeling like an outsider, and I am thinking to myself, I keep working like this, I am a maniac. I mean, people are going to put me away, why can't I relate? I can make a painting as good as Frank Stella or an abstraction if I wanted to, so in my most primitive goofiness, I put in these little holes. I mean, I used these things like an abstract artist. I wanted to be loved.

CB: You were doing that in the *Bathrooms*, too.

JD: Yeah.

GC: But in the *Bathrooms*, there is a more controlled ambiguity. In the *Palettes*, is the idea of the hole an ideal pure form, or is it just a casual thing?

JD: Casual.

CB: Was your use of raw, unfinished materials, such as saw horses, wood planks, tree logs, etc., a response to Minimalism at the time?

JD: I have a relationship to these materials, not just in the tools that you use on them, but in the materials themselves.

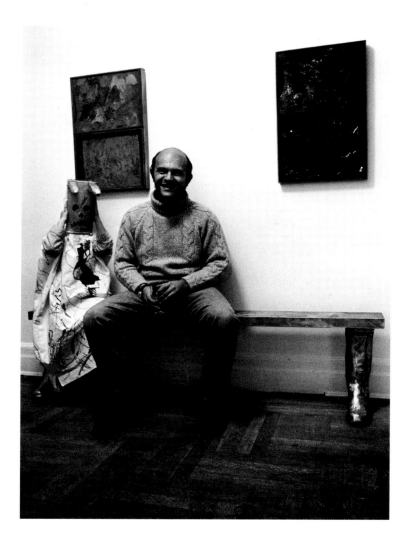

113. Jeremiah and Jim Dine seated on A Boot Bench Ochre #2, *1965, cast aluminum, 17 1/2 x 71 x 12 inches (44.5 x 180.3 x 30.5 cm), Private Collection, New York; on the wall is* Black and Red Paint Boxes, *1963 (fig. 121). Photo by Ugo Mulas*

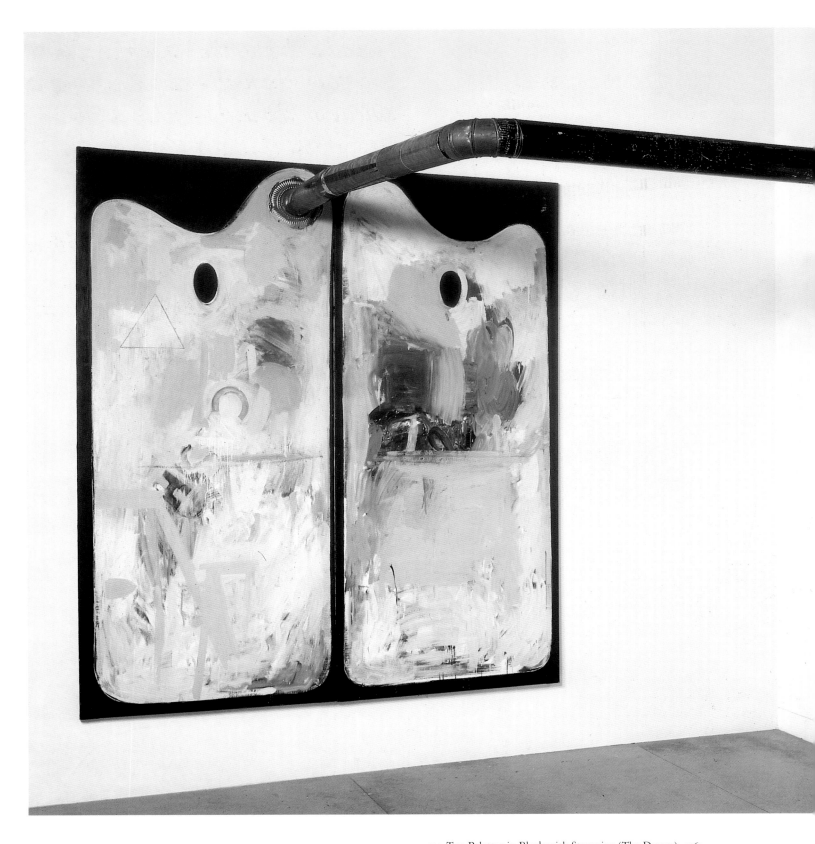

114. Two Palettes in Black with Stovepipe (The Dream)*, 1963*
Mixed-media assemblage: Oil on canvas with galvanized steel stovepipe
and painted Masonite panel
Canvas: 7 feet 1 1/2 inches x 6 feet (214.6 x 182.9 cm);
Masonite: 4 feet 3 inches x 2 feet 9 1/2 inches (129.5 x 85.1 cm);
11 feet 3 1/2 inches x 8 feet 9 1/2 inches (344.2 x 267.2 cm) overall
Sonnabend Collection

"*I had a dream that summer of a palette on the wall—a painting of a palette on the wall—with a pipe coming out of it going into a fireplace, and I thought I would translate it literally, as literally as I could. I arrived at a palette with a stovepipe coming out and turning a corner into an adjacent wall into a canvas which was plain black.*"
(*Jim Dine, 1966*)

115. Red Palettes, *1963*
Mixed-media assemblage: Oil and oil-covered
wooden palette on canvas
60 x 36 x 4 inches (152.4 x 91.4 x 10.2 cm)
Collection of the Estate of Frederick R. Weisman

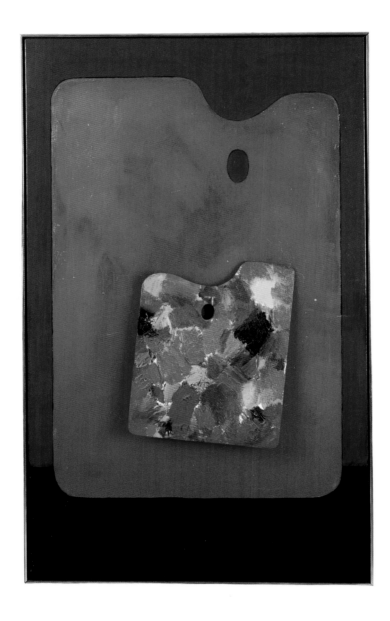

116. Hatchet with Two Palettes,
Slate No. 2, 1963
*Mixed-media assemblage: Oil on canvas,
with wood post, metal chain, and axe
6 feet x 4 feet 6 inches x 1 foot
(182.9 x 137.2 x 30.5 cm)
Collection of Robert E. Abrams*

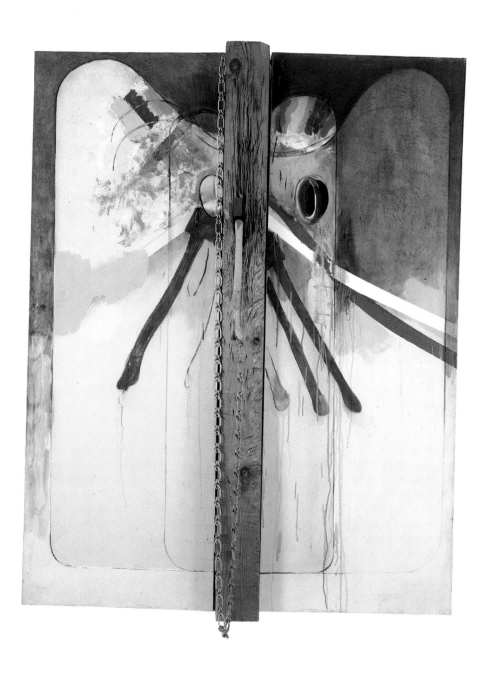

117. Little Blue Palette, *1963*
Oil on canvas
24 x 20 inches (61 x 50.8 cm)
The Parrish Art Museum, Southampton,
New York. Gift of Stanley Posthorn in
memory of Norman Mann.

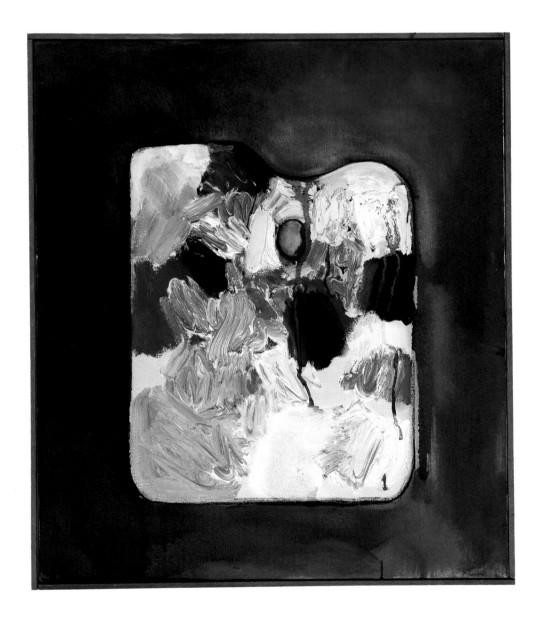

118. Black and Red Paint Boxes, *1963*
Mixed-media assemblage: Oil on wood
and wooden palette, and two wooden boxes
Two panels: 26 x 17 1/4 inches
(66 x 43.8 cm) each
Private collection, New York

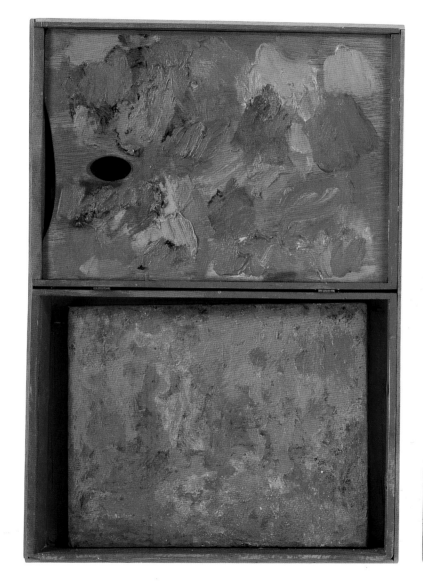

119. Two Palettes (International Congress
of Constructivists and Dadaists, 1922) #1, *1963*
Mixed-media assemblage: Oil and metal rod
on canvas
6 x 6 feet (182.9 x 182.9 cm)
Collection of Mr. and Mrs. Abraham I. Sherr

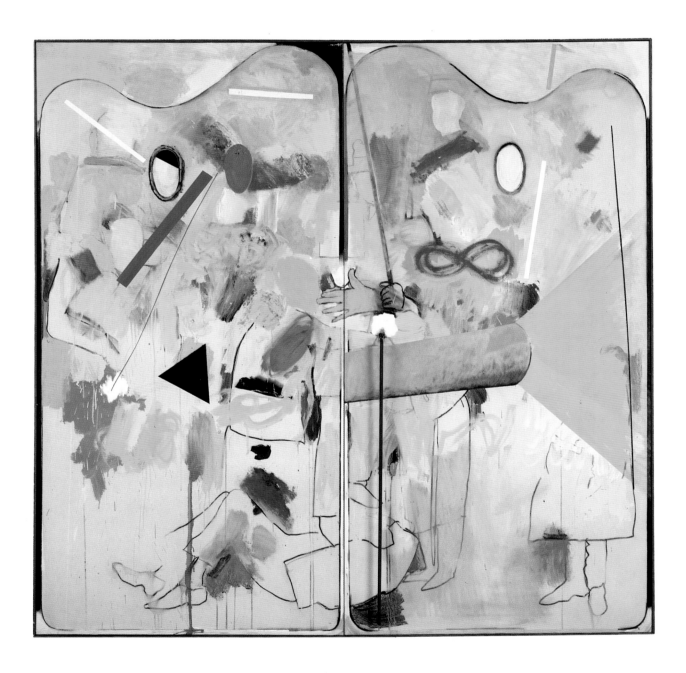

120. Two Palettes (International Congress
of Constructivists and Dadaists, 1922) #2, *1963*
Mixed-media assemblage: Oil and part of a
wooden vise on canvas
6 x 6 feet (182.9 x 182.9 cm)
Collection of Maria and Conrad Janis,
Beverly Hills

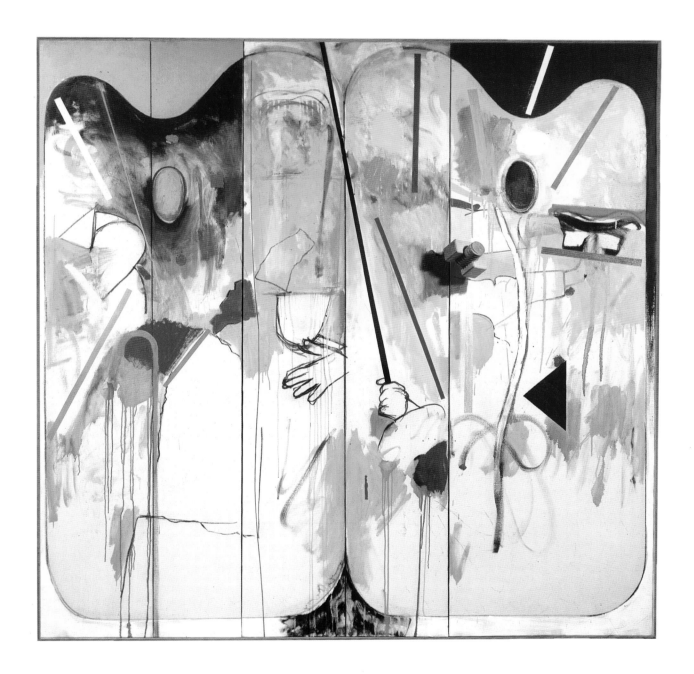

121. A Color Chart, *1963*
Oil and charcoal on canvas
6 feet 1/4 inch x 4 feet (183.5 x 121.9 cm)
Private collection, New York

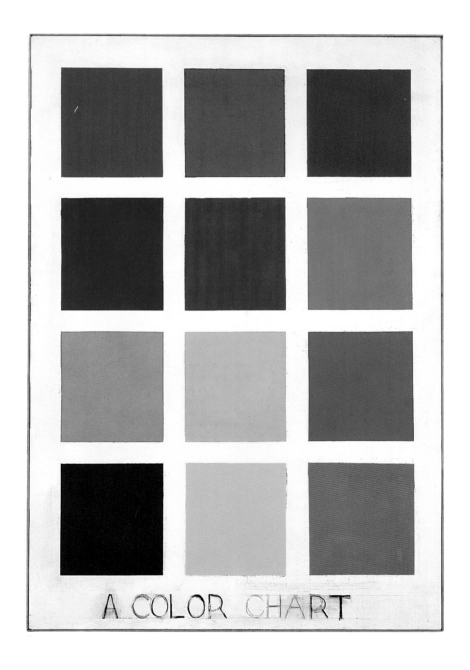

122. Red Devil Color Chart No. Two, *1963*
Mixed-media assemblage: Oil and wood on canvas
7 x 5 feet (213.4 x 152.4 cm)
Grey Art Gallery & Study Center,
New York University Art Collection.
Gift of John A. and Margaret H. Cook Fund Inc.,
1969

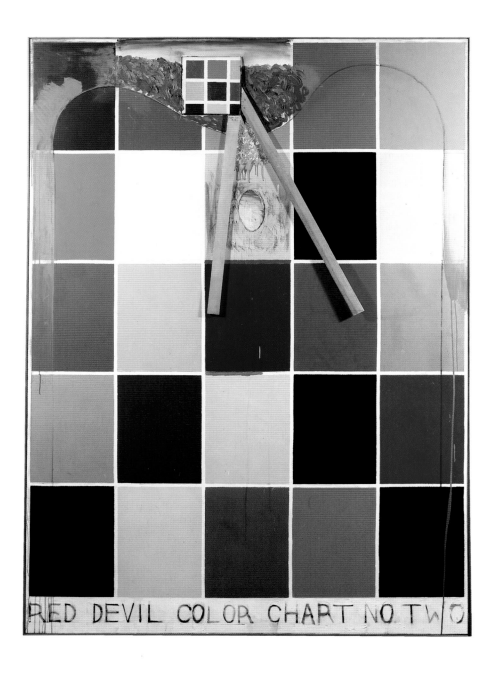

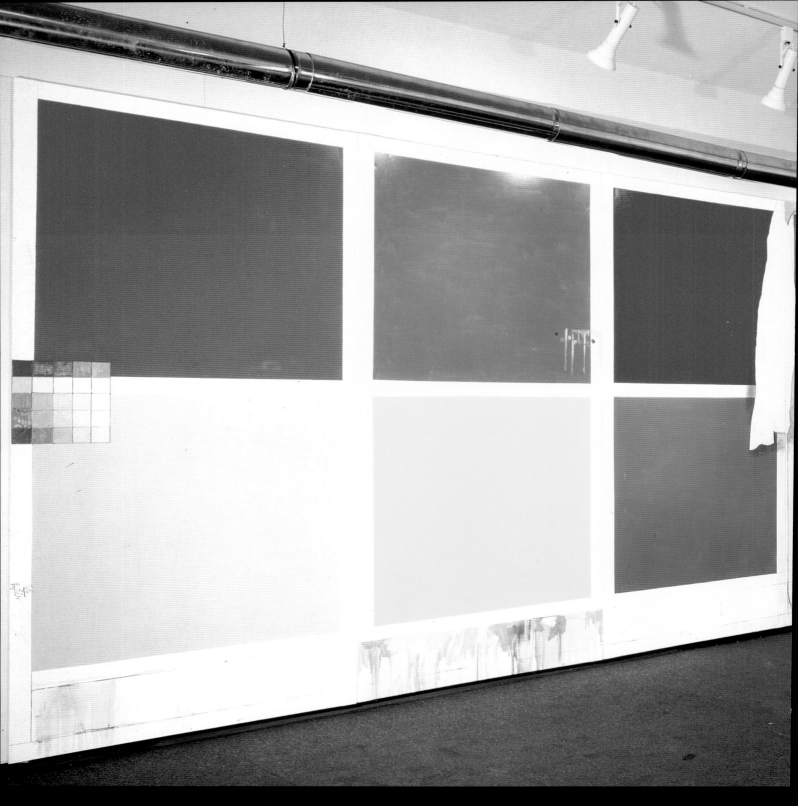

123. Installation of Jim Dine *exhibition held at Sidney Janis Gallery, New York, October 27–November 21, 1964. Pictured (left to right):* My Long Island Studio *and* Dream #2, *both 1963.*

Dream #2, *1963*
Mixed-media assemblage: Oil, metallic paint, and charcoal on canvas, with section of galvanized steel stovepipe and aluminum sheet metal mounted on a strainer
6 x 4 x 23 feet (182.9 x 121.9 x 701 cm)
Solomon R. Guggenheim Museum, New York. Gift of the artist

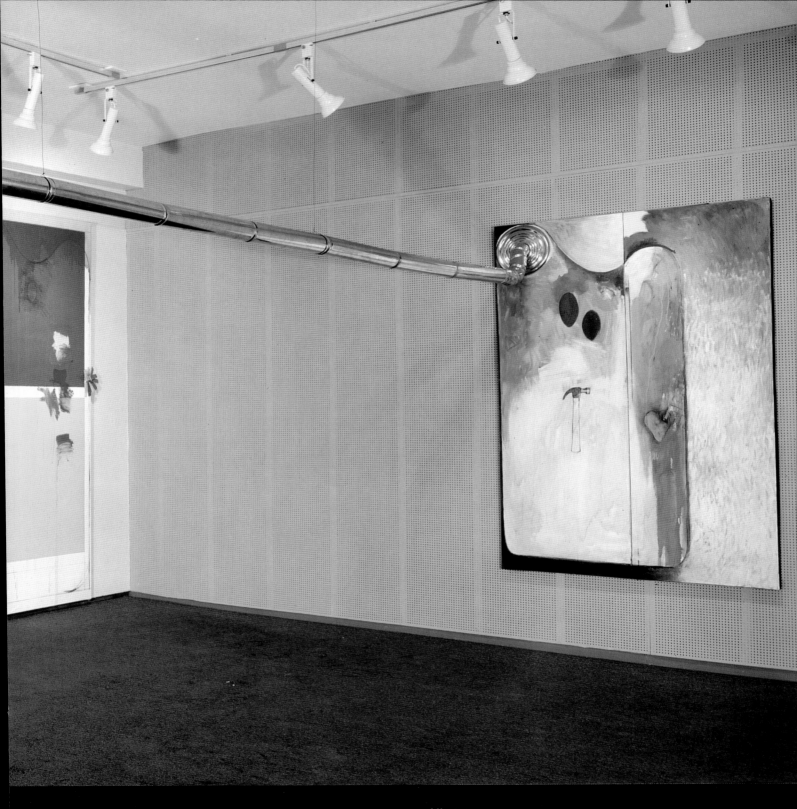

following two pages:
124. Installation of Jim Dine *exhibition*
held at Sidney Janis Gallery, New York,
October 27–November 21, 1964.
Pictured (left to right): Double Red
Bathrobe, *1964;* 17-Colored Self-Portrait,
1964; Self-Portrait Next to a Colored
Window, *1964 (fig. 131)*

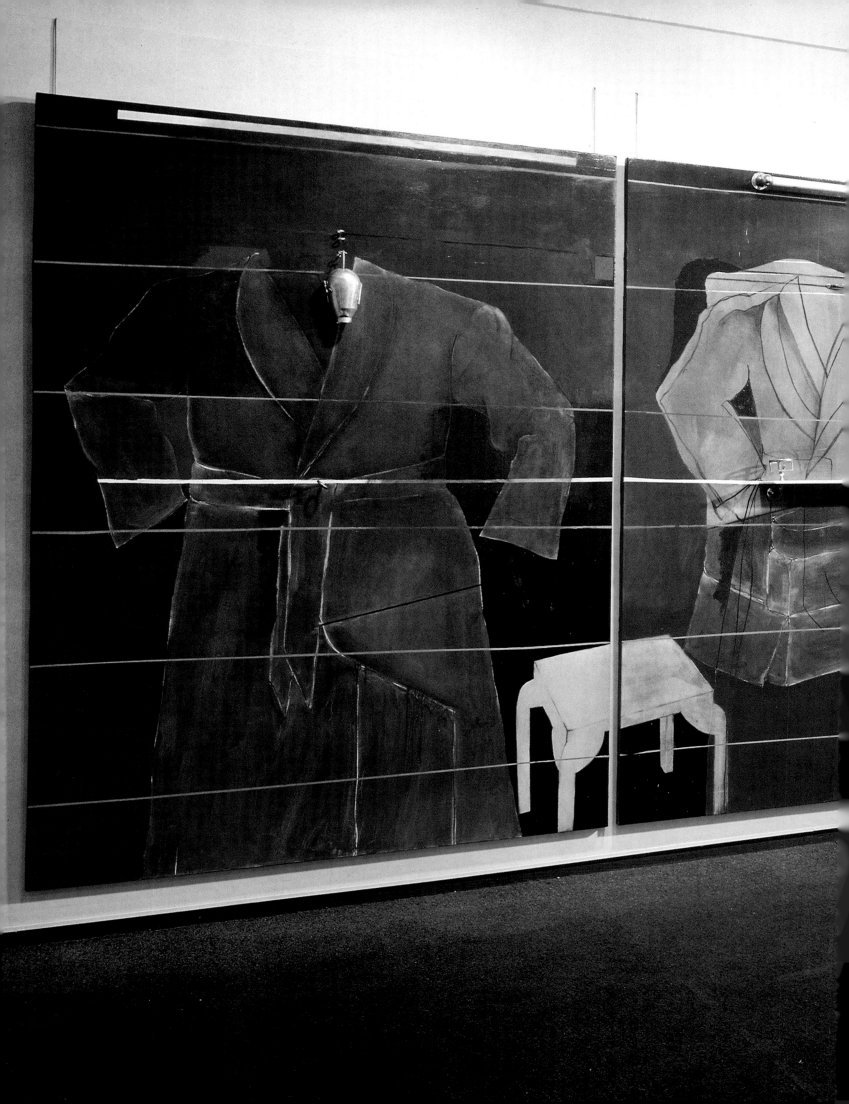

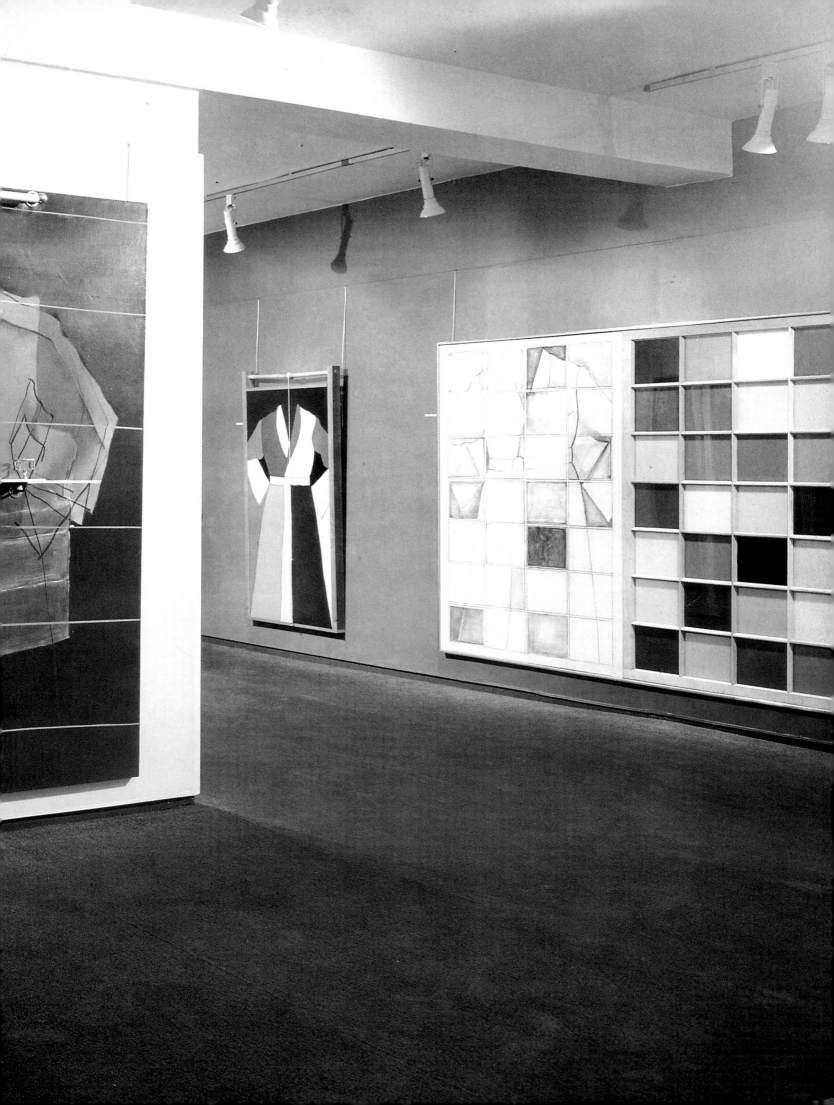

CB: What motivated you to begin the series of *Bathrobe* pictures?

JD: Well, I had been seeing a psychiatrist for two, maybe two and a half years. I was focusing on myself, obviously, and I'd been trying to find a way to make a self-portrait besides just looking in the mirror. I thought there must be some other way to make a self-portrait. The *Suits* were an earlier attempt to make a self-portrait. So, before I did the *Bathrobes*, I made the two *White Suits*, beginning with *White Suit (Self-Portrait)* [1964, fig. 125]. In that one, the suit has been superimposed on the Plexiglas, but underneath is a rectangle and a square. I actually put my psychiatrist in— there is a black panel, and there was a square and a rectangle in the relationship of the analysis. And there was *Isometric Self-Portrait* [1964, fig. 130], which is just a suit jacket, and *Silver Chrome Jacket* [1964]. So, I was looking for a way to make self-portraits. I guess I found it, actually. One Sunday, in the *New York Times Magazine*, I saw this ad for bathrobes, and it was a bathrobe with nobody in it. It looked like me. It looked like my physique. So I thought, If I use this, I really can make a miraculous self-portrait. And it was a found object, you could say. And that's how it began.

CB: Did you feel that the *Suits* didn't quite work as self-portraits?

JD: They did, but it's just that when I saw the bathrobe, it was more precise. It looked like I was truly in it. And therefore I felt I was destined to use it.

GC: What I notice in *White Suit #2* [1964, fig. 126] is that it sends some radiation, and there is a kind of Constructivist abstraction.

JD: It is a way to make a person stand up and give them some support.

GC: It's not the inside of your soul?

JD: Not specifically.

GC: What does the chain mean for you in *Isometric Self-Portrait*?

JD: It's just something I had bought to exercise with. I mounted it on the wall, and then I put the chain in and I'd pull it. I once read a book about a psychological case study of a little boy who . . . I forget what had happened to him, but I think he had no parents, or his parents wouldn't touch him as a child, so then as a teenager, you couldn't get near him, without him telling you, "Be careful when walking, you'll trip on the wires." He had all these imaginary wires coming off of him, going into the wall, imaginary walls, for energy. He was unable to live alone in his own body. I think in those years, I was unable to live alone without being scared. It's only in the last few years where I really felt that I was in my own head and reasonably comfortable getting out there.

GC: So, it's the tool that you hook to yourself in a certain way.

JD: In some way. And also it's a way to make structure for yourself. Listen, my worst nightmare is that I will melt like Black Sambo's tigers.

GC: So, the dress also is something without structure. A kind of inflatable skin, without anything you could hold on to.

CB: Why are the bathrobes empty?

JD: They aren't. I never include the head, but the body is mine.

GC: Why did you incorporate ropes and chains in many of these works [see figs. 126, 127, 130, and 132]?

JD: I used to like looking at ropes and chains when I went to the sailing-supply store in East Hampton. Some of them just appealed to me, and I'd figure out what I think I could use. The same thing with the other found objects in my works. That's how I ended up making *Charcoal Self-Portrait in a Cement Garden* [1964, fig. 133], which I also did in East

Hampton. I was driving by Agway, a farm-and-garden-supply store. And going by Agway, I checked it out, and there were these cement garden decorations broken outside on the ground. So, I bought them, and took them home, and put them in front of this drawing of a robe and made a self-portrait. It just seemed to work right for me.

CB: Besides *Four Rooms* [fig. 109], where the painted chair remains on the floor, this appears to be one of the first times you associate an object not just with the canvas, so that you establish a sculptural presence apart from the painting.

JD: That's not the way I was thinking about it at the time. This fell into place the minute I saw the objects—I knew that I wanted to do it this way. I was commenting on history, on memento mori.

CB: So the "cement garden" is like a graveyard.

JD: Yes. It's a graveyard.

CB: Were you beginning to think about structure when you made *Stephen Hands Path* [1964/98, fig. 134] and *Self-Portrait Next to a Colored Window* [1964, fig. 131]?

JD: I always thought about structure, but I never did anything with it until I experienced it. In *Stephen Hands Path*, I wanted to make a surface that was three colors, not a hundred. And I did *Self-Portrait Next to a Colored Window* in every different color that I could get from the color chart. Plus the window likewise—a real window that I bought at a lumberyard. I painted in the back. And then drew it here, the window next to it, and broke up the color.

GC: Why such color at this stage?

JD: Because I wanted to use every color of paint I had. It's the idea of the color chart applied to the *Bathrobes*.

CB: You seem to have moved from brushwork to a more graphic treatment of line and color.

JD: It's like poster art. It was a pleasure to use this great house paint. You just paint in coats with it.

GC: So you're cleaning up your technique. I see a lot of direction in a piece like *Stephen Hands Path*, for instance. And in *Self-Portrait Next to a Colored Window* it's the idea of Color Field rather than Pop. It feels very modern and European.

JD: You think so? Why? Tell me why! Because I always hear this. Not about this particular work, but about myself all the time. What's European about it?

GC: I think it's a sort of richness of history, of coloring objects. It's going back to Titian, to all these artists, with this idea of richness, naturally done with a flat color, but the complexity is not objective. It's so unreal. You will never find an object like that, unless I am going in the direction of painting, and not in the direction of the object. That's the idea of Pop. Because you cannot define a popular object like that. It's so authentic. This idea of gravity on the surface.

CB: In 1965 you performed *Natural History* [figs. 138–40]. It had been more than four years since you had done a theatrical work. Why did you go back to doing performance?

JD: Well, because this time it wasn't for me. Because they came to me. Alan Solomon and Steve Paxton ran this New York Theater Rally, and it was Bob Morris and Bob Rauschenberg, and Oldenburg and me, and Whitman, and lots of dancers from the Judson Church. I resisted making the work for a long, long time, and everybody said, '"You know, you should come." Then Solomon said, "You have to do something." I had been writing down my dreams for two years every day, and I took the dreams and made them into a long stream-of-consciousness prose piece. And I read them on tape. That was the soundtrack; it took a half an hour. It was extremely long for the audience, and extremely painful for me to hear. I just read the content of the dream into an audio. So, it was just continually going along like a narrative,

without really having subject matter. *Car Crash* was violent and expressive; *Natural History* I felt was depressed and mannered. And I think I would've been happy just to play the tape, rather than going through all these machinations with these people there doing these different things.

CB: How did you stage it?

JD: It was in the round. Performed in a huge circle, and I was in the center just smoking, just sitting there listening to the whole thing and smoking. The audience was around the sides. And the performers were all people I knew. Altogether it was more theatrical for me. It was also where I ended my friendship with Rauschenberg. We didn't speak for twenty years because his friend Paxton fucked around with all my props, with my set—the tables and chairs that the performers sat on. He moved them away, and I screamed at him. He called me on the telephone, and he said, "You can't do this to me." And I said, "Yes, I can." I hung up the phone again, and Rauschenberg was there, and he stopped talking to me, along with Paxton. But you know, it had no joy. All of the four earlier performances had joy and and an ecstatic thing. This had no joy. This was cool. Not intellectual, but it was planned more.

GC: Was the movement very slow?

JD: Yes, very slow. It would be cool, because I have a way of being really cool, but it wasn't full of obvious expressionist themes, or robotic. It was an examination of my unconsciousness in public.

CB: Was it the way you also behaved in therapy?

JD: No, not at all. In fact, I was free of therapy by then.

CB: Did you feel like you were absent, just sitting in the chair?

JD: Somewhat absent. Certainly self-revelatory, because of the meaning of experience. Also, the audience had an expectation. After all, five years before I had made four things, and through the year, everyone was on the floor laughing and excited, and then I ask them to come here and listen to my unconscious. When it was over, everything just stopped.

CB: And you didn't expect the audience to react that way?

JD: No. I was so involved with the text that I thought they would be blown away. But the audience was silent. Nobody said a word. And later somebody said to me, "It's very stolid." Solomon brought me out of retirement with this one. and I just thought, I am never doing this again.

GC: Does remembering your early work torture you?

JD: It's my social problem about getting along in this imaginary universe that I thought I was in called "the art world." Where of course I am still isolated by these works, because of their personal content, and here I am thinking that I am communicating something. These works are about the arrangement of objects. But it's also fragmentation. It's my idea of what was contemporary. I don't know what the hell I was thinking of, but of course here I am isolated in my little neurotic cocoon, here I am fighting and railing against Minimalism. Here I am in the same apartment house as Alan Solomon—he's living down the hall. So, I am seeing him every day almost. And he is talking to me about Castelli . . . he is the great Leo apologist. Here I am not with Leo, I am with Sidney, because of what we've talked about before, and I am trying to be part of something, and yet, I am not part of anything except myself. This world I made.

125. White Suit (Self-Portrait), *1964*
Mixed-media assemblage: Oil and plastic
buttons on canvas, with Plexiglas
Three panels: 6 feet x 3 feet x 3 inches
(182.9 x 91.4 x 7.6 cm) each
Stedelijk Museum, Amsterdam

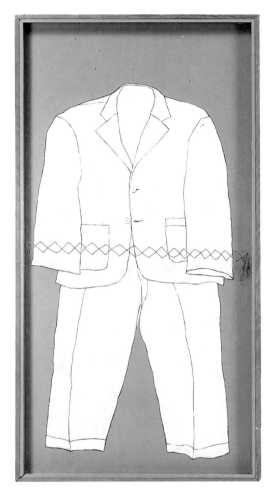
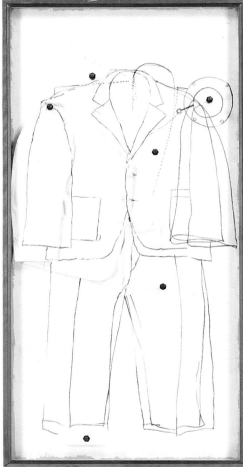
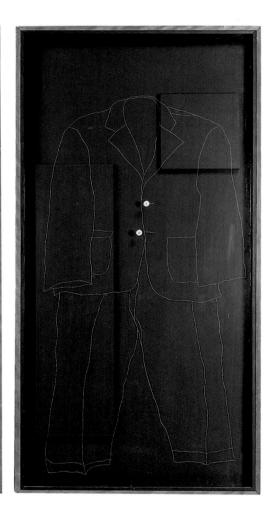

126. White Suit #2 (Self-Portrait), *1964*
*Mixed-media assemblage: Oil, charcoal,
electric cords and outlets, functioning
light bulb, magnifying glass, wire, and
metal hooks on canvas, with metal chain
and padlock*
5 feet 11 1/2 inches x 6 feet (181.6 x 182.9 cm)
Courtesy of PaceWildenstein

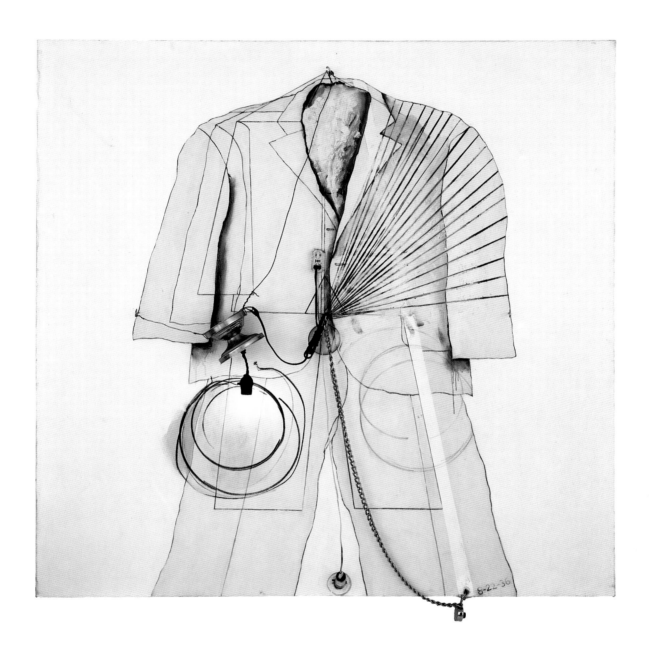

"*I'm not a Pop artist.*" (*Jim Dine, 1966*)

127. Palette (Self-Portrait No. 1), *1964*
Mixed-media assemblage: Oil, metal chain,
and watch on canvas
7 feet 1/2 inch x 5 feet (214.6 x 152.4 cm)
Collection of the Orange County Museum of Art,
Newport Beach, California.
Gift of Mr. and Mrs. Gene R. Summers,
Laguna Beach

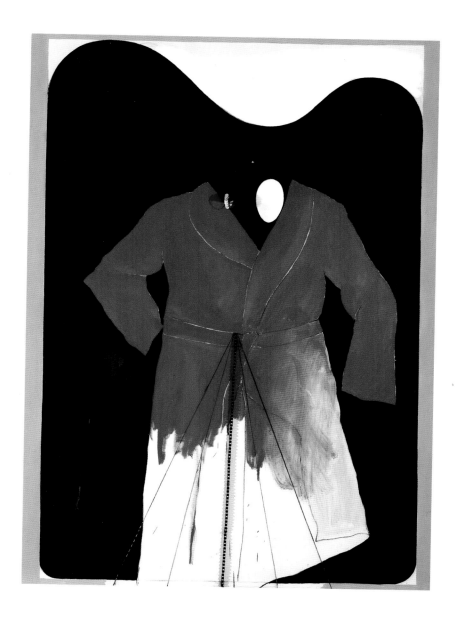

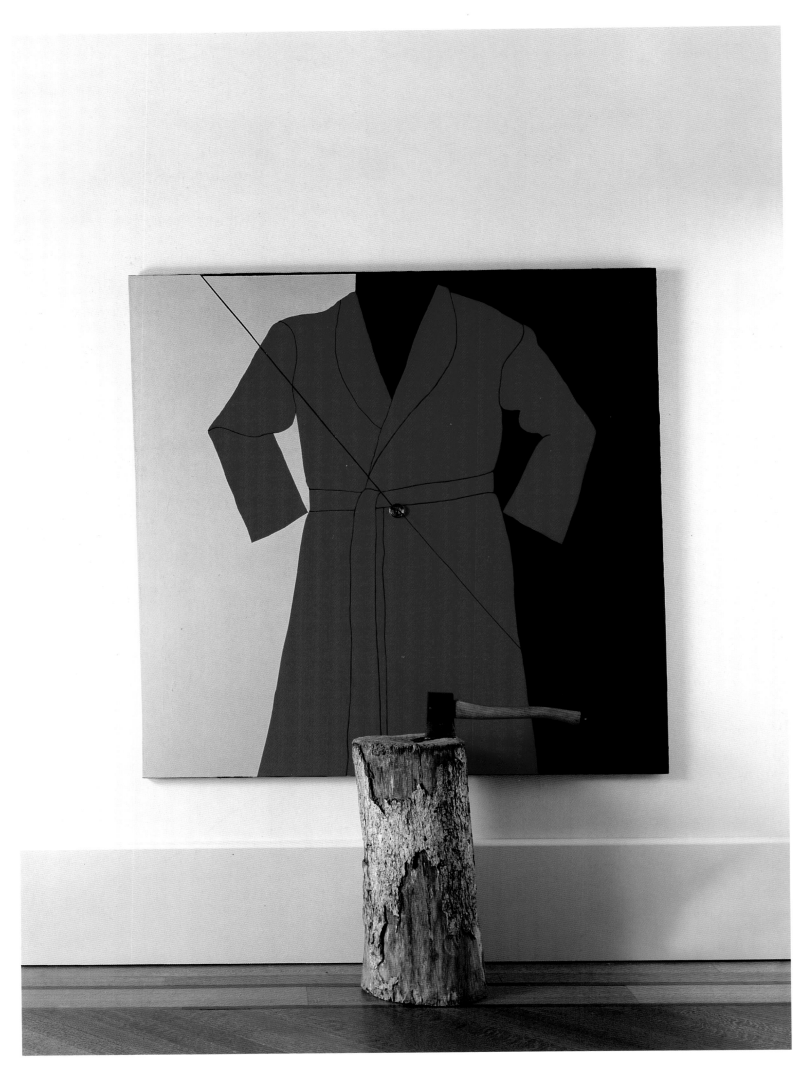

CB: What led you into sculpture?

JD: I went into sculpture because of Bob Kulicke. In the '60s he was a framer. He's the man who invented the plastic box frame. At the time, he was working with Rosa Esman. And Rosa had this press, and she wanted to publish this Pop art box of objects. Segal did a plastic chicken; I did the *Rainbow Faucet*. That *Faucet* was sand-cast in aluminum. And through that we met this guy called Dave Bassinow. This guy was a genius in sand-casting. He lived in Philadelphia. That's where I made *Air Pump* [1965, fig. 146]; that's where I made all of this sculpture.

GC: What material were you casting from?

JD: From plaster. And then it would be sand. It wasn't wax.

GC: The surface is totally different from wax casts.

JD: It's much rougher. They were not fine casters. These are people who are casting plumbing pipes and things.

GC: What is your feeling of doing this kind of three-dimensional work, in getting out of the canvas and making a standing object?

JD: And making my own objects. It's the first time. And I felt really excited by this. It was energizing. *The Red Axe* [1965, fig. 149], *A Nice Pair of Boots* [1965, fig. 137], *A Boot Bench Ochre #2* [1965, fig. 113]—all those are ideas that I didn't have in my mind. They just came to me down at my studio. I put things together, I'd say, "Cast this." I'd put some more things together and cast them.

GC: So were you just collaging things?

JD: Yeah. Sometimes collaging.

CB: Were some of them made from real objects?

JD: Some are real objects, others are me making things with plaster down at the sculpture studio. Plus, in a corner I am making the *A.R. at Oberlin* paintings [1966, figs. 147, 148], a series of paintings that I named with the initials of a troubled student I'd met when I was an artist-in-residence at Oberlin College for a week, and who I identified with somewhat. They are not about her, but about a field of blue. I used car/truck paint, and I sprayed it on. I never sprayed on a huge ground before, and it was like the characters appeared on the stage again—on the real blue. I sprayed them with a compressor, in a corner down there, where we worked in this big studio foundry, and I am using the objects, crap that I found on the floor from the sculpture. And a lot of things are casts of my own arm, my own hand.

CB: So, the objects in the *A.R. at Oberlin* paintings are also being done at the same time you're doing the sculpture.

JD: And the objects were cast on purpose.

GC: What is the difference for you between putting real shoes in *My Tuxedo Makes an Impressive Blunt Edge to the Light* [1965, fig. 141] and casting these objects in 1966?

JD: Well, the real shoes are more ephemeral. They are going to go. The bronze is not going to go. But I don't think I was doing it for that. I think it was a collage technique.

GC: Just the difference of material.

JD: I like changing material. I like material itself.

CB: You'd said that you were painting with one hand tied behind your back that same year. Did the sculpture allow you to bring both hands forward in the creative act?

JD: The sculpture gave me a much bigger breadth of vision. Much bigger.

CB: Did you feel more permission to work figuratively in sculpture than you did in painting?

JD: No, it's still fragmented. I never got much feedback on the sculpture, but I loved it. I thought it looked great. It was just what I wanted to do then.

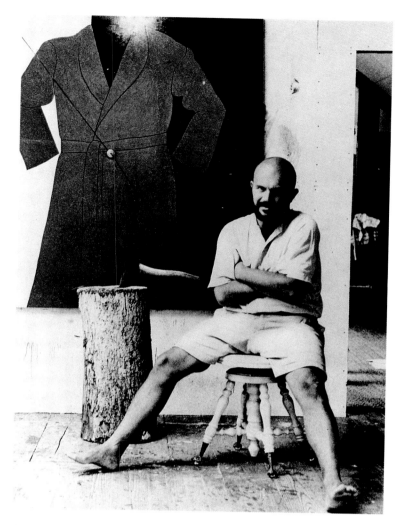

facing page:
128. Red Robe with Hatchet (Self-Portrait), *1964*
Mixed-media assemblage: Oil and metal on canvas, with log and axe, connected to the canvas with wire
7 feet 3 inches x 5 feet x 2 feet (221 x 152.4 x 61 cm)
Virginia Museum of Fine Arts, Richmond.
Gift of Sydney and Frances Lewis

129. Dine pictured with Red Robe with Hatchet (Self-Portrait), *1964, in his Easthampton studio, New York, Summer 1964. Photo by Hans Namuth*

130. Isometric Self-Portrait, *1964*
Mixed-media assemblage: Enamel,
metal chain, and metal bar on canvas
Two panels: 6 feet 3 inches x 7 feet 3 1/4 inches x
5 1/2 inches (190.5 x 221.6 x 14 cm) overall
Private collection, New York

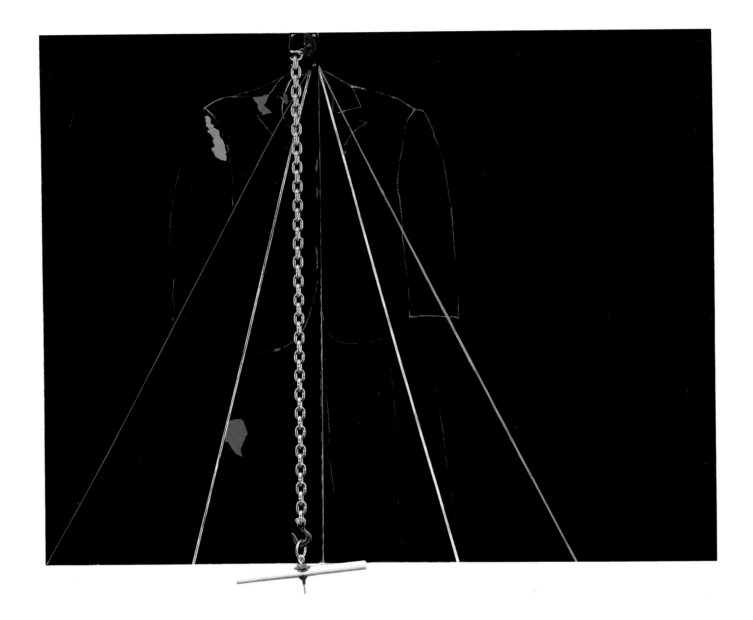

131. Self-Portrait Next to a Colored
Window, *1964*
Mixed-media assemblage: Charcoal on
canvas under multipane window
with painted wooden window frame, oil
on glass and wood
5 feet 10 7/8 inches x 8 feet 3 1/2 inches
(180 x 252.7 cm)
Dallas Museum of Art.
Dallas Art Association Purchase,
Contemporary Arts Council Fund 1965.1

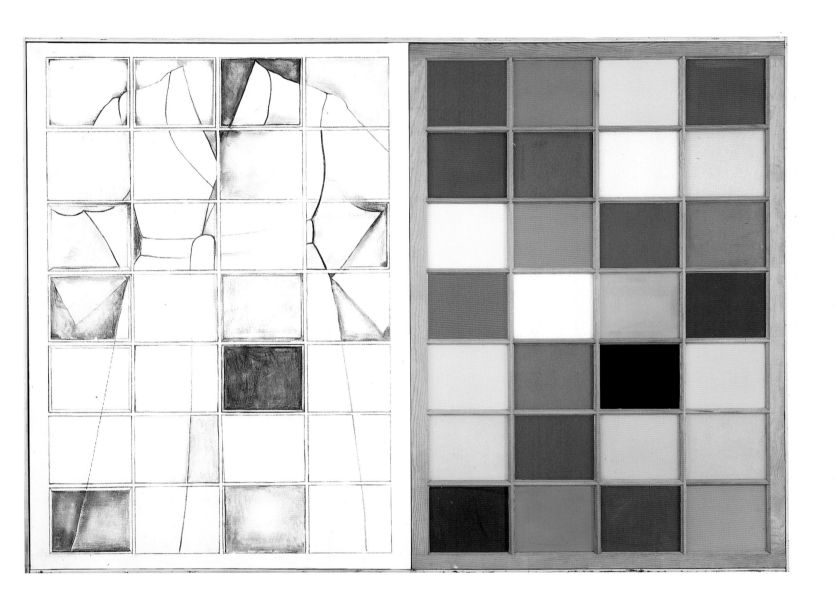

132. Red Robe #2, *1964*
Mixed-media assemblage: Oil, penknife,
metal chain, wire, painted wooden dowel,
and metal hinge on canvas
7 x 5 feet (213.4 x 152.4 cm)
Yale University Art Gallery, New Haven.
Gift of Richard Brown Baker, B.A. 1935

facing page:
133. Charcoal Self-Portrait in a Cement
Garden, *1964*
Mixed-media assemblage: Charcoal
and oil on canvas, with five cement objects
9 feet x 4 feet x 2 feet 3 inches
(274.3 x 121.9 x 68.6 cm)
Allen Memorial Art Museum,
Oberlin College, Ohio.
Roush Fund for Contemporary Art, 1965.

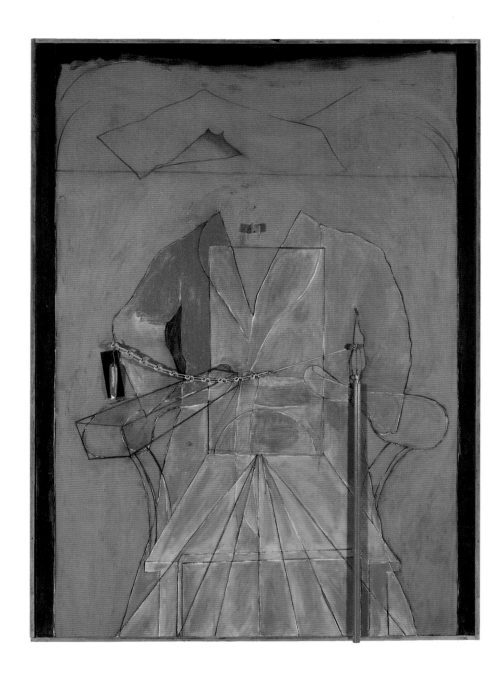

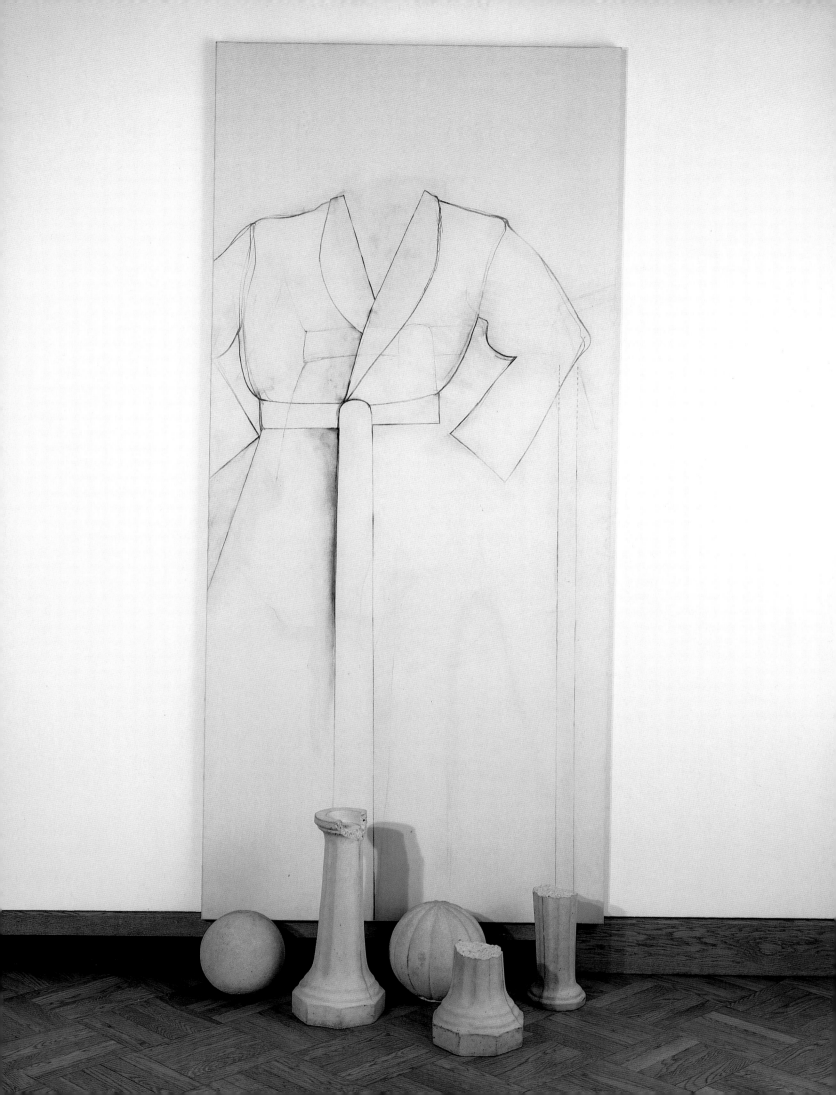

GC: What did it mean for you to move from using objects in your paintings to transforming them into a traditional sculpture?

JD: When I first cast an object for a work, my assistant at the time said to me, "I don't understand why you cast it. Why didn't you just keep the regular objects?" And I told her that by casting them, you neutralize the objects and then you bring them back with your own power, without the history they had before in a lot of ways. I think that's what it really is.

CB: Does it go back to your switch from using junk in the earliest pieces to liking new objects better?

JD: I'd rather put my own history on it, and it's a way to make a tabula rasa sort of thing.

GC: Does *The Ribbon Machine* [1965, fig. 144] relate to the *Color Charts* [see figs. 121, 122]?

JD: It relates to that, but also, I was sick in bed, and I remember I always had paper on the wall next to my bed in those years, and I would draw in the morning there, and I saw the pelvis, probably the female pelvis, as two wheels with an axle in between. I just started to draw the pelvis and then I guess refined it to these two wheels, like the Giacometti chariot, in a way. But then I thought to myself, Wouldn't it be beautiful against the aluminum to have cloth? The ribbons are very alive! They are—it's a horrible thing for me to say—like Morris Lewis.

GC: So you used the ribbons like hair, on the sides?

JD: Yeah. The two things, like at the angle or something. And it's just one of those crazy ideas, goofy ideas. That's all. But it was also the same way I loved the Brooks Brothers suits. I would go to Brooks Brothers and look at the fabric; and to this day, it's the same thing as paint charts, as color charts. It's the lineup of things in a serial way, like if one color is beautiful, then two is more beautiful. It's like "more is more."

GC: And why the red in the sculptures? What does that color mean?

JD: I always go to red. It's my favorite color.

GC: Many of your sculptures function as furniture. Were you going back to reality in a certain way? In the paintings, you took reality and used it, and now you reverse its logic in the sculpture?

JD: Sort of, but also it's probably one of those things that probably came to me in some mild dream, to have this boot bench. And I took these motorcycle boots, cast them, and then I cast a board and I welded it. It seemed so simple. And I know that you could say it comes from Surrealism.

CB: There are several sculptures where the tools no longer just define the edges, but become the ground itself, such as *Double Hammer Doorway* [1965, fig. 143].

JD: *Double Hammer Doorway* was the first time I made it more than a tool itself. Instead of trusting just one little hammer. I found a way to elongate because of the sculpture, it allowed me to elongate and to integrate the shaft of the hammer into this pole, so that it's one long thing. This *Double Hammer Doorway* is bigger than me. You could walk through it. *The Red Axe* [1965, fig. 149] is the same thing.

GC: There are two possibilities you considered: the dream of any vision that you are doing, you add the vision to reality; but also you are taking something out of yourself—you know, you get rid of. So there are two realities. One you add to reality, and one you get rid of yourself. Just the idea that you have tons of dreams, but when you realize one, you take off. You are getting rid of one, and you have tons of them. How do you select what dreams to act on? How do you know what to get rid of?

JD: Some dreams one gets rid of because you can't sit with them, they are so disturbing that the human psyche doesn't allow it. It's the way for you to remain alive, otherwise it would kill you. Others you get rid of, because they don't interest you or you don't understand them. And it's a question of just time, too. You don't keep it.

CB: Do you have serial dreams, where you dream the same thing?

JD: No, but I have different dreams with the same setting. Most of my dreams take place in a house, which is me, which is my unconscious. And the house has various levels. They frequently take place in the basement, depending on how I am feeling, what I am talking about.

CB: Was it when you were you beginning to fight this resistance to be a figurative painter that you started to think more about leaving New York?

JD: I was thinking about it because in '65 I was thirty years old, and I'd never been to Europe. As I said, I couldn't travel. Couldn't fly, couldn't do this. And even when I went to Europe the first time, I went by ship. I went because a print publisher paid the way, and said, "Come and make a portfolio." And I thought: Great! Nancy and I took the boys. Nick was one year old, not even one year old; he'd just been born. We went to London by boat and stayed six weeks. Robert Fraser rented a house for us. I felt like I'd been let out of jail. I became a human! I mean, I met everybody that was there. They were so generous to me. Hamilton and Hockney and Paolozzi, who was a monster. You ever see him?! He absolutely looks like a monster, too! But he's an exciting mind. A really smart man! And they were seductive with me. They wanted to hear what I had to say. And I was easy! I went out every night. It was cheap. You had a baby-sitter. You had nannies. We went everywhere. I knew everybody. I had the greatest time! And after six weeks, I had to go, and I was really unhappy. Went home, and I changed. It changed my life. It was the spring of '66 that I went. The fall of '66, I went to Cornell to teach. I left New York because Janis said that I owed him forty thousand dollars. Because I had been drawing on twenty-five hundred dollars each month to live, and plus he lent me eight thousand dollars to buy a house in East Hampton. It was all signed with notes and things, but I thought, Jesus! Forty thousand dollars! I don't think I owe him that. And he got very unpleasant with me. He said, "You know, we have to face up to these things, and blah, blah, blah." This was so typical of me at that time. I didn't talk it over with Nancy, I didn't talk it over with anybody. I said to myself, "I can't be in chattel, I cannot be like this. What I am going to do is not give him any paintings. I am not going to paint." So, just at that moment I got a phone call from Cornell, asking me to come for the year. So, I said, "Sure." I took it. So, I made ten thousand dollars that year, and I was able to go to Cornell, and everybody went to school, and blah, blah, blah.

CB: Had you taught on the college level before that year?

JD: I had taught at Yale once a week for a year, in '65, with Tworkov. But really, I was teaching really heavy duty at Cornell, and it was a big experience for me being there. After a year I moved to London, because the print dealer owed me nine thousand bucks. So, I picked it up in London, and we lived for a whole year on nine thousand bucks, because London was like Mexico then, it was so cheap. Really poor! So, when I went to London, I had a friend who was a lawyer, who said, "You don't have to live like this. Worried about Janis, owing him forty thousand dollars. Let me call his lawyer." I didn't have a lawyer. I said, "Okay." He calls his lawyer and they had meetings, and meetings, and meetings.

And we got all the paintings back. Then Janis owed me maybe twenty-five or thirty thousand dollars. The lawyer dropped dead by the way. My lawyer killed him, I think. He just dropped dead one day of a heart attack. And Janis said, "No hard feelings." But meanwhile, then I was launched into a European life. And I never really looked back after that. It's where I always was comfortable in my skin, in Europe. It just seemed right for me. The sky looked like where I could be myself. Really, I found myself in Europe, in London.

CB:. What were the first works that you did in Europe?

JD: When I first went to London, and stayed for six weeks, Paolozzi said to me, "Let's collaborate." I said, "What a great idea. I never thought of that," but it was in the spirit of what was going on there. I was collaborating with these people. By interacting with humans for the first time in a long time. So what he did was, he would give me collage material that he had collected, and I would collage it. And I guess it was the spirit of the times, but all I made was these very big penises that I painted in gouache, or I painted rather realistic vaginas, which were isolated from the human body. They were just vaginas, with his collage material. Robert Fraser had a show of this work, and it was confiscated by the police. When I moved there, all I did was print. I didn't paint because of Janis for that first year, '67. I wasn't painting then, so I wouldn't have to give Janis anything. The next year, in September, we moved into a house, a very grand house in a famous square, Chester Square, owned by a friend of mine, who was uncomfortable being rich and an artist. She was a liberal American woman, who was from a very rich family. She moved to a little worker's cottage that made her feel better, and she said that as long as you pay the taxes, or whatever it was, they weren't very much, you could live there free for a year. So, we lived with no furniture in this huge mansion in Chester Square in Belgravia. And we tore the place up. My kids tore it up. We played baseball in the hallway. There were windows broken. And I painted in a huge drawing room. It was there in the autumn of 1968 that I made the first *Name Painting* [1968–69, fig. 155]. Ugo Mulas came because I knew him from the Solomon days in New York, he came and photographed me painting the *Name Painting*. And I started to really seriously write poetry. So, I wrote every day like a prayer. Every day I would write. Then I got to know a lot of poets and small-press book publishers. Really good typographers and great guys. One who was an American expatriate, and had been in the Second World War, a wonderful man, called Asa Benvenisti. He had a press called Trigram, and he published a book of my poems, and we were very friendly. Plus, I had a dear friend there called Rorie McEwan. He was a Scottish nobleman, but also an Indian musicologist, and a botanical painter. Very unusual amateur man who was a great guitar player. He knew all these musicians, and I spent many evenings with everybody I could think of. Beatles, and Everly Brothers . . . I mean, Rock 'n Roll was very big. Plus, classical Indian musicians. He had concerts. I had a life there. American and French and Italian poets were coming through all the time for conferences. I saw poets all the time in the friendliest way. There was no rancor, no jealousy, no striving among the artists. Because there was no money! There is nothing to lose! Easy to be a friend when there is no money involved.

CB: What was the impetus behind the *Name Paintings*?

JD: Well, I thought to myself, I can remember everyone I ever met in my life. So that's what I tried to do. I went over my whole life and I wrote the names of everyone who I knew and who I met.

GC: So, you become an archivist of yourself.

JD: Yeah, I did. The reason for the second *Name Painting* was because I wasn't finished. It's a continuation. The first one begins with my grandpa and my grandmother, and goes from when I was born in 1935 until 1965. It's just charcoal on raw canvas. The second one has more paint on it, and goes from 1965 to 1969. Each of them took about a month to do.

GC: So, you consider it a kind of visual scroll. Or was it just an intellectual decision? It's very conceptual, in a certain way. And it's very emotional.

JD: It's emotional and conceptual, yes. And sometimes I realized I made mistakes about when I met someone, and I liked leaving the mistakes. I was building up a patina in a certain way.

CB: Did the work function like a drawing to you.

JD: Yes, it is like a drawing. It looks like Monet, too, a little bit.

GC: The year 1968 was a kind of a magical date for your generation. What are your recollections?

JD: I was always against the war in Vietnam. I was in London, but I was in Paris when they were throwing bombs and tear gas. I was unable to get out of Paris, and finally they bused us to the army base, and flew us out on a little plane. And I remember I bought a bottle of vodka on the plane. I was so scared. And it landed on grass in an air field in the South of England. I felt alive in London. And I felt it was a sexual moment. London was very sexy then. Very sexy. I mean, not absurdly. It really was. It was like the first time you saw a mini skirt for instance. It was really something. They were breaking out. It was like a real revolution.

CB: Did you have representation in London?

JD: Just Ileana Sonnabend in Paris. But Ileana wasn't showing much, because I wasn't giving her anything. I extricated myself from Janis in fall of '68, and then I started to work in Chester Square. We lived in Chester Square for three years. And I started to work there, and I made a number of paintings, including *Colour of the Month of August* [1969, fig. 153].

CB: Did the spoken language of *Natural History* [figs. 138–40] prompt you to embark on the *Name* paintings?

JD: No, I started to understand that I have a feeling for language. And I have—Robert Creeley always says about me—I have this very particular relationship to words and to language, which is different from a lot of people, I think he is implying. And I see words as objects, too, that I can use and manipulate and place around. My technique of writing is the same as my technique of everything. It's like pick and choose—it's a collagist technique. I've taken to writing actually on big walls now. And then I can look at it, and change, and correct, and move things around.

CB: Did you always edit yourself?

JD: Always. If you can do it great the first time, you'll do it better the next time. So, I usually rub out, which is a way of editing; and I am determined to make something work, so I make a silk purse out of a pig's ear. It's an alchemical idea.

GC: The process of the different stages.

JD: Bringing things to consciousness.

CB: And that works both in paintings and in the drawing?

JD: And writing. And in drawing, and in painting. I scrape, I scrape out, I scrape out. When I have a beautiful passage, most of the time I take it out. And then I go again.

CB: Did you always try to paint to your own scale?

JD: The odd exception is when I make a big painting, I mean a really big painting, it's not my own scale necessarily, and I have to go up and down the ladders, but for the most part, I am most comfortable with my size.

CB: We've seen how drawing affects your painting. How did printmaking affect the painting?

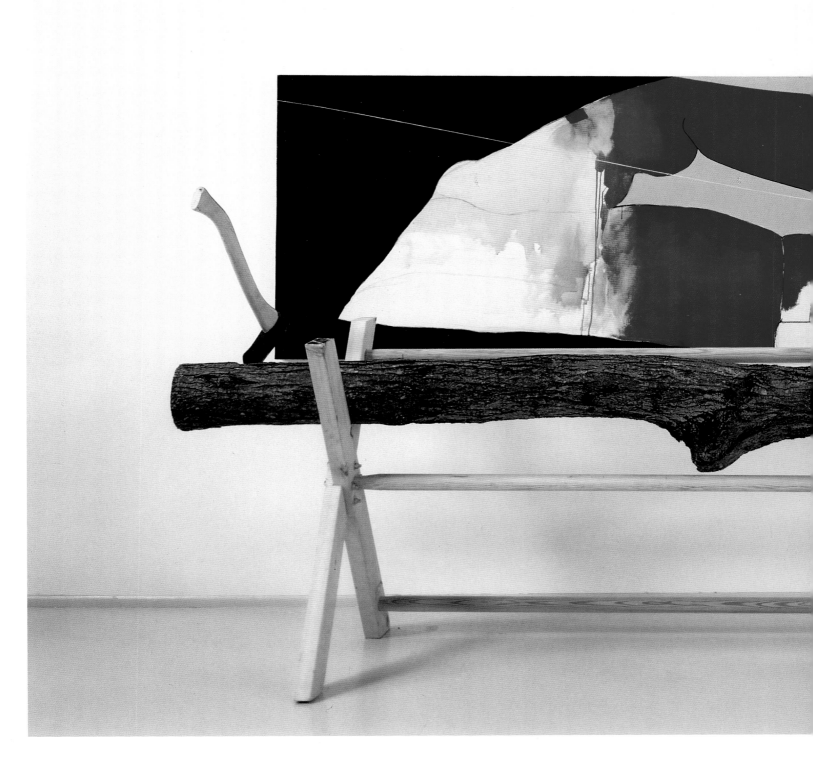

134. Stephen Hands Path, *1964/98*
Mixed-media assemblage: Enamel and
charcoal on canvas, with wooden sawhorse,
log, and axe
4 feet 7 inches x 10 feet x 2 feet 4 inches
(139.7 x 304.8 x 71.1 cm)
Private collection, New York

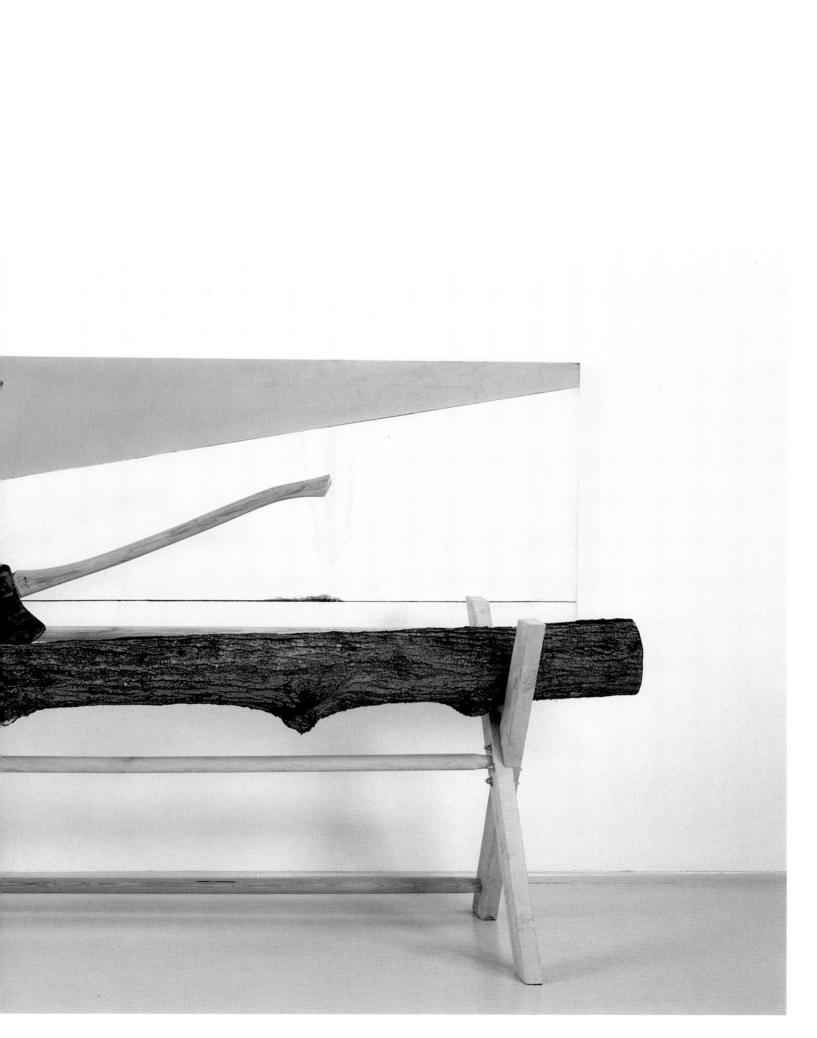

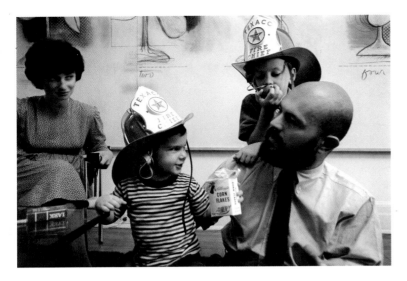

135. *The Dine family in their West End Avenue apartment, New York, 1964 (left to right): Nancy, Matthew, Jeremiah, and Jim. Photo by Ugo Mulas*

136. *Dine constructing* The Red Axe *in his New York studio, 1965. Photo by Ugo Mulas*

"Walking Memory: A Conversation with Jim Dine, Clare Bell, and Germano Celant" was based on a series of discussions that took place on September 9, 11, 20, and 21, 1998 in New York City.

JD: In 1967 I was not painting, but I was printing all the time; every day I was printing. Because in the first place, I was tired of being alone. I am a very good collaborator. I enjoy it. And printing is a sociable thing to do. You hang out with the printers, you have a good time, you talk, you change. And I was getting a lot of ideas. And the printmaking informs everything. I mean, they all inform each other. For me, it's all the same.

CB: How did you come to use the heart as a motif in your work?

JD: There was a painter named Norman Kantor, I think he was called, in the late '50s, who made a heart and a red cross and a lot of other signs like that in a little show on Tenth Street, and I never forgot it. I thought it was very effective against the ground. And then when I was asked to design the *Midsummer Night's Dream* for the Actor's Workshop in San Francisco, I incorporated it as a kind of symbol. So, it's something. It struck a chord with me. I thought it was as good a symbol as any to hang all my paint on, hang my landscape on, and to work in and out of, to keep the interpretation loose, could be a lot of things. It seemed to me a universal symbol. And I don't mean just for love. Because in a certain way it is an abstraction of a lot of things. It's a human form. And it's pushing the interpretation if you say that a human heart looks like this, but this does come from the idea of a human heart.

CB: What prompted you to pay homage to American trompe l'oeil painting in *Five Chicken Wire Hearts (for James Peto)* [1969/98, fig. 154]?

JD: I had this idea of cutting hearts out of chicken wire. At that time, I didn't feel I needed to make a painting. I felt I didn't need the support. It's a tableau to be looked at. A diorama.

CB: Did you feel at this point that you just didn't need paint?

JD: I didn't want paint on this piece. I wanted color to come from the object.

GC: In all of your early works where you utilize existing material, did you use these objects because there was a freedom in using them, or was it an intentionally radical gesture for you?

JD: I realized I wanted to be a modern man, make modern art. I saw all that stuff on the street as a vast studio. You could use everything. That's the thing that struck me—that I could use anything. Anything! When I found the bedspring that I used to make *Bedspring* [fig. 58], I didn't see it as a bedspring. I saw it formally as this mysterious object that metaphorically could be turned into something that was anonymous, but then became personal. If I picked up what I considered neutral objects, they lost their neutrality when I put my hand to them, or when I put them in conjunction with something else, whatever that means. Duchamp was very . . . I am not a Marcel-man. I am not intelligent enough for that; I do not have that kind of intellect, nor do I have that rarefied sensibility. I am refined in another way, I think. But I was more pleased to be verified. I mean, he gave me some reason that I could say, "Oh, look at that. That guy put a toilet there!" Now, he was making a joke. He was also saying, "Fuck you!" I never did anything to say "Fuck you!" I never ever thought this was a protest against my bourgeois upbringing. I never thought what I did was a protest against anything. I only did what I had to do to get the work out. That's all I did. I did it so I could be an artist, so I could make what I thought was art. I never did it for social reasons, for political reasons. I was put here by God to be an artist, and I've tried to fulfill that destiny. That's all.

137. A Nice Pair of Boots, *1965*
Enamel paint on cast bronze
Two boots: 16 x 11 x 4 inches
(40.6 x 27.9 x 10.2 cm) each
Sonnabend Collection

following six pages:
138. Dine and James Silvia in a performance
of Dine's Natural History (The Dreams),
part of the First New York Theater Rally,
a performance held May 1–3, 1965.
Photo by Elisabeth Novick

139 and 140. Performers in Dine's
Natural History (The Dreams), *part*
of the First New York Theater Rally,
a performance held May 1–3, 1965.
Photos by Elisabeth Novick

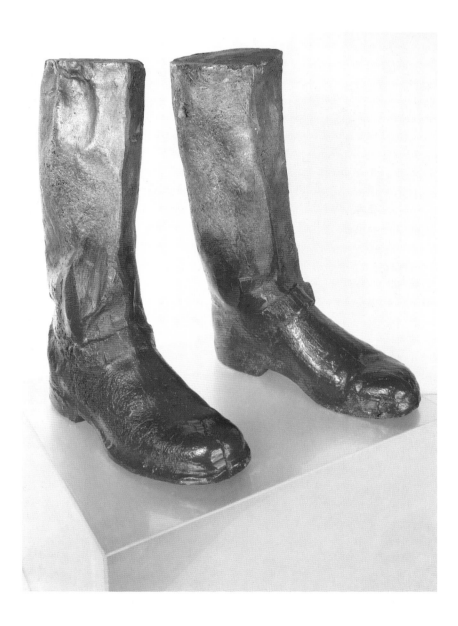

"I believe that exposure can be used as a medium and I was totally pleased with what I did. It was completely successful because it was about exposing yourself, making it difficult for the audience through exposure, asking them to relate to you rather than you relating to them."
(Jim Dine, 1966)

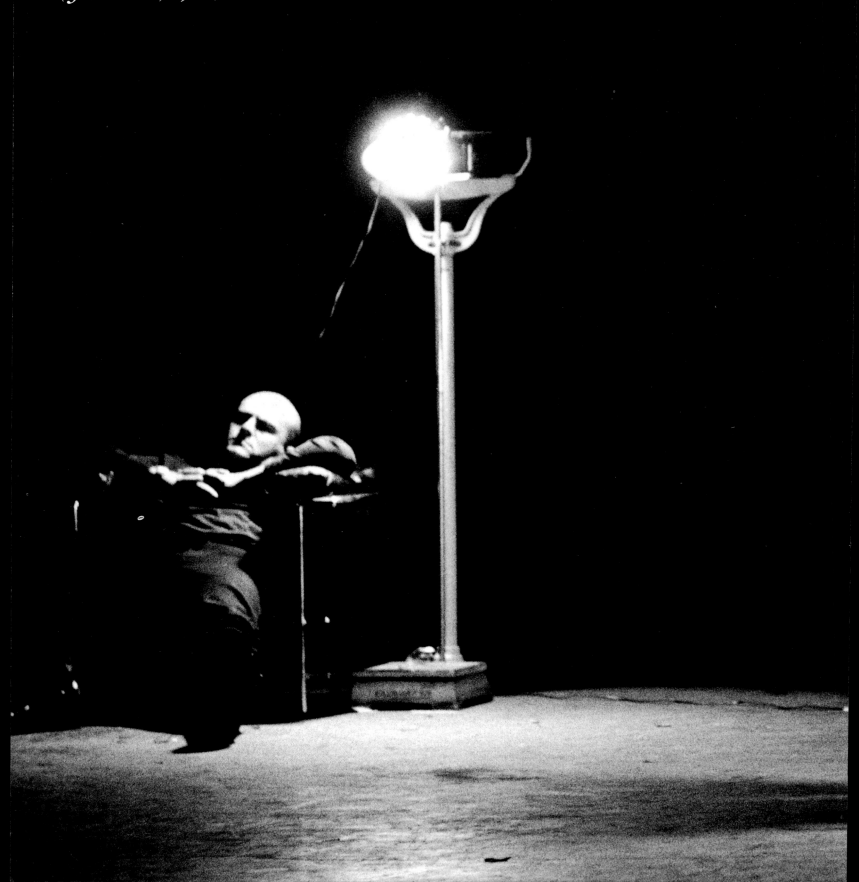

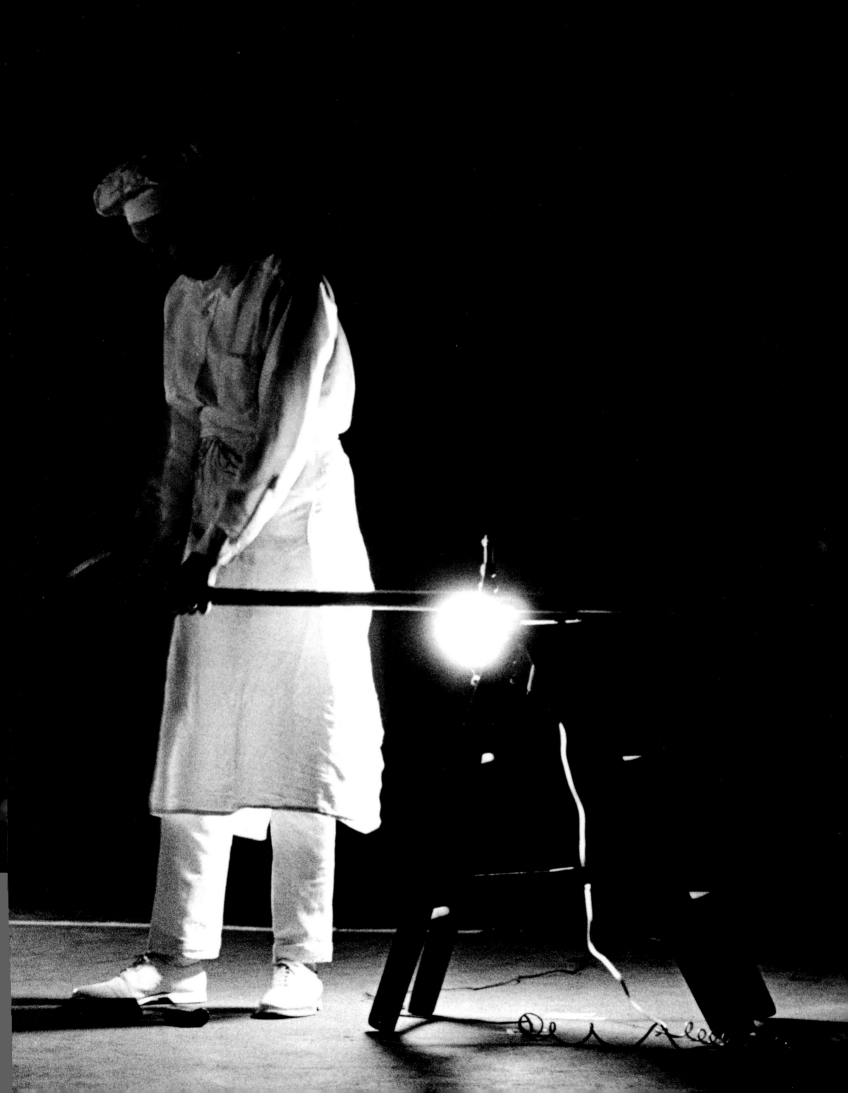

141. My Tuxedo Makes an Impressive
Blunt Edge to the Light, *1965*
Mixed-media assemblage: Oil, charcoal,
and tuxedo jacket and pants on wire hangers
on canvas, with a pair of shoes below
6 x 6 feet (182.9 x 182.9 cm)
Private collection, New York

142. Walking Dream with a Four-Foot
Clamp, *1965*
*Mixed-media assemblage: Oil and charcoal
on canvas, with clamp and spanner
attached above*
5 feet x 9 feet (152.4 x 274.3 cm)
Tate Gallery, London, 1998

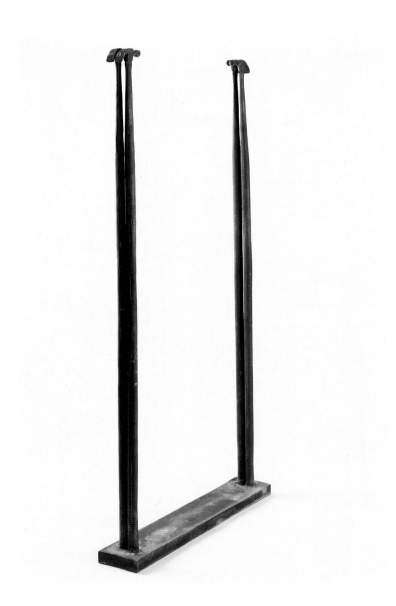

143. Double Hammer Doorway, *1965*
Cast aluminum
6 feet 6 inches x 3 feet 6 1/2 inches x 7 1/4 inches
(198.1 x 102.9 x 18.4 cm)
Collection of Mr. and Mrs. Bradley Lowe

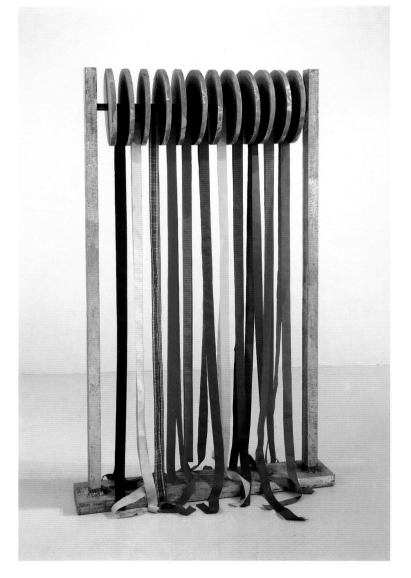

144. The Ribbon Machine, *1965*
Cast aluminum with ribbons
5 feet 8 1/2 inches x 3 feet 4 1/2 inches x 1 foot
(174 x 102.9 x 30.5 cm)
Private collection, New York

145. Summer Table, 1965
Cast bronze
H: 39 1/2 inches (100.3 cm); diam.: 30 inches
(76.2 cm)
Private collection, New York

146. Air Pump, 1965
Cast aluminum
6 feet 9 1/2 inches x 2 feet 11 5/8 inches
(207 x 90.5 cm), including base
Collection of Frits de Knegt

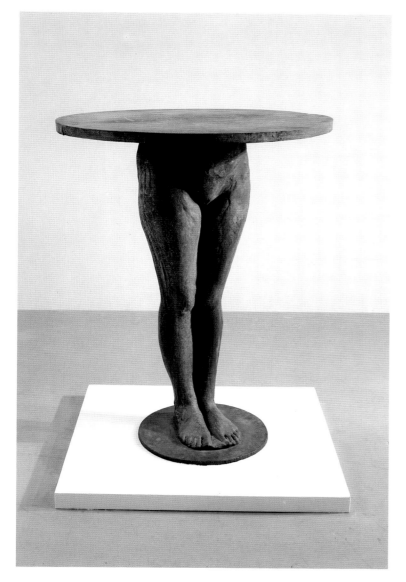

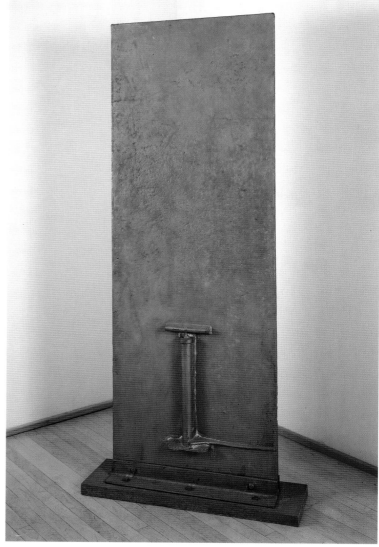

147. A.R. at Oberlin #5 (A Thing of
Rilke), 1966
Mixed-media assemblage:
Automobile lacquer on canvas with bronze
6 feet 11 7/8 inches x 3 feet 11 1/4 inches
(213 x 120 cm)
Museum Boijmans Van Beuningen,
Rotterdam

148. A.R. at Oberlin #4 (Putting Aside
Reo Blue), 1966
Mixed-media assemblage:
Automobile lacquer and rubber-insulated
wire on canvas, with metal clamp on wood
plank below
7 feet x 4 feet x 11 inches
(213.4 x 121.9 x 27.9 cm)
Private collection, New York

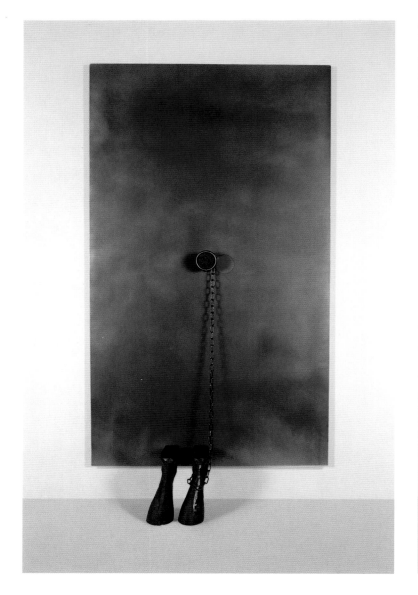

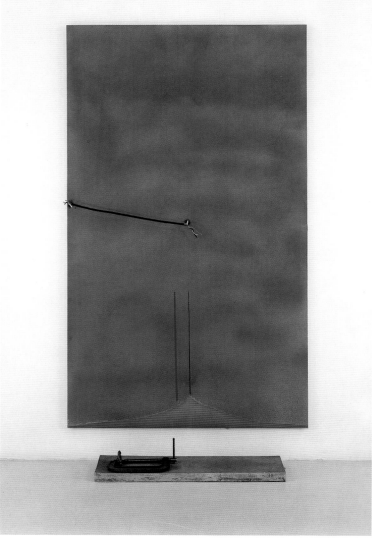

149. The Red Axe, *1965*
Enamel paint on cast aluminum
1 foot 2 inches x 7 feet 4 inches x 3 1/2 inches
(35.6 x 223.5 x 8.9 cm)
Private collection, New York

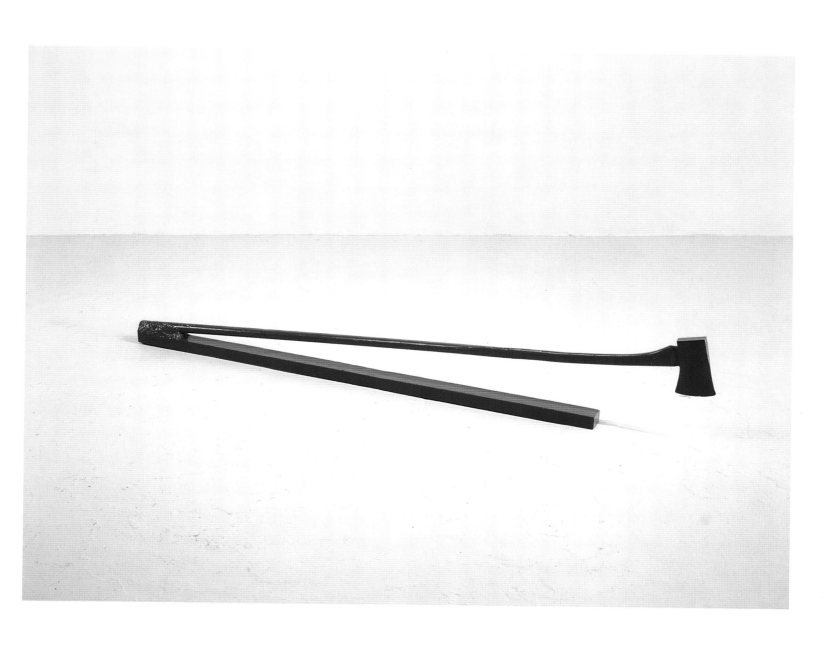

150. Nancy and I at Ithaca (Green),
1966 – 69
Mixed-media assemblage: Cloth on plywood
7 feet x 3 feet 6 inches x 8 inches
(213.4 x 101.6 x 20.3 cm)
Private collection, New York

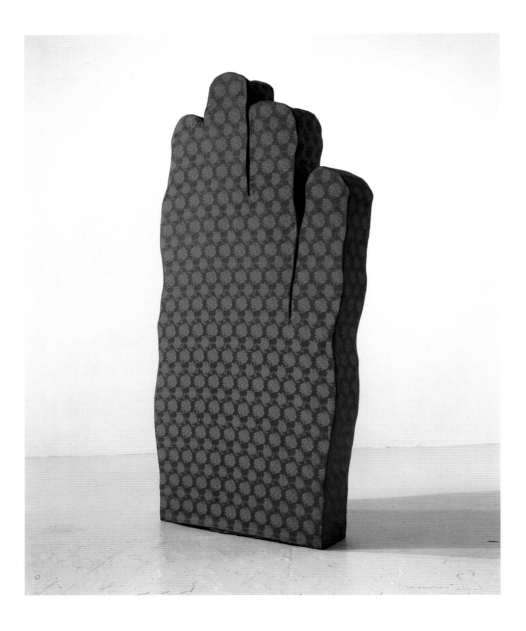

151. Nancy and I at Ithaca (Straw Heart),
1966–69/1998
Sheet iron and stra
5 feet 2
(157.5 x
Private

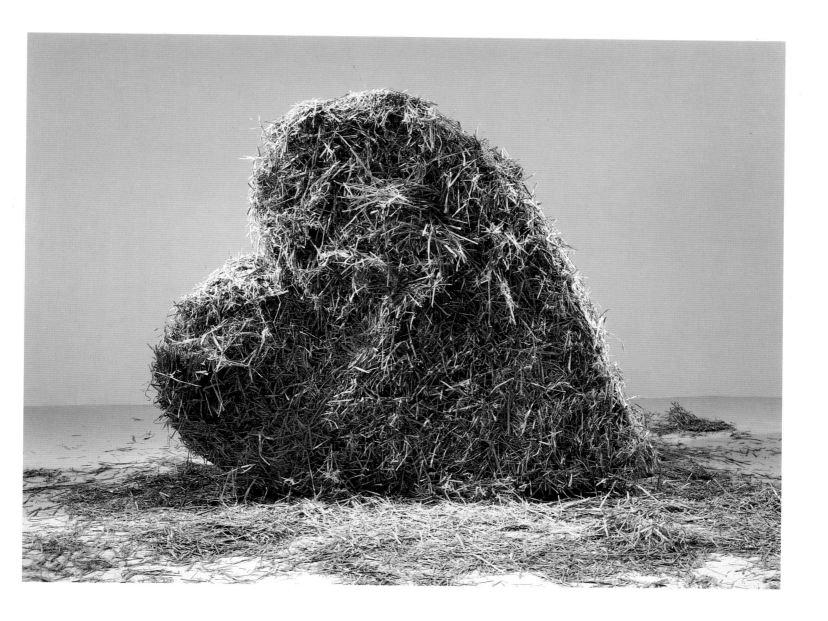

152. Sawhorse Piece, *1968–69/98*
Mixed-media assemblage: Oil on canvas,
with rubber, hair, rubber paint can,
metal paint can, C clamp, paint brush,
paint bucket, and two wooden sawhorses
3 feet 7 inches x 12 feet x 3 feet 11 inches
(109.2 x 365.8 x 119.4 cm)
Private collection, New York

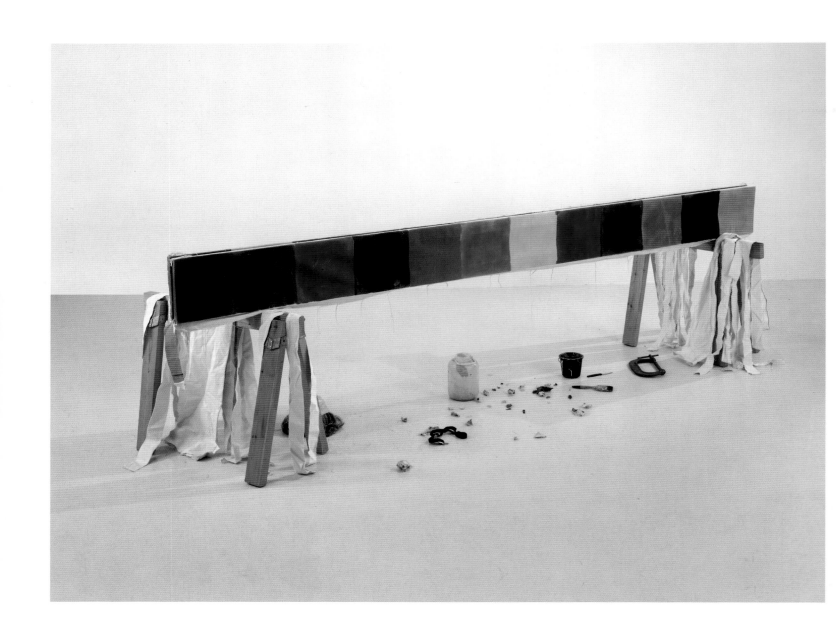

153. Colour of the Month of August, *1969*
Mixed-media assemblage: Acrylic on canvas,
with ribbons, cowboy boot, two bricks, paint
can, axe, and stool
7 feet 2 inches x 8 feet 2 3/4 inches
(218.4 x 250.8 cm)
Denver Art Museum, National Endowment
for the Arts Purchase Fund, Hilton Hotel
Corp., Albert A. List Foundation, Inc.,
Alliance for Contemporary Art, and
anonymous donors

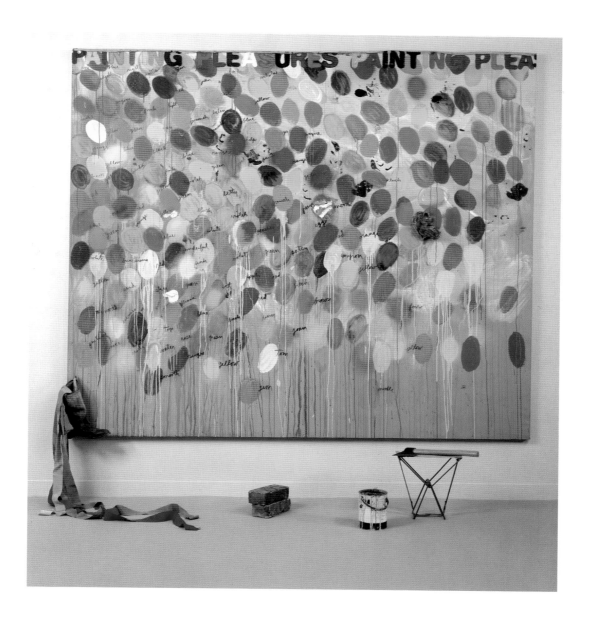

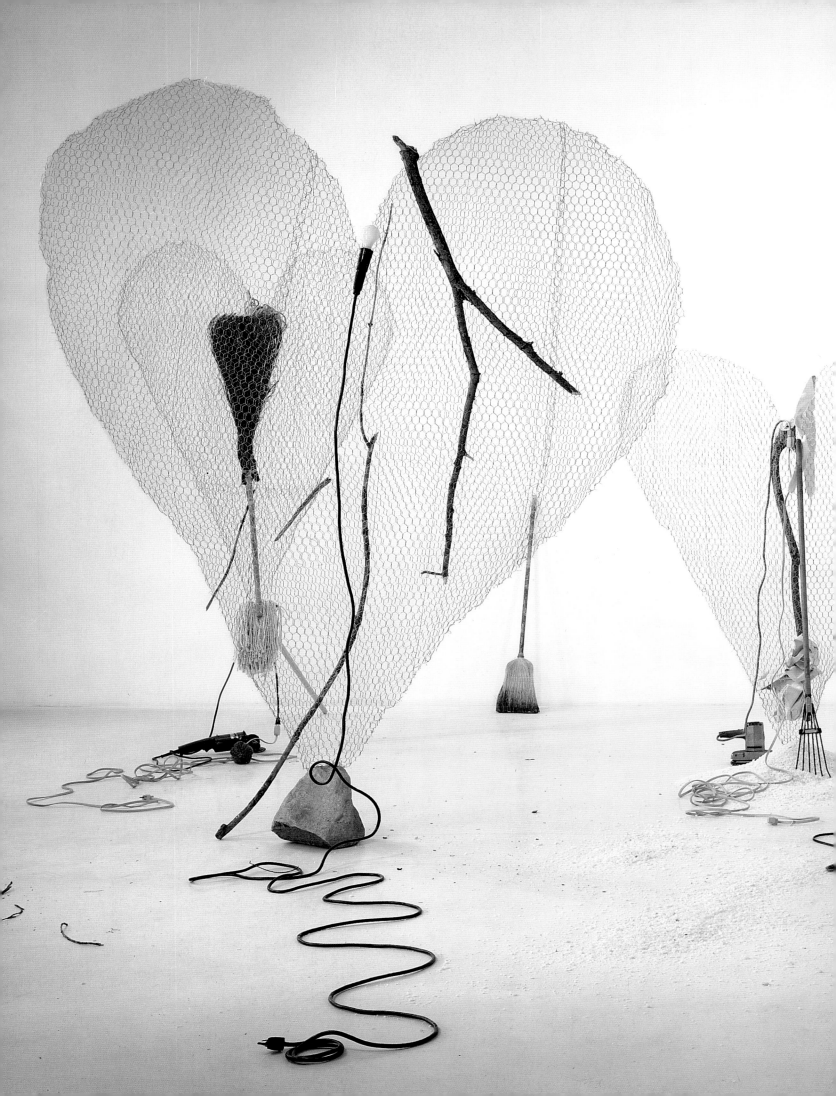

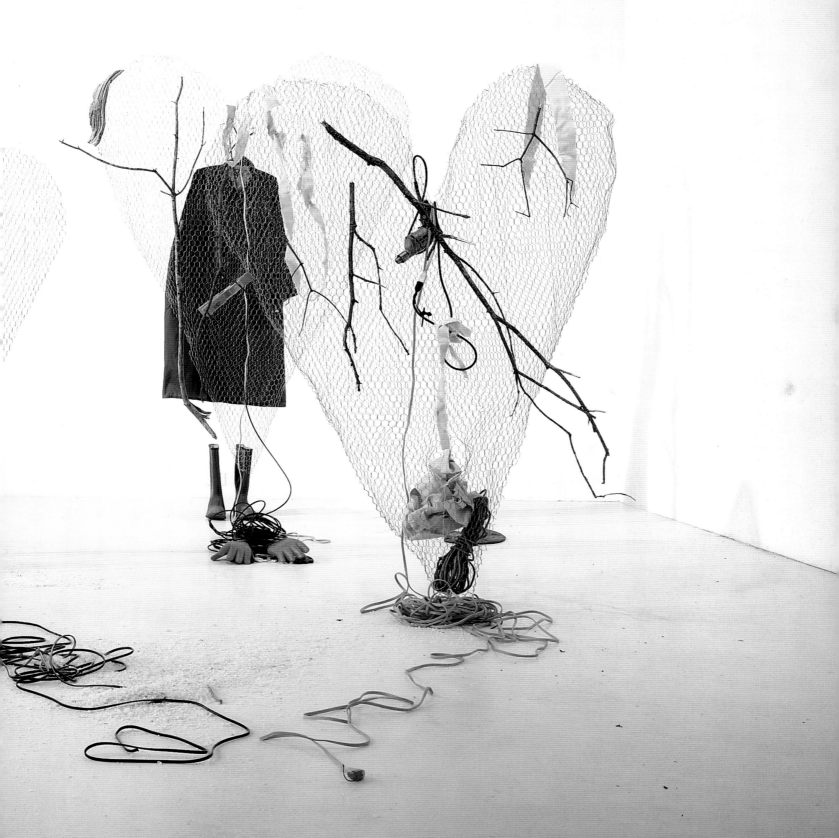

154. Five Chicken Wire Hearts
(for James Peto), *1969/98*
Mixed-media assemblage: Chicken wire,
canvas, rock salt, tree branches, rope,
electric cords, gloves, electric sander, rake,
electric drill, clamp, lightbulb in socket,
extension cords, electric grinder, mop, broom,
rubber boots, and rubber raincoat
Dimensions variable
Private collection, New York

155. Name Painting #1, 1968–69
Charcoal on canvas
6 feet 7 1/2 inches x 15 feet 7 1/2 inches
(201.9 x 476.3 cm)
Collection of Patsy Orlofsky

following two pages:
156. Dine constructing Name Painting #1
in his Chester Square studio, London,
Autumn 1968.
Photo by Ugo Mulas

Chronology
Kara Vander Weg

This chronology was based on the recollections of the artist and a variety of other sources, many cited in the Select Bibliography. Also, Joseph Jacobs, Curator of American Art at the Newark Art Museum, kindly shared his own research. Marco Livingstone graciously allowed the use of an advance copy of his book Jim Dine: The Alchemy of Images *(New York: Monacelli Press, 1998); and Marcus Ratliff provided invaluable information, particularly concerning the early years of the Judson Gallery.*

1935
June 16: James Lewis Dine is born in Cincinnati, Ohio, son of Stanley and Eunice Cohen Dine (his brother, Tom, is born in Cincinnati on February 29, 1940). Dine's grandfather, Morris Cohen, owns a hardware store there; his father owns a smaller one across the Ohio River in Covington, Kentucky. Dine works at both stores during his boyhood summers, an experience that will be reflected in his art.

1946
Dine takes his first art class at the Cincinnati Art Museum with Carlos Cervantes, a Mexican-American veteran of World War II. Daily class assignments include working outdoors with poster paints on manila paper. Dine views the museum collection, and later in life he will remember many of the works he sees there, including paintings by Paul Cézanne and seventeenth-century Spanish artist Francisco de Zurbarán. He will also recall that a reproduction of nineteenth-century American painter Frank Duveneck's *The Whistling Boy*, 1872, displayed in his grandparents' house, affected his artistic development.

1947
Dine's mother dies of cancer.

Fall: Dine enters Walnut Hills High School in Cincinnati.

1948
Dine studies watercolor painting at the studio of artist Vincent Taylor in Cincinnati.

June: Dine's father remarries.

1951
An adversarial relationship with his stepmother compels Dine to move into the home of his maternal grandparents in Cincinnati. Dine's grandfather teaches him carpentry, mechanics, and sewing. He begins making art in the basement of the house, painting over old canvases and on wooden paint stirrers.

1952
Dine sees reproductions of works by Georges Braque and Pablo Picasso that inspire his fascination with objects affixed to the canvas. Works that impress him include several guitar papiers collés and Picasso's painted bronze sculpture *Glass of Absinthe*, 1914.

1953
Dine takes evening classes with artist Paul Chidlaw at The Art Academy of Cincinnati.

Summer: Dine graduates from Walnut Hills High School.

Dine works as a camp counselor in Freyberg, Maine. During a vacation he travels to New York and visits the Museum of Modern Art, where Larry Rivers's painting *Washington Crossing the Delaware*, 1953, is on view; it makes a great impression on Dine.

Fall: Dine enters the College of Applied Arts at the University of Cincinnati.

1954
Dine purchases Paul J. Sachs's *Modern Prints and Drawings: A Guide to a Better Understanding of Modern Draftsmanship* (1954).

The book includes reproductions of works by German Expressionists such as Erich Heckel, Ernst Ludwig Kirchner, and Emil Nolde that influence Dine.

Fall: Dine transfers to the College of Arts and Sciences at the University of Cincinnati.

1955
January: Dine transfers to Ohio University in Athens, Ohio.

Dine begins reading *Art News* and is particularly interested in works by Robert Motherwell, Robert Rauschenberg, and Kurt Schwitters that he sees in the magazine.

September: Dine leaves Ohio to spend the fall at the School of the Museum of Fine Arts in Boston studying graphic arts, life drawing, design, art history, and painting.

1956
Dine returns to Ohio University from Boston. He studies and copies Old Master drawings and practices life drawing. At least once a month, he makes the ten-hour drive from Athens to New York to visit art galleries.

1957
June 16: Dine marries Nancy Minto on his twenty-second birthday.

Dine earns a Bachelor of Fine Arts from Ohio University in June and enters the Master of Fine Arts program at the Graduate College there in the fall.

1958
Dine writes to artist Lester Johnson in New York, expressing admiration for his work, which features abstract treatments of figurative motifs.

April 22: Allan Kaprow performs his first Happening (a combination of environmental art and theater in which the audience becomes an integral part of the events) at Rutgers University in New Brunswick, New Jersey. Seeing his work as affiliated more with objects than performance, Kaprow describes the subsequent Happenings he orchestrates as "painting in the shape of a theater." Although the objectives of the two artists are separate, Kaprow's avant-garde performance works—a step beyond the static medium of abstract painting—will profoundly influence Dine.

June: Dine leaves the Graduate College following his required solo show. His exhibition of paintings and assemblages is very unpopular with some students and residents of Athens, and several students deface the works.

Dine and Nancy move to a house in Patchogue, Long Island, New York. Both acquire teaching positions at local elementary schools, Dine as the art instructor at the Bay Avenue Elementary School. He takes Crayola crayons from the classroom and experiments with melting them to use as a painting medium.

Late summer: Dine and Nancy begin to make the two-hour car trip into Manhattan three or four times a week to socialize with other artists working in the city, including Johnson and Red Grooms (Johnson introduces Dine to Grooms, a student of his).

Fall: Marcus Ratliff, a former high-school classmate of Dine, is attending Cooper Union, where he is majoring in art. Ratliff lives in student housing at the Judson Memorial Church, 239 Thompson Street, at Washington Square, which strives to include the surrounding Greenwich Village intellectual community in its events. After Ratliff and several other Cooper Union students clear out the church's basement to use as a studio space, a storage room is converted into a gallery.

1959
January: Under the direction of the Judson's associate minister, Bernard E. ("Bud") Scott, Dine, Ratliff, Tom Wesselmann, and others organize the church's basement gallery into the Judson Gallery, to show their work and that of similar-minded young artists. Wesselmann is a former Cincinnati resident and a Cooper Union schoolmate of Ratliff's.

February 13–March 7: The Judson Gallery's inaugural exhibition includes paintings, drawings, and collages by Dine, Ratliff, and Wesselmann.

March: Ratliff and Wesselmann meet Claes Oldenburg, who works in the Cooper Union library; Dine meets Oldenburg soon afterward.

March 14–April 4: Dine exhibits in a group show of drawings and prints at the Judson Gallery that also includes works by Grooms, Ratliff, Daniel Spoerri, Wesselmann, and others.

May 10: Dine's first son, Jeremiah, is born. In his honor, Dine paints *Altar for Jeremiah* (fig. 24).

July: En route to his uncle's cabin in rural Kentucky, Dine is involved in a car accident. Approximately one month later Dine is driving with Nancy and Jeremiah to Cleveland and is involved in a second car crash. These incidents inspire a series of drawings in 1959, the painting *Car Crash*, 1960 (fig. 49), and his 1960 performance *Car Crash* (see November 1960).

August: While Nancy recuperates from accident-related injures in Cleveland with Jeremiah, Dine returns to their 1623 First Avenue apartment in New York. He uses the small living room as a studio. Dine begins to collect discarded objects (including the bedspring for his 1960 assemblage *Bedspring* [fig. 58]) from the city's streets.

Dine begins teaching art at the Rhodes School, a private high school in Manhattan, and takes his students to visit the Museum of Modern Art, the Whitney Museum of American Art, and the Museum of Natural History. During his lunch hour, he frequents the Brooks Brothers clothing store in order to study the fabrics of the suits and ties on display.

October 2–23: Dine participates in a group show at the Judson. Other artists who exhibit include Oldenburg, Ratliff, and Wesselmann.

October 4, 6–10: Dine attends Allan Kaprow's *18 Happenings in Six Parts*, which inaugurates the opening of the Reuben Gallery, New York. Participants in the event include Sam Francis, Grooms, Dick Higgins, Johns, Rauschenberg, Lucas Samaras, George Segal, and Robert Whitman. Anita Reuben's space will become a forum for performances by visual artists, including Dine, over the next several years.

November 13–December 3: Dine and Oldenburg show together at the Judson Gallery in *Dine/Oldenburg*. After the exhibition closes, Dine destroys most of his works.

December 2: Dine, Johnson, Kaprow, and Oldenburg participate in the panel discussion "New Uses of the Human Image in Painting" at the Judson.

December 4–31: Dine participates in a Christmas group show of drawings and prints at the Judson Gallery.

December 18–January 5, 1960: Dine first exhibits at the Reuben Gallery in the group show *Below Zero*, which includes work by Grooms, Kaprow, Oldenburg, Rauschenberg, Segal, and Whitman.

1960
Dine meets gallery owner Ileana Sonnabend. Dine also meets Jasper Johns and Rauschenberg during the year.

Dine participates in *Young Americans*, his first museum show, at the Andrew Dickson White Museum at Cornell University, Ithaca, New York.

January: Dine's first art environment, *The House* (figs. 34–35), is on view at the Judson Gallery while it is under construction; it is completed January 30, and remains on view until early March. The piece incorporates found and newly constructed objects in a room through which the audience can move. The work is part of Dine's and Oldenburg's *Ray-Gun* exhibition at the gallery, January 4–March 23.

February 29, March 1–2: As part of the *Ray-Gun* exhibition, a series of performances entitled *Ray Gun Spex* is staged at the Judson Gallery. Dine creates and participates in his first performance piece, *The Smiling Workman* (figs. 1, 37–39), which is presented on all three evenings. For this piece, Dine rapidly paints the phrase "I love what I'm doing" on canvas before drinking simulated red "paint" (actually tomato juice) and pouring it over his head. Other Spex participants include Higgins, Al Hansen, Kaprow, Oldenburg, and Whitman.

March: The March 1960 issue of *Art News* contains critic Irving Sandler's review of the works that Dine is scheduled to show at his first solo exhibition at the Reuben Gallery in April. After Sandler's piece is published, Dine creates new work for the show.

April 1–14: Dine has his first solo show at the Reuben Gallery. He attends the opening wearing clown makeup and a red suit he has made for the occasion (a version of his Smiling Workman persona from his performance work a month earlier). Gallerist Martha Jackson first sees Dine's art at this venue and offers him a $4,000 annual stipend to allow him to quit teaching and focus exclusively on making work. Dine accepts her offer and joins her New York gallery.

Spring/Summer: Dine and Nancy move to an apartment at 44 East Third Street, New York. The Reuben Gallery relocates below them in the same building. Dine works out of a studio in the basement and concentrates on painting, creating such works as *The Valiant Red Car* (fig. 48) during this time.

June 6–24: Dine shows for the first time at the Martha Jackson Gallery in the group exhibition *New Media –*

New Forms. The work by Dine included here is his assemblage *Chair*, 1960 (see fig. 57, *Hanging Chair #2*, a related work). Seventy-one artists participate in this popular show, including John Chamberlain, Grooms, Johns, Kaprow, Louise Nevelson, and Oldenburg.

June 11: Dine performs his *Vaudeville Collage* (figs. 40–42) at the Reuben Gallery's *An Evening of: Sound – Theater – Happenings*. George Brecht, Kaprow, Richard Maxfield, and Whitman also create Happenings for the evening, and Dine acts in Whitman's opera *E.G.*

September 27–October 22: The Martha Jackson Gallery mounts *New Media – New Forms, Version 2* in response to the popularity of the first show. Dine is among the seventy-two artists included; his assemblage *The Blonde Girls*, 1960, is shown.

November 1–6: Dine presents his performance piece *Car Crash* (figs. 12, 13, 44–46), which he performs with friends Pat (Muschinski) Oldenburg, Judy Tersch, and Ratliff at the Reuben Gallery. Dine is dressed in a silver costume and executes sketches on a blackboard while Pat Oldenburg reads from a script and a recorded soundtrack replicates honking cars.

December 16–18: Dine performs his *A Shining Bed* (figs. 51–53) at the Reuben Gallery as part of the *Varieties* program presented for the Christmas season. In addition to Dine, other *Varieties* participants include Simone Morris and Oldenburg. This is the last of Dine's performances in 1960, and he begins to focus on painting.

Dine completes the life-size, allegorical self-portrait *A 1935 Palett* (fig. 26); the year 1935 in the title refers to the year of his birth.

1961
Dine suffers from agoraphobia and vertigo, psychological problems that stem from a difficult childhood. Although these problems will later be treated through psychoanalysis, they prevent him from traveling outside New York until 1964.

Dine begins combining articles of clothing with paint on canvas in works such as *Orange Tie* (fig. 68), *Red Suspenders* (fig. 70), and *Coat* (fig. 74). Another, *Green Ties in a Landscape* (fig. 73), combines elements of assemblage and landscape painting.

January 7–31: Dine constructs his *Rainbow Thoughts* environment at the Judson Gallery.

May: Dine shows in his first European group exhibition, *Modern American Painting*, at the United States Information Service Gallery, London.

May 25–June 23: *Environments – Situations – Spaces* at the Martha Jackson and David Anderson galleries includes works by Brecht, Dine, Walter Gaudnek, Kaprow, Oldenburg, and Whitman. Dine's environment *Spring Cabinet* (fig. 64) is installed in Jackson's gallery and features buckets of paint that were hung from the ceiling and were supposed to drip their contents onto a palette-shaped canvas on the floor; however, the "action" component of making this "drip painting" was eliminated by the gallery.

August 17: Dine's second son, Matthew, is born.

October 2–November 12: *The Art of Assemblage*, organized by William Seitz, opens at the Museum of Modern Art, New York. It is the first major museum exhibition to address assemblage and showcases the work of 142 American and European artists. Dine is not included, although a photograph of his performance piece *Car Crash* appears in the exhibition catalogue.

1962

January 9–February 3: Dine has his first solo show at Martha Jackson (in conjunction with the Anderson Gallery). Twenty-two works in various mediums are exhibited.

Summer: The Dines spend the summer in East Hampton, New York. Johns visits them and introduces Dine to Tatyana Grosman, founder of the lithography press Universal Limited Art Editions (ULAE), West Islip, New York. Dine browses the local hardware store and purchases the medicine chests, towel racks, and soap dishes that he will use in his *Bathroom* series. He also begins his first *Tool* pictures during this time, and makes lithographs on the subjects of tools and toothbrushes.

Dine moves with his family to 522 West End Avenue, New York and rents a studio near Second Avenue and Fifth Street.

Ileana Sonnabend visits Dine's studio and sees his *Tool* paintings.

Sidney Janis visits Dine and offers him $250 as an advance if he will join his New York gallery, an offer which Dine accepts.

Dine begins to construct a series of paintings that re-create memories of his childhood bedroom, including *Child's Blue Wall* (fig. 108).

Dine's studio is broken into, and his *Palette* drawings are stolen, as well as objects affixed to several paintings.

September 14: Dine is included in a *Life* magazine article, "Young Leaders of the Big Breakthrough: A Red-Hot Hundred," highlighting one hundred successful young women and men in America.

Fall: Dine begins undergoing psychoanalysis.

September 25–November 19: Dine is included in the Pasadena Art Museum's exhibition *The New Paintings of Common Objects*, a West Coast exhibition of Pop art organized by Walter Hopps.

November 1–December 1: Dine's assemblage *Lawnmower* (fig. 89) is presented in *International Exhibition of the New Realists*, a group show at the Sidney Janis Gallery featuring twenty-nine artists from the U.S. and France who are considered to be Pop artists or *Nouveaux Réalistes*. Among the artists included are Arman, Yves Klein, Roy Lichtenstein, Oldenburg, Segal, Andy Warhol, and Wesselmann.

October 27: Dine's first European solo exhibition opens at the Galleria Dell'Ariete, Milan, and includes his recently completed *Tool* paintings *Sickle* (fig. 83) and *Colorful Hammering* (fig. 91).

December: ULAE publishes Dine's first two series of lithographs, *Tools* and *Toothbrushes*.

1963

February 4–March 2: The Sidney Janis Gallery mounts its first solo exhibition of Dine's work. Selections from his *Bathroom* and *Child's Room* series are included. Also exhibited is the assemblage *Four Rooms* (fig. 109), consisting of a four-panel painting and upholstered chair, which Rauschenberg cites as an inspiration for his 1962–63 painting *Barge*.

Spring: Dine begins his *Palette* series, a group of paintings and assemblages featuring real palettes and painted images of palettes, sometimes combined with tools or industrial parts. He also begins to create his *Color Charts*, replicas of hardware-store house paint charts.

March 13: Galerie Ileana Sonnabend, Paris, shows works from Dine's *Tool* series.

March 14–June 12: Dine participates in his first New York museum exhibition, *Six Painters and the Object*, organized by Lawrence Alloway at the Solomon R. Guggenheim Museum, New York. Works by Dine presented here include *Tattoo* (fig. 75) and *Coat* (fig. 74), both 1961. The five other artists in the show are Johns, Lichtenstein, Rauschenberg, James Rosenquist, and Warhol.

April 18–June 2: Dine shows in *The Popular Image Exhibition* organized by Alice Denney at the Washington Gallery of Modern Art in Washington, D.C. Oldenburg, Rauschenberg, and Warhol are among the other artists included.

Summer: Dine spends the summer in East Hampton, New York. Exploring the subconscious through his work, Dine creates *Two Palettes in Black with Stovepipe (The Dream)* (fig. 114), based on a dream he had envisioning such a combination of objects, and *Dream #2* (see fig. 123).

Fall: Dine sees a photograph of the 1922 Dada Congress (with Jean Arp, Hugo Ball, Tristan Tzara, and Theo van Doesburg) in Robert Motherwell's 1951 book *The Dada Painters and Poets: An Anthology*. It inspires him to create *Two Palettes (International Congress of Constructivists and Dadaists, 1922), #1* and *#2* (figs. 119, 120), both of which he completes in one month's time.

The Dines move to 470 West End Avenue, New York. Art historian and curator Alan Solomon is one of their neighbors in the building. Dine uses his former residence at 522 West End Avenue as a studio for a year and then begins working out of his apartment.

October 24–November 23: Dine is included in *The Popular Image* at the Institute of Contemporary Art, London. Works by thirteen artists associated with Pop art are shown.

November: Dine is interviewed for G. R. Swenson's *Art News* article "What is Pop Art? Answers from 8 Painters, Part I." Other participants in the two-part series are Johns, Robert Indiana, Lichtenstein, Oldenburg, Rosenquist, Warhol, and Wesselmann.

December 12–February 5, 1964: Dine participates in the *Black and White* exhibition, organized by Solomon, at the Jewish Museum, New York. Works by Josef Albers, De Kooning, Johns, Rauschenberg, and others are shown.

1964

Dine continues to pursue the idea of self-portraiture. Following a series of *White Suit* self-portraits, Dine begins to evoke his own figure in his works through the motif of an uninhabited bathrobe. The *Bathrobe* paintings are inspired by a robe he sees in an advertisement in the Sunday *New York Times Magazine*.

Summer: Dine vacations with his family on Long Island. He creates *Stephen Hands Path* (fig. 134) in reference to the East Hampton road of the same name.

June 20–October 18: The exhibition at the United States Pavilion in the 1964 Venice *Biennale* includes works by eight artists—Chamberlain, Dine, Johns, Morris Louis, Kenneth Noland, Oldenburg, Rauschenberg, and Frank Stella; Dine is one of the younger artists shown. Several works by Dine are presented, including *Black Shovel*, 1962 (fig. 87). Rauschenberg wins the International Grand Prize in Painting. Alan Solomon is the commissioner of the exhibition.

October 27–November 21: Dine has his second solo exhibition at the Sidney Janis Gallery with works that address the theme of self-portraiture, including *Palettes*, *Color Charts*, and *Bathrobes*.

1965

Spring: Dine starts to make sculptures in cast bronze and sand-cast aluminum, beginning with *A Nice Pair of Boots* (fig. 137), which replicates a pair of motorcycle boots in enamel painted bronze, part of a series exploring the themes of body fragments and clothing.

March 7: Dine's third son, Nicholas, is born.

May 1–3: The *First New York Theater Rally*, organized by Solomon and Judson dancer Steve Paxton, is held May 1–26 at a former television studio at West Eighty-first Street and Broadway, New York. Visual artists and performers associated with the Judson Dance Theater are also involved. Dine creates and is the principle performer in *Natural History (The Dreams)* (figs. 138–40), a performance piece based on excerpts from dreams he remembered and wrote down in 1963.

June 1–July 3: Several new sculptures by Dine are shown at the Robert Fraser Gallery, London. Dine later admits his relief at escaping the scrutiny of American critics and his peers by exhibiting overseas.

Fall: Dine gives guest lectures at the Yale University School of Art and Architecture in New Haven, Connecticut.

October 23: A solo show of Dine's work opens at the gallery Gian Enzo Sperone, Turin.

November 3–24: *Jim Dine: Artist in Residence* is held at the Allen Memorial Art Museum, Oberlin College, Oberlin, Ohio. It is Dine's first solo museum exhibition and features a variety of works, some on loan from private collections.

November 14–24: Dine is an artist-in-residence at Oberlin College. During this time he provides criticism for advanced art classes. Shortly afterwards, he creates *A.R. at Oberlin*, a series of mixed-media assemblages inspired by German romantic poet Rainer Maria Rilke and by one of his students.

1966

An interview between Dine and Solomon is filmed and broadcast as part of the educational television series *U.S.A.: Artists*.

Spring: Dine travels outside of the United States for the first time to publish his print portfolio *Tool Box* with the London publisher Paul Cornwall-Jones at Editions Alecto.

March 11: The San Francisco Actors Workshop Guild presents Shakespeare's *A Midsummer Night's Dream* in the Marines' Memorial Theater, San Francisco, reworked by director John Hancock into a contemporary theatrical performance that is similar to many staged Happenings. Dine creates the set and costumes (his first use of the signature heart motif) for the performance, which will travel to the Pittsburgh Playhouse and Manhattan's Theatre De Lys.

Fall: Dine is the visiting critic at the College of Architecture, Cornell University, Ithaca, New York, during the 1966–67 academic year. He shows a seven-part sculpture in the exhibition *Nancy and I at Ithaca*, on view at the Andrew Dickson White Museum, April 7–30. Influenced by his friendship with several literary figures, including B. H. Friedman and Robert Creeley, Dine begins to write poetry at this time.

September 13–October 15: Dine has a show of drawings at the Robert Fraser Gallery. Exhibited are collages created through collaboration with British artist Eduardo Paolozzi, photographs taken in conjunction with Michael Cooper, and a *Tool Box* screenprint. Also featured are drawings of genitalia that are confiscated by London police on September 20 after being deemed pornographic. (A legal battle will close the show.)

October 3–29: Dine's work is included in Sidney Janis's *Erotic Art* group show. Works by Dine on display include a series of collages that incorporate references to Antonin Artaud.

1967

Dine and Robert Kidd, director of London's Royal Court theater, collaborate on a script adapting Oscar Wilde's novel *The Picture of Dorian Gray* for the stage. Dine creates costumes and set designs; however, the play is never put into production because a participant refuses to wear the costume Dine has designed.

January 14–February 12: Dine is part of a three-person show along with Oldenburg and Segal at the Art Gallery of Ontario, Toronto. In his essay for the exhibition catalogue, Solomon refers to Dine as a "hot artist in a cool time."

April 28–October 27: The exhibition *American Painting Now*, organized by Solomon, is held at the United States Pavilion of the Canadian World Exhibition, Montreal. Dine creates a thirty-five foot mural for the show, which also includes Helen Frankenthaler, Indiana, Johns, Ellsworth Kelly, Lichtenstein, Motherwell, Barnett Newman, Rauschenberg, and others.

June: Dine and Nancy move to London, first to 68 Prince of Wales Drive, Battersea Park, and later to 60 Chester Square. Their friends include artists Richard Hamilton and R. B. Kitaj. Dine also corresponds regularly with poets Ted Berrigan, Creeley, Kenneth Koch, and Ron Padgett. He concentrates on writing poetry and printmaking.

June 27–October 6: Dine is one of 150 international artists included in *Documenta 4* in Kassel, West Germany. He shows recent mixed-media assemblages. He also exhibits his costume designs for *Dorian Gray* and several paper collages on which he collaborated with Paolozzi.

August 8–September 24: Dine's costume and set designs from the 1966 San Francisco production of *A Midsummer Night's Dream* are exhibited at the Museum of Modern Art, New York.

1968

Dine begins his most abstract works to date, including *Color of the Month of August*, 1969 (fig. 153).

Spring: Dine visits Paris for the first time to work on prints based on his *Dorian Gray* costume designs. The Musée Rodin particularly impresses him.

Petersburg Press, London, publishes *The Picture of Dorian Gray*, a book of thirteen original lithographs of the costumes and stage sets designed by Dine.

Fall: Dine makes *Name Painting #1* (figs. 155–56). The work is an effort to recall every individual he has known or met up to the year 1965 by recording his or her name in charcoal on the canvas.

1969

Dine completes *Name Painting #2*, which includes the names of people he met between 1965 and 1969.

Spring: Dine's first book of poetry, *Welcome Home Lovebirds*, is published by Trigram Press, London. The publication is illustrated with Dine's drawings and includes all of his writings to date, beginning with work done during his time at Cornell in 1966. He dedicates the book to poets Friedman, Rory McEwen, and Padgett.

May 29: An exhibition of Dine's two *Name Paintings* opens at the Robert Fraser Gallery.

Fall: During one of his frequent visits to the home of Myron and Patsy Orlofsky in South Salem, New York, Dine creates the site-specific installation *Five Chicken Wire Hearts (for James Peto)* (fig. 154). James Peto was a nineteenth-century American artist famous for his hyper-real trompe-l'oeil paintings.

Select Bibliography
Kara Vander Weg

Writings and Illustrated Books by the Artist

The Adventures of Mr. and Mrs. Jim and Ron. New York: Grossman Publishers, 1969.

Big Green Day. London: Trigram, 1968. Poems by Tom Raworth, illustrations by Dine.

Jim Dine. London: Robert Fraser Gallery, 1966. Drawings and collage collaborations with Eduardo Paolozzi, photographic dreams with Michael Cooper, and a *Tool Box* screenprinted by Kelpra Studios.

The Picture of Dorian Gray. London: Petersburg, 1968. In collaboration with Robert Kidd. Illustrated with thirteen original lithographs by Dine.

The Poet Assassinated. New York: Holt, Reinhart, and Winston, 1968. Text by Guillaume Apollinaire (trans. by Ron Padgett) with illustrations by Dine.

Rory McEwen & Jim Dine. New York: Atlantic Recording and the Museum of Modern Art, 1969. Book and one sound disc, 33 1/3-rpm. Contains songs and poems written and performed by the authors and a silkscreened print by each.

Welcome Home Lovebirds. London: Trigram, 1969. Poems and illustrations by Dine.

Work From the Same House. London: Trigram, 1969. Photographs by Lee Friedlander, etchings by Dine.

Photographs and Etchings. London: Petersburg, 1969. Original consisted of a portfolio of sixteen sheets, each with a photograph by Friedlander and an etching by Dine.

Interviews and Statements
Sources cited below may also appear in other sections of the Select Bibliography.

Ackley, Clifford S. and Jim Dine. "A Conversation with Jim Dine." Unpublished transcript of interview, March 23, 1983.

Diamonstein, Barbaralee. "Barbaralee Diamonstein and Jim Dine." *Inside New York's Art World*. New York: Rizzoli, 1979.

Dine, Jim. "A Statement." Transcribed from a recorded interview in Michael Kirby, *Happenings: An Illustrated Anthology*. New York: Dutton, 1965.

———. Statements and poems by the artist. *Rolling Stone* (San Francisco), no. 40 (Aug. 23, 1969), pp. 36–38.

———. "Lithographs and Original Prints: Two Artists Discuss their Recent Work." *Studio International* (London) 175, no. 901 (June 1968), p. 337.

———. Talk given at 92nd Street YM-YWHA, New York, as part of the "Artists' Visions" series, November 12, 1985. Reels containing audio portion of talk on deposit with the 92nd Street YM-YWHA. Portion of transcription reprinted in *Jim Dine: Painting Drawings Sculpture*. New York: Pace Gallery, 1986, unpaginated.

Enright, Robert, with introduction by Meeka Walsh. "Regarding Jim Dine: An Interview with Robert Enright." *Border Crossings* (Winnipeg) 12, no. 4 (Oct. 1993), pp. 8–24.

Fraser, Robert. "Dining with Jim: Robert Fraser Talks to Jim Dine about London and New York." *Art and Artists* (London) 1, no. 6 (Sept. 1966), pp. 48–53.

Glaser, Bruce. "Another Look at Pop Art," April 19, 1965. Audiotape. Recorded and broadcast by WBAI, New York.

Gruen, John. "All Right, Jim Dine, Talk!" *New York: The World Journal Tribune Magazine* (New York), Nov. 20, 1966, p. 34.

Hooten, Bruce Duff. Interview with Dine. Feb. 26, 1965, as part of the Archives of American Art Oral History Program. Audiotape and unpublished transcript on deposit at the Archives of American Art, Smithsonian Institution, Washington, D.C.

Koch, Kenneth. "Test in Art." *Art News* (New York) 65, no. 6 (Oct. 1966), pp. 54–57.

Krens, Thomas. Interview with Dine in *Jim Dine Prints: 1970–1977*. New York: Harper & Row, Icon Editions, 1977.

Lucie-Smith, Edward. "Flamboyance and Eclecticism: London Commentary." *Studio International* (London) 171, no. 878 (June 1966), pp. 265–67.

"New Uses of the Human Image in Painting." Unpublished transcript from a panel held on December 2, 1959 at the Judson Memorial Church, New York. Transcript in the Judson Memorial Church archive, New York.

Shapiro, David. "An Interview with Jim Dine," and "Jim Dine: Statements." *New York Arts Journal*, (New York) no. 23 (1981), pp. 25–30.

Swenson, G[ene] R. "What is Pop Art? Answers from Eight Painters, Part I: Jim Dine." *Art News* (New York) 62, no. 7 (Nov. 1963), pp. 25, 61–62.

W[ilson], J[oanne S.] "Works and Words: Sister Mary Corita, Jim Dine, Luis Camnitzer: Prints: Another Thing." *Artist's Proof* (New York) 6, no. 9–10 (1966), pp. 96–105.

Willard, Charlotte. "Eye to I." *Art in America* (New York) 54, no. 2 (March/April 1966), pp. 49–59.

Books About the Artist

Feinberg, Jean E. *Jim Dine*. New York: Abbeville, 1995. Includes bibliography, chronology, exhibition history, and previously published statements by the artist.

Glenn, Contance W. *Jim Dine Drawings*. New York: Harry N. Abrams, 1985. Includes bibliography, chronology, and statements by the artist.

Livingstone, Marco. *Jim Dine: The Alchemy of Images*. New York: Monacelli, 1998. Includes bibliography, chronology, and statements by the artist.

Shapiro, David. *Jim Dine: Painting What One Is*. New York: Harry N. Abrams, 1981. Includes bibliography, interview, and previously published statements by the artist.

Articles About the Artist

Barrett, Cyril. "Jim Dine's London." *Studio International* (London) 172, no. 881 (Sept. 1966), pp. 122–23.

Calas, Nicolas. "Jim Dine: Tools & Myth." *Metro* (Milan), no. 7 (1962), pp. 76–79.

Dienst, Rolf-Gunter. "Die Ironisierung des Gegenstandes: Zu Den Arbeiten von Jim Dine." *Das Kunstwerk* (Stuttgart) 1–2, no. 11 (Oct.–Nov. 1967), pp. 11–22.

Goldman, Judith. "Jim Dine's Robes: The Apparel of Concealment." *Arts Magazine* (New York) 51, no. 7 (March 1977), pp. 128–129.

Gruen, John. "Jim Dine and the Life of Objects." *Art News* (New York) 76, no. 7 (Sept. 1977), pp. 38–42.

Henri, Adrian. "New York Happenings: Oldenburg, Dine, Whitman, Monk." In *Total Art: Environments, Happenings, and Performance*. New York and Toronto: Oxford University Press, 1974.

Johnson, Ellen H. "Jim Dine and Jasper Johns: Art About Art." *Art and Literature* (Lausanne), no. 6 (Autumn 1965), pp. 128–40.

Jouffroy, Alain. "Jim Dine, au Télescope/Through the Telescope." *Metro* (Milan), no. 7 (1962), pp. 72–75.

Kozloff, Max. "The Honest Elusiveness of James Dine." *Artforum* (San Francisco) 3, no. 3 (Dec. 1964), pp. 36–40.

Lucie-Smith, Edward. "Flamboyance and Eclecticism: London Commentary." *Studio International* (London) 171, no. 878 (June 1966), pp. 265–267.

———. "Jim Dine. New American Attitudes to the Figurative." *The Painter & Sculptor* (London) 5, no. 3 (winter 1962–3), pp. 8–13.

Robinson, Frank and Michael Shapiro. "Jim Dine at Forty." *The Print Collector's Newsletter* (New York) 7, no. 4 (Sept.–Oct. 1976), pp. 101–105.

Ruzicka, Joseph. "Jim Dine and Performance." *American Art of the 1960s. Studies in Modern Art, no. 1*. New York: Museum of Modern Art, 1991.

Sandler, Irving. "Environments and Happenings: Kaprow, Grooms, Oldenburg, Dine, and Whitman." *The New York School: The Painters and Sculptors of the Fifties*. New York: Harper & Row, 1978.

Smagula, Howard J. "James Dine." *Currents: Contemporary Directions in the Visual Arts*. Englewood Cliffs, N.J.: Prentice Hall, 1983.

Smith, Brydon. "Jim Dine: Magic and Reality." *Canadian Art* (Toronto) 23, no. 100 (Jan. 1966), pp. 30–34.

Solomon, Alan R. "Jim Dine and the Psychology of the New Art." *Art International* (Lugano) 8, no. 8 (Oct. 20, 1964), pp. 52–56.

Zack, David. "A Black Comedy. . . The San Francisco Actor's Workshop Invites Jim Dine to Design Sets and Costumes for 'A Midsummer Night's Dream.'" *Artforum* (Los Angeles) 4, no. 9 (May 1966), pp. 32–34.

Films

Jim Dine: Childhood Stories, 1992. 16-mm film, color, with sound, 30 minutes. Directed by Peggy Stern for Outside in July. Produced by Nancy Dine.

Jim Dine, London, 1970. 16-mm film, color, with sound, 28 minutes. Directed by Michael Blackwood and Christian Blackwood, narrated by Jim Dine. Produced by Blackwood Productions, Inc.

"U.S.A.: Artists, Jim Dine," 1966. Television broadcast, black and white, with sound, 30 minutes. Written by Alan R. Solomon. Directed by Lane Slate. Music composed by Manny Albam. Produced by National Education Television, New York, in conjunction with the Radio Center. Part of the Alan R. Solomon archives on deposit with the Archives of American Art, Washington, D.C., reel no. 3922. Interview with the artist.

Publications and Reviews Accompanying Solo Exhibitions

Exhibitions appear in chronological order.

Reuben Gallery, New York, *Jim Dine*, April 1–14, 1960.
—S[andler], I[rving] H. "Reviews and Previews: Jim Dine." *Art News* (New York) 59, no. 2 (April 1960), p. 17.
—V[entura], A[nita]. "In the Galleries: James Dine." *Arts Magazine* (New York) 34, no. 7 (April 1960), p. 73.

Reuben Gallery, New York, *Car Crash*, Nov. 1–6, 1960.
—Johnston, Jill. "Art: Car Crash." *The Village Voice* (New York), Nov. 10, 1960, p. 8.
—P[eterson], V[alerie]. "Reviews and Previews: Jim Dine." *Art News* (New York) 59, no. 8 (Dec. 1960), pp. 16–17.

Judson Gallery, New York, *Rainbow Thoughts*, Jan. 7–31, 1961.
—J[ohnston], J[ill]. "Reviews and Previews: Jim Dine." *Art News* (New York) 59, no. 10 (Feb. 1961), p. 15.

Martha Jackson Gallery and David Anderson Gallery, New York, *Jim Dine*, Jan. 9–Feb. 3, 1962. Exh. cat. *Jim Dine—New Paintings*, with essay by Lawrence Alloway.
—J[ohnston], J[ill]. "Reviews and Previews: James Dine." *Art News* (New York) 60, no. 9 (Jan. 1962), pp. 12–13.
—Sandler, Irving. "In the Art Galleries." *New York Post Magazine*, Jan. 21, 1962, p. 12.
—Kozloff, Max. "Art." *The Nation* (New York), Jan. 27, 1962, p. 5.
—"Art: Three Oldsters, Two Youngsters." *Progressive Architecture* (New York) 43, no. 2 (Feb. 1962), p. 60.
—"Art: The Smiling Workman." *Time* (New York) 79, no. 5 (Feb. 2, 1962), p. 44.
—Kozloff, Max. "'Pop' Culture, Metaphysical Disgust and the New Vulgarians." *Art International* (Zurich) 6, no. 2 (March 1962), pp. 34–36.
—T[illim], S[idney]. "New York Exhibitions: In the Galleries: Jim Dine, Peter Saul, James Rosenquist." *Arts Magazine* (New York) 36, no. 6 (March 1962), pp. 46–47.

Galleria dell'Ariete, Milan, *Jim Dine*, opened Oct. 27, 1962. Exh. cat. with essay by Alain Jouffroy (French, with introduction in Italian).

Sidney Janis Gallery, New York, *New Paintings by Jim Dine*, Feb. 4–March 2, 1963. Exh. cat. with essay by Öyvind Fahlström.
—J[ohnston], J[ill]. "Reviews and Previews: Jim Dine." *Art News* (New York) 62, no. 1 (March 1963), p. 14.
—Preston, Stuart. "Current and Forthcoming Exhibitions: New York." *The Burlington Magazine* (London) 105, no. 720 (March 1963), p. 140.
—Tillim, Sidney. "New York Exhibitions: Month in Review." *Arts Magazine* (New York) 37, no. 6 (March 1963), pp. 59–62.
—Fried, Michael. "New York Letter." *Art International* (Lugano) 7, no. 3 (March 25, 1963), pp. 51–52.
—Ashton, Dore. "Correspondents: Letter from New York." *Canadian Art 85* (Ottawa) 20, no. 3 (May/June 1963), pp. 188–190.

Galerie Ileana Sonnabend, Paris, *Jim Dine*, opened March 13, 1963. Exh. cat. with previously published texts by Alain Jouffroy and Nicholas Calas and essays by Gillo Dorfles and Lawrence Alloway (French).

Sidney Janis Gallery, New York, *Jim Dine*, Oct. 27–Nov. 21, 1964. Exh. cat.
—G[ablik], S[uzi]. "Reviews and Previews: Jim Dine." *Art News* (New York) 63, no. 7 (Nov. 1964), p. 12.
—R[oss], F[elice] T. "Gallery Previews in New York." *Pictures on Exhibit* (New York) 38, no. 2 (Nov. 1964), p. 10.
—"Discredited Merchandise." *Newsweek* (New York) 64, no. 19 (Nov. 9, 1964), pp. 94, 96.
—J[udd], D[onald]. "In the Galleries: Jim Dine." *Arts Magazine* (New York) 39, no. 3 (Dec. 1964), p. 72.
—Picard, Lil. "The New School of New York." *Das Kunstwerk* (Stuttgart) 18, no. 6 (Dec. 1964), pp. 26–33 (English).
—Rose, Barbara. "New York Letter: Pop Art Revisited." *Art International* (Lugano) 8, no. 10 (Dec. 1964), pp. 48–49.

Robert Fraser Gallery, London, *Jim Dine, Recent Paintings*, June 1–July 3, 1965. Exh. cat.
—Barrett, Cyril. "London Commentary." *Das Kunstwerk* (Stuttgart) 19, no. 2 (Aug. 1965), pp. 27–28 (English).
—Whittet, G.S. "Visiting Fire-eaters: London Commentary." *Studio International* (London) 170, no. 868 (Aug. 1965), pp. 80–82.
—Melville, Robert. "The Victimized Figure." *Architectural Review* (London) 140, no. 823 (Sept. 1965), p. 203.
—Rykwert, Joseph. "Mostre a Londra." *Domus* (Milan), no. 430 (Sept. 1965), p. 31 (English).

Gian Enzo Sperone, Turin, *Jim Dine*, opened Oct. 23, 1965. Exh. pamphlet with chronology and exhibition history.

Allen Memorial Art Museum, Oberlin College, *Works by the Oberlin Artist-in-Residence: Jim Dine*, Nov. 3–24, 1965.
—Alloway, Lawrence. "Apropos of Jim Dine." *Allen Memorial Art Museum Bulletin* (Oberlin College) 23, no. 1 (fall 1965), pp. 21–24. Foreword by John R. Spencer, pp. 2–3, and uncredited exh. cat. text pp. 25–27.
—Rushton, Ruth. "Alloway Describes Dine's 'Rich' Work, Notes Its 'Robust & Pictorial' Quality." *Oberlin Review*, Nov. 19, 1965, pp. 1, 8.
—"Artist-in-Residence." *Oberlin Alumni Magazine*, Jan. 1966, pp. 24–25.

Robert Fraser Gallery, London, *Jim Dine Drawings*, Sept. 13–Oct. 15, 1966. Exh. cat., *Jim Dine: 1966*, with text by Cyril Barrett and chronology.
—Lucie-Smith, Edward. "Flamboyance and Eclecticism: London Commentary." *Studio International* (London) 171, no. 878 (June 1966), pp. 265–67.
—Burr, James. "London Galleries: Man of Iron and Steel." *Apollo* (London) 84, no. 55 (Sept. 1966), pp. 234–36.
—Schmidt, Dana Adams. "Art by American Seized in London." *The New York Times*, Sept. 21, 1966, p. 44.
—Russell, John. "London: Dine and the Bobbies." *Art News* (New York) 65, no. 7 (Nov. 1966), pp. 58, 87.
—Lynton, Norbert. "London Letter." *Art International* (Lugano) 10, no. 9 (Nov. 20, 1966), pp. 50–54.
—Russell, Paul. "Pornography Scare Stops Town in London." *artscanada* (Toronto) 24, no. 2 (Feb. 1967), Supplement, p. 1.

Sidney Janis Gallery, New York, *New Paintings, Sculpture & Drawings by Jim Dine*, Nov. 1–26, 1966. Exh. cat.
—Kramer, Hilton. "The Thingification of Sculpture." *The New York Times*, Nov. 13, 1966, section 2, p. D17.
—C[ampbell], L[awrence]. "Reviews and Previews: Jim Dine." *Art News* (New York) 65, no. 8 (Dec. 1966), p. 10.
—Roberts, Colette. "Les Expositions: New York." *Aujourd'hui* (Paris) 10, nos. 55–56 (Dec. 1966–Jan. 1967), illus. p. 183.
—N[emser], C[indy]. "In the Galleries: Jim Dine" *Arts Magazine* (New York) 41, no. 3 (Dec. 1966–Jan. 1967), p. 68.
—Kozloff, Max. "New York: Jim Dine, Janis Gallery." *Artforum* (Los Angeles) 5, no. 5 (Jan. 1967), p. 56.
—Young, Mahonri Sharp. "Letter from U.S.A.: Rembrandt, Heeramaneck and Dine: Sidney Janis." *Apollo* (London) 85, no. 60 (Feb. 1967), p. 145.

Stedelijk Museum, Amsterdam, *Jim Dine: Tekeningen*, Nov. 18, 1966–Jan. 1, 1967. Exh. cat. with essay by Alan R. Solomon.

Andrew Dickson White Museum, Cornell University, Ithaca, New York, *Nancy and I at Ithaca*, April 7–30, 1967. Exh. cat. with notes by William C. Lipke, photos by Lipke and John White, designed by Dine.
—Green, Roger. "Jim Dine, Artist-in-Residence: The Ribbon Machine Master Unravels his Art." *The Cornell Daily Sun* (Ithaca), Feb. 9, 1967, p. 9.
—"Campus News Briefs: Cornell Artist-in-Residence to Present Work." *The Cornell Daily Sun* (Ithaca), April 5, 1967, p. 6.
—Lipke, William C. "Perspectives of American Sculpture: 1 'Nancy and I at Ithaca'—Jim Dine's Cornell Project." *Studio International* (London) 174, no. 893 (Oct. 1967), pp. 142–45.

Museum of Modern Art, New York, *Jim Dine Designs for "A Midsummer Night's Dream,"* Aug. 8–Sept. 24, 1967. Exh. cat with introduction by Virginia Allen.
—Wasserman, Emily. "New York: James Dine, Museum of Modern Art." *Artforum* (New York) 6, no. 2 (Oct. 1967), p. 57.

Martha Jackson Gallery, New York, *Treasures from Inventory III: Jim Dine: Paintings, Drawings and Collages 1958–1961*, Dec. 30, 1967–Jan. 13, 1968.
—N[emser], C[indy]. "In the Galleries: Treasures from Inventory III" *Arts Magazine* (New York) 42, no. 3 (Dec. 1967–Jan. 1968), p. 52.
—L[evin], K[im]. "Reviews and Previews: Jim Dine." *Art News* (New York) 66, no. 9 (Jan. 1968), p. 12.

Robert Fraser Gallery, London, *Jim Dine: Two Paintings*, opened May 29, 1969.
—Russell, John. "London: London Dine." *Art News* (New York) 68, no. 5 (Sept. 1969), p. 22.

Kunstverein München, Munich (organized by the International Council of the Museum of Modern Art, New York), *Jim Dine*, Oct. 30–Dec. 7, 1969. Exh. cat. with foreword by Carl-Albrecht Haenlein, previously published essays by Jan Kott and Virginia Allen, essay by Peter Brook, and interview with G.R. Swenson and Dine (German). Previously published poetry by Jim Dine, Dorian Gray scene by Dine and Robert Kidd (English). Includes bibliography and exhibition history (German). Traveled to Kunsthalle Nürnberg, Dec. 12, 1969–Jan. 14, 1970 (exh. cat.); Kestner-Gesellschaft, Hannover, March 20–April 26,

1970 (exh. cat. with introduction by Wieland Schmied, an interview with G.R. Swenson and Dine [German], and previously published poetry by Dine [English]. Includes chronology [German], exhibition history, and bibliography[English]); Palais des Beaux-Arts and Paleis voor Shone Kunsten, Brussels, May 12–June 14, 1970 (exh. cat. in French and Dutch).

Galerie Ileana Sonnabend, Paris, exhibition, Nov. 1969.
—Peppiatt, Michael. "Paris." *Art International* (Lugano) 14, no. 1 (Jan. 20, 1970), pp. 81–84.

Whitney Museum of American Art, New York, *Jim Dine*, Feb. 27–April 19, 1970. Exh. cat. with essay by John Gordon, statement by Ron Padgett, and poem and previously published statement by Dine. Includes bibliography and exhibition history.
—Shapiro, David. "Jim Dine's Life-in-Progress." *Art News* (New York) 69, no. 1 (March 1970), pp. 42–46.
—Kramer, Hilton. "The Art of Jim Dine: Expressionism Plus Objects." *The New York Times*, March 8, 1970, p. D21.
—"Art: Poet of the Personal." *Time* (New York) 95, no. 10 (March 9, 1970), pp. 50–53.
—P[erret], G[eorge] A. "Reviews: In the Museums: Jim Dine." *Arts Magazine* (New York) 44, no. 6 (April 1970), p. 54.
—Pincus-Witten, Robert. "New York: Jim Dine, Whitney Museum and Sonnabend Gallery." *Artforum* (New York) 8, no. 9 (May 1970), pp. 74–75.
—Garcia-Herráiz, Enrique. "Crónica de Nueva York: '22 Realists' y Jim Dine, en el Whitney: Jim Dine." *Goya* (Madrid), no. 96 (May–June 1970), pp. 368–369.
—Vinklers, Bitite. "New York: Jim Dine; Keith Sonnier." *Art International* (Lugano) 14, no. 5 (May 20, 1970), p. 82.
—Butler, Joseph T. "The American Way With Art: Jim Dine Exhibition." *The Connoisseur* 175, no. 704 (Oct. 1970), p. 134.

Sonnabend Gallery, New York, *Jim Dine*, Feb. 28–March 28, 1970. Exh. cat. with essay by John Russell. Includes exhibition history.

Kestner-Gesellschaft, Hannover (organized in collaboration with Galerie Mikro, Berlin, and Petersburg Press, London), *Jim Dine*, March 20–April 26, 1970. Exh. cat., *Jim Dine: Complete Graphics*, (Berlin: Galerie Mikro, 1970) edited by Wibke von Bonin and Michael S. Cullen, with essays by John Russell and Tony Towle.

Museum Boymans-van Beuningen, Rotterdam, *Jim Dine: Schilderijen, Aquarellen, Objecten en het Complete Grafishe Oeuvre*, Feb. 20–April 12, 1971. Organized by Liesbeth Brandt Corstius. Exh. cat. with introduction by R. Hammacher-van den Brande, essay by Christopher Finch, previously published interview with Kenneth Koch, and original and previously published statements and poetry by Dine (Dutch and English). Includes bibliography, chronology, and exhibition history (English).

Galerie Gimpel & Hanover, Zurich, *Jim Dine: Bilder, Collages Skulpturen, 1962–72*, Sept. 22–Oct. 25, 1972.
—Daval, Jean-Luc. "Lettre de Suisse: Zurich: Actualité zurichoise: Jime [sic] Dine." *Art International* (Lugano) 17, no. 1 (Jan. 1973), p. 44.

Galerie Gérald Cramer, Geneva, *Jim Dine: Estampes originales, Livres illustrés, Divers*, Nov. 1972–Jan. 1973. Exh. cat. with previously published essays by John Russell, Tony Towle, and Wieland Schmied (English).

La Jolla Museum of Contemporary Art, California, *Jim Dine: The Summers Collection*, May 18–July 7, 1974. Exh. cat. with introduction by Jay Belloli and bibliography.

Sonnabend Gallery, New York. *Jim Dine, Works 1958–63*, Jan. 7–Feb. 4, 1984.
—Levin, Kim. "Centerfold: Art: Jim Dine: Works 1958–1963." *The Village Voice* (New York) 29, no. 4 (Jan. 24, 1984), p. 68.
—Smith, Roberta. "Art: Fashions of the Times." *The Village Voice* (New York) 29, no. 4 (Jan. 24, 1984), p. 82.
—Feinstein, Roni. "Jim Dine's Early Work." *Arts Magazine* (New York) 58, no. 7 (March 1984), pp. 70–71.
—Zelevansky, Lynn. "New York Reviews: Jim Dine—Early Work: Sonnabend." *Art News* (New York) 83, no. 5 (May 1984), pp. 159, 161.

Publications and Reviews Accompanying Group Exhibitions
Exhibitions appear in chronological order.

Judson Gallery, New York, *Dine/Oldenburg*, Nov. 13–Dec. 3, 1959.
—V[entura], A[nita]. "In the Galleries: Claes Oldenburg, James Dine." *Arts Magazine* (New York) 34, no. 3 (Dec. 1959), p. 59.

Judson Gallery, New York, *Ray-Gun*, Jan. 4–March 23, 1960.
—Kiplinger, Suzanne. "Art: Ray-Gun." *The Village Voice* (New York) 5, no. 17 (Feb. 17, 1960), p. 11.
—"Art: Up-Beats." *Time* (New York) 75, no. 11 (March 14, 1960), p. 80.

Martha Jackson Gallery, New York, *New Media – New Forms*, June 6–24, 1960. Exh. cat, *New Forms – New Media 1*, with foreword by Martha Jackson and essays by Lawrence Alloway and Allan Kaprow.
—Constable, Rosalind. "Scouting Report on the Avant-Garde." *Esquire* (New York) 55, no. 6 (June 1961), pp. 83–88.
—Canaday, John. "Art: A Wild, but Curious, End-of-Season Treat." *The New York Times*, June 7, 1960, section 5, p. 32.
—"Art: Here Today . . ." *Time* (New York) 75, no. 24 (June 20, 1960), p. 62.
—Hess, Thomas B. "Mixed Mediums for a Soft Revolution" *Art News* (New York) 59, no. 4 (summer 1960), pp. 45, 62.
—Sandler, Irving. "Ash Can Revisited, A New York Letter." *Art International* (Zurich) 4, no. 8 (Oct. 25, 1960), pp. 28–30.
—Constable, Rosalind. "Martha Jackson: An Appreciation." *Arts Magazine* (New York) 44, no. 1 (Sept./Oct. 1969), p. 18.

Reuben Gallery, New York, *An Evening of: Sound – Theater – Happenings*, June 11, 1960.
—Johnston, Jill. "Dance: New 'Happenings' at the Reuben." *The Village Voice* (New York) 5, no. 35 (June 23, 1960), p. 13.

Reuben Gallery, New York, *Varieties*, Dec. 16–18, 1960.
—P[etersen], V[alerie]. "Reviews and Previews: Varieties." *Art News* (New York) 59, no. 10 (Feb. 1961), p. 16.

Martha Jackson Gallery, New York, *Environments – Situations – Spaces*, May 25–June 23, 1961. Exh. cat. with artists' statements.
—K[roll], J[ack]. "Reviews and Previews: Situations and Environments." *Art News* (New York) 60, no. 3 (May 1961), p. 16.
—"Art: Jumping on Tires." *Newsweek* (New York) 57, no. 24 (June 12, 1961), pp. 92–93.

The Dallas Museum for Contemporary Arts, *1961*, April 3–May 13, 1962. Exh. brochure with introduction by Douglas MacAgy.
—Askew, Rual. "Reviews: Dallas." *Artforum* (San Francisco) 1, no. 1 (June 1962), p. 7.

Pasadena Art Museum, California, *The New Painting of Common Objects*, Sept. 25–Oct. 19, 1962. Organized by Walter Hopps. Exh. cat. with introduction by John Coplans.
—Coplans, John. "The New Paintings of Common Objects." *Artforum* (San Francisco) 1, no. 6 (Nov. 1962), pp. 26–29.
—Langsner, Jules. "Los Angeles Letter, Sept. 1962." *Art International* (Zurich) 6, no. 9 (Nov. 25, 1962), pp. 49–52.

Arts Council of the YM-YWHA, Philadelphia, *Art 1963—A New Vocabulary*, Oct. 25–Nov. 7, 1962. Exh. brochure with artists' statements.

Sidney Janis Gallery, New York, *International Exhibition of the New Realists*, Nov. 1–Dec. 1, 1962. Exh. cat. *The New Realists*, with preface by John Ashbery, excerpt from previously published essay by Pierre Restany (English trans. by Georges Marci), and essay by Sidney Janis.
—O'Doherty, Brian. "Art: Avant-Garde Revolt: 'New Realists' Mock U.S. Mass Culture in Exhibition at Sidney Janis Gallery." *The New York Times*, Oct. 31, 1962, p. 41.
—Sandler, Irving. "In the Art Galleries." *New York Post Magazine*, Nov. 18, 1962, p. 12.
—Rosenberg, Harold. "The Art Galleries: The Games of Illusion." *The New Yorker* (New York) 38, no. 40 (Nov. 24, 1962), pp. 161–62.
—Hess, Thomas B. "Reviews and Previews: New Realists." *Art News* (New York) 61, no. 8 (Dec. 1962), pp. 12–13., illus. p. 42.
—T[illim], S[idney]. "In the Galleries: The New Realists." *Arts Magazine* (New York) 37, no. 3 (Dec. 1962), pp. 43–44.
—Restany, Pierre. "Le Nouveau Réalisme à la Conquête de New York." *Art International* (Zurich) 7, no. 1 (Jan. 25, 1963), pp. 29–36.
—Rudikoff, Sonya. "New Realists in New York." *Art International* (Zurich) 7, no. 1 (Jan. 25, 1963), pp. 38–41.
—Irwin, David. "Pop Art and Surrealism." *Studio International* (London) 171, no. 877 (May 1966), pp. 187–91.

Solomon R. Guggenheim Museum, New York, *Six Painters and the Object*, March 14–June 12, 1963. Organized by Lawrence Alloway. Exh. cat. with preface by Thomas M. Messer and essay by Alloway. Traveled to Los Angeles County Museum of Art, July 24–Aug. 20, 1963; Minneapolis Institute of Arts, Sept. 3–29, 1963; University of Michigan Museum of Art, Ann Arbor, Oct. 9–Nov. 3, 1963; Rose Art Museum, Brandeis University, Waltham, Mass., Nov. 18–Dec. 29, 1963; Museum of Art, Carnegie Institute, Pittsburgh, Jan. 17–Feb. 23, 1964; Columbus Gallery of Fine Arts, March 8–April 5, 1964; Art Center in La Jolla, April 20–May 17, 1964.
—Preston, Stuart. "On Display: All-Out Series of Pop Art: 'Six Painters and the Object' Exhibited at the Guggenheim." *The New York Times*, Western edition, March 21, 1963, p. 8.
—Roberts, Colette. "Les Expositions à l'Etranger: New York." *Aujourd'hui* (Paris) 7, no. 41 (May 1963), pp. 48–49.

—Rose, Barbara. "Pop Art at the Guggenheim." *Art International* (Lugano) 7, no. 5 (May 25, 1963), pp. 20–22.

—Judd, Donald. "New York Exhibitions: In the Galleries: Six Painters and the Object." *Arts Magazine* (New York) 37, no. 9 (May–June 1963), pp. 108–9.

—Seldis, Henry J. "The 'Pop' Art Trend: This, Too, Will Pass." *Los Angeles Times*, Aug. 4, 1963, Calendar sec., p. 2.

—Factor, Don. "Reviews: Six Painters and the Object and Six More, L.A. County Museum of Art" *Artforum* (San Francisco) 2, no. 3 (Sept. 1963), pp. 13–14.

Contemporary Arts Museum, Houston, *Pop! Goes the Easel*, April 1963. Exh. cat. with text by Douglas MacAgy.

Washington Gallery of Modern Art, Washington, D.C., *The Popular Image Exhibition*, April 18–June 2, 1963. Organized by Alice Denney. Exh. cat. with foreword by Denney and essay by Alan R. Solomon. Cover designed by Dine. *Record of Interviews with Artists Participating in The Popular Image Exhibition, The Washington Gallery of Modern Art, April 18–June 2, 1963*, 33 1/3-rpm phonograph record. Recorded and edited by Billy Klüver in collaboration with the Washington Gallery of Modern Art. *On Record: 11 Artists 1963* (New York: Experiments in Art and Technology), 1981. Audiocassette released 1993. Sound tape reel, phonograph record, and partial transcript of interviews on deposit at the Archives of American Art, Smithsonian Institution, Washington, D.C.

—Getlein, Frank. "Art-Radio: Art and Artists: Modern Art Pop Show Is Strictly Dullsville." *The Sunday Star* (Washington, D.C.), April 21, 1963, p. C12.

—"Show Business: Happenings." *Time* (New York) 81, no. 18 (May 3, 1963), p. 73.

William Rockhill Nelson Gallery of Art, Atkins Museum, Kansas City, Missouri, *Popular Art: Artistic Projections of Common American Symbols*, April 28–May 26, 1963. Exh. cat. with essay by Ralph T. Coe.

Oakland Art Museum and the California College of Arts & Crafts, *Pop Art USA*, Sept. 7–29, 1963. Organized by John Coplans. Exh. cat. with foreword by Paul Mills and essay by Coplans.

Institute of Contemporary Arts, London, in collaboration with Ileana Sonnabend Gallery, Paris, *The Popular Image*, Oct. 24–Nov. 23, 1963. Exh. cat. with essay by Alan R. Solomon.

Albright-Knox Art Gallery, Buffalo Fine Arts Academy, Buffalo, *Mixed Media and Pop Art*, Nov. 19–Dec. 15, 1963. Exh. cat. with foreword by Gordon M. Smith and essay by Lawrence Alloway.

Munson-Williams-Proctor Institute, Utica (organized by the Poses Institute of Fine Arts, Rose Art Museum, Brandeis University, Waltham, Mass.), *New Directions in American Painting*, Dec. 1, 1963–Jan. 5, 1964. Exh. cat. with introduction by Sam Hunter. Traveled to Isaac Delgado Museum of Art, New Orleans, Feb. 7–March 8, 1964; Atlanta Art Association, March 18–April 22, 1964; The J. B. Speed Art Museum, Louisville, May 4–June 7, 1964; Art Museum, Indiana University, Bloomington, June 22–Sept. 20, 1964; Washington University, St. Louis, Oct. 5–30, 1964; The Detroit Institute of Arts, Nov. 10–Dec. 6, 1964.

The Contemporary Arts Center, Cincinnati, *An American Viewpoint, 1963*, Dec. 4–21, 1963. Exh. cat.

The Jewish Museum, New York, *Black and White*, Dec. 12, 1963–Feb. 5, 1964. Exh. cat. with preface by Alan R. Solomon, introduction by Ben Heller, and essay by Robert Motherwell.

—Kozloff, Max. "The Many Colorations of Black and White: An Examination of the Jewish Museum's Recent 'Black and White' Exhibition." *Artforum* (San Francisco) 2, no. 8 (Feb. 1964), pp. 22–25.

Sidney Janis Gallery, New York, *Four Environments by Four New Realists*, Jan. 3–Feb. 1, 1964.

—Roberts, Colette. "Les Expositions à New York." *Aujourd'hui* (Paris) 8, no. 44 (Jan. 1964), pp. 96–97.

—Ashton, Dore. "Art." *Arts and Architecture* (Los Angeles) 81, no. 2 (Feb. 1964), pp. 6, 9.

—Swenson, G.R. "Reviews and Previews: Four Environments." *Art News* (New York) 62, no. 10 (Feb. 1964), p. 8.

—Lippard, L.R. "New York: Four Environments by New Realists." *Artforum* (San Francisco) 2, no. 9 (March 1964), pp. 18–19.

—Rose, Barbara. "New York Letter." *Art International* (Lugano) 8, no. 3 (April 25, 1964), pp. 52–56.

Wadsworth Atheneum, Hartford, Connecticut, *Black, White, and Grey: Contemporary Painting and Sculpture*, Jan. 10–Feb. 9, 1964.

—Wagstaff, Samuel J. "Paintings to Think About." *Art News* (New York) 62, no. 9 (Jan. 1964), pp. 38, 62.

Dwan Gallery, Los Angeles, *Boxes*, Feb. 2–29, 1964. Exh. brochure with acknowledgements by John Weber and text by Walter Hopps.

Moderna Museet, Stockholm, *Amerikansk Pop-Konst: Jim Dine, Roy Lichtenstein, Claes Oldenburg, James Rosenquist, George Segal, Andy Warhol, Tom Wesselmann*, Feb. 29–April 12, 1964. Exh. cat. with foreword by K. G. Hultén, essays by Chell Buffington, Öyvind Fahlström, Nils-Hugo Geber, Henry Geldzahler, Alain Jouffroy, Billy Klüver, and Alan R. Solomon, and previously published statement by Jonas Mekas. Includes artists' statements and bibliography (Swedish). Traveled to Louisiana Museum, Humlebaek, April 17–May 24, 1964; Stedelijk Museum, Amsterdam, June 22–July 26, 1964 (exh. cat. with essay by Solomon [Dutch]).

Poses Institute of Fine Arts, Rose Art Museum, Brandeis University, Waltham, *Recent American Drawings*, April 19–May 17, 1964. Exh. cat. with foreword by Sam Hunter and introduction by Thomas H. Garver.

Tate Gallery, London (organized by the Calouste Gulbenkian Foundation), *54–64: Painting and Sculpture of a Decade*, April 22–June 28, 1964. Exh. cat. with anonymous essay.

—Melville, Robert. "Gallery: Prospect for the Future." *The Architectural Review* (London) 136, no. 810 (Aug. 1964), pp. 134–36.

Thirty-second International Biennial Exhibition of Art, Venice, June 20–Oct. 18, 1964. Exh. cat. *Catalogo della XXXII Biennale Internazionale d'Arte*. Exh. cat. of U.S. artists, *XXXII International Biennial Exhibition of Art Venice 1964, United States of America: Four Germinal Painters, Four Younger Artists* (New York: The Jewish Museum) (English and Italian).

—White, Jean M. "USIA Venice Exhibition Will Lean to 'Pop Art.'" *The Washington Post*, April 3, 1964, p. A3.

—Valsecchi, Marco. "Alla Biennale esplode la neurosi vitalistica." *Il giorno* (Rome), June 20, 1964, p. 10.

—"Art: Carnival in Venice." *Newsweek* (New York) 64, no. 1 (July 6, 1964), pp. 74–75.

—Genauer, Emily. "Art: The Merchandise of Venice." *The New York Herald Tribune*, July 12, 1964, Sunday Magazine, p. 21.

—Restany, Pierre. "La XXXII Biennale di Venezia, Biennale della Irregolarita" and "The XXXII Biennial Exhibition in Venice: A Triumph of Irregularity in Art." *Domus* (Milan), no. 417 (Aug. 1964), pp. 27–42. (French, Italian, and English).

—Baro, Gene. "The Venice Biennale." *Arts Magazine* (New York) 38, no. 10 (Sept. 1964), pp. 32–37.

—Carluccio, Luigi. "Alla XXXII Biennale di Venezia." *Domus* (Milan), no. 418 (Sept. 1964), pp. 45–55.

—Gassiot-Talabot, Gérald. "La Panoplie de l'Oncle Sam à Venise." *Aujourd'hui* (Paris) 8, no. 47 (Oct. 1964), pp. 30–33.

—Tomkins, Calvin. "The Big Show in Venice." *Harper's Magazine* (New York) 230, no. 1,379 (April 1965), pp. 98–104.

Stedelijk Museum, Amsterdam, *American Pop Art*, June 22–July 26, 1964. Exh. cat. with text by Alan R. Solomon.

Haags Gemeentemuseum, The Hague, *Nieuwe Realisten*, June 24–Aug. 31, 1964. Exh. brochure with essays by W.A.L. Beeren, Jasia Reichardt, Pierre Restany, and L.J.F. Wijsenbeck (Dutch, English, and French). Traveled to Akademie der Künste, Berlin, as *Neue Realisten & Pop Art*, Nov. 20, 1964–Jan. 3, 1965 (exh. cat. with essay by Werner Hoffmann, includes bibliography and glossary of terms); Palais des Beaux-Arts, Brussels, as *Pop Art, Nouveau Réalisme, Etc.*, Feb. 5–March 1, 1965 (exh. cat. with preface by Jean Dypréau and essay by Pierre Restany).

Solomon R. Guggenheim Museum, New York, *American Drawings*, Sept. 17–Oct. 27, 1964. Organized by Lawrence Alloway. Exh. cat. with foreword by Thomas M. Messer and introduction by Alloway. Includes bibliography and artists' statements. Traveled to University of Michigan Museum of Art, Ann Arbor, Nov. 11–Dec. 13, 1964; Grand Rapids Art Museum, Jan. 10–Feb. 7, 1965; University Gallery, University of Minnesota, Minneapolis, Feb. 24–March 21, 1965; Denver Art Museum, June 6–July 4, 1965; Dallas Museum of Fine Arts, July 25–Aug. 22, 1965; Columbus Gallery of Fine Arts, Ohio, Sept. 12–Oct. 10, 1965; Krannert Art Museum, University of Illinois, Champaign-Urbana, Nov. 14–Dec. 5, 1965.

Sidney Janis Gallery, New York, *Three Generations*, Nov. 24–Dec. 26, 1964. Exh. cat, *A Selection of 20th Century Art of Three Generations*.

Solomon R. Guggenheim Museum, New York, *Eleven from the Reuben Gallery*, Jan. 6–28, 1965. Exh. cat. with introduction by Lawrence Alloway. Includes gallery exhibition history.

—Lippard, Lucy R. "New York Letter." *Art International* (Lugano) 9, no. 3 (April 1965), pp. 48–64.

Dwan Gallery, Los Angeles, *Drawings by Claes Oldenburg, Jim Dine, Robert Whitman, Ben Talbert*, Feb. 9–March 6, 1965.

—Factor, Don. "Los Angeles: Drawings by Dine, Oldenburg, Talbert, and Whitman." *Artforum* (San Francisco) 13, no. 7 (April 1965), p. 9.

—Marmer, Nancy. "Los Angeles Letter." *Art International* (Lugano) 9, no. 4 (May 1965), pp. 43–46.

Worcester Art Museum, Worcester, Mass., *The New American Realism*, Feb. 18–April 4, 1965. Exh. cat. with prefatory note by Daniel Catton

Rich and introduction by Martin Carey. Includes artists' quotations.

Milwaukee Art Center, Milwaukee, *Pop Art and the American Tradition*, April 9–May 9, 1965. Organized by Tracy Atkinson. Exh. cat. with essay by Atkinson.

Whitney Museum of American Art, New York, *A Decade of American Drawings: 1955–1965*, April 28–June 6, 1965. Exh. cat. with foreword by Donald M. Blinken.

First New York Theater Rally, New York, May 1–26, 1965. Produced by Steve Paxton and Alan R. Solomon, sponsored by Pocket Theater, Robert Rauschenberg, and Surplus Dance Theater.
—Windish-Graetz, Caroline. "It Happened." *The New York Herald Tribune*, May 5, 1965, p. 24.
—Novick, Elizabeth. "Happenings in New York." *Studio International* (London) 172, no. 881 (Sept. 1966), pp. 154–59.

Sidney Janis Gallery, New York, *Recent Work by Six Artists*, May 5–31, 1965. Exh. cat., *Recent Work by Arman, Dine, Fahlstrom, Marisol, Oldenburg, Segal*.

Gian Enzo Sperone, Turin, *Pop*, June/July 1965. Exh. cat.

Sidney Janis Gallery, New York, *Pop and Op*, Dec. 1–31, 1965.
—Ashton, Dore. "Commentary from Washington and New York: New York." *Studio International* (London) 171, no. 874 (Feb. 1966), pp. 80–81.
—Benedikt, Michael. "New York Letter: Two Groups." *Art International* (Lugano) 10, no. 2 (Feb. 20, 1966), p. 66.

Sidney Janis Gallery, New York, *Erotic Art 66*, Oct. 3–29, 1966. Exh. cat. with introduction by Sidney Janis.
—"In the Picture: Erotica." *Arts Magazine* (New York) 40, no. 9 (Sept.–Oct. 1966), pp. 12–13.
—Mellow, James R. "New York Letter." *Art International* (Lugano) 10, no. 9 (Nov. 20, 1966), pp. 54–59.

Art Gallery of Ontario, Toronto, *Dine/ Oldenburg/ Segal*, Jan. 14–Feb. 12, 1967. Organized by Brydon Smith. Exh. cat. with preface by Brydon Smith and essays by Ellen H. Johnson, Alan R. Solomon, and Robert Pincus-Witten. Previously published statements by Dine and Oldenburg, original statement by Segal. Traveled to Albright-Knox Art Gallery, Buffalo, Feb. 24–March 26, 1967.
—Russell, Paul. "Exhibitions: *Dine Oldenburg Segal: Painting/Sculpture*." *artscanada* (Toronto) 24, no. 2 (Feb. 1967), Supplement, p. 3.

United States Pavilion, Expo '67, Montreal, *American Painting Now*, April 28–Oct. 27, 1967. Exh. cat. with essay by Alan R. Solomon. Traveled under sponsorship of Institute of Contemporary Art, Boston, to Horticultural Hall, Dec. 15, 1967–Jan. 10, 1968.
—Lipke, William C. "Expo Roundup: Jim Dine's Red Mural for the U.S. Pavilion." *artscanada* (Toronto) 24, no. 113 (Oct. 1967), supplement p. 10.

Museum of Modern Art, New York, *The Sidney and Harriet Janis Collection*, Jan. 17–March 4, 1968. Exh. cat. (Greenwich: New York Graphic Society, 1972), *Three Generations of Twentieth-Century Art: The Sidney and Harriet Janis Collection of the Museum of Modern Art*, with foreword by Alfred H. Barr, Jr., and introduction by William Rubin. Traveled to Minneapolis Institute of Arts, May 15–July 28, 1968; The Portland Art Museum, Sept. 13–Oct. 13; The Pasadena Art Museum, Nov. 11–Dec. 15; San Francisco Museum of Modern Art, Jan. 13–Feb. 16, 1969; Seattle Art Museum, March 12–April 13; Dallas Museum of Fine Arts, May 14–June 8; Albright-Knox Art Gallery, Buffalo, Sept. 15–Oct. 19, 1969; Cleveland Museum of Art, Nov. 18, 1969–Jan. 4, 1970; Kunsthalle, Basel, Feb. 28–March 30, 1970; Institute of Contemporary Arts, London, May 1–31, 1970; Akademie der Künste, Berlin, June 12–Aug. 2, 1970; Kunsthalle, Nürnberg, Sept. 11–Oct. 25, 1970; Württembergishcher Kunstverein, Stuttgart, Nov. 11–Dec. 27, 1970; Palais des Beaux-Arts, Brussels, Jan. 7–Feb. 11, 1971; Kunsthalle, Cologne, March 5–April 18, 1971.

Dayton's Gallery 12, Minnesota, *Contemporary Graphics Published by Universal Limited Art Editions*, Feb. 21–March 6, 1968. Exh. cat. with introduction by Harmony Clover.

Documenta 4, Kassel, West Germany, June 27–Oct. 6, 1968. Exh. cat., vols. 1–2 with foreword by Dr. Karl Branner; vol. 1 with foreword by Arnold Bode and essays by Max Imdahl, Jean Leering, Jürgen Harten, and Janni Müller-Hauck; vol 2 with essays by Günther Gercken and Werner Spies (German).

University of California, Art Gallery, Irvine, *New York: The Second Breakthrough, 1959–1964*, March 18–April 27, 1969. Exh. cat. with preface and essay by Alan R. Solomon.

Sidney Janis Gallery, New York, *Seven Artists: Dine, Fahlstrom, Kelly, Marisol, Oldenburg, Segal, Wesselmann*, May 1–31, 1969. Exh. cat.

Hayward Gallery, London, *Pop Art Redefined*, July 9–Sept. 3, 1969. Organized by John Russell and Suzi Gablik. Exh. cat. (New York/Washington: Praeger, 1969) with foreword and introduction by Russell and Gablik and critical statements by Lawrence Alloway, John McHale, and Robert Rosenblum. Includes and artists' statements and individual chronologies.
—Russell, John. "Pop Reappraised." *Art In America* (New York) 57, no. 4 (July–Aug. 1969), pp. 78–89.

Metropolitan Museum of Art, New York, *Prints by Five New York Painters: Jim Dine, Roy Lichtenstein, Robert Rauschenberg, Larry Rivers, James Rosenquist*, Oct. 18–Dec. 8, 1969. Exh. cat.
—Glueck, Grace. "Art Notes: Hanging Henry's Show." *The New York Times* (Aug. 3, 1969), pp. D21–22.

Whitney Museum of American Art, New York, *American Pop Art*, April 6–June 16, 1974. Organized by Lawrence Alloway. Exh. cat. (New York and London: Collier Books and Collier Macmillan in association with Whitney Museum of American Art, 1974) with text by Alloway.
—Perreault, John. "'Classic' Pop Revisited." *Art in America* (New York) 62, no. 2 (March–April 1974), pp. 64–68.
—Geldzahler, Henry and Kenworth Moffett. "Pop Art: Two Views." *Art News* (New York) 73, no. 5 (May 1974), pp. 30–32.

Dallas Museum of Fine Arts and Pollock Galleries, Southern Methodist University, *Poets of the Cities: New York and San Francisco, 1950–1965*, Nov. 20–Dec. 29, 1974. Exh. cat. (New York: E.P. Dutton, 1974) with foreword by Harry S. Parker II and Kermit H. Hunter and essays by Neal A. Chassman, Robert Creeley, Lana Davis, John Clellon Holmes, and Robert M. Murdock. Biography and bibliography by Debra Anne Payne. Traveled to San Francisco Museum of Art, Jan. 31–March 23, 1975; Wadsworth Atheneum, Hartford, April 23–June 1, 1975.
—Perrone, Jeff. "Reviews: 'Poets of the Cities,' San Francisco Museum of Art." *Artforum* (New York) 13, no. 9 (May 1975), pp. 82–89.

Whitney Museum of American Art, New York, *Blam! The Explosion of Pop, Minimalism and Performance 1958–64*, Sept. 20–Dec. 2, 1984. Organized by Barbara Haskell. Exh. cat. (New York: Whitney Museum of American Art in association with W. W. Norton, 1984) with text by Haskell, essay by John G. Hanhardt, and bibliography and chronology by Susan J. Cooke.

The Art Museum, Princeton University, *Selections from the Ileana and Michael Sonnabend Collection: Works from the 1950s and 1960s*, Feb. 3–June 9, 1985. Exh. cat. with introduction by Allen Rosenbaum and essays by Jonathan Bloom, Malcolm R. Daniel, Isabelle Dervaux, Julia Hicks, Sam Hunter, John Otte, Robert Pincus-Witten, and Erica Wolf. Traveled to Archer M. Huntington Art Gallery, University of Texas at Austin, Sept. 8–Oct. 27, 1985; Walker Art Center, Minneapolis, Nov. 23, 1985–March 9, 1986.

National Museum of American Art, Washington, *The Martha Jackson Memorial Collection*, June 21–Sept. 15, 1985. Organized by Harry Rand. Exh. cat. (Washington: Smithsonian Institution Press, 1985) with foreword by Charles C. Eldredge and essay by Rand. Includes exhibition history.

Galleria Nazionale d'Arte Moderna, Rome, *La Collezione Sonnabend. Dalla Pop Art in Poi*, April 14–Oct. 2, 1989. Exh. cat. (Milan: Electa, 1989) with introductory texts by Vincenza Bono Parrino and Francesco Sisinni and essays by Achille Bonito Oliva, Michel Bourel, Maurizio Calvesi, Germano Celant, Jean-Louis Froment, Christos M. Joachimides, Peter Ludwig, Augusta Monferini, Grégoire Muller, Giuseppe Panza, Robert Pincus-Witten, Michel Ragon, Harald Szeemann, and Edi de Wilde. Traveled to Museo Nacional Centro de Arte Reina Sofía, Madrid, Oct. 30, 1987–Feb. 15, 1988; CAPC Musée d'Art Contemporain de Bordeaux, May 6–Aug. 21, 1988; and "Zeitgeist" Gesellschaft Hamburger Bahnhof, Berlin, Dec. 7, 1988–Feb. 26, 1989.

Royal Academy of Arts, London, *Pop Art*, Sept. 13–Dec. 15, 1991. Exh. cat. (London: Royal Academy of Arts and Weidenfeld and Nicholson, 1991) edited by Marco Livingstone, with introductions by Livingstone and Sarat Maharaj, essays by Dan Cameron, Constance W. Glenn, Thomas Kellein, Livingstone, Alfred Pacquement, and Evelyn Weiss (English trans. by David Britt), and artists' biographies by Elizabeth Brooks, Philip Cooper, Simonetta Fraquelli, Caroline Odgers, and Joanna Skipwith. Anthology of writings on American, British, and European Pop art and international Pop art chronology. German edition (Munich: Prestel, 1992) includes additional biography of John Chamberlain by Flora Fisher. Spanish edition (Madrid: Electa España, Elemond, 1992) includes additional essay on Pop art in Spain by Valeriano Bozal and an additional biography of Luis Gordillo by Sagrario Aznar. Second English edition for Montreal (Montreal Museum of Fine Arts, 1992) includes additional preface by Pierre Théberge. Revised version traveled to Museum Ludwig, Cologne, Jan. 23–April 19, 1992; second revised version, *Die Pop Art Show*, traveled to Museo Nacional Centro de Arte Reina Sofia, Madrid, June 23–Sept. 14, 1992; third revised version traveled to the Museum of Fine Arts, Montreal, Oct. 23, 1992–Jan. 24, 1993.

—Crow, Thomas. "The Children's Hour." *Artforum* (New York) 30, no. 4 (Dec. 1991), pp. 84–88.

Museum of Contemporary Art, Los Angeles, *Hand-Painted Pop: American Art in Transition, 1955–62*, Dec. 6, 1992–March 7, 1993. Organized by Donna De Salvo and Paul Schimmel. Exh. cat. (Los Angeles: Museum of Contemporary Art; New York: Rizzoli, 1992), edited by Russell Ferguson, with foreword by Richard Koshalek, introduction by De Salvo and Schimmel, and essays by David Deitcher, De Salvo, Stephen C. Foster, Dick Hebdige, Linda Norden, Schimmel, Kenneth E. Silver, and John Yau. Includes bibliography. Traveled to Museum of Contemporary Art, Chicago, April 3–June 20, 1993; Whitney Museum of American Art, New York, July 16–Oct. 3, 1993.

Scottsdale Center for the Arts, Scottsdale (organized by American Federation of Arts), *Neo-Dada: Redefining Art, 1958–62*, Nov. 4, 1994–Jan. 1, 1995. Exh. cat. (New York: American Federation of Arts in association with Universe Publishing, 1994) with essays by Maurice Berger, Susan Hapgood, and Jill Johnston. Includes interviews, artists' statements, and bibliography. Traveled to the Equitable Gallery, New York, Jan. 27–March 26, 1995; Sara Campbell Blaffer Gallery, University of Houston, June 2–July 30, 1995; Tufts University Art Gallery, Medford, Mass., Oct. 6–Dec. 3, 1995; Florida International University Art Museum, Miami, Jan. 5–March 3, 1996.

The Carnegie Museum of Art, Pittsburgh, *Charles H. Carpenter, Jr.: The Odyssey of a Collector*, March 23–June 9, 1996. Exh. cat. with memoir by Charles H. Carpenter, Jr. and essay by Kay Larson.

The Museum of Contemporary Art at the Geffen Contemporary, Los Angeles, *Out of Actions: Between Performance and the Object 1949–1979*, Feb. 8–May 10, 1998. Organized by Paul Schimmel. Exh. cat. with foreword by Richard Koshalek and essays by Guy Brett, Hubert Klocker, Shinichiro Osaki, Schimmel, and Kristine Stiles. Includes chronology and bibliography. Traveled to MAK (Austrian Museum of Applied Arts), Vienna, June 17–Sept. 6, 1998; Museu d'Art Contemporani, Barcelona, Oct. 15–Jan. 6, 1999; Museum of Contemporary Art, Tokyo, Feb. 11–April 11, 1999.

General Reference Books and Catalogues

Amaya, Mario. *Pop as Art: A Survey of the New Super Realism*. London: Studio Vista, 1965. Reprint. *Pop Art . . . and After*. New York: Viking, 1966.

Banes, Sally. *Greenwich Village 1963: Avant-Garde Performance and the Effervescent Body*. Durham and London: Duke University Press, 1993.

Hansen, Al. *A Primer of Happenings & Time/Space Art*. New York: Something Else Press, 1965.

Kirby, Michael. *Happenings: An Illustrated Anthology*. New York: Dutton, 1965.

McDarrah, Fred W. with Thomas B. Hess and Gloria S. McDarrah. *The Artist's World: In Pictures: The New York School*. New York: Shapolsky, 1961, second ed. 1988.

Reiss, Julie H. "From Margin to Center: The Spaces of Installation Art, 1958–1993." Ph.D. diss., City University of New York, 1996.

Seitz, William. *The Art of Assemblage*. New York: The Museum of Modern Art, 1961.

Solomon, Alan R. With photographs by Ugo Mulas. *New York: The New Art Scene*. New York: Holt, Rinehart, and Winston, 1967.

General Reference Articles

Articles include references to Dine or provide general information for the 1959–1969 time period.

Alloway, Lawrence. "Art in Escalation. The History of Happenings: A Question of Sources." *Arts Magazine* (New York) 41, no. 3 (Dec. 1966–Jan. 1967), pp. 40–43.

Barozzi, Paolo. "16 'Happenings' a New York." *Metro* (Milan), no. 3 (1961), pp. 114–16.

Celant, Germano. "Artspaces." Translated by Jane Carroll. *Studio International* (London) 190, no. 977 (Sept./Oct. 1975), pp. 116–123.

Constable, Rosalind. Papers, 1935–1967, unpublished, unpaginated; in Time Inc. Corporate Archives, New York.

Drucker, Johanna. "Collaboration With Object(s) in the Early Happenings." *Art Journal* (New York) 52, no. 4 (winter 1993), pp. 51–58.

du Plessix, Francine. "Painters and Poets" *Art in America* (New York) 53, no. 5 (Oct.–Nov. 1965), pp. 24–56.

Gray, Cleve. "Print Review: Tatyana Grosman's Workshop." *Art in America* (New York) 53, no. 6 (Dec. 1965/Jan. 1966), pp. 83–85.

Haywood, Robert E. "Heretical Alliance: Claes Oldenburg and the Judson Memorial Church in the 1960s." *Art History* (Oxford and Cambridge, Mass.) 18, no. 2 (June 1995), pp. 185–212.

Hess, Thomas B. "Collage as a Historical Method." *Art News* (New York) 60, no. 7 (Nov. 1961), pp. 30–33, 69–71.

"Introducing the Generation: A Foldout Gallery: Young Leaders of the Big Breakthrough: A Red-Hot Hundred." *Life* (Chicago) 53, no. 11 (Sept. 14, 1962), p. 4.

Jackson, Martha Kellogg. Interview with Paul Cummings, May 23, 1969. Audiocassette and transcript on file with the Archives of American Art, Smithsonian Institution, Washington, D.C. Reel no. 4210.

Kaprow, Allan. "Happenings in the New York Scene." *Art News* (New York) 60, no. 3 (May 1961), pp. 36–39, 58–62.

———. "A Legacy of Jackson Pollock." *Art News* (New York) 57, no. 6 (Oct. 1958), pp. 24–26, 55–57.

Kozloff, Max. "Art and the New York Avant-Garde." *Partisan Review* (New Brunswick) 31, no. 4 (fall 1964), pp. 535–54.

Mandelbaum, Ellen. "Isolable Units, Unity, and Difficulty." *Art Journal* (College Art Association of America, New York) 27, no. 3 (spring 1968), pp. 256–61, 270.

"The New Interior Decorators." *Art in America* (New York) 53, no. 3 (June 1965), pp. 52–61.

Restany, Pierre. "Une Tentative Américaine de Synthèse de l'Information Artistique: les Happenings." *Domus* (Milan), no. 405 (Aug. 1963), pp. 35–42 (French, English, and Italian).

Rose, Barbara. "Dada Then and Now." *Art International* (Zurich) 7, no. 1 (Jan. 25, 1963), pp. 22–28.

Solomon, Alan R. Papers on deposit with the Archives of American Art, Smithsonian Institution, Washington, D.C. Reel nos. 3921–3928.

———. "American Art Between Two Biennales." *Metro* (Milan), no. 11 (1966), pp. 24–35.

Swenson, G. R. "The New American 'Sign Painters'" *Art News* (New York) 61, no. 5 (Sept. 1962), pp. 44–47, 60–62.

Wedewer, Rolf. "Environments and Rooms." Translated by Michael Werner. *Art and Artists* (London) 5, no. 4 (July 1970), pp. 16–19.

Wesselmann, Tom. Jan. 16, 1984, segment of interview with Irving Sandler. Interviews conducted Jan. 3–Feb. 8, 1984, as part of the Archives of American Art Oral History Program. Audiocassettes and unpublished transcript on deposit with the Archives of American Art, Smithsonian Institution, Washington, D.C.

Index of Reproductions

By figure number. Works are by Jim Dine unless otherwise noted.

Photo credits

By figure number.

1, 13, 40-42, 44-46, 51-53, 55, 64: Robert R. McElroy; 2, 142: John Webb,
© Tate Gallery London; 3, 20, 27, 29, 56, 62, 71, 93, 95, 99, 104, 109, 130,
134, 141, 144, 145, 149–52: Ellen Page Wilson, courtesy PaceWildenstein;
4: Bill Jacobson, courtesy PaceWildenstein; 5: courtesy photographic
archives of Museo Nacional Centro de Arte Reina Sofía; 7, 18, 30, 60, 75:
© 1998 The Museum of Modern Art, New York; 8, 129: Hans Namuth,
©Hans Namuth 1990; 9: ©1999 The Museum of Modern Art, New York;
12: John G. Ross; 19, 23, 25: Ellen Page Wilson; 21: Tony Walsh; 22, 68:
Bob Mitchell; 24: Oscar Balducci; 26: Michael Tropea; 28, 77, 94, 114, 137:
courtesy Sonnabend Gallery; 31, 36, 43, 50, 54: Ellen Labenski; 32, 33, 119:
Gordon Riley Christmas; 34-35, 37-39: Martha Holmes/Life Magazine,
© Time Inc.; 49, 155: courtesy Monacelli Press; 57, 133: John Sigfried,
© Allen Memorial Art Museum, Oberlin College, Ohio; 58: David
Heald; 59, 100: Sheldan C. Collins, N.J. © 1998 Whitney Museum of
American Art, New York; 61: C. Kaufman; 63: Geoffrey Clements,
courtesy Special Collections, Frances Mulhall Achilles Library, Whitney
Museum of American Art, New York; 65: Bill Jacobson Studio, courtesy
PaceWildenstein and Monacelli Press; 66: Lothar Schnepf; 67: ©1987
The Metropolitan Museum of Art, New York; 69: courtesy Richard Gray
Gallery, Chicago/New York; 70: Mimmo Capone; 72: © The Solomon R.
Guggenheim Foundation, New York; 74: courtesy Carnegie Museum of
Art; 76: courtesy PaceWildenstein; 82: courtesy Gio Marconi; 84: ©1991
Douglas M. Parker, Los Angeles; 85: Scott Miles; 87: courtesy Baltimore
Museum of Art; 91: courtesy Sotheby's New York; 92: courtesy
PaceWildenstein and Monacelli Press; 96: Dan Soper; 97, 123, 124: Eric
Pollitzer, courtesy Sidney Janis Gallery; 98: Phillips/Schwab; 103: Robert
Häusser, Darmstadt; 107: Janet Woodard, Houston; 110: © 1998 The Art
Institute of Chicago, all rights reserved; 111: Sheldan C. Collins, N.J.
© 1996 Whitney Museum of American Art, New York; 112: Dirk Bakker;
113, 135, 136, 156: Ugo Mulas, © Ugo Mulas Estate; 117: Gary Mamay;
118: courtesy PaceWildenstein, © Ellen Page Wilson 1991; 121, 148, 154:
Gordon Riley Christmas, courtesy PaceWildenstein; 122: © Grey Art
Gallery and Study Center, New York; 126: courtesy PaceWildenstein; 127:
Susan Einstein; 128: Katherine Wetzel, © Virginia Museum of Fine Arts;
138–40: Elisabeth Novick, © 1998 Elisabeth Novick; 143: Ian Reeves 1998;
147: Tom Haartsen; 153: Ruriel Anssens.

Bibliographic sources

By page number.

46: Dine, *Welcome Home Lovebirds: Poems and Drawings* (London: Trigram
Press, 1969), p. 26; 58: Ibid, p. 18; 66: Dine, in "Jim Dine," *Rolling Stone*
(San Francisco), no. 40 (August 23, 1969), p. 36; 78: Reprinted in Michael
Kirby, *Happenings: An Illustrated Anthology* (New York: Dutton, 1965),
p. 190; 88: Dine, quoted in Ibid, p. 187; 96: Dine, *Welcome Home Lovebirds*,
p. 20; 108: Dine, quoted in an interview with Alan R. Solomon for
"U.S.A. Artists, Jim Dine," National Educational Television, Channel 13,
New York, 1966; 112: Dine, *Welcome Home Lovebirds*, p. 35; 128: Dine,
quoted in Solomon; 130: Ibid; 152: Dine, *Welcome Home Lovebirds*, p. 47;
166: Dine, quoted in G. R. Swenson, "What is Pop Art?" *Art News* (New
York) 62, no. 7 (Nov. 1963), p. 61; 172: Dine, *Welcome Home Lovebirds*, p. 10;
179: Dine, quoted in Solomon; 196: Dine, quoted in Gruen, "All Right
Jim Dine, Talk!" *New York: World Journal Tribune* (New York) Nov. 20,
1966, p. 34; 210: Dine, quoted in Solomon.